THE GREAT
PAINTERS
OF CHINA

MAX LOEHR

THE GREAT PAINTERS OF CHINA

Icon Editions

HARPER & ROW, PUBLISHERS

NEW YORK

Cambridge	London
Hagerstown	Mexico City
Philadelphia	São Paulo
San Francisco	Sydney

1817

THE GREAT PAINTERS OF CHINA

ISBN: 0-06-435326-5 (cloth); 0-06-430105-2 (paper)

Library of Congress Catalog Card Number: 79-6030

80 81 82 83 84 10 9 8 7 6 5 4 3 2 1

❦ Contents ❦

❦ *Preface* ❦

Art : a second nature, mysterious too, but more intelligible ;
for it springs from intelligence.

To an educated Chinese this saying of Goethe might have an almost familiar ring. He would remember that two centuries earlier an eminent painter and theorist named Tung Ch'i-ch'ang (1555–1636) had made a pronouncement that dealt with the same matter. He said, 'In terms of the wonders of scenery, painting does not equal nature. In terms of the marvels of brush and ink, however, nature decidedly does not equal painting.'

The marvels Tung had in mind were the creations of the great masters since antiquity—works extant or, if lost, unforgotten—the works on which tradition rests. Respectful of that tradition, the Chinese painters produced much that alluded to it, in subject or, more importantly, in style. Some of their allusive images barely rose above the level of faithful copies. Others were free imitations of an enduring prototype. Still others modified, sometimes drastically, the style of the alleged model. It was in this last category, where the personality of the 'copyist' fully asserted itself, that something like a continuous dialogue with the ancients began, lending a quality of transparency to the story of later painting. In that imaginary dialogue, rational matter such as style or pictorial ideas was discussed as if it were nature.

Serious inquiries into the question of an artist's freedom in respect of form-likeness had begun as far back as Sung, a phase of intense realism (tenth–thirteenth centuries), which left no problem of form-likeness unsolved. That phase was followed by the subjective expressionism of the Yüan (fourteenth century), when realism no longer mattered; and it was preceded by phases concerned with the creation of intelligible symbols for visual reality, trees and rocks, water and clouds.

The author, who with Konrad Fiedler believes that art exists not to express its time but to give content to its time, attempts here to present the story of Chinese painting in a meaningful sequence: phases of unified content or intrinsic meaning, independent of extraneous, non-artistic factors.

What the writer ventures to ask of his readers is leniency on two points. The first one is my having given short shrift to matters of historical and cultural backgrounds, on the assumption that painting, like music or calligraphy, is a more or less closed system; much of those background matters remain extraneous and are unsuited to explain creative events. The second point concerns my somewhat uneven treatment of the earlier and the later periods, respectively; though dictated to some extent by the nature and quantity of the available, extant works, this unevenness may in part have been caused by my own preferences and limitations. Whatever the shortcomings of this book, I had the good fortune of receiving the unfailingly given encouragement of Laurence Sickman and James Cahill.

Like all writers in the field of Chinese painting, I am greatly indebted to the work of Osvald Sirén, to whose seven volumes of *Chinese Painting, Leading Masters and Principles* the reader is often referred.

Specifically I wish to acknowledge with thanks the help given by the following persons: Professor J. C. Y. Watt, Institute of Chinese Studies in the Chinese Uni-

versity of Hong Kong at Shatin; Mrs Fumiko Cranston, Research Assistant in the Rübel Asiatic Research Bureau of the Fogg Art Museum, Harvard University; Signora F. Superbi of the Fototeca Berenson at I Tatti in Florence-Settignano; Mrs Y. L. Chao, Librarian in the Rübel Asiatic Research Bureau. To Dr Rei Sasaguchi I am very grateful for having arranged visits to private and public collections in Japan in 1976. To Dr Louisa Fitzgerald Huber, Assistant Professor of Chinese Art in the Department of Fine Arts, Harvard University, I am indebted for her selflessly given time in reading and correcting the chapters 6 to 10, as well as for supplying the Bibliography. Mr Robert W. Bagley, Ph.D. candidate in Chinese art at Harvard University, kindly read, and improved upon, some of the earlier chapters. To Mr and Mrs R. W. Finlayson of Toronto I am much beholden for permitting me to reproduce in colour the magnificent *Lotus* by Tao-chi in their collection. I likewise am grateful to Mr Low Chuck Tiew (Liu Tso-ch'ou), Hong Kong, for the permission to illustrate two outstanding works from his collection, a Chang Feng (Fig. 176) and a Ch'en Hung-shou (Fig. 162).

My acknowledgements of the courteously given permission to reproduce works in the possession of private collectors, museums and institutions will be found in the captions to the illustrations.

Finally, I wish to express my feeling of gratitude to the publishers, Phaidon Press, for their patience and care, and in particular to the editor, Miss Penelope Marcus, but for whose circumspection and energy my manuscript might never have gone to the printer.

M. L.
Cambridge, Mass.

The rise of pictorial art

In a concise survey of the art of painting in China we may become aware of a meaningful sequence of phases, which in turn can guide us toward an historical concept of the story of painting. Of course, it is possible to appreciate the artistic values of a work of whatever period without any such concept at all. For a fuller understanding, however, a work needs to be seen in its historical place.

Chinese painting did not begin with pictures. It began, millennia before, with ornamental designs, freely invented and unencumbered by the necessity of imitating nature. The surrender of the freedom of invented forms to the seeming unfreedom of observed forms was a fateful step taken about the time of the Western Han (206 B.C.–A.D. 8). This new art of representing external reality in pictorial form made unprecedented demands on visual knowledge and imagination, demands so challenging to the artistic avant-garde of the time that the long unrivalled older art of ornamental design unavoidably came to be relegated to a lower level. Still, ornamental art not only supplied the inexperienced new realists with their first workable conventions for landscape elements, such as the terrain, a cliff or a forested range, but also remained a well-spring of solutions for the elusive phenomena of water, clouds, or fire as late as the sixth century.

Whether a work was ornamental or representational, what was valued was the quality of aliveness. This quality, which vouches for artistic value, does not, of course, depend on subject-matter or motif. Even a pattern of the utmost simplicity—such as the parallel strokes on a Neolithic pottery sherd from Kansu in the Stockholm Museum of Far Eastern Antiquities (Fig. 1)—possesses life and a modicum of joyous expression. When some thousands of years later, after endless metamorphoses, there appeared such incalculable, fiery, curvilinear, ornamental patterns as those on the lacquer-painted coffins from the Ma-wang-tui Tomb No. 1 at Ch'angsha in Hunan, dating from the early second century B.C. (Fig. 2), they occurred in association with one of the oldest known realistic pictures, painted on a banner from the same tomb (Pl. 1). The picture, surrounded by symbolic configurations of sun and moon, dragons, animals and human figures, apparently represents the lady who was buried in this lavishly equipped tomb. She is a matronly figure in a robe with curvilinear patterns, facing two kneeling servants; behind her, slightly smaller and slimmer, stand three women in a tightly-knit group, wearing plain robes as do the two servants. The spacing accentuates the figure of the lady in the middle. Like the attendants she is shown in profile and standing on a ground-line. The discrepancy between ground-line and implied oblique recession in the case of the three women remains unresolved. The conquest of the third dimension, depth, was yet to come.

A closer look at the swirling cloud patterns on the coffin (Fig. 2) reveals them to be the haunts of strange creatures, otherworldly in their behaviour and character, of animals pursued, and of large birds. This remarkable combination of ornamental forms with more or less realistic creatures roaming between them[1] also distinguishes a few early Han bronze tubes decorated in gold and silver inlay, where

traditional 'cloud ornaments' function as landscape settings. In one section of such a
tube in the Tokyo University of Arts, a tiger hunt in the hills is represented (Fig. 3).[2]
The lines forming the terrain or the hills are derived from ornaments, but they are
reinterpreted and given a new function. Between these vigorously curved lines there
appear flying birds and various animals, such as deer, a bear, a boar, and a hare.
Largest is the figure of a mounted hunter who turns back, in the posture of the Par-
thian shot, aiming his bow at a tiger behind him. Here, there is as yet no vision of
hills. The realistically rendered fauna is attached to a conventional pattern, which
thereby assumes the role of hills or cliffs. The same principle of organization ob-
tains in the décor of a bronze tube of somewhat earlier date in the collection of the
late Marquis Hosokawa.[3]

The earliest known attempts to represent realistic scenes in more or less pictorial
form take us back to the period of the Warring States (488–222 B.C.). These scenes,
found both in relievo and intaglio on bronze vessels, represent in silhouette the
figures of warriors, boatmen, musicians, hunters, trees, buildings and the like. The
scenes shown in our example (Fig. 4) depict indoor events, perhaps at a feudal
court: in the upper register, either games are being played or drinks prepared; in
the lower register, kneeling men strike a set of bells; women, a set of stone chimes
and a drum; the woman farthest left appears to play a small wind instrument. The
percussion instruments are suspended from a long rack supported by a big bird
figure at either end.[4] Compared with the sophistication and verve of contemporary
ornamental design in whatever medium (painting on clay, lacquer painting, cast
bronze, metal inlay), these proto-pictorial, almost diagrammatic representations

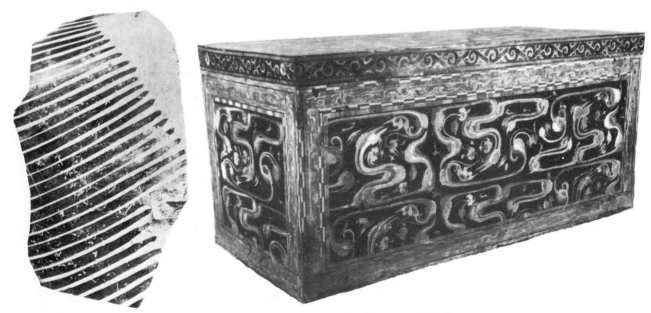

FIG. 1 Neolithic pottery sherd from Ma-chia-yao, Kansu. Stockholm, Museum of Far Eastern
Antiquities.

FIG. 2 Lacquer-painted coffin from the Ma-wang-tui, Ch'ang-sha, Hunan. First half second century
B.C. Ch'ang-sha Museum.

seem curiously primitive. Nor can they be securely traced in the pictorial tradition that began in the Han period.

Unexpected in Han art are new forays into the world of nature, as in relief designs on clay tiles from the distant province of Szechwan. One of these tiles depicts in low relief the mountainous setting of a salt mine at Ch'iung-lai, southwest of Ch'eng-tu (Fig. 5). In the lower left corner we can make out a tall scaffold, where four men are busy hauling up the brine. Further to the right, two men are shown carrying brine to a saltern in the lower right corner, where another man kneels in front of a long stove, fuelling the fire. Bounded by the outlines of three conical hills, the scenes appear, as it were, in projection on the flat surfaces of those hills. The three hills rise from the lower edge and therefore share the same ground-line, although their overlapping would suggest a recession from right to left. The same

A B

FIG. 3A–B A Tiger Hunt: Animals and a Mounted Hunter and Tiger in a Landscape-like Setting. Drawings of gold inlay pattern on a bronze tube from Lo-lang, Korea, c. 100 B.C. Tokyo, University of Fine Arts.

FIG. 4 Musicians and Other Figures. Intaglio diagram on a bronze *Hu*. The Warring States period. Peking, Ku Kung Po-wu-yüan.

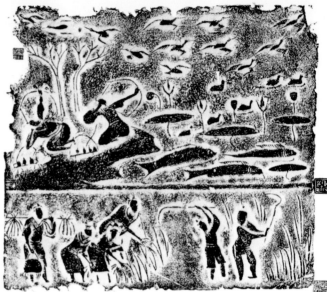

FIG. 5 A Salt Mine at Ch'iung-lai. Clay tile. From Szechwan.

FIG. 6 Bird Hunters and Harvesters. Rubbing from a clay tile. From Szechwan.

spatial discrepancy was observed in the picture from Ma-wang-tui. A fourth cone emerges behind the hills in front. Higher up and farther back there rises a large and boldly drawn formation that stretches across the entire width of the slab. A range of smaller cones surmounted by trees fills the remaining space along the upper edge. Trees and animals enliven the faces of the hills throughout. There is no indication of foliage on any of the trees. Presumably the sharp linear definition given those leafless trees was found telling enough.

Another clay tile from Szechwan represents less imposing subjects: bird hunters by a lake in the upper tier, and harvesters in the field in the lower tier (Fig. 6). The lake, however, is symbolized by flowering lotus and big fish, rather than represented, and while the sky is full of wild ducks in flight, there is no indication of a distant shoreline. The harvesters stand on a slightly tilted ground as indicated by the simple device of obliquely receding rows of the plants about them. Moreover, while most of the figures occupy an imaginary ground-line near the lower edge, one of the men is clearly set back into deeper space.

What I should like to stress is the fact that originally painting was concerned with ornamental design. When at last, in the early Han dynasty, there occurred a shift toward the representation of reality in pictorial form, there was a variety of sources to draw on, ranging from ornament as such to the new, direct, and unprecedented conquests from nature. What mattered from here on was the creation of expressive conventions.

Notes

1. See *Ch'ang-sha Ma-wang-tui i-hao Han-mu*, vol. 2, pls. 38–56.
2. After Mizuno, *Painting of the Han Dynasty*, no. 2.
3. See Rostovtzeff, *Inlaid Bronzes*, pls. 2–3.
4. After Consten, *Das alte China*, p. 238, fig. 30; also see Sullivan, *Birth of Landscape Painting*, figs. 8–11.

Figure painting of the Six Dynasties
(221–589)

Unavoidably this chapter deals with names and memories rather than works. The actual paintings of the masters active between Han and T'ang are probably lost, and all that remains are literary echoes and an occasional copy after some unknown model. But the names of the earliest masters resounded through the centuries. Their merits were passionately argued by T'ang and pre-T'ang critics; Sung writers claimed to own or to have seen works by some of them; Ming painters still followed their styles, or professed to do so, without ever having encountered a single original work.

Earliest among those half-legendary figures was **Ts'ao Pu-hsing**, a native of Wu-hsing in Chekiang, south of T'ai Hu (Grand Lake), who was active in the early years of the Wu Kingdom (222–80) and was regarded as the foremost painter of his time. His favourite subjects were dragons, tigers, wild animals and barbarians, and he is said to have painted a Buddha figure of monumental size, fifty feet high. There is nothing anachronistic about the former subjects, but the Buddha image might seem to coincide all too conspicuously with the recorded beginnings of a Buddhist community at Chien-yeh (Nanking), the Wu capital, in about 247. Ts'ao was apparently still active about the middle of the century, for it is recorded that *Red Dragon Appearing above the Waters of the Blue Stream*, a picture much admired by Lu T'an-wei, was commissioned from him in 238 by Sun Ch'üan, emperor of Wu (the fourth in the scroll *Thirteen Emperors* by Yen Li-pen in the Boston Museum of Fine Arts). A single work attributed to Ts'ao was in the collection of Emperor Hui Tsung (reigned 1101–1126), a scroll entitled *The Dark Female Receiving a Military Tally from the Yellow Emperor*. Often mentioned in the art literature of later times but not before Sung, it was described as being of utterly strange style. The Yüan critic T'ang Hou, however, who once saw the scroll at Ch'ien-t'ang, thought it was a work of late T'ang or early Sung date. The 'Mysterious Woman', as the name of the dark female might also be rendered, taught Huang Ti, the Yellow Emperor, the arts of war and helped him to defeat the monstrous Ch'ih-yu, mythical war-god and inventor of metal weapons.

The only reference to style to be found in the stories about Ts'ao Pu-hsing concerns his handling of drapery, described as clinging to the figures like wet clothes. But the saying,

> Ts'ao's garments come out of the water,
> Wu's scarves are fluttering in the wind[1]

cannot be older than Wu Tao-tzu (c.689–c.758) and moreover was also used to describe the figures of Ts'ao Chung-ta of the Northern Ch'i Dynasty (550–77). This later Ts'ao was far more likely to be compared with an eighth-century master than was the Ts'ao of the third century, all the more so since the latter's works were already lost by about the year 500. Hsieh Ho, who wrote his *Ku Hua-p'in-lu* at about that time, speaks of a *Dragon Head* in the Imperial Library of the Southern

Ch'i Dynasty (479–502) as the last remnant of Ts'ao Pu-hsing's oeuvre. Thus, the accounts offer no hint about Ts'ao's style.

As for his dragons, for which he was chiefly remembered, we may not go far wrong by imagining them as prototypes of the ghostly creatures that are known from Korean tombs of the Koguryŏ Kingdom (37 B.C.–A.D. 668), where colourful wall paintings depict dragons eerily disembodied, all rhythm and speed. It is far more difficult to suggest any figure painting of the same period that might possibly be related to Ts'ao Pu-hsing's style. The only important work likely to date from the third century is a group of painted bricks given by Dr Denman Ross to the Museum of Fine Arts, Boston. A detail from one of the bricks (Fig. 7) shows a group of ladies in their state attire, their slender figures drawn with marvellous freshness and elegance. The forms are large, securely outlined with modulated brush strokes, and sweep rhythmically across the intervening spaces. That these gracefully moving figures are ultimately derived from the design of a master draughtsman cannot be doubted, and he may have been a contemporary of Ts'ao Pu-hsing. If so, the Ross Bricks may give us a tantalizing hint of the level of figure painting in Ts'ao Pu-hsing's days.

Wei Hsieh, who like Ku K'ai-chih was active under the Eastern Chin (317–420) at Nanking (then called Chien-k'ang), is said to have been a pupil of Ts'ao Pu-hsing. On chronological grounds it seems preferable, however, to think of him as a follower, who must have been familiar with some of Ts'ao's paintings. His rank as an artist has troubled the consciences of critics ever since Hsieh Ho, who, in recognition of Wei's command of all the Six Principles established in the *Ku Hua-p'in-lu*, placed him in his first class, after Lu T'an-wei and Ts'ao Pu-hsing. The Six Principles are:

1. animation through spirit-consonance;
2. structural method in the use of the brush;
3. fidelity to the object in portraying forms;
4. conformity to kind in applying colours;
5. proper planning in the placing of elements;
6. transmission of the experience of the past in making copies.

Hsieh Ho further recognized Wei's marvellous 'spirit-consonance' (*ch'i-yün*) and his achievement of *ching*, a refinement, minuteness, or precision that contrasted with the *lüeh*, a summary or casual quality of all older art. Ku K'ai-chih also admired Wei Hsieh profoundly and he may have influenced Hsieh Ho in ranking Wei above himself. Ku spoke of *The Seven Buddhas* and the larger version of *The Heroines* (*Lieh-nü*) as imposing yet sensitive images; *The Heroines* and *North Wind* (after a theme in the *Odes*) he considered beyond his reach. Chang Yen-yüan, author of the *Li-tai ming-hua-chi* (847), admits he first felt uneasy about Wei Hsieh being placed above Ku K'ai-chih, but then decided to let Ku speak for himself in this matter and to let Hsieh Ho's judgement stand.

Among Wei's paintings noted in the *Li-tai ming-hua-chi* the *Shang-lin Park* is designated as a 'white' or 'blank' painting (*pai hua*);[2] it is the first recorded instance of a landscape without colour, relying on ink outline alone, an outline elsewhere described as 'fine like a spiderweb, yet forceful'. This 'yet forceful' seems as if it

were registering something unexpected, as does the 'marvellous spirit-consonance' achieved despite some shortcomings in the master's degree of naturalism. If any conclusion can be drawn from these few and tersely expressed reactions of his critics, it could be that while Wei Hsieh may not quite have equalled Ts'ao Pu-hsing in sheer skill, nevertheless his unwonted elaboration, which may have seemed timid when compared with the simpler, rougher, and perhaps bolder manner of his predecessors, was finally recognized as a positive quality. As late as the sixteenth century, Wei Hsieh was counted by Wang Shih-chen (1526–90) among the four saints of figure painting—an honour he shared with Ku K'ai-chih, Lu T'an-wei, and Wu Tao-tzu.

Ku K'ai-chih (344–405?) from Wu-hsi, Kiangsu, north of Grand Lake was, according to the *Li-tai ming-hua-chi*, one of the three disciples of Wei Hsieh.[3] He was of the same generation as Wang Hsien-chih (344–88), the son of Wang Hsi-chih (321–79), and he was also a contemporary of Kumārajīva (350–409), the princely Buddhist monk from Karashahr and immensely influential translator of Mahayana scriptures from Sanskrit into Chinese. Ku was barely ten in 353 when Wang Hsi-chih wrote his *Lan-t'ing chi-hsü* ('Preface to the collection of poems composed at

FIG. 7 Group of Ladies. Detail from a late Eastern Han painted brick. Boston, Museum of Fine Arts, Dr Denman Ross Collection.

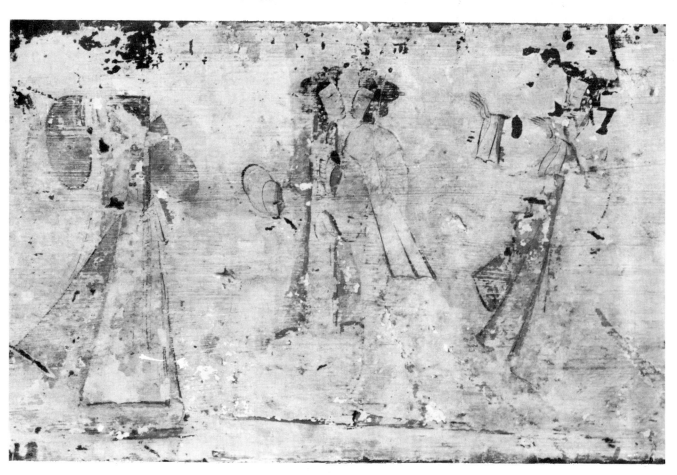

Lan-t'ing'), a prose essay imbued with feelings of the transience of human existence and the inevitability of death—a model of literary composition and, what is more, the supreme model of calligraphy of all time. Ku's official biography in the *Tsin-shu*,[4] while placing him in the 'Garden of Literature', acknowledges his fame as a painter and portraitist with the exquisite compliment of quoting the notable Tsin statesman Hsieh An (320–85): 'Since man existed, there has been none like him.' The biography also leaves no doubt about his character being compounded of intelligence and tomfoolery, or 'intelligence and folly' in the words of General Marshal Huan Wen (312–73), under whom he served as aide-de-camp. Ku died at the age of sixty-one while holding office as Cavalier Attendant-in-ordinary, a position of high honour given to men of declining years.[5]

Ku K'ai-chih's fame as a painter was established when in 364, at the age of twenty, he did a wall painting representing Vimalakīrti—the brilliantly conceived character of a layman who denies himself no worldly pleasures and yet confounds the Buddha's disciples by his deeper understanding of metaphysical notions such as non-duality—for the Wa-kuan-ssu, or Tile Coffin Temple, at Chien-k'ang. If the date can be trusted, Ku's mural was painted before Kumārajīva's translation of the *Vimalakīrti-Nirdeśa sūtra*, and would, therefore, have been based on the earlier translation made during the second quarter of the third century by Chih-ch'ien (a contemporary of Ts'ao Pu-hsing in the Wu Kingdom). Chang Yen-yüan in the *Li-tai ming-hua-chi* credits Ku with being the first to portray Vimalakīrti 'with pure and emaciated features that plainly showed his illness'—the illness of existence in a world of suffering. Since the Wa-kuan-ssu burned down in 396, and the mural presumably perished, Chang must have made his judgement from another version of the portrait. In chapter three of the same text such a portrait is indeed recorded as having survived the Buddhist persecution of 845, and the passage tells that Ku K'ai-chih was the first to give a psychological interpretation of the person portrayed. Ku's serious concern with the expression of the human face is evident from several passages in his biography and also speaks through what survives of his own writings.

Ku K'ai-chih is the only painter of antiquity represented today by extant copies and in addition by a possible original, the famous handscroll in the British Museum known as *The Admonitions of the Instructress to the Palace Ladies* or, less cumbrously, *Nü Shih Chen* (Pl. II, Figs. 8, 9). This scroll consists of a sequence of scenes preceded by short inscriptions from a text by one Chang Hua (232–300). The moralizing tone of the text, tempered by a feeling of the transience of human affections, did not hinder Ku from applying his witty or irreverent touch to some of the illustrations, even though he was deeply serious in his graphic expression of the subject-matter—the relationship between men and women, specifically that of the prince to his consorts. Painted in ink and colour, mainly vermilion, on silk, the figures are drawn in exceedingly fine, barely modulated brush lines, such as were first used, we may imagine, by Wei Hsieh. There is nothing of the sketchiness and sweep of the Ross Bricks in these figures, even though they resemble the ladies on the bricks as types. Nothing is left to chance. The tenderly and precisely drawn lines define luxurious draperies, postures, and characters, moreover conveying somehow an aura of human refinement, enhanced by the spacing and relative isolation of each of the figures.

夫言如微榮辱由茲勿謂玄漠靈鑒無象
勿謂幽昧神聽無響箴無待爾榮天道惡
盈無恃爾貴隆者隆鑒于小星戒彼
逐比心鑒斯則繁爾類

FIG. 8 Attributed to Ku K'ai-chih, *An Emperor*. Detail from *The Admonitions of the Instructress to the Palace Ladies*. London, British Museum. See also Plate II.

By comparison with earlier periods the degree of differentiation achieved in the characterization of these figures is a cause for wonder. A Han figurine might indicate little more than 'woman', but the figures in this scroll tell infinitely more—sex, age, breeding and, if vaguely, something of the individual character. Doubtless it was this deeper probing into man's soul that accounts for Ku's statement that in painting there was nothing more difficult than man.

None of the figures is a stereotype in either design or expression. But some of them have suffered irreparable damage through retouching. The draperies, which are unretouched or marred only by a few scraggy ink lines added by a later hand, show delightful curvilinear formations, which are not simply representational but nearly abstract designs. The lineament of the emperor's attire (Fig. 8), for instance, while approximating to the posture of a squatting person, does not really describe what is underneath the delicate, rhythmic structure of undulating outlines and intersecting oval shapes. This playful elegance is more obvious in the invented forms of the lady's floating scarves (Pl. 11) and in the softly shaded curtains of the bed, tied with broad, slowly twisting ribbons (Fig. 9). Unlike the design of the curtains, which is only comparable to later styles of the sixth or seventh century, that of the floating scarves recurs in the copies after Ku's *Nymph of the Lo River* (Fig. 10) and in the engraving on the sixth-century stone sarcophagus in the Nelson Gallery of Kansas City (see page 24 below).

The dates proposed for the *Admonitions* range from Eastern Tsin (late fourth century) to Northern Sung (tenth and eleventh centuries). Most critics favour a T'ang date: the oldest seal on this scroll, '*Hung-wen-kuan*', dates from the T'ang period and the texts are written, as plausibly shown by Nakamura Fusetsu, in T'ang style. More important, however, is the question of how faithfully this scroll represents the style of a fourth-century original. The answer must be that, except the motif of the mountain, there are no significant traits to conflict with the earliness of its style. But the mountain is treated in a manner incomparably more sophisticated than the archaic hills of the *Nymph of the Lo River* or, for that matter, any mountain scenery up to the sixth century if not the seventh.

The Nymph of the Lo River is based, like the *Admonitions*, on a literary composition, in this case a piece of rhythmic prose by Ts'ao Chih (192–232), a son of Ts'ao Ts'ao. Ts'ao Chih describes his encounter with the fairy, a daughter of the mythical emperor Fu-hsi, supposed to have drowned in the Lo River. It is a handscroll of which there exist three versions, none of them apparently older than Sung: the Peking version, which is the most complete and refined; the Freer Gallery fragment (Figs. 10, 11), vouched for as Ku's work in a colophon by Tung Ch'i-ch'ang; and a lesser variant in the Liao-ning Museum. These versions are consistent enough to suggest a common prototype of archaic style, whose authorship, however, remains uncertain. Any fourth-century original might well have passed for a Ku K'ai-chih by the time of Sung when Ku had become something like 'Mr Fourth Century'. Unlike the *Admonitions*, this work places the scenes in a continuous landscape setting (Figs. 10, 11), which is of a touching simplicity, consisting only of hills, trees and waters. The hills form simple silhouettes not far removed from Han conventions. The trees, of two or three carefully distinguished types, are related to the hills with a blithe disregard of scale; they are lovely in their rudimentary expressiveness

as willows or gingkos rather than just trees. For the waters, there is as yet no formula beyond flow and swirl or, generally, a linear pattern that characterizes water as such rather than its particular states. There is no such thing as depth or space yet, unless it is generated around some three-dimensional object or configuration, as in Han designs.

Of *The Heroines* (*Lieh Nü T'u*), imaginary portraits inspired by the text of Liu Hsiang (80–9 B.C.) on 'Heroic Women of Antiquity' (*Ku Lieh Nü Chuan*), there exists a Sung version at the Hui-hua-kuan in Peking, said to be after Ku K'ai-chih. It is a coarser work than the *Admonitions*; the faces, in particular, lack subtlety and warmth. But the grandiose design of the robes is stylistically compatible with the *Admonitions*, although the statuesque figures possess a monumental and sombre quality of their own. A touch of plasticity in these figures is suggested by the technique of shading, which in the *Admonitions* appears only in the curtained bed. If the question of how these two scrolls, or more exactly the originals behind them, relate to each other stylistically and chronologically should be answered some day, we shall have a clue to Ku's development as a painter.

FIG. 9 Attributed to Ku K'ai-chih, A Curtained Bed. Detail from *The Admonitions of the Instructress to the Palace Ladies*. London, British Museum. See also Plate II.

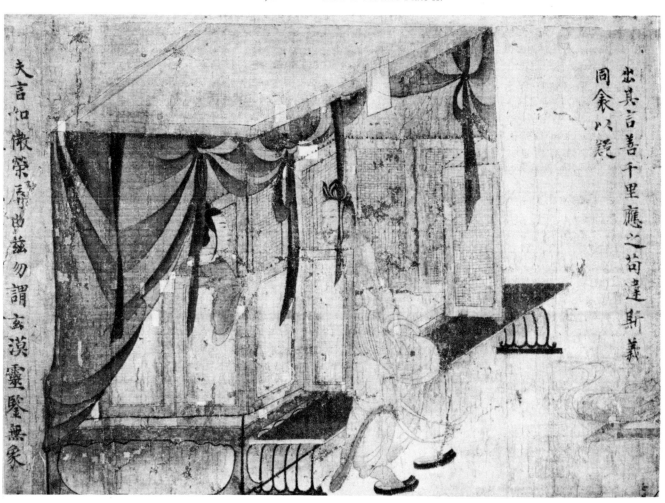

FIG. 10 Detail from *The Nymph of the Lo River*. Washington, D.C., Freer Gallery of Art.

The artist whom Ku K'ai-chih appears to have admired most among his contemporaries was **Tai K'uei**, a native of Anhui. Having died in his sixties or seventies in 396, the year the Wa-kuan-ssu burnt down, he was about fifteen to twenty years Ku's senior. Ku considered Tai's painting of *The Seven Sages of the Bamboo Grove* to be a masterpiece beyond compare. If this was the younger man's response, Tai K'uei's paintings must have become important to him at some point—notwithstanding his primary dependence on Wei Hsieh. Perhaps the Wa-kuan-ssu was a likely setting in which Ku K'ai-chih could have encountered a Tai K'uei mural quite early in his career.

But Tai K'uei's activities were not limited to painting. He was also a writer, calligrapher, bronze-caster and a sculptor, working in wood and dry-lacquer (*chia-chu*), a technique he may have invented, as Pelliot was inclined to believe.[6] Presumably Tai's most noteworthy contribution was in the field of Buddhist sculpture. His verdict that the sculpture of the past was rude and clumsy, and the praise bestowed by his contemporaries upon his own work, encourage us to think of his images as greatly refined and spiritualized—endowed, in Soper's words, with a new beauty and expressiveness.[7] Mi Fei (1051–1107), who owned a painting of Kuan-yin done, he was convinced, by Tai K'uei, describes the figure in his *Hua-shih* as 'a celestial being, of male sex, dignified and serene', and then quotes with approval the *Li-tai ming-hua-chi*: 'The Buddha appeared [in art] from the Han period onward, but perfection was only attained with Tai K'uei.'[8] None of the texts, however, give any hint as to his style. And fourth-century Buddhist sculpture is exceedingly rare; its history, non-existent. One non-Buddhist monument is the only archaeological evidence that might be thought of as possibly, and remotely, connected with Tai K'uei on chronological, thematic, and geographic grounds. A tomb of the late fourth century in the vicinity of Nanking, excavated in 1960, was found to contain two pictorial brick panels representing *The Seven Sages of the Bamboo Grove* (with an eighth figure added for symmetry). Even in the crude transposition into the relief lines of stamped bricks all the grace and rhythm of the original design is not lost (Fig. 12). Quite logically the excavators compared the designs with those of

FIG. 11 Detail from *The Nymph of the Lo River*. Washington, D.C., Freer Gallery of Art.

Ku Kʻai-chih, and Soper pointed out some specific resemblances to the draperies in the *Admonitions* scroll.[9] Yet in all likelihood, the styles of Ku and Tai were similar enough to justify linking the Nanking bricks with either man's work; but the temptation to substitute these bricks for the else lost oeuvre of Tai Kʻuei is hard to resist.

Tsung Ping (375–443) and **Wang Wei** (415–43) are names that evoke the beginnings of pure landscape painting in China, the least known among the achievements of fifth-century painting. For want of visual evidence, the literary fragments in which these men speak of their feelings and aspirations as landscape painters have received much attention. While Tsung emerges, in Michael Sullivan's characterization, 'as the type of pure artist whose eyes are open in wonder at the miracle of nature and astonishment at his own mysterious powers', Wang (whose life was forty years shorter) was 'the *wen-jen* par excellence, the scholar of high intelligence and a speculative turn of mind to whom painting is but one among many channels by which a man of culture seeks to express himself.'[10] The core of their message is an insistence on the spiritual element in landscape. In Tsung Ping's own words, 'landscape, although it does consist of matter, attains to the spiritual.'

Tsung Ping, who came from Honan Province and was active under the Liu Sung Dynasty (420–78), apparently was the first to claim for the artist a place not inferior to that of the 'sage' in the spiritual hierarchy of the world. His main ideas were summed up thus by Liu Hai-su:

1. The artist's excitement by nature's spirituality and the sage's [power of] excitation through his spirituality are in the same way dependent on the Tao.
2. The task of the painter consists in transposing nature onto his silk, from which the beholder will re-experience nature's grandeur as it had first affected the painter.
3. Each, whether creator or beholder, seeks the fullness of life, that is the manifestation of freedom of spirit.[11]

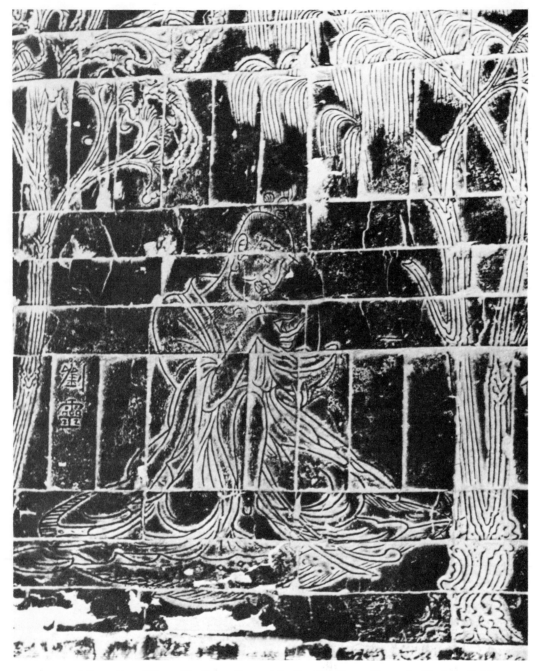

FIG. 12 A Sage. Detail from *The Seven Sages of the Bamboo Grove*. From the Nanking Bricks.

Wang Wei, from Shantung, had studied, like Ku K'ai-chih, the works of Wei Hsieh and, according to Hsieh Ho, fully understood Wei's concepts. Hsieh Ho did not rate Wang highly, but he was bluntly contradicted by Chang Yen-yüan who maintained that Wang's ideas were profound and his works exalted. Wang Wei's *Preface on Painting* has been handed down in an abbreviated and probably distorted form in Chang Yen-yüan's *Li-tai ming-hua-chi*.[12] The following passages may serve to illustrate Wang's position.

When speaking of painting, what we ultimately are looking for is nothing but the [expressive] power contained in it. Even the ancients did not make their pictures as mere topographic records of cities, districts and townships . . . Based on the shapes is an indwelling spiritual force (or soul, *ling*); what activates that force is the mind (or heart, *hsin*). If the mind ceases, that spiritual force is gone because what it relies on [to become visible] is not activated. The eye has its limitations; what it does see is not the whole (but only the exterior).

Wang's position, which essentially agrees with that of Tsung Ping, was interpreted thus by Chu Chu-yü: 'Painting is not restricted to a quasi-real reflection of actuality; it is more important that the painter be able to express the spirit immanent in the phenomena.'[13]

It was rightly observed by Sirén that, if measured by their surprisingly advanced theories and words, the paintings of these men would doubtless strike us as rather primitive. He suggested that the 'gap' between theory and realization was due to the painters striving to open new roads.[14] Actually, it is more likely that it is in the nature of words to create such seeming discrepancies; being universals, the words fit all stages of pictorial conceptions, while the latter are always specific.

Lu T'an-wei (*c*.440–500) from Wu (Kiangsu), 'who learned from Ku K'ai-chih', was singled out for the highest praise in the *Ku Hua-p'in-lu* of Hsieh Ho, who ranked him first among all the masters: 'Embracing the past and giving birth to the future, he stands alone from antiquity to the present . . . He rises beyond the highest grade: nothing else need be said, and [even] to label him "first class" is doing him wrong.'[15] This judgement of Hsieh Ho's was never contested. But he neither gave any reasons for it, nor did he attempt to describe Lu T'an-wei's formal qualities. Apparently it was no earlier than the eighth century that we hear, through Chang Huai-kuan, of Lu's brush line being as strong and sharp as if cut with an awl, and drawn without interruption (like the grass writing of Wang Hsien-chih) in shapes of beautifully clear structure. From what little information there is, Chu Chu-yü concludes that Lu T'an-wei was an artist of keen observation and comprehension of things, arriving at forms that vibrated with life and exposed the inner spirit—so affecting the viewer, as Chang Huai-kuan said, that he might tremble with fear as if he were face to face with divine presences. What may have endeared Lu T'an-wei to Hsieh Ho was, perhaps, this deeper realism, as well as his extraordinary range of subject-matter: figures, especially Buddhist images, portraits, animals, the motif of Cicada and Sparrow, scenes from the Classics, and old stories. He was less interested in landscape; according to the *T'ang-ch'ao ming-hua-lu* by Chu Ching-hsüan, his landscapes, plants and trees were finished in a coarser manner.[16]

In his early years Lu T'an-wei was attached to the entourage of, and painted the portrait of, a prince, Sung Ming Ti (reigned 465–72), described as a truculent politician, generous supporter of Buddhism, and lover of the arts. It would be perfectly proper, therefore, to count Lu among the court painters, in contrast to the hermits, Tsung Ping and Wang Wei. Of his works, no fewer than about one hundred were known in T'ang times. Ten works apparently survived as late as Northern Sung, being listed as part of the collection of Emperor Hui Tsung, but they are

FIG. 13 Yüan Ku. Detail from the Nelson Gallery Stone Sarcophagus. Sixth century. Kansas City, Nelson Gallery and Atkins Museum.

unrecorded in T'ang literature. Only one of the titles reappears in the Southern Sung Imperial collection, a picture of Mañjuśrī that was still seen by Chou Mi (1232–1308) and T'ang Hou (c.1330), and even by the late Ming critic Chang Ch'ou (1577–1643). One of Lu T'an-wei's works was seen by Su Tung-p'o in 1076 in a pitiful condition at the Kan-lu-ssu, a temple in Chekiang that was saved from destruction during the persecution of 845:

> On broken boards, a painting by master Lu:
> A green lion, playfully curled up;
> Above there are two celestial beings
> Waving their hands like soaring phoenixes.
> Though brush and ink have almost completely faded,
> It remains a model to hand down, not to be improved.[17]

A characterization of Lu T'an-wei's style may never be possible, unless a stone engraving after his design should some day be discovered. What, for the present, might be taken as possibly amounting to archaeological evidence of his influence are the engraved scenes from six stories of filial sons on the **Nelson Gallery Stone Sarcophagus** in Kansas City, a monument of surpassing quality and importance, dating from about a generation or so after Lu T'an-wei (Figs. 13, 14). Obviously the stone-cutter relied either on an outline copy of a painted scroll, or on some other enlarged format derived from that scroll, which must have been a work of renown in its time to be chosen for the reproduction in stone. To think of the great Lu T'an-

FIG. 14 House on Fire. Detail from the Nelson Gallery Stone Sarcophagus.

wei in this connection is almost inevitable, if chiefly on chronological grounds. On the other hand, the engraving also represents the supreme example of sixth-century landscape design known to us, a fact not easily compatible with the recorded neglect of landscape on Lu's part.

The scene shown (Fig. 13) depicts the story of the pious grandson Yüan Ku who, in a time of famine, saved his grandfather from being left to die in the wilderness and, thereby, incidentally saving his father from the guilt of parricide. In the left half of the picture the grandfather squats abandoned under a cedar by a stream; the departing Yüan Ku picks up the empty stretcher used to bring the old man, and his father, irritated, haughtily tells him that it is no longer needed. But in the next scene, having been told that the stretcher might well come in handy in the future, the father understands the point and is seen humbled: he willingly assists in carrying grandfather back, while his son, whose head is turned affectionately toward the old man, walks in front.

The setting is framed by strange, lectern-like, vertical rocks with slanting tops that rise from the bottom of the scene. Another rock, slightly recessed, is placed in the centre to separate the scene at the left from that at the right. Between these rocks stand tall trees: a warped cedar or juniper, leftmost; then a pair of trees with upswept foliage, three Wu-t'ung trees, and a pine with double trunk. Their arrangement recalls the row of evenly spaced trees on the bricks of the fourth-century tomb, mentioned in the passage of T'ai K'uei (p. 22 above), which however do not suggest a landscape but are simply a device for framing the figures. Beyond

the figures, rocks and trees, we notice sharply drawn horizontal layers of 'distance'—
terrain, water, and mist—and further still, a range of low hills vaguely suggesting a
continuum with the foreground scene. In the upper right corner are a few scudding
clouds, very like the cloud-scrolls of Han derivation that are used to frame the
picture.

The similarity of the ornamental cloud-scrolls and the clouds in the picture offers
a clue to the mode of perception underlying a landscape of this kind. The artist is
unevenly acquainted with the phenomena of the real world. His realism is therefore
limited. He has mastered the human figure, of course, as well as the grandest objects
in his compositions, the trees, which he has deeply experienced and admirably
defined. But when it comes to such bewildering and, so to say, amorphous matter as
rocks, terrain, clouds, or flames, the master relies on inherited conventions and
ornamental forms, which are intelligible because they are conventional. The fanci-
ful tors capped by tiny forests and sprouting grass, for instance, can readily be
traced back to the first, groping conversions of undulating ornaments into rolling
hills in Han art. Yet while the connection between the ornamental clouds in the
picture and the shapes of the cloud-scroll border is obvious, the actual clouds are
here no longer a pattern but freely varied. The drawing of flames in one of the
stories (Fig. 14) is another instance of purely ornamental form given representa-
tional function.

It is in the spatial relationships that the painter was least realistic. The problems
of coherent recession and rational scale did not exist for him. But he was aware of
the aspect of distance, as shown by the ranges of low hills suspended between hori-
zontal streaks somewhere beyond the shallow stage of foreground scenery.

Reality, in a landscape of this stage, is tied to objects. The objects alone are real.
Neither space, as such, nor atmosphere exists as yet. The advance over Han designs
consists in the fact that clouds rather than birds are used to symbolize the air. The
realism of this stage is one of gradation or levels. Things of a finite, unvarying shape
are realistically depicted. Those of varying shape, like the rocks, are invented or
freely altered conventional forms. Those, finally, of indefinite shape, like the clouds
and fire, are rendered simply as ornamental forms. Nowhere is there any element
that lacks precise definition. No raw chunks of observed nature are admitted that
might disturb the precarious unity of the design.

Chang Seng-yu (c.470–550) was a native of Wu-chung in Kiangsu, who held
various offices such as General of the Right Army and Prefect of Wu-hsing (the
home of Ts'ao Pu-hsing) under the Liang Dynasty (502–57). He ranks with the
foremost pre-T'ang masters, Ku K'ai-chih and Lu T'an-wei, and his name is
linked to theirs in the triad Ku–Lu–Chang by Chang Huai-kuan (c.725). Chang
Huai-kuan defended Seng-yu against a disparaging appraisal by Yao Tsui (mid-
sixth century), and in addition gave the following lapidary characterization of the
three masters' individual strengths:

> Of the marvellous achievements in portraiture,
> Chang's was the flesh,
> Lu's, the bones, and Ku's, the spirit.[18]

The context of this terse formulation makes it plain that Chang Seng-yu did not just paint the 'flesh' but rather captured one aspect of appearances not realized by his predecessors—that of plasticity and volume. Another novel feature was his modelling with light and dark shades, to produce an effect of relief. Still another innovation affected the proportions of his figures. Ku and Lu, in Waley's words, 'gave their angels, court-ladies, and heroines long, oval faces; Seng-yu changed the fashion; his beauties were round-faced and plump.'[19] (A similar, rather abrupt change can be observed in Buddhist sculpture from about the middle of the sixth century.) Furthermore, Seng-yu was recognized for having been the first to experiment, in his landscapes, with a 'boneless' technique of applying colour without ink outlines, a technique believed to be derived from Indian or Central Asian styles.

One major work existing today can claim to be connected with Chang Seng-yu. It is the handscroll of *The Five Planets and Twenty-eight Constellations* from the Abe collection, in the Osaka Municipal Museum, showing 'the true images' of the deities of the planets and of twelve of the Lunar Mansions. The missing sixteen figures were painted on a second scroll, which was separated or lost as early as the beginning of the seventeenth century and not since recovered, to judge from the records left by Chang Ch'ou (*c*.1616) and An Ch'i (*c*.1742). The authorship of the Osaka scroll is not established. The colophons attached to it, one by Tung Ch'i-ch'ang dated 1636, the year of his death, and one by Ch'en Chi-ju (1558–1639), attribute it to Wu Tao-tzu and Yen Li-pen respectively. Others have thought it to be the work of Liang Lin-ts'an (first half of eighth century), who had supplied the inscriptions in 'small seal' script preceding the images. That this scroll bears seals from the time of Hui Tsung's reign speaks in favour of identifying it with the item listed under Chang Seng-yu in the *Hsüan-ho hua-p'u*. But in any case, tracing the pedigree of the Osaka scroll, which was in An Ch'i's collection, does not alter the fact that there already existed several versions of this important work in Ming times. One such version, which presented the complete series of the twenty-eight Lunar Mansions and is therefore not identical with the Osaka scroll, came to Japan early enough to be copied by Tani Bunchō (1765–1842), as observed by Yashiro.

The gods are represented as mysterious beings of solemn bearing, some of them in human form, others with animal heads on human bodies and thus very like the twelve Chinese deities of the zodiac. Of the latter variety are the gods of the adjoining mansions named 'Ox' and 'Woman' (Figs. 15, 16) in the northern quadrant, which overlap the zodiac divisions of Sagittarius, Aries, and Aquarius. The figure attired in the resplendent robe of a Chinese official, though designated as 'Ox', is represented with the head of a he-goat or Capricornus, while 'Woman', in a similar attire but drawn in magnificent curves, is a human figure with the head of a ram or Aries. The drapery of this figure (Fig. 16) is a marvel of design. Slanting parallels that fall to the ground with a slight twist are contrasted in counterpoint, as it were, with the drooping curves that radiate from the elbows upward to the shoulders and downward into the sleeves. Shaded alternately light and dark in a rhythmic sequence, these draperies are reminiscent of the bed curtains in the *Admonitions* (Fig. 9). It seems that the painter's deepest interest lay in the organization of the almost musical, linear themes afforded by these robes.

Compared with those of the *Admonitions*, Chang Seng-yu's figures have gained in

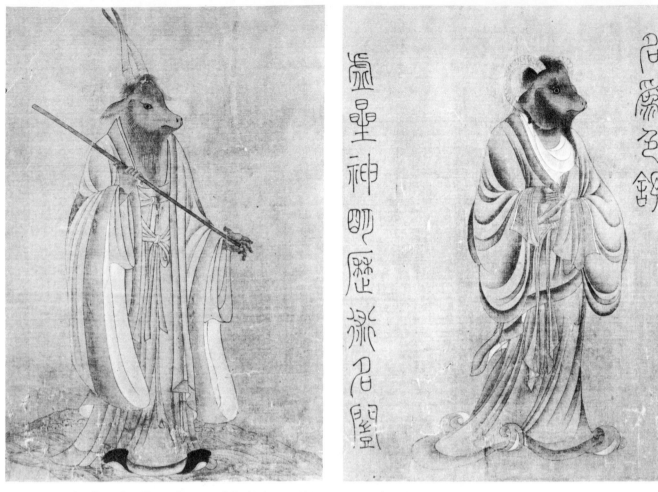

FIG. 15 Attributed to Chang Seng-yu, Niu (Ox). Detail from *Deities of the Constellations*. Osaka, Osaka Municipal Museum.

FIG. 16 Attributed to Chang Seng-yu, Nü (Woman). Detail from *Deities of the Constellations*. Osaka, Osaka Municipal Museum.

corporeality and precise definition of every detail, while lacking psychology entirely; what they express instead is a supramundane otherness, remote from human feeling. The drawing of the robes in flowing lines and very precise forms reveals a flair for monumentality, quite unlike the airy, gracefully playful draperies in the *Admonitions*, and approaching the style of Yen Li-pen's *Emperors* (Fig. 18), as would fit the supposed date of the original designs. There is little doubt that for all the artist's devotion, skill, and likely faithfulness to his model, the present scroll is a copy, executed with dispassionate accuracy but wanting the life-giving touch of an individual hand. But whatever the actual date of this work, its model may well go back to the sixth century.

Another aspect of Chang Seng-yu lived on in vague memories of a new landscape style that dispensed with ink outlines and depended on colour alone for its 'boneless' structures. The alleged copies now extant are incompatible with what is now known of sixth-century landscape. Still, one hanging scroll, listed under Chang's name in *Ku Kung shu-hua-lu*[20] as *Snowy Mountains and Red Trees*, deserves to be mentioned on account of its astonishingly rich colour. It ranges from red to orange,

yellow, green, bluish green, light blue, bluish and brown hues. But there are also ink contours in the mountains, washed over with opaque white. Because of its almost complete isolation a work of this kind is hard to judge, though interesting as an historical puzzle.

Ts'ao Chung-ta, who in Pelliot's estimate[21] was active under the Northern Ch'i Dynasty (550–77) and Sui Dynasty (581–618) until about 590, has been considered by many as an immigrant from Northwestern India or Sogdiana. Pelliot thought him to be Chinese, and recently Chu Chu-yü equated his birthplace with the ancient Ts'ao in Ting-t'ao-hsien, southwest Shantung.[22] His paintings of the 'foreign images of Buddhism' were regarded as unequalled in his time, but he did not limit himself to Buddhist subjects. More important, however, is a description of his style given after older sources in Kuo Jo-hsü's *T'u-hua chien-wen-chih* of 1074, where he is compared with Wu Tao-tzu:

> Wu's brush gave the effect of revolving motion, and his robes billowed upward. Ts'ao's brush gave compactly layered forms, and his robes were clinging and tight. Hence it came about that later generations spoke of the Wu scarves fluttering in the wind, the Ts'ao robes coming out of the water.[23]

The account leaves no doubt that the 'wet' robes were the invention of Ts'ao Chung-ta and not of Ts'ao Pu-hsing, his namesake of the third century mentioned at the beginning of this chapter.

It is probably not possible to link any painting now extant with the style of Ts'ao Chung-ta. But it is clear that his style was distinct from that of Chang Seng-yu as well as that of Wu Tao-tzu. We may not go far wrong to imagine his figures as resembling the Buddhist sculpture of Northern Ch'i with its clinging, tightly folded draperies over strongly emphasized bodies—contrasting sharply with the virtually disembodied statuary of the Northern Wei, which consisted of spiritualized heads and energized draperies only.

Notes

1. Sun Ta-kung, *Chung-kuo hua-chia*, p. 402.
2. *Ibid.*, p. 670.
3. Ch. 2, pt. 1.
4. Ch. 92.
5. Chen Shih-hsiang, *Biography of Ku K'ai-chih*.
6. Pelliot, 'Les statues en "laque sèche"', pp. 181–207.
7. Soper, 'Southern Chinese Influence', p. 48.
8. *Hua shih*.
9. Soper, 'A New Chinese Tomb Discovery', p. 86.
10. Sullivan, *Birth of Landscape Painting*, p. 104.
11. Liu Hai-su, *Chung-kuo hui-hua shang-ti liu-fa lun*.
12. Ch. 6.
13. Chu Chu-yü, *T'ang-ch'ien hua-chia*, p. 62.

14. *CP*, I, p. 37.
15. *Mei-shu ts'ung-shu*, 3/6/2.
16. *T'ang-ch'ao ming-hua-lu*, Soper tr., p. 206.
17. *Tung-p'o ch'üan-chi*, apud Chu Chu-yü, *T'ang-ch'ien hua-chia*, p. 25.2.
18. Sirén, *CP*, I, p. 46.
19. Waley, *Introduction*, p. 85.
20. Ch. 5.
21. Pelliot, in *T'oung Pao*, vol. 22, no. 4, pp. 153 ff.
22. *T'ang-ch'ien hua-chia*, p. 23.
23. Ch. 1:14, quoting *Li-tai ming-hua-chi*; cf. Soper tr., pp. 16 f.

Figure painting of Sui *(589–617)*
and T'ang *(618–907)*

With the exception of Chan Tzu-ch'ien, a master of such merit that a Yüan critic, T'ang Hou, writing in 1329,[1] spoke of him as the founder of T'ang painting, the Sui painters do not seem to have left a deep mark in history. Their names are recorded with tempered admiration; obviously their works did not evoke the same sympathetic response as did those of the great masters of earlier times. Their works, of course, are lost—again excepting the case of Chan Tzu-ch'ien, to whom is attributed at least one work, the most archaic landscape scroll now extant. This scroll, as well as the copy of another made by the Sung emperor Hui Tsung, will be treated in the discussion of landscape painting in Chapter 4.

Cheng Fa-shih, whose home province is unknown, was regarded as foremost among the followers of Chang Seng-yu. He was honoured with prestigeful titles under the Northern Chou (557–81) at Ch'ang-an, where he continued to be active, and officially recognized, under the Sui. His strength apparently lay in portraiture. In a style at once 'vigorous and graceful', he was able to 'capture the moral integrity of grave demeanour [in dignitaries], and to express through gentle beauty and modest deportment the elegance of demureness [in women]', in Li Ssu-chen's words (quoted by Chang Yen-yüan).[2] Li continues with a poetic description of Cheng's accomplishments as a painter of narrative themes and of landscape, the latter description suggesting colourful, intricately designed pictures of decorative effect. Cheng Fa-shih's historical importance is vouched for by the report that he was one of the masters studied by Yen Li-pen; Yen may have known his picture of *Sui Wen Ti Entering a Buddhist Temple*. Cheng also painted an imaginary portrait of the Maurya emperor Aśoka as well as pictures entitled *A Spring Outing* (identical in theme with the archaic scroll that goes under the name of Chan Tzu-ch'ien) and *Reading the Stele*. There is an album leaf with the latter title in the Palace Museum in Taipei.[3] It shows Ts'ao Ts'ao (155–220) facing a stele erected for the girl Ts'ao O (second century B.C.), who ended her own life in the river where her father had drowned. But this painting appears to have been ascribed to Cheng only on account of the subject matter; its style is irreconcilable with a pre-T'ang date. No other works in existence today are connected with this master, whose style therefore is lost.

Tung Po-jen, a native of Ju-nan in Honan, like Chan Tzu-ch'ien is said to have been self-taught. He must have been endowed with uncommon intellectual powers to have earned, while still a youth, so flattering an epithet as 'Sea of Wisdom'. When the Sui came to power in 581, he could already look back upon a career under the Northern Ch'i (550–77) and Northern Chou (557–81), with posts as elevated as that of General of the Palace Guards. Li Ssu-chen (in Chang Yen-yüan) praised Chan and Tung equally for their ability of conveying, beyond the exact rendition of outward appearance, the inner states of their subjects—to a degree apt to make their

celebrated forerunners 'change countenance and turn pale'.[3a] This judgement of Li
Ssu-chen's, incidentally, may be the most forthrightly positive one ever passed on
Sui painting generally. In Chang Yen-yüan's time, Tung Po-jen's oeuvre, in addi-
tion to his murals, comprised such titles as *Chou Ming Ti's Hunting Excursion, Sui
Wen Ti Naming Horses in his Stables*, and *Maitreya*, among others. In Emperor Hui
Tsung's collection his oeuvre was reduced to a single work, a painting based on
Taoist scripture. Today, no trace of his hand is known.

Yen Li-pen (*c*.600–73) appears in later criticism as the dominating figure among
the early T'ang painters. His ancestors of three generations had held offices under
the successive dynasties in the north, as far back as Northern Wei. His father, Yen
P'i, who according to the *Sui-shu*[4] came from Sheng-lo in Yü-lin (Sui-yüan), was
Vice-Director of Construction under the Sui; during a campaign against Liao-tung
he died suddenly at the age of forty-nine, much lamented by Emperor Yang Ti
(reigned 605–17). The boy Yen Li-pen grew up in Wan-nien, the eastern part of
Ch'ang-an, the capital, and from an early age was trained in the arts by his father,
then by his elder brother. The latter, Yen Li-te, relied on his collaboration in two
recorded works, *The Tribute Bearers* and *The Emperor's Insignia*. These titles
suggest objective, accurate, pictorial records, perhaps in the manner of the father,
Yen P'i, a skilled engineer as well as a painter; his style was the foundation of the
painting of his sons, who seem to have inherited all of his talents. Yen Li-te
held the post of President of the Board of Public Works, and on his retirement was
succeeded, sometime between 656 and 660, by Yen Li-pen. But the latter rose to
higher office; in 668 he was appointed Prime Minister on the Right, and enfeoffed
as Baron of Po-ling. Two years later he received the title of Secretary-General of
the Secretariat.

Despite the recognition evident in his extraordinary career, Yen Li-pen found it
unsufferable that, because of his known ability as a painter, he might be called upon
to perform 'like a menial'. He even advised his sons not to become painters—
although he admitted that 'even if insulted he was unable to quit [painting]'.
Something he may well have found insulting is the saying (based on two consecu-
tive passages of the *Thousand Character Classic*):[5]

[The Minister on the Left] proclaims authority in the Sha-mo [Desert]
[The Minister on the Right] attains wide fame through cinnabar and blue,

according to the *Li-tai ming-hua-chi*[6] hinting that neither man had the capacity to
fill his post.

Along with the training received from his elders, Yen Li-pen studied the work of
the major Sui masters, especially Cheng Fa-shih, although his greatest admiration
seems to have been reserved for Chang Seng-yu of the Liang Dynasty. As early as
626 he received important commissions. That year the Crown Prince, Li Shih-min
(597–649), who reigned as T'ai Tsung from the following year onward, asked him
to commemorate a gathering of eminent scholars that had taken place at the Prince's
palace in 621; the painting was known as *The Eighteen Scholars at the Palace of
[the Prince of] Ch'in*. For a similar work commissioned in 643, *The Twenty-Four
Meritorious Officials of the Ling-yen-ko*, the Emperor himself wrote the encomia.

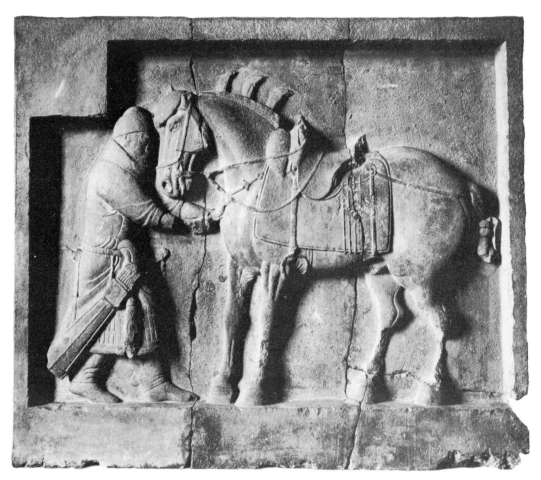

FIG. 17 General Ch'iu Hsing-kung Removing an Arrow from the Charger Autumn Dew. Stone relief from the Chao-ling, designed between 636 and 649. Philadelphia, University Museum.

Yen Li-pen also took part in designing T'ai Tsung's mausoleum, the Chao-ling, the planning of which began in 636—after the death of the Empress, who had asked for a simple burial that should be no burden to the people. Yen's series of portraits (murals?) for the tomb, now lost, was still in existence in the ninth century; it is not recorded whether he also had a hand in the design of the still extant set of six monumental stone reliefs depicting the Emperor's favourite war horses. But their style compares well with that of the *Emperors* scroll in Boston, to judge from the compact, neatly outlined and sparingly defined figure of General Ch'iu Hsing-kung (585–665), who is shown removing an arrow from the chest of the charger, Autumn Dew, on one of two stone slabs in the University Museum, Philadelphia (Fig. 17).

Yen contributed surprisingly little to Buddhist painting. A single mural at the Tz'u-en-ssu in Ch'ang-an is mentioned in the *T'ang-ch'ao ming-hua-lu*.[6a] Only four

Buddhist themes appear in the considerable list of his works given in the *Hsüan-ho hua-p'u* of 1120: *Vimalakīrti* (in two versions), *The Peacock King, Kuan-yin*, and *Brushing the Elephant*. Of Taoist images there are three times as many, while the rest are portraits, gods of the planets and constellations, and pictorial records of contemporary events, the total amounting to forty-two works. Even today there remain quite a few works purporting to be from his hand. None has more convincing credentials than the handscroll of *The Emperors of the Past* at the Museum of Fine Arts in Boston, even though it is not recorded in T'ang literature. Of the paintings discussed so far it is the first that is generally accepted as being partly original.

The attribution to Yen Li-pen is made in the first colophon attached to the scroll. Its writer is unidentified because the signature and part of the text are effaced, but the cyclical date *keng-tzu* (1000, or 1060 at the latest) is still legible. This colophon is followed by many shorter, again partly obliterated, inscriptions, some of which are dated in accordance with 1058, 1068(?), 1097, 1111, and 1135.[7]

The emperors, represented with their entourages, are thirteen in number, beginning with one labelled 'Chao Wen Ti of the Western Han' (either Wen Ti, 179–157 B.C., or Chao Ti, 86–73 B.C.) and ending with Sui Yang Ti (605–17), in whose reign Yen's father died. It is not evident why the painter should have chosen the personages he did, omitting others with less tarnished or even admirable records. Perhaps he depended on models accessible to him; he may for instance have known Cheng Fa-shih's portrait of Sui Wen Ti, the penultimate emperor in his series (Fig. 18). The likeliest explanation of his seemingly random selection is that the scroll in its present form is no longer complete. As a matter of fact, parts of it were beyond repair as early as 1188, when Chou Pi-ta (1126–1204) added a colophon to record that the scroll had been purchased by his elder brother Pi-cheng for the sum of 500,000 cash, and immediately remounted by one Li Chin for 40,000 cash. Of the thirteen groups then remaining, Chou took only the seventh (Hsüan Ti of the Ch'en Dynasty) to be authentic. In fact, as Tomita has observed, the scroll consists of two portions differing both in execution and in silk fabric. The first six groups appear to be later replacements, though older than the twelfth century. The following seven groups are painted on a finer silk, and probably by one and the same superior hand. Between the two portions there is a conspicuous chronological discontinuity. None of the southern rulers of the Eastern Tsin, Liu Sung, Southern Ch'i, and Liang dynasties, nor any of the northern dynasts of Northern Wei, Eastern and Western Wei, or Northern Ch'i are represented. It stands to reason that this gap of 280 years between Tsin Wu Ti and Ch'en Hsüan Ti is due to an accidental loss or irreparable damage.

Sirén has raised the question of the nature of these alleged portraits. He assumed that the 'interpretation of the various characters' is likely to be the painter's own, but added the conflicting observation that the figures are 'characterized with a typifying neutrality' caused either by a conscious stress on 'the archaic origin of the models' or by the limitations of 'a copying painter'.[8] The problem is more complicated, however. We cannot be sure that the identifications—supplied by an unknown hand—are reliable. It is disturbing that Ch'en Fei Ti, ninth in the sequence, is represented as a bearded man in his forties or fifties, although he abdicated in his fifteenth year and probably died before he was sixteen (by Western reckoning).

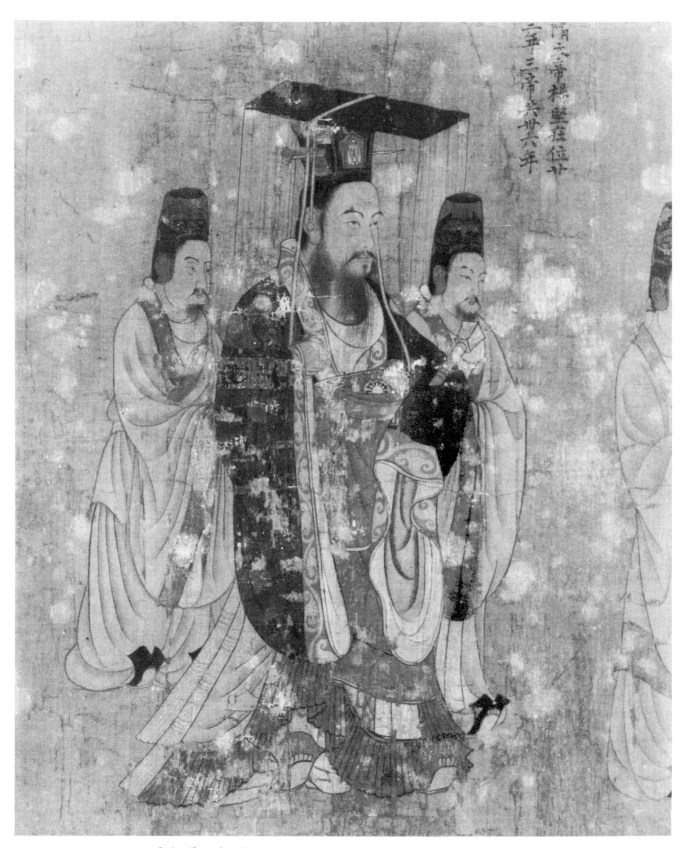

FIG. 18 Attributed to Yen Li-pen, The Sui emperor Wen Ti. From the handscroll *Portraits of the Emperors*. Boston, Museum of Fine Arts, Ross Collection.

If the figure does represent Fei Ti, as the inscription asserts, it would show that the painter was indifferent to biographical facts, hence unable to offer an interpretation of character, be it his own or derived from an earlier model. Inevitably we are led to conclude either that some, or all, of the figures are not true likenesses, or that the identifying inscriptions must be discounted as irrelevant additions.

Perhaps the painter was on firmer ground when he came to portray persons as recent as the last two in the sequence, the two Sui emperors—'tigers and wolves', according to Tu Fu.[9] Shown here (Fig. 18) is the founder of the short-lived dynasty, Wen Ti (reigned 581–604), who had succeeded by 589 in unifying the empire under his rule. Wen Ti is represented in hieratic scale, buttressed by two attendants wearing *mao* caps of black gauze; he wears a ceremonial robe with palmette border, and the *mien* ceremonial 'crown' topped with tasselled board. The figure of the emperor agrees essentially with a type that occurs earlier in the scroll no fewer than six times, namely the 'audience' type, whose stance is that assumed by the sovereign when presenting himself in audience before an awestruck court. The forms of the draperies are large and distinct, almost monumental, and in the light robes of the two ministers the harmonious rhythm of the curved lines is enhanced by strong shading. These draperies cannot compare for sheer gracefulness with the lineament we saw in the Chang Seng-yu figure of Aries (Fig. 16); but Chang's Aries lacks the volume, compactness, and weight that are conveyed by the baggier and clumsier shapes of the Yen Li-pen figures. Remarkable as a matter of design are the subtle variations in the palmette borders, especially those surrounding the large opening of the emperor's left sleeve. His face is drawn with sureness and great economy of detail. Here again the forms are large and clear, and the fleshy features may be an aspect deriving from Chang Seng-yu. The face is individual enough to suggest a portrait; it was a face that frightened the last ruler of Ch'en (reigned 582–89; tenth emperor in the scroll), as recounted in the *Nan shih*: 'Disturbed by the threatening tone of communications from the Sui in the north, he [the Ch'en emperor] commissioned a deputy envoy, Yüan Yen, to do a portrait of Sui Wen Ti secretly [during the course of] an official mission. When he had returned the last ruler glanced at it, and then said fearfully: I do not want to look at that man.'[10] This happened in 588. The following year Nanking fell to the armies of Sui Wen Ti, and the last Ch'en ruler abdicated.

A noteworthy analogy to the emperors in audience pose occurs in Cave 220 (Pelliot 64) at Tun-huang, dated in accordance with 642.[11] Falling within the Cheng-kuan era (627–50), when, according to the first colophon, Yen Li-pen painted *The Emperors*, this date firmly corroborates the chronological position traditionally given this famous scroll. At Tun-huang the context is the story of Vimalakīrti, a theme represented among Yen's recorded works; and in style the mural is more readily compatible with *The Emperors* than some other pictures of greater or lesser merit that go under Yen Li-pen's name.

Judged from the evidence of *The Emperors*, Yen's lineament may seem rather to renounce the ornamental beauty of Chang Seng-yu's flowing line and to aim instead at unaffected simplicity and power; yet the two are fundamentally similar. The individual line is continuous, even, and firm; it is a line that describes objectively, shunning caprice and surprises.

T'ang records speak of **Wei-ch'ih I-seng** (or **Yü-ch'ih I-seng**) as a foreigner from Tokharestan or from Khotan who came to China about 627. He was consequently thought of as a contemporary of Yen Li-pen until rather recently, when T. Naga-hiro noticed that the foundation years of temples housing the painter's frescoes indicate that he was still active in 710.[12] Furthermore, if his life spanned roughly the years 650 to 715, it is impossible that he was the son of Wei-ch'ih Po-chih-na, another artist from Khotan who had come to Ch'ang-an during the Sui period (581–617). If the several works now known and regarded as copies after I-seng give any clue as to his style, it was utterly unlike that of Yen Li-pen, indeed un-Chinese. It is to experience this contrast of Chinese and un-Chinese qualities of form that these copies after I-seng ought briefly to be mentioned. They form a small body of works exhibiting a measure of stylistic consistency. Such traits as they share may therefore be taken as characteristic of their prototypes, supposed to be from the hand of I-seng. There are altogether five works: *The Buddha under a Mango Tree* in the Boston Museum, 'respectfully copied by Ch'en Yung-chih' (first half eleventh century); an untitled handscroll (detail, Fig. 19) in the Berenson collection, Settignano, perhaps based on I-seng's *Dancing Girls from Kucha* (as suggested by Arthur Waley); a handscroll in the Stoclet collection, Brussels, formerly known as 'The Clerical Orgy' or 'The Drunken Taoist', now designated by Sirén as *A Scene of Grief in the Tent of a Central Asian Chieftain*; *Vaiśravaṇa Enthroned*, assigned to Wu Tao-tzu in an inscription (by Emperor Hui Tsung?) at the top of the painting, in the Palace Museum, Taipei; another version of the *Vaiśravaṇa*, attributed in Ming colophons to Wei-ch'ih I-seng, in the Freer Gallery, Washington.[13]

There occurs in all of those works a drapery pattern consisting of a profusion of wiry, undulating lines and curls along the hems. It is handled almost descriptively in the Stoclet scroll, is very mannered in the Berenson scroll (Fig. 19), and is treated in a rather haphazard and structureless fashion in the Boston picture, where it seems to depict flowing water rather than a robe. Another noteworthy feature of the Stoclet scroll is the heaviness of the tree foliage, which forms a large pitch-dark silhouette obscuring the organic structure of the tree almost completely; the Boston picture presents a tediously detailed and overworked mass of foliage, trunk, and rocks. A third trait worth remarking is the frequency with which non-Chinese ethnic types are represented in these scrolls. The bald, bearded Buddha figure is, to my knowledge, unparalleled in Chinese painting. The little figures of the dancer and the musicians in the *Vaiśravaṇa* pictures and in the Berenson scroll are genuinely foreign, as is the emotional abandon expressed in the thematically puzzling Stoclet scroll. One further exotic feature is the technique of *impasto*, which, however, occurs only in the Boston picture.

The foregoing observations—which do not touch upon the question of skill— would seem to imply a certain disregard of realism; a lack of striving for either monumental or classic form, exemplary and intelligible always; and a measure of smallishness, manifest in the insistence on formulas in endless repetition—as if there were no aversion to saying little by much, no compulsive search for economy of formal means. The Chinese approach exemplified by Yen Li-pen's *Emperors* by contrast is eminently rational, objective, unemotional, and concerned with classic form even at the expense of psychology. In addition, it gives a lively sense of the

valori plastici, absent in the designs derived from the Central Asian master.

It is perhaps disappointing that Wei-ch'ih I-seng, when judged from the few copies of uneven quality, and only tentatively ascribed to him, does not fare too well; but there is nothing else from which to judge. Quite possibly his reputation was enlarged by the tolerance and curiosity of the cosmopolitan environment in which he was fortunate enough to find himself, and where his works may have been esteemed precisely *because* of their exotic, un-Chinese aspects. If so, his influence is likely to have been ephemeral. To search for it, specifically, in a classical Far Eastern monument of the period, the set of murals which survived until recently in the Kondō of Hōryūji at Nara, dating toward 700, is an unpromising enterprise.

In the realm of purely Chinese painting, the murals in the **Tomb of Princess Yung-t'ai** (706), discovered in 1960 near Ch'ang-an, at last dispel all uncertainties as to the style and artistic level of painting at the capital around the year 700.

Yung-t'ai was the seventh daughter of Emperor Chung Tsung and granddaughter of the dynamic usurper Empress Wu (reigned 684–705). In 701, at the age of sixteen, the princess was put to death, along with her husband, for having remarked upon the love affairs of her grandmother the Empress. In the year of Empress Wu's death (705), Chung Tsung, who had been restored to authority the year before, arranged for a sumptuous reburial of his unfortunate daughter.

The new tomb was constructed about fifty miles west of Ch'ang-an, at the foot of Mount Liang. From its entrance a tunnel slopes down to a level passage about eighteen metres below the surface, leading to two connected vaulted chambers, an antechamber and the tomb chamber proper. The whole plan on a north-south axis measures eighty-seven metres in length. The walls of the level passage and the chambers were decorated with paintings, unfortunately much damaged in the past when the tomb was pillaged. The surfaces of the painted walls were carefully prepared. According to R. C. Rudolph's account, 'a foundation of clay and straw was first plastered over the walls to even out any irregularities; a layer of very fine white clay (kaolin) with cotton fibres in it was spread over this, and the surface rubbed and polished until it was smooth; finally, a coat of size was applied.'[14] The underdrawing was done with a brown pigment, the final delineation, in ink.

Best preserved are the paintings on the east wall. Proceeding down the corridor, one passes a group of soldiers, then a long green dragon (guardian animal of the east), a palace tower, five groups of five soldiers and their leader, a spear rack, then two horses with their grooms. The head of one of the soldiers in the fifth group is turned toward the grooms (Fig. 21). With firm, broad, somewhat sketchy strokes the painter has drawn the portrait-like face of a robust, self-assured, dependable male with attractive features, large eyes, and steady gaze.

Most important is the mural on the east wall of the antechamber, depicting a procession of beautiful young women (Figs. 22, 23). In groups of seven and nine they approach from left and right, as if in attendance upon an imaginary visitor or at a ceremonial gathering. The figures, drawn life-size, are very slender, of noble carriage, and individualized. Their postures suggest a slow, solemn movement. Like statuary they are isolated and clearly disposed on the ground plane, which is manipulated with surprising finesse.

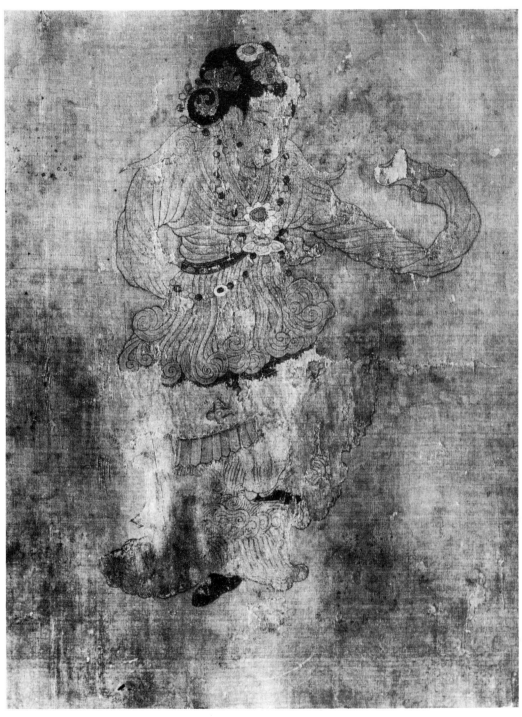

FIG. 19 Attributed to Wei-ch'ih I-seng, Dancing Girl. From a handscroll in the Berenson collection. Settignano, Florence, Villa I Tatti.

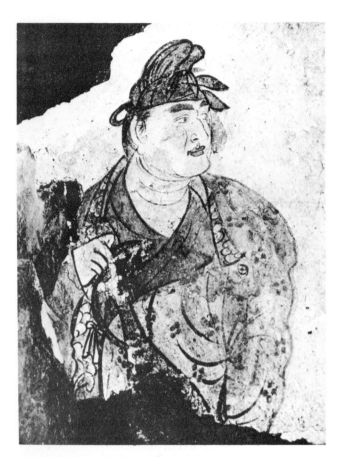

FIG. 20 Portrait of a Lutenist. Fragment of a mural from the tomb of Wei Tung. 708. Sian, Shensi
Provincial Museum.

FIG. 21 Face of A Soldier. Detail from a mural in the tomb of Princess Yung-t'ai. 706. Sian, Shensi
Provincial Museum.

What appears to have changed considerably since Yen Li-pen and, more obvi-
ously, since Chang Seng-yu, is the nature of the *lineament*, which here, suddenly,
is freed from its slavery to ornamental pattern. Simpler lineament, descriptive
rather than ornamental, gives more roundness to the figures, and this effect, com-
bined with their spacing, provides a clear measure of depth. Compared to these
murals, even Yen Li-pen's draperies, despite their relative simplicity, have a hard,
contrived touch; and when we look back to Chang's figure of the female deity of the
constellation Aries (Fig. 16), we may become aware of a decorative, gently and
naïvely meretricious quality that was not obvious before. Perhaps it is worth noting
that there is not one stroke in these murals that might recall Wei-ch'ih I-seng, who
in 706 was presumably at the height of his career. The murals are distinguished by a
freshness, elegance, simplicity, and naturalness that set them apart from all older
art. Unquestionably they are the work of a master painter—not only on account of
their surpassing quality, but also because of the rank and motivation of the patron,

Emperor Chung Tsung, who with such splendour sought to atone for the death of his child.

Two years before the discovery of the tomb of Princess Yung-t'ai, there was found in the same locality the much smaller tomb of a T'ang prince, **Wei Tung**, who was a younger brother of Lady Wei, Emperor Chung Tsung's consort. Wei Tung died in 692 at the age of fourteen, and his remains were reburied in 708, presumably by order of Empress Wei. Much of the painted decoration in his tomb was destroyed by moisture. Among the surviving fragments, the portraits of a lady and of a Westerner who holds a lute (Fig. 20) are equally remarkable. Wearing a Central Asian or Iranian costume but a Chinese cap, the young man, whose Caucasian physiognomy is unmistakable, shares in the joyous vitality and aplomb that seem to be characteristic of the secular portraiture of this period, perhaps even augmented in his case by an air of boldness hard to match.

Wu Tao-tzu (*c*.689–*c*.758), considered the greatest of all China's figure painters, was a youth of sixteen or seventeen when the pictures in the Yung-t'ai tomb came into being. There is no other monument so apt to illuminate, however faintly, the darkness that has fallen over this master's oeuvre. Hitherto his works could only be envisaged in the imagination—and the imagination was fed by scanty evidence indeed: a stone-engraving or two, copies unconvincing or worse, and the vague descriptions given in the few early texts. 'If there were just one of his paintings left', Werner Speiser said, 'the history of Far Eastern art would look different'.[15]

Wu Tao-tzu was born in the town of Yang-chai in the K'ai-feng district (Honan) around the year 689 (Wang Po-min's estimate[16]). As he was orphaned at an early age and poor, his livelihood may have depended on his apprenticeship with a professional painter and image maker named Chang Hsiao-shih. From about 710 or 711 he lived in Lo-yang, establishing his fame with wall-paintings done for Buddhist and Taoist temples. When Emperor Hsüan Tsung (reigned 713–56) visited the eastern capital in 717, Wu found himself appointed *Nei-chiao Po-shih* or Professor of Interior [Palace] Instruction, whose duty it was, in Waley's words, 'to teach the Court ladies writing, arithmetic, and the fine arts generally'.[17] Agreeable though it doubtless was, the position left Wu too little freedom; he could paint only when the Emperor desired it. His promotion to the rank of Companion to Prince Ning, who was an elder brother of the Emperor, removed that disadvantage. The appointment was a form of recognition given to men of talent and learning, and probably in the nature of a sinecure. After the death of Prince Ning in 731, Wu was on the staff of the minister, Wei Ssu-li. He lived in Ch'ang-an throughout his last forty years, but was able to travel to Kansu, Shansi, Hopei, and Szechwan. The journey to Szechwan was undertaken during the T'ien-pao era (742–55) on the Emperor's orders, so that Wu might experience and study the spectacular scenery along the Chia-ling River; it resulted in a large mural that ushered in a new style of landscape painting. Subsequently, when Ch'ang-an was sacked by the rebel forces of An Lu-shan in the summer of 756, Wu Tao-tzu, like Tu Fu and Wang Wei, was caught by the event. He survived and was still alive in 758 when his pupil Lu Leng-chia died—spent from his efforts to equal his master, of whom nothing is heard thereafter.

The great art historians of late T'ang, Chu Ching-hsüan (*c*.840) and Chang Yen-yüan (847), writing three generations later, left no clear-cut descriptions of Wu's style or of specific works by him. But they clearly express a sense of awed admiration. Chu places him above all other T'ang painters.[18] To Chang, he was the supreme master of all time.

Wu is said to have studied Ku K'ai-chih, Lu T'an-wei, and Chang Seng-yu; his early work may have shown his indebtedness to them. But his mature style, by all accounts, was distinct from theirs. Chu, in his *T'ang-ch'ao ming-hua-lu*, makes the very interesting observation that 'Whenever I myself have seen a painting by master Wu, I have never found it at all remarkable in ornamental quality. What is incom-

FIG. 22 Procession of Court Ladies. Detail from a mural in the tomb of Princess Yung-t'ai. 706. Sian, Shensi Provincial Museum.

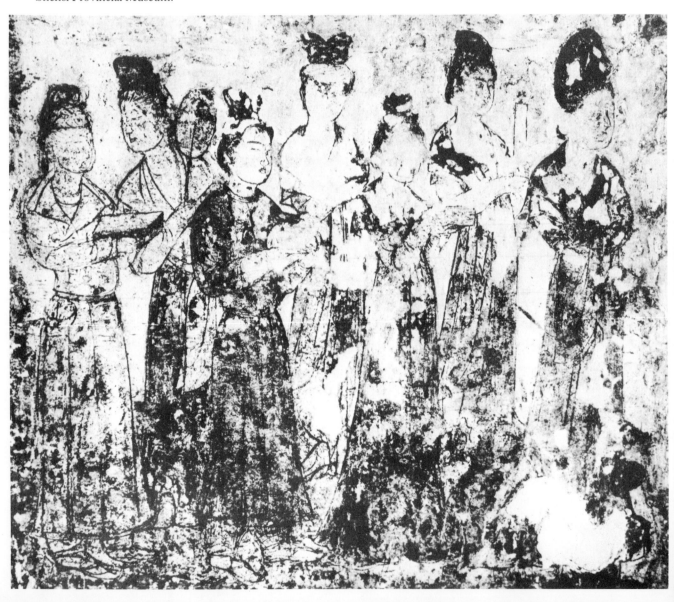

parable is his brush-work, which is always profusely varied and full of untrammelled energy. In a number of instances his wall paintings were carried out in ink alone . . .'[19] Chang attempts a description of Wu's brush line in his 'Discourse on the Brush Techniques of Ku, Lu, Chang, and Wu'. Sirén gave the following translation of the passage: 'While common people fix their attention on the [complete] outlines, he split and scattered the dots and strokes, and while others observe the likeness of the shapes most carefully, he did not consider such vulgar points.'[20] Chang reverts to this terse and rather puzzling statement further on in the same discourse when answering an imaginary interlocutor's objection:

FIG. 23 Procession of Court Ladies. Detail from a mural in the tomb of Princess Yung-t'ai. 706. Sian, Shensi Provincial Museum.

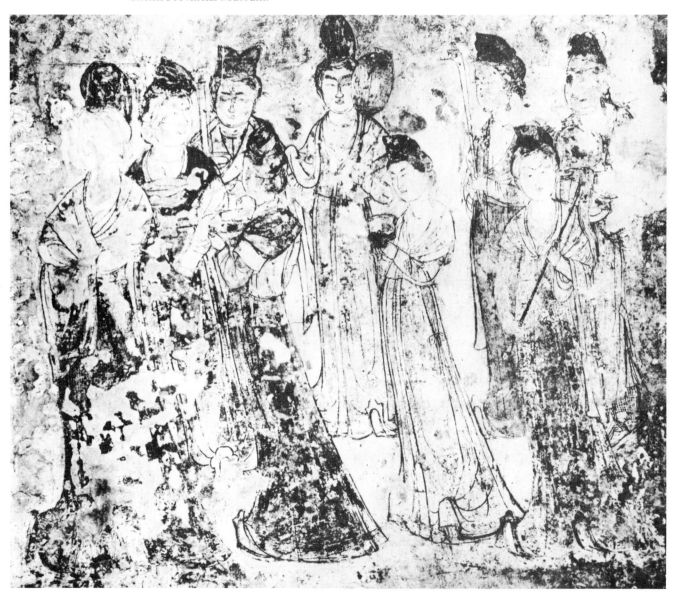

If subtle and profound thought produces works thorough and precise, then what about those whose brushwork is not thorough? My answer was as follows. The divine [quality] of Ku and Lu must not be judged from their outlines [alone]. When you speak of works thorough and precise, [I would answer that] Chang and Wu are so marvellous [simply because] one or two of their strokes suffice to make an image emerge. If the splitting and scattering of dots and strokes was regarded as a deficiency in their time, [we ought to be aware of the fact that] although the brush was not thorough, yet the idea was. If you know that in painting there are two [opposed] styles, the loose and the dense, then you can begin to talk about painting.[21]

It is curious that the passage, written almost a century after Wu's lifetime, still reads like an apologetic.

Tung Yu (active 1119–26), author of the *Kuang-ch'uan hua-pa*, stresses a different aspect of Wu's style in a passage that was translated in Waley's *Introduction*: 'Wu Tao-tzu's figures remind one of sculpture. One can see them sideways and all round. His line-work consists of minute curves like rolled copper wire; however thickly his red or white paint is laid on, the structure of the forms and modelling of the flesh are never obscured.'[22]

The three-dimensional effect of Wu's figures was noted also by Su Tung-p'o. In an inscription written in 1085 on a painting by the master there occurs the following passage: 'Wu Tao-tzu's figures might have been drawn from lantern-shadows on the wall. They seem to walk out of the picture and back into it; they project, can be seen from each side. The flat planes and tilted angles fit into one another as though by a natural geometric law.'[23]

The full text of Su's colophon was translated by Sirén, who in a lucid summary points out that 'the great admiration evoked by the master's works did not depend simply on his impetuous way of wielding the brush, but also on the fact that he had mastered certain means of representing space, movement and cubic volume in a hitherto unknown degree.'[24]

These advances of formal means correspond neatly to those we can see in actuality in the anonymous wall-paintings of 706 in the tomb of Princess Yung-t'ai. Dating so early, this monument, which was unknown at the time Sirén wrote, makes it certain that Wu Tao-tzu was not the first to introduce these rational and realistic advances; he had indeed not created, but mastered them. The Yung-t'ai murals document a level of realism that became an integral part of Wu's style but leave unrevealed its more personal traits, especially his brush stroke. We cannot hope to find these traits in any of the copies, or alleged copies, connected with him. But a stone-engraving at the Tung-yüeh-miao, a Taoist temple at Ch'ü-yang in Hopei, may with some confidence be taken as a faithful approximation to a Wu Tao-tzu design representing, according to the inscription, *The Spirit of Heng-yüeh*, the sacred mountain of the north (Fig. 24). It is a design of tremendous power. Most remarkable, and least likely to have been distorted in transmission, is the fact that the figure is not immediately obvious, but has to be discovered. It is enmeshed in a larger unit that is all energy and movement. The demon does not generate the forces here made visible; they act upon him. His frenzy is a matter of style. So is the

formation of the big, twisted loop and pointed, billowing ends of his scarves, and the admirably invented broad expanse of his windswept hair, through which weave the strands of a tassel dangling from his halberd. The neat expanse of striae representing the hair serves as a foil for the demon's right hand, all its fingers spread as though bursting with energy. It is a detail that must have seemed most lifelike to Wu's contemporaries; it recurs in other works connected with the Wu tradition, notably in the fragment of a silk painting from Turfan in the Staatliche Museen, Berlin.[25] As soon as we examine the design of the mighty demon's body, however, our admiration dwindles. In contrast to the perfection of the rest, the body, especially what is meant to represent the muscles, is a jumble of unco-ordinated, hence inexpressive, short curly strokes; they are most obvious, and disturbingly meaningless, in the left arm and left leg. Most likely the fault lies with the copyist rather than the stone-cutter. Yet these coarsely rendered, short, dis-connected curves and scattered dots are—if they correspond to the descriptions given by Chang Yen-yüan and Tung Yu quoted above—a trait derived from Wu Tao-tzu. The trend toward such loose, spontaneous and energy-charged lineament was, however, clearly prefigured in some of the soldiers' heads in the tomb of Princess Yung-t'ai of 706 and in the portrait of the Westerner in Wei Tung's tomb of 708 (Figs. 21, 20), so that it would be wrong to surmise a radical departure from tradition on the part of Wu Tao-tzu. Rather, he brought a tradition to lasting perfection.

Of his contemporary, **Chang Hsüan**, no biographical details are recorded save that he was born at Ch'ang-an and active in the K'ai-yüan era (713–42). But Chang must have lived and worked till well after 748, since several of his representations of one of Yang Kuei-fei's sisters are called Kuo-kuo Fu-jen (Lady Kuo-kuo), a title the lady received only when she was ennobled in 748.

Chang was surprisingly unlike Wu Tao-tzu. Even if there were no visual evidence of either man's works, the titles alone would still suffice to give hints of their parti-cular mentalities. Wu, with boundless imagination and creative furor, seems to roam the universe; Chang's world is smaller, being confined to the women and children of the nobility in Ch'ang-an. Among forty-seven paintings listed under Chang Hsüan in the *Hsüan-ho hua-p'u* there is not one of Buddhist or other religious subject matter; none dealing with cosmology, mythology, or history; no formal portrait; and few of landscape other than as a setting for figures. Chang was exclusively concerned with life around him, which he must have studied closely and known intimately, especially in its pleasures and moments of joy.

Equally surprising is the fact that, as far as the extant copies tell, his style too was quite unlike that of Wu Tao-tzu. Where Wu is of imposing vitality, Chang is gentle and subdued, unassertive and sober. His brush lines are thin, extremely delicate, without any sign of dash or temperament. His compositions give the impression of being calculated with mathematical precision. All this seems to amount to a quiet revolt against the grandiose themes and formal brilliance of Wu and his pre-decessors.

These characterizations depend mainly on the handscroll called *Ladies Preparing Newly Woven Silk* in the Museum of Fine Arts in Boston. It is a copy by no less

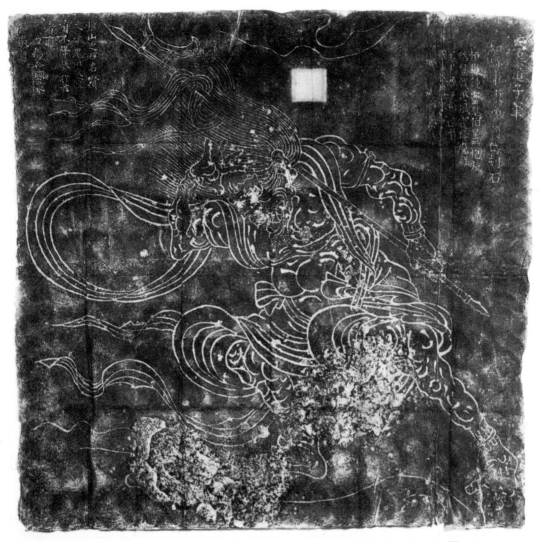

FIG. 24 The Spirit of Heng-yüeh. Rubbing from a stone engraving said to be after Wu Tao-tzu.
Boston, private collection.

eminent a personage than Emperor Hui Tsung (reigned 1101–26), as is credibly
stated in a short inscription by the Chin emperor Chang Tsung (reigned 1190–1208)
written in a hand modelled on and deceptively like Hui Tsung's own. A seal reading
Ming-ch'ang following the inscription corresponds to the first period, *nien-hao*, in
Chang Tsung's reign, a device used from 1190 through January 1196; the latter
date is therefore a secure *terminus ante quem*. The scroll is done on silk in rich and
bright colours of subtly chosen hues. No setting or background is indicated; the
figures themselves create the space about them. There are twelve, so distributed
that six are to the right and six to the left of centre—a centre that the composition
ignores. Reading from right to left, there is a sequence of three groups (Fig. 25A–C),
comparable to the movements of a sonata.

The first group comprises four women standing close together, two of them beating silk in a trough. Their poles are raised so as to form a parallel pair inclined slightly to the left. The space between them is empty. The other two women are readying themselves or waiting to participate. Their poles rest on the ground, leaning slightly to the right and departing subtly from a parallel position. The women's heads appear at systematically varied angles, 'like a sequence of four lunar phases', as Arnheim phrased it in a remarkable description of this group.[26] One detail that should not be overlooked, not of composition but of design and observation, is the lowered hands of the two ladies in the centre guiding the heavy poles. The group as a whole emphasizes verticality.

The second group comprises three seated figures in different postures, spinning, sewing, and fanning the charcoal in a brazier. This group makes a pronounced contrast with the first, as well as with the following group. There is no overlapping, the movements are diversified, the postures complicated.

The third group is made up of five figures. Four of them, engaged in ironing a roll of raw silk, form a variation of the first group; but they are so widely separated by the length of silk that this variation achieves a horizontal emphasis. The fifth figure is that of a child who plays beneath the silk—almost with the same decorum and purposefulness as the serious, strangely silent adults. Surpassingly sensitive is the young girl facing the lady who irons; although her face is hidden, an individual life is captured in her frail figure, which appears to have been *seen*, rather than invented.

Hui Tsung's painting is executed with such tenderness and precision that it would seem arbitrary to assume that the faces are not faithful to the original. In other words, their lack of individuality must not be regarded as due to the copyist's failing. These surprisingly uniform faces represent an ideal type rather than individual persons.

This indifference to individuation may be seen even in a scroll said to portray the three sisters of Yang Kuei-fei, the Ladies of Ch'in, Han, and Kuo, who are shown on horseback with a small retinue in a composition no less meticulously executed than the one just described. It is a scroll in the Palace Museum collection in Taipei given a title adopted from one of Tu Fu's poems,[27] *Li Jen Hsing* ('The Ways of the [Court] Beauties') and said to be a copy after Chang Hsüan made by Li Kung-lin (c.1040–1106). Its connection with Chang Hsüan is not documented, nor is there anything to indicate why Li Kung-lin should have been credited with the execution of the copy; but there are no features irreconcilably opposed to the dual attribution. The style here copied, along with the attire of the equestriennes and the decor of the caparisons, is unquestionably T'ang; while the elegance and concinnity of the configuration at large agrees well with the Chang Hsüan in Boston—as does the fact that the ladies' faces are completely stereotyped. The main group shows vacuous, white-powdered faces quite without individuality.[28] No exception is made for the Lady of Kuo, though she was known for her disdain of cosmetics, as Tu Fu records:

> The Lady Kuo-kuo enjoys imperial favours.
> At dawn she enters the Palace on horseback [not dismounting].
> She scorns to defile her face with make-up and powder;
> Her eyebrows only lightly brushed, she appears before her lord.[29]

Despite her enviable complexion, she and her sisters received, as Soper notes in his translation of *Kuo Jo-hsü's Experiences*, 'a monthly stipend of 100,000 cash apiece for beautification alone'.[30]

There exists another version of this work in the Liao-ning Provincial Museum, Mukden, attributed by Chang Tsung to Emperor Hui Tsung in an inscription again followed by the regnal seal *Ming-ch'ang*, exactly as in the case of the scroll of *Ladies Preparing Newly Woven Silk* in Boston. The title given in the inscription is not *Li Jen Hsing* but *Lady Kuo-kuo on a Spring Outing*, and the Mukden copy differs somewhat in design from the Taipei version. The ground plane is tilted more steeply; the heads of the horses are more feelingly drawn, and their eyes, staring fiercely at the viewer, have an uncannily intense effect of aliveness; and most notably, the faces of the three sisters—as far as can be told from a pale reproduction in the *Liao-ning-sheng Po-wu-kuan ts'ang-hua-chi*[31]—are not those of puppets but of distinct personalities. That this last feature is an achievement of the copyist improving on his model is rather improbable; in all likelihood it was present in the model, partly preserved here and lost in the Taipei version.

Of the few facts to go by in our attempt to understand the historical rôle played by Chang Hsüan, of whom not one authentic stroke now remains, none seems so important as his extreme remove from Wu Tao-tzu in matters of both style and content. Not only does it vouch for Chang's originality, but it also indicates that such diversity among coeval masters was possible and acceptable in his time. A second point of interest is the existence of two copies by the Sung emperor Hui Tsung, who obviously must have admired and felt an affinity for the work and manner of this master. Finally, it is significant that Chang Hsüan had so great a follower as Chou Fang, ranked second only to Wu Tao-tzu in the *T'ang-ch'ao ming-hua-lu*;[31a] this too tells of Chang's independence as an artist, and moreover suggests that his style was deeply in tune with his time, as well as rich in possibilities for the future.

Chou Fang (*c.*740–800) was born into an aristocratic family of Ch'ang-an. He moved with ease in the high circles of the capital, where he found the models of femininity he most admired: 'women of rich and opulent beauty with an air of being wealthy and noble', to quote Sirén's translation of T'ang Hou (1329).[32] While he remained aloof from country folk, his paintings of gentlewomen were 'unsurpassed in any age', according to Chu Ching-hsüan (840s). But Chou Fang's range was by no means limited to the portrayal of women.

His career as an artist was summed up in a terse statement made by Chang Yen-yüan (847) who said, 'at first he imitated Chang Hsüan, but later he became somewhat different'.[33] The T'ang writer does not explain how Chou Fang was different. But he praises the extraordinary elegance of deportment in Chou's figures, the strength and simplicity of design in his robes, and the beauty of the soft shades of his colour. Although Chang's comments are too unspecific to enable us either to accept or reject any particular work or copy sailing under the flag of Chou Fang, they do apply to a body of works fairly consistent in style attributed to him.

One among them has the air of a T'ang original—*Court Ladies Adorning their Hair with Flowers*, a handscroll in the Liao-ning Provincial Museum in Mukden.[34]

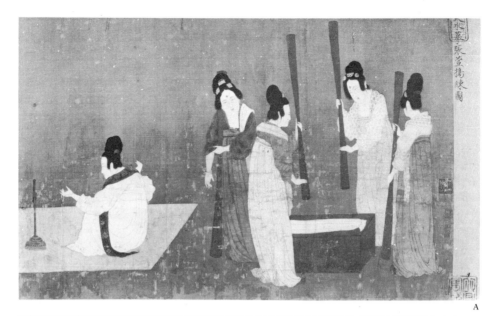

A

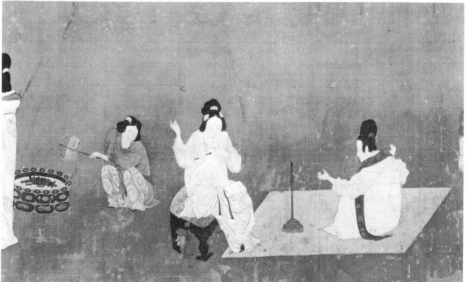

B

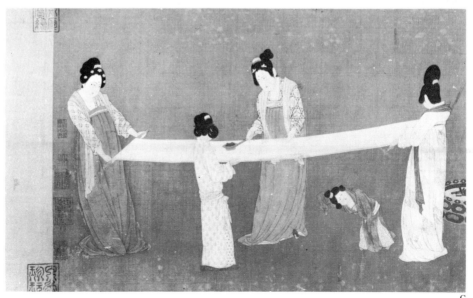

C

FIG. 25A–C Emperor Hui Tsung, *Ladies Preparing Newly Woven Silk*. Copy after an original by Chang Hsüan. Boston, Museum of Fine Arts. See also Plate III.

It is a scroll of considerable interest (Figs. 26, 27). For the first time we are faced with a work that neither portrays identifiable persons, nor depicts any story or action. Nothing happens in this picture. The four tall figures might represent the same model drawn four times—in various robes and in varying, self-conscious poses adopted to display graceful attitudes. The tallness of these figures is emphasized by two female figures of like proportions but much smaller scale. A crane stalks decorously in front of the third of the main figures, the only one who stands fully erect. Exempt from all this decorum are two pugs, Pekinese to all appearances, who rush full tilt toward the women at either side. A flowering magnolia behind a rock at the left margin indicates a garden scene.

There is a faintly melancholy air about this group, whose only *raison d'être* seems to lie in the purely aesthetic sphere of appearance. We cannot discern any expressed relationships between the women, although they seem to share a common mood of languor and loneliness. Their main function is a formal one, for they are simply elements of a configuration in which the design of the robes appears to matter most. The brush lines are fine and unobtrusive, completely subordinate to their descriptive function, and, like those of Chang Hsüan, without any calligraphic flourish. Perhaps the studied poses are a device for varying the presentation of robes and draperies, which indeed are marvels of design and colouring. The faces and coiffures however, lacking variety, contribute to the total effect chiefly through their uniform and only slightly forced contrast of white and black. In the luxurious robes we find subtle variations of plain and patterned, diaphanous and opaque materials in exquisitely modulated combinations of a limited colour range—chiefly vermilion, purple, crimson, and pink—set off with uncoloured areas and sparingly used white. Compared with the crisp, almost shrill colour of the Chang Hsüan in Boston (Fig. 25), Chou Fang's palette seems very sophisticated. Chang Yen-yüan's remark about the soft beauty of his colour might just possibly imply that Chou Fang had discovered for himself colour harmonies untried before him.

The more widely known handscroll in the Nelson Gallery called *Tuning the Ch'in and Drinking Tea* (Fig. 28), a Northern Sung copy after Chou Fang or a master close to him, shows a less recondite subject. A few women have gathered in a garden corner. One of them is seated on a flat rock next to a blooming cassia tree, tuning her instrument. To her left sits a stout, matronly woman on a tabouret; seen from the back, her twisted and foreshortened, complicated posture is convincingly rendered, and her slipping scarf adds an expressive touch of lassitude. Separated from this figure by a young *wu-t'ung* tree is a third lady, who is seen from the front; she too is seated, but in a more attentive attitude which is beautifully expressed in her silhouette, more nearly congruent with that of the *ch'in*-player. The three women are flanked by two standing girls, wearing broad sashes, who serve them tea. As for the content of this composition, which again portrays no action, it cannot very well be the effect of music on the listeners, as has sometimes been suggested; it rather evokes the more undefinable state of expectation preceding a performance.

Closely related to the Kansas City scroll is a larger composition in handscroll form at the Hui-hua-kuan in Peking entitled *Palace Ladies with Silk Fans*,[35] a copy of which is in the Moore collection at Yale University.[36] Both the worn condition and the high quality of the Peking scroll are suggestive of a late T'ang date, possibly

about 800 or so, and of the hand of the master we encountered at a near remove in the Kansas City scroll. Once more the figures are not active, but seem overcome with fatigue, almost drowsy. Having listened, or performed, or embroidered, or conversed, these persons seem wrapped in their feelings, withdrawn, pensive and melancholy. Of the *élan* of early T'ang there is very little left here. What instead appears is a deeper awareness of a person's inner existence, which in this masterly drawing is conveyed also through the animated, even intelligent faces. The copies

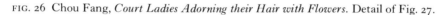

FIG. 26 Chou Fang, *Court Ladies Adorning their Hair with Flowers*. Detail of Fig. 27.

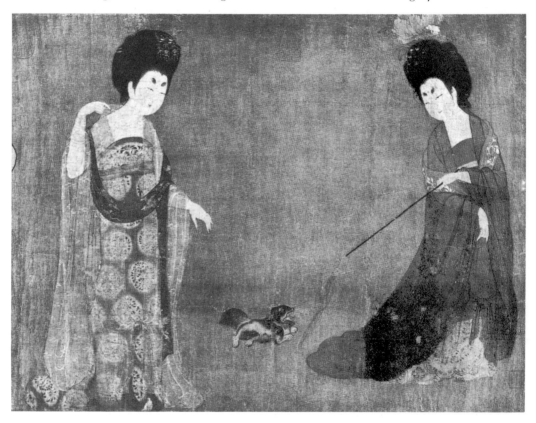

FIG. 27 Chou Fang, *Court Ladies Adorning their Hair with Flowers*. Handscroll. Mukden, Liao-ning Provincial Museum.

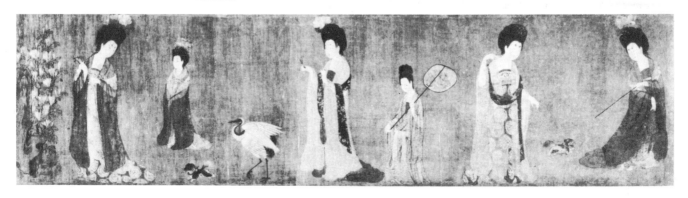

tell how easily such faces turn under the imitator's hand into graceless, wooden visages; in a technique so infinitely sparing and therefore so exacting the slightest slip or deviation can be disastrous.

There exists a third picture attributed to Chou Fang, similar to the preceding two and sharing with them certain differences from the Mukden Museum's *Court Ladies Adorning their Hair with Flowers*. It is a short handscroll in colour on silk representing *Ladies Playing Double Sixes* [a board game like backgammon] and preserved in two versions, one in the Palace Museum in Taipei, the other and earlier one in the Freer Gallery (Fig. 29). The protagonists are two elderly women, impressive characters even in this copy. The colouring is subdued and harmonious, yet unlike either Chang Hsüan's or that of the Mukden Chou Fang, while the brush line, in Sickman's description, 'is thin and flowing with few abrupt angles'.[37]

The prominence of the brush line is one of the traits common to all three of the scrolls just described. It is most pronounced in the Peking scroll, which on all counts ranks first in quality; and there the lines are not overly thin or flowing, but straight, disconnected, and angular—deliberately avoiding curves. This kind of lineament, so unlike Wu Tao-tzu's, far from Chang Seng-yu's, and worlds apart from that of Wei-ch'ih I-seng, might be derived from Chang Hsüan. At any rate, the consistency of style and attribution makes it difficult to deny Chou Fang's ultimate authorship. Yet current Chinese publications speak of 'a T'ang master' in the case of these three scrolls but of 'Chou Fang' in the case of the Mukden scroll, which is accepted as authentic also by Y. Yonezawa.[38]

As mentioned before, Chou Fang's range of subjects was not limited to court ladies or children, but comprised Confucian, Taoist, and Buddhist themes. He is credited by Chang Yen-yüan with having established the iconographic type of the Water-moon Kuan-yin (Sanskrit, Udakacandra-Avalokiteśvara), the image of the Bodhisattva of Compassion gazing at the moon's reflection in the water and meditating on the insubstantiality of the phenomenal world. Records of his wall-

FIG. 28 Copy after Chou Fang, *Tuning the Ch'in and Drinking Tea*. Kansas City, William Rockhill Nelson Gallery and Atkins Museum.

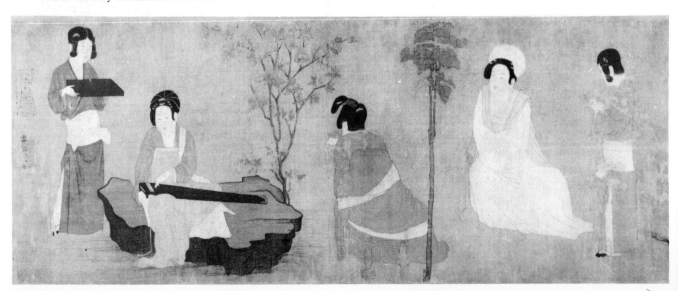

paintings, which also mention a Water-moon Kuan-yin, show that Chou Fang was not deterred by monumental formats. In addition he must have been among the foremost portraitists of his time, if we can credit an anecdote told in the *T'ang-ch'ao ming-hua-lu* that has him compete with, and surpass, Han Kan, who was about thirty years his senior. But the same text, while according Chou Fang so high a place, does not in its final verdict suppress what to its author appeared to be weaknesses: 'Chou's paintings of Buddhist icons, of Taoist Immortals, of secular figure subjects in general, and of gentlewomen in particular, all belong in the inspired class. Only in his saddle-horses, birds and beasts, plants and trees, and woodland rocks did he fail to realize completely their forms.'[39] The same T'ang critic registers no such limitations in the case of Wu Tao-tzu; on the contrary, he credits Wu with mastery of landscape and architecture in addition to the subjects just enumerated.

FIG. 29 Attributed to Chou Fang, *Ladies Playing Double Sixes*. Washington, D.C., Freer Gallery of Art.

But Chou Fang's narrower scope is an important trait in his artistic character. His complete indifference to landscape in particular is apparent from the titles of the seventy-two paintings listed under his name in the *Hsüan-ho hua-p'u*: none among them can be interpreted as a landscape pure and simple.

A less famous contemporary of Chou Fang's later years, around 800, was the court painter, muralist and portraitist, **Li Chen**, the only T'ang painter of whose oeuvre some undisputed specimens are left. These are a set of five large *kakemono* kept at Tōji (or Kyōōgokokuji) in Kyoto, one of the great temples of the Shingon Sect, having been brought there by Kōbō Daishi (774–835), the Japanese founder of the sect, on his return from China in 806. They represent three Indian and two Chinese patriarchs of the esoteric Mantra Sect (Chinese, *Chen-yen*, Japanese, *Shingon*, meaning 'True Word'). Unfortunately these impressive works are in a dilapidated condition. The only nearly intact face is that of Amoghavajra (705–74). His shaven head and lean, ascetic features are defined with the same firm, thin outlines and light shading as his austere, blackish, unadorned robe (Fig. 30). To the right of his tense figure, the priest's name is supplied in Siddham letters (A-mo-gha-va-jra), the Chinese equivalent (Pu-k'ung Chin-kang) being given at the left; above the names hover enormous Chinese characters of weirdly ornamental design reading 'Sanskrit style' and 'Chinese name', respectively. Supposedly these inscriptions were added by Kōbō Daishi himself. Since it is recorded that Li Chen was assisted by his disciples in the execution of these portraits, we may surmise that he was responsible primarily for the physiognomies. The figure of a standing acolyte next to the effaced image of Hui-kuo (746–805), for instance, which is well preserved except for the head, clearly betrays an inferior, inexperienced hand. The somewhat unexciting design of the drapery, which is rendered in sparing, thin, and mostly straight lines, appears to imitate Chou Fang's much superior manner.

The monk **Kuan-hsiu** (832–912) from Lan-ch'i in Chekiang was the last of the great T'ang masters specializing in the representation of the human figure. But his images are utterly unlike those conceived before him. In particular, they are not classical.

While still a child of six or seven he was left in the care of a Ch'an monastery. Before his ordination at the age of twenty his poems had already won him a reputation—not altogether deserved, in Arthur Waley's opinion.[40] Monastic duties took Kuan-hsiu to Kiangsi and Fukien, Chekiang and Hupei. About 902 he moved to Szechwan (Shu), where he was well received by the local ruler, Wang Chien (reigned 901–18), who conferred upon him the title of Ch'an-yüeh Ta-shih (Japanese, 'Zengetsu Daishi').

Works attributed to, or derived from, Kuan-hsiu still exist in Japan. Chief among these are three sets of wall-scrolls representing the Sixteen (sometimes Eighteen) Lo-han (Japanese, *Rakan*, Sanskrit, *Arhat*, meaning 'Worthy' or 'Venerable'), the saints of ancient Buddhism. They are represented as single, seated figures of bewilderingly strange, expressively distorted physiognomies which symbolize their spiritual struggles on the path toward emancipation. One such set, comprising sixteen scrolls, is in the Imperial Household collection in Tokyo; once

FIG. 30 Li Chen, *Portrait of Amoghavajra*, Kyoto, Tōji.

owned by Shōmyōji in Kanazawa (near Yokohama), and then the property of Baron Takahashi during the Meiji period, it is older than the others. A set of eighteen scrolls at Kōdaiji in Kyoto was brought to Japan by the priest Shunjō in 1211. It is an urbanely beautiful Sung work, far from the fearsome ugliness of the first set. At Seiryōji in Kyoto is a third series, once more of sixteen scrolls, which also seems to go back to Southern Sung, even though its less literal and painstaking, rather fluent and elegantly simplifying technique suggests a somewhat later date than that of the Kōdaiji series. As the Seiryōji set is executed in ink only, it is tempting to equate it with the *suiboku* ('ink wash') set of eighteen Lo-han that Shunjō received as a gift from the abbess of K'ai-hua-ssu at Lin-an (Hang-chou), as related in a Japanese record written thirty-three years after his return; but Kobayashi believes the Lin-an set to be lost.[41]

The Shōmyōji set in the Imperial Household collection,[42] which around 1890 was mounted on wooden boards, shows unmistakable signs of hoary age. Retouch-

ing and repairs account for the coarsening of once subtle passages. Yet nowhere does there appear any trait suggestive of a date as late as Sung. In fact it would be difficult to justify taking this set as a copy of later date rather than an original version or contemporary replica. At any rate, there is no way of telling on stylistic grounds. Extraordinary enough on account of its subject matter and form, the set is made even more interesting by an inscription on the eleventh picture—alleged to be Kuan-hsiu's self-portrait in the guise of Rāhula, the Buddha's son[43]—that gives exact information as to when, where, and for whom the series was executed. The inscription is much effaced, however, and would be illegible but for the lucky survival of a stone-engraved reproduction of an almost identical series of the Sixteen Lo-han from Sheng-yin-ssu at Ch'ien-t'ang, Chekiang; the eleventh slab of this series bears an inscription of identical wording and, like that of the scroll, written in seal script. It says

> Of the Sixteen Lo-han at Huai-yü-shan [Monastery] in Hsin-chou [Kiangsi], ten figures, the work of the Monk of the Western Peak, Kuan-hsiu, were delivered from the Ho-an [Monastery] at Teng-kao [Chekiang] at the beginning of Kuang-ming [880]. At the beginning of Ch'ien-ning [894], at Chiang-ling [Hupei], on the twenty-third day of the first winter moon [November 24], work to complete the set of sixteen rolls commenced . . . [after an interval approaching ?] sixteen years. In good time the Ch'an monk Ching-chao arrived from the north to ask [for the pictures], which he will take with him to Huai-yü this year.

Of the Sheng-yin-ssu set, which in effect authenticates the Shōmyōji set, we know only that it was transferred thither from Ch'ang-ming-ssu (east of Hang-chou) in 1735; that it was provided with inscriptions by Ch'ien-lung in 1764; and that some-time thereafter, having in the meantime been engraved in stone, it was lost. Be that as it may, the two series, both claiming as they do to be the work done for the Huai-yü-shan Monastery between 880 and 894/5, ought to be completely identical. Actually they are not. In particular, the two figures of Subinda and Nakula, num-bers 4 and 5 in the Shōmyōji set, are replaced by Nandimitra and Vānaka in the Sheng-yin-ssu set. Moreover, there are discrepancies of detail which cannot well be explained as liberties taken by the stone-engraver; rather they presuppose different models. The names of the sixteen *Arhat* of the Tokyo set strictly agree with those enumerated by Nandimitra in a sūtra translated by Hsüan-tsang in 654.[44] Nandi-mitra, therefore, might appear in a series of eighteen Lo-han, but not of sixteen. Such was in fact the case with the set of eighteen presented to Shunjō by the abbess at Lin-an, who said to the Japanese visitor, 'Number 17, Ch'ing-yu tsun-che [the Venerable Nandimitra] resembles you, Master of the Law!' Perhaps the Sheng-yin-ssu set did once comprise eighteen figures, and the numbers 17 and 18 were used to remedy the loss of numbers 4 and 5. It is a question we cannot hope to answer. But it bears on the more important problem of the relationship between the stone-engravings and the paintings in Tokyo. Both purport to be the Huai-yü-shan series, which therefore must have existed in more than one version. Without paying further attention to the observable differences between the two sets, we can be certain of these two facts: first, the Tokyo paintings and the stone-engravings are

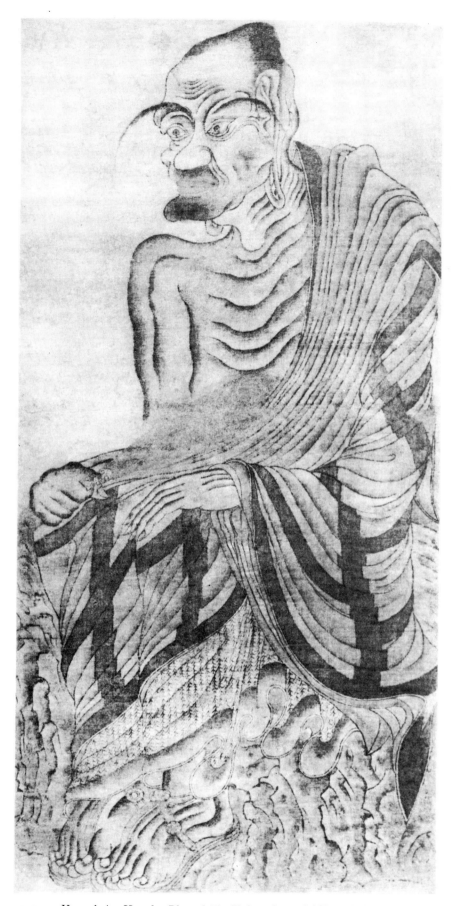

FIG. 31 Kuan-hsiu, *Kanaka-Bharadvāja*. Tokyo, Imperial Household collection.

independent of each other, and second, their designs are approximately the same. It is the combination of these facts that 'authenticates' the Tokyo set which, moreover, happens to be superior in quality.

One of the best preserved pictures is the third in the series, that of Kanaka-Bharadvāja (Fig. 31). He wears a light red robe with black stripes forming 'steps' in keeping with the pattern of folds. A green undergarment is indicated by narrow stripes of green at the sleeve-ends. The robe, which leaves the chest and right shoulder uncovered, is represented with innumerable folds drawn in a slow, deliberate manner that seems to renounce both the elegant sweep of Wu Tao-tzu's draperies and the calculated economy of Chou Fang's. The pattern of folds continues, as it were, over the chest and neck and face, always in bundles of similar curves of a slightly geometric quality. This inorganic character of the lines, which are shaded in a peculiar, dry technique without modelling effect, is strongly visible in the left hand—which looks like a glove—and left foot, which almost looks skinned. On this worn-out body sits a grotesquely shaped head with features that speak of self-torture and desperate searching rather than victory or ultimate liberation. The eyebrows form large arcs like antennae, jutting far out from the forehead. The staring, unseeing eyes are sunk in deep concentration; the pathos and power of the image are focused in them.

In the face of Piṇḍola, the first of the set (Fig. 32), the bold and apparently unprecedented manner of defining the warped, emaciated features of a saintly monk through aggregates of repeated curves is even more pronounced. His long, narrow eyes reveal a state of calm indifference and a formidable power of penetration. These qualities drew the attention of a notable priest of the Ming period, Tzu-po Ta-shih (1543–1603), who wrote encomia for a set of copies after Kuan-hsiu's *Sixteen Lo-han* and described this same head (quoted in Chinese by Kobayashi):

> The skull is extraordinary—
> Hillocks alternating with hollows.
> The eyes lie deep under cliffs.
> Where they flash, nothing remains hidden.[45]

Kuan-hsiu's *Arhats* rise to a level of abstraction we have not heretofore encountered. At the same time they probe deeply into what might be called the typology of the religious individual. There is a richness of experience, imagination, and vision here that is not sufficiently acknowledged by an insistence on the ugly, grotesque or repellent appearance of these types. Dating from 880, they are the creation of a Ch'an monk who was thirteen or so when, in 845, the Buddhist church in China went through its worst ordeal. Growing up in a monastic environment, even a boy must have been aware of, and in some way affected by, that disaster. Perhaps the importance of Arhat images in the later ninth century had to do with the traumatic experience of the persecution of 845; in any case, it was left to Kuan-hsiu to contribute the most unnaïve, profoundly appealing formulations of these images.

FIG. 32 Kuan-hsiu, *Piṇḍola*. Tokyo, Imperial Household collection.

Notes

1. *Hua-chien.*
2. *Li-tai ming-hua-chi*, ch. 8, p. 250; cf. Soper's translation in *Textual Evidence*, p. 64.
3. *KKSHL*, ch. 6, 167.
3a. *Li-tai ming-hua-chi*, ch. 8, p. 254.
4. Ch. 68.
5. Nos. 601–8.
6. Ch. 9, p. 268.
6a. Soper, 'T'ang-ch'ao ming-hua-lu', p. 213.
7. Further dates relevant to the pedigree of the scroll will be found in Tomita, *Portfolio* (Han to Sung), pp. 3–4.
8. *CP*, I, pp. 100–1.
9. *Tu Fu's Gedichte*, I, 29.
10. Soper, *Textual Evidence*, p. 24.
11. Akiyama and Matsubara, *Buddhist Cave Temples*, pl. 39.
12. Nagahiro, 'On the Painter Wei-ch'ih I-seng'.
13. All five paintings are reproduced in *CP*, III, pls. 42–7.
14. Rudolph, 'Newly Discovered Chinese Painted Tombs'.
15. Speiser, *China : Geist und Gesellschaft*, p. 153.
16. *Wu Tao-tzu.*

17. Waley, *Introduction*, p. 112.

18. Soper, 'T'ang-ch'ao ming-hua-lu', p. 208.

19. Ibid., p. 210.

20. *Li-tai ming-hua-chi*, ch. 2, pt. 2; translated in *CP*, I, p. 115.

21. *Li-tai ming-hua-chi*, ch. 2, pt. 2, p. 65.

22. Waley, *Introduction*, p. 117.

23. Ibid., p. 116.

24. *CP*, I, p. 117.

25. Cohn, *Chinese Painting*, text fig. 24; Sickman and Soper, pl. 65 B.

26. Arnheim, p. 111.

27. *Tu Fu's Gedichte*, II, 16.

28. Reproduced in colour in Cahill, *Chinese Painting*, p. 20.

29. *Tu Fu's Gedichte*, XVIII, 46.

30. p. 193, footnote 630.

31. Vol. 1, pls. 36–8.

31a. Soper, 'T'ang-ch'ao ming-hua-lu', pp. 210–12.

32. *CP*, I, p. 145.

33. *Li-tai ming-hua-chi*, ch. 10, pp. 316–17.

34. Two sections of the scroll are reproduced in colour in Akiyama and others, *Neolithic to T'ang*, pl. 199, while the complete composition appears in black and white in *Liao-ning-sheng Po-wu-kuan*, pls. 13–15.

35. Wang Po-min, pls. 5–10; *CP*, III, pl. 108.

36. *Chinese Paintings in the Collection of Ada Small Moore*, pl. 21.

37. Sickman and Soper, p. 88.

38. Akiyama and others, *Neolithic to T'ang*, entry 199.

39. Soper, 'T'ang-ch'ao ming-hua-lu', p. 212.

40. Waley, *Introduction*, p. 166.

41. Kobayashi, *Zengetsu daishi*.

42. *Tō Sō*, vol. 1, pls. 6–11; Kobayashi, *Zengetsu daishi*.

43. *Tōyō*, vol. 8; *CP*, III, pl. 114.

44. Nanjio Bunyiu, *A Catalogue of the Chinese Translation of 'The Buddhist Tripitaka'*, Oxford, 1883, no. 1466.

45. Kobayashi, *Zengetsu daishi*, p. 551.

Landscape painting of Sui and T'ang

The master recognized in his time as the first 'realistic' landscapist, **Chan Tzu-ch'ien** (*c.*550–*c.*604) from P'o-hai in northern Shantung, was versatile enough also to be remembered for his figure paintings, which represented such traditional subjects as the Five Planets, the Pole Star, Lokapāla Vaiśravaṇa, Vimalakīrti, and Fu Sheng, the late third-century B.C. scholar who saved parts of the *Shu-ching* when Ch'in Shih-huang-ti ordered the *Classics* to be burned. Surprisingly, the earliest landscape handscroll in existence, *Travellers in Spring* (Fig. 33), a river scene of convincingly early design and appearance, was attributed to Chan Tzu-ch'ien in an inscription by Emperor Hui Tsung. There is no reason to reject his attribution out of hand even though it is unsupported.

FIG. 33 Chan Tzu-ch'ien, *Travellers in Spring*. Peking, Ku Kung Po-wu-yüan.

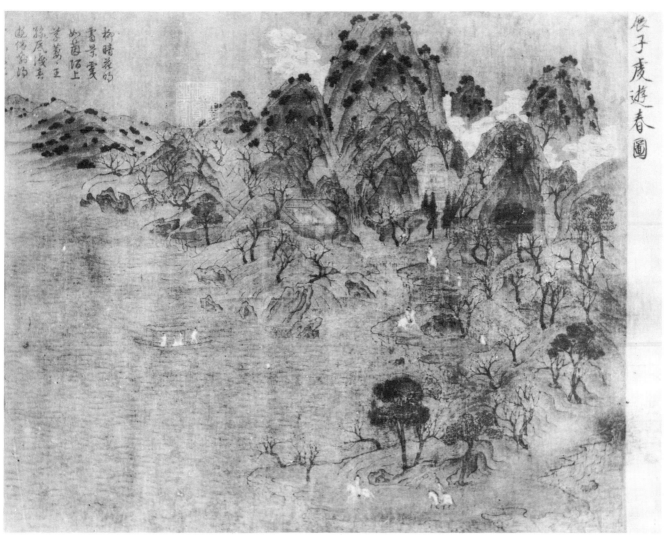

A wide and open expanse of evenly rippled water extends far back toward a veiled horizon. On the right side, shown in the reproduction, there rises above a tilted, hilly terrain a formation of steep hills of uniformly conical shape. They are accentuated by dark patches of vegetation placed along their boxed contours. Swirling white clouds circle about the most distant peaks. Scattered over the promontories and hills are small, leafless, blossoming trees of uniform type. The figures of the few travellers, some on foot, some on horseback, and some being ferried across the river, form bright spots among the subdued green and blue of the slopes and hills and water. An interesting and apparently novel feature is the design of angular, layered rock in the escarpments along the banks. Architectural units are placed awkwardly, like alien elements, among the folds of the asperous terrain.

This precious small work, while still primitive as a landscape, exemplifies a stage far beyond that of the Nelson Gallery Sarcophagus (Figs. 13, 14), especially as regards spatial and proportional relationships. Particularly striking is the coherent recession of the shore line. To place this work as early as implied by the attribution, toward 600, is hard to justify. In fact, the chief motifs—mountains, rocks, trees, and the water pattern—agree closely with various eighth-century works and copies after eighth-century models, so that this scroll may be more securely placed in the later seventh century or even around 700. But the assumption that the scroll is a Sung copy is difficult to reconcile with the fact that Hui Tsung considered that it dated five centuries back in time; moreover, clear Sung features are absent.

Another landscape by Chan Tzu-ch'ien in the Northern Sung Imperial collection bore the title *Picking Melons*. No valid later record of this work exists. But the same title recurs among the pictures listed in the *Hsüan-ho hua-p'u*[1] under the early eighth-century artist Li Chao-tao, which suggests that Chan Tzu-ch'ien's ideas lived on into early T'ang and possibly contributed to the formation of the blue-and-green landscape style, whose founders were Li Ssu-hsün and his son, Li Chao-tao. Perhaps Chan's composition was the basis from which, after several metamorphoses, Li Chao-tao's *Travellers in the Spring Mountains* and, ultimately, the grandiose *Ming-huang's Journey to Shu* (Fig. 39) emerged.

Li Ssu-hsün, or Senior General Li, was a gentleman painter who as a grandson of the Prince of Ch'ang-p'ing, a younger cousin of the first T'ang emperor, was a member of the imperial clan and throughout his life occupied positions befitting his station. During the perilous years of the reign of Empress Wu (690–704) he was in hiding, but in 705 was appointed Lord of the Court of Imperial Family Affairs, and ennobled as duke. For some time he was Chief of the Prefectural Office of I-chou (Ch'eng-tu, Szechwan). In 713 he was promoted to General of the Left Imperial Body-Guard and enfeoffed as Duke of P'eng-kuo. His last title was that of General of the Right Body-Guard. According to the *T'ang-shu* he died in 718.[2]

'Perhaps the only painting by Li Ssu-hsün in existence', to quote the Catalogue of the National Palace Museum, *Ku-kung shu-hua-lu*,[3] is *Sailing Boats and a River-side Mansion* (Fig. 34), a riverscape painted in vivid colour on a now damaged and darkened silk. The experienced eighteenth-century collector An Ch'i had treasured it as an indubitable T'ang painting. The composition resembles thematically the Chan Tzu-ch'ien *Travellers in the Spring*.[4] But the ground is so steeply tilted that

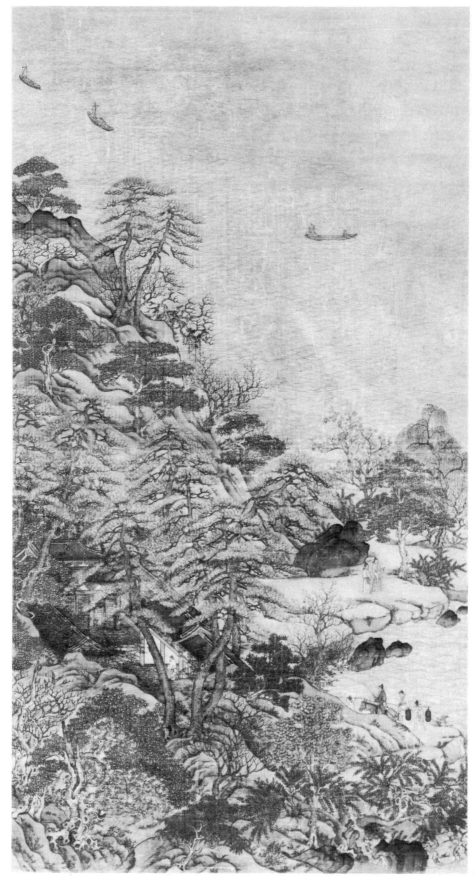

FIG. 34 Attributed to Li Ssu-hsün, *Sailing Boats and a Riverside Mansion*. Taipei, National Palace Museum.

the horizon lies outside the picture, and the terrain is covered all over by a luxuriant vegetation of pines and more exotic plants, which are executed in a painstaking technique, in forms not known to occur after T'ang. The pine trees, too, are rendered in a manner that seems unparalleled in later painting. Another archaic feature is the persistent crevicing of the terrain, which is tinted in a limpid green along the contours while a few exposed rocks are shaded in a darker blue. The same blue pigment is used to set off the roofs of the mansion from the bright red of its woodwork. As the painting is not signed but merely attributed to Li Ssu-hsün—of whom not a single authenticated work is known—its authorship must be left open. Also the question of its actual date is not settled. Despite these uncertainties the work reveals on formal grounds no post-T'ang features except, perhaps, in such details as the figures, which do have a Sung flavour. Possibly, then, as is assumed by Sirén,[5] it is a Sung copy, whose accuracy we are unable to judge and not entitled to doubt.

The general's son, **Li Chao-tao** (c.675–740 ?), though known as Little General Li, had no military rank, his position being that of Under-Secretary to the Heir-Apparent. As a painter, therefore, he was a non-professional like Li Ssu-hsün, and no less celebrated than his father for colourful 'blue-and-green' landscapes, often heightened with gold contours and abounding with fine detail. But the great T'ang critics who wrote a century after the younger Li's death were at variance in their estimate of the relative merits of the two Lis. Chu Ching-hsüan, in his *T'ang-ch'ao ming-hua-lu*, firmly places the Little General below the 'inspired' Senior, saying that 'Chao-tao did not equal his father in intelligence and strength of brush, though his depictions of landscapes and of birds and beasts were very detailed and clever.'[6] His verdict was accepted in such later texts as the *Hsüan-ho hua-p'u* and *Ko-ku yao-lun*,[7] but Chang Yen-yüan's *Li-tai ming-hua-chi*, on the contrary, states that 'Li Chao-tao, having changed his father's style, even surpassed him, and [moreover] created a new theme, the seascape.'[8]

Alas, these judgements do not enable us to reconstruct the style of either one of the Lis, and to apply them to any particular work is a hopeless task. In the innumerable extant copies their styles have coalesced into one. Even so, as visual statements they can tell us more than the words of the ancient writers do. What these copies or imitations usually show are more or less compact compositions with palatial buildings of imposing complexity, which in most cases include octagonal pavilions, surrounded by a multitude of cliffs or hills, rivers and lakes and waterfalls, tall trees and distant groves, bridges and boats, and people in festive attire everywhere. A naïvely bold disregard of plausibility in the formation of the cliffs and in the architectural structures is so persistent that it seems to be a characteristic of the originals rather than the imitators' licence. But the hall-mark of this school is a combination that is always present—in the mountains and cliffs, rocks and terrain—of two mineral pigments: azurite blue and malachite green. The blue may be intense and dark; the green is usually bright and fresh. Gold is used in many ways, though perhaps most conspicuously to give a texture to walls or overhangs of exposed rock by sharp, angular flicks of the brush; the technique of texturing is called the 'small axe-chip'.

Of the works purporting to be Li Chao-tao's, only *The Storeyed Pavilion of*

Lo-yang (*Lo-yang Lou*), in the Palace Museum, Taipei, is signed; but it is unlikely to be older than Sung.[9]

A large vertical scroll in the same collection, *Picture of the Winding River* (*Ch'ü Chiang T'u*), which depicts the scenery around an artificial lake southeast of Ch'ang-an, is a strangely primitive work ascribed to Li Chao-tao.[10] The lower third is taken up by a vast architectural ensemble along the river, where pleasure boats move to and fro. The upper portion shows a long embankment with willows and firs, above which rises a tall formation of rocks of uniformly rounded and fissured shapes and sizes. This formation is handled indecisively and fails to create the effect of recession, distance, and atmosphere. The hundreds of figures scattered among the buildings, on the water, and on the banks, all seem entirely T'ang in appearance. Both the landscape elements and the roofs of the buildings are coloured in bright hues of blue and green. Gold is used copiously in fine outlines of rocks and wavelets, as well as in softly gleaming washes on some of the rocks. The technical procedure apparently consisted of the following steps: first, outline drawing in ink; second, a wash of colour; third, application of gold for contours and of ink dabs to 'roughen' and diversify the rock surfaces. Done in opaque colour on a light brown silk, this painting is hard to place. Possibly it is the work of a lesser hand than Chao-tao's, though conceivably of his time; but more probably it is a later copy.

A stylistically related fragment of circular shape in the Palace Museum, *Auspicious Snow on Shang-lin Park*,[11] loosely classified as an anonymous Sung work, may well be coeval with the preceding scroll. It agrees in essential features, such as the design of the rocks with their peculiar, coarse texture, and dabs of ink; the shapes of the pine trees; the groves of feathery firs on distant hills and bluffs; and the strong tilt of the ground. Thematically, it forms a pendant to the *Ch'ü Chiang*: the Shang-lin was a pleasure park west of Ch'ang-an, which, like the former, dated back to pre-Han times.

Another comparable composition, again from the Palace Museum, refers once more to the Ch'ü Chiang setting. It is the picture of a palace at the foot of surging cliffs, with winding waterways in the foreground and blue-and-green hills beyond (Fig. 35). Entitled *The Ways of the [Court] Beauties* (*Li Jen Hsing*), after Tu Fu's poem on Emperor Ming-huang's extravagant entertainments of Yang Kuei-fei and her sisters,[12] it depicts a world which Li Chao-tao probably did not live to see, the decade from 745 to 755. This *terminus ante quem non* provided by the subject-matter would not preclude a possibly much later date of this picture. There seem to be no traits opposed to a T'ang date, however. Despite the painter's efforts to indicate recession, the forms cling to the surface. A band of cloud that separates the palatial towers from the crags behind them creates no illusion of space or atmosphere; it remains a device of interrupting adjoining areas of design that otherwise would fuse into one plane, a device of neatly silhouetting the roofs and trees. A detail to note is the lady on horseback on the pavement of the terrace; well may this tiny, yet conspicuous figure represent Lady Kuo-kuo as

At dawn she enters the Palace on horseback [not dismounting],

as in Tu Fu's quatrain—quoted above apropos of Chang Hsüan's painting with the same title, *Li Jen Hsing*.[13]

A different aspect of the tradition tied to Li Ssu-hsün and Li Chao-tao lives on in a few handscrolls, none of them originals, where instead of the overwhelmingly detailed vistas of parks and palaces peopled with gay throngs there unfold vast panoramas of pure landscape or of land and sea. A remarkable instance is a long *Gold-and-Green Landscape* from the collection of Sasagawa Kisaburō.[14] It depicts a continuous stretch of isles and land and mountains remote and sombre along the sea-shore (Figs. 36, 37). A sequence of ever changing formations, the whole is permeated by varying rhythms, like an arrangement in consecutive 'movements'. In principle the painter has already come to grips with the necessity of organizing his visual material in a manner analogous to music, doing justice to the dimension of time. It is a pity that this copy was done by an inferior hand, for it may well represent the earliest design of its kind in existence. Its archaic character can readily be measured by comparison with a beautiful scroll in blazing colour, *Sea and Sky at Sunrise*, in the Metropolitan Museum of Art, a copy attributed to the eminent Chao Po-chü of early Southern Sung and inscribed with the cipher of Emperor Kao Tsung (reigned 1127–62). But a Chao Po-chü may have taken sovereign liberties with his T'ang models by introducing ideas of his own or making compositional changes to bring insufferably archaic passages up to date.

A third group of pictures given to Li Chao-tao consists of variations on the theme of 'Emperor Ming-huang's Journey to Shu', an event of 756 when the Emperor fled from his capital to Ch'eng-tu in Szechwan. The connection with Li Chao-tao might simply be ruled out as an anachronism. But this neat disposition on grounds of subject-matter only leaves unanswered the question of the design and style of the landscape setting. The landscape might be based on an older model, unconnected with the sad event of 756. Literary evidence suggests that this may indeed have been the case.

Su Tung-p'o (1036–1101) speaks of a work by Li Ssu-hsün entitled *Ming-huang Picking Melons*. His description, translated by Li Lin-ts'an,[15] appears to fit the extant versions of *Ming-huang's Journey to Shu*—except that the latter do not show the incident of gathering melons. Moreover, since Li Ssu-hsün died in the sixth year of Ming-huang's reign, 718, his painting cannot have depicted the event of 756, almost forty years later. That painting, therefore, should not be identified with the *Journey*.

Among six landscapes by Li Chao-tao, the *Hsüan-ho hua-p'u*[16] records a picture named *Picking Melons*. A short note on the painter gives a hint about the subject-matter. When Crown Prince Hung was poisoned by the Empress Wu, his mother, in 675, her second son, Prince Hsien, feared for his life. In the hope of moving the Empress he wrote a song (*tz'u*) known as *Song of the Yellow Terrace Melons* (*Huang T'ai Kua Tz'u*), alluding to the princes, who are picked one by one like the melons, until the creeper dies. It was to no avail; degraded to the status of commoner in 680 Hsien was forced to commit suicide in 684, when he was thirty-three.[17] The painting was motivated by the same anxiety and pleaded the same cause as the song on which it was based. While employing a metaphor presumably of long standing, it was done as a solemn warning, in pictorial terms, to the Imperial clan, a political manifestation tied to an historical moment, presumably between 675 and 680. At that time Li Chao-tao was an infant; the attribution of the picture to him is an

obvious mistake in the Sung catalogue. The painter can only have been his father, Li Ssu-hsün, who was the same age as Prince Hsien and was experiencing the same tribulations.

FIG. 35 *The Ways of the [Court] Beauties*. Taipei, National Palace Museum.

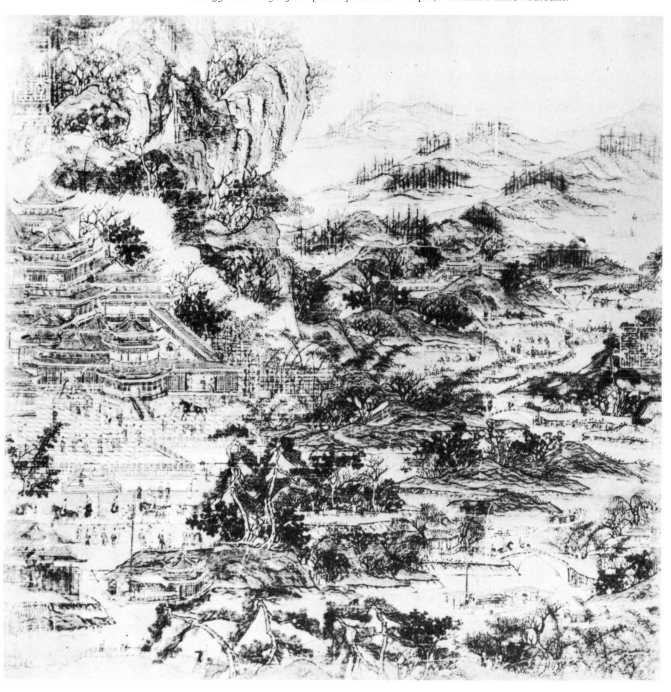

Yeh Meng-te (1077–1148) gives an account of 'a copy after Li Ssu-hsün's painting, *Ming-huang's Journey to Shu*' in his *Pi-shu lu-hua*. It contains the following passage: 'There is a garden with melons by the roadside, and some of the court-ladies have entered the garden and are picking melons; so that some people avoid [the real issue behind the picture] by designating it as *Picking Melons*.'[18] Again we note a serious mistake: if the picture was in fact Li Ssu-hsün's work, the subject could not be the *Journey* but had to be the *Melons*, and the depiction of the melon garden argues in favour of the latter theme as well as of Li Ssu-hsün's authorship.

Confused though these accounts be, they leave no doubt that there existed two original works of entirely different subjects. One was Li Ssu-hsün's *Picking Melons*, dating from about 675–80. The other was a glorified representation of Emperor Ming-huang's flight to Szechwan in 756, euphemistically entitled *Ming-huang's*

FIG. 36 Section of *Gold-and-Green Landscape*. Scroll, Sasagawa collection.

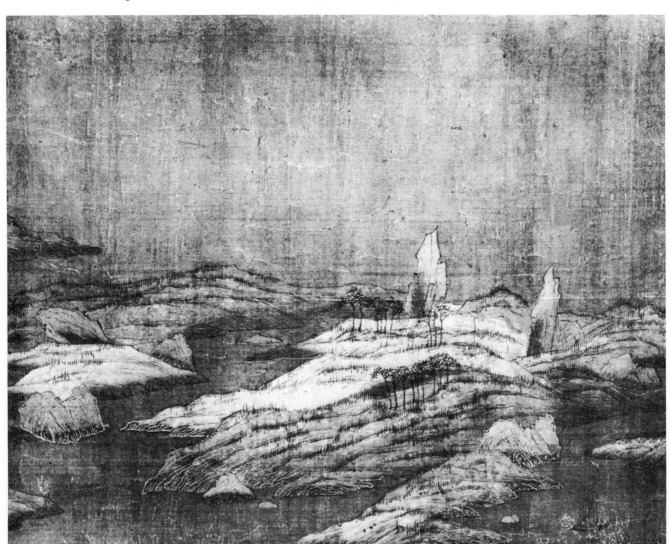

Journey to Shu, by an artist of unknown name and date, though he was painting probably only several decades afterwards at a time when—as in the case of the famous song of Po Chü-i (772–846), *The Everlasting Remorse*, of about 800—it had become 'possible to use the theme without giving offence to the Imperial family'.[19] Perhaps the painting was inspired by that song, at least thematically. As for its form, however, does not the very confusion with the older work, *Picking Melons*, so easily interpreted as the *Journey*, suggest that it was modelled on the older work? No other explanation can do justice to the apparent 'interchangeability' of the two subjects and to the ever conjured name of Li Chao-tao. Too young to have been the originator of the *Melons*, he was too old to have conceived the *Journey*; but he may well have copied the former, perhaps adding some version of his own, so that his name became linked to the topic of the *Melons*.

FIG. 37 Section of *Gold-and-Green Landscape*. Sasagawa collection.

While there seems to be no trace of *Picking Melons* left, there exist today no less than three important versions of *Ming-huang's Journey*: two of them in Taipei, one in Philadelphia. Their stylistic diversity is amazing. It goes far beyond such points as 'hands' or 'brushwork', and possibly reveals opposed 'schools' or 'traditions', which might have coexisted by about 800. The picture in the University Museum of Philadelphia (Fig. 38) with its glowing, opaque colours and formidable array of towering crags agrees in basic features with the alleged Li Chao-tao scroll (Fig. 40). It embodies the blue-and-green style so perfectly that, as an instance of that style and irrespective of the actual date, it would seem to be rather older than about 800. Possibly this picture reflects the stage of Li Ssu-hsün or even, it is tempting to think, his famous composition, *Picking Melons*. This work, which bears the imprint of a powerful artistic intelligence, also happens to be the earliest of the grand mountain scenes that were to become the foremost concern of the landscape painters from then on.

The captivating version of the *Journey* in the National Central Museum, Taipei, a horizontal wall-scroll which until 1911 was kept at the Jehol Palace, may have to be understood as a 'modernized' adaptation (Fig. 39). The large elements are re-arranged to fit the wider and lower format. At the same time a changed technique relying on outline and limpid colouring has brought about a transformation of the total effect. The design is flawless, pellucid, and incredibly precise; the palette, vivid and comparatively differentiated. There is very little of pattern or repetition in the form and surface of the rocks, which are defined by carefully modulated washes and by peculiarly deliberate contours, which are sharp and even. These contours closely resemble those of the rocks surrounding the halo of the Buddha in an embroidered hanging from Tun-huang, which Waley rated 'perhaps the finest piece of pictorial art in the [Stein] collection'.[20] The manner in which the rocks are drawn may thus be an authentic T'ang feature. Conversely, a certain trait—brush-strokes formed with a small transverse tip or end like a nail-head—was taken to indicate a Sung mannerism by Li Lin-ts'an in his 'Study' devoted to this work, whose thematic significance he was the first to recognize. Yet as an isolated trait the 'nail-head' stroke remains a trivial clue. It does not reveal anything about the style or substance of the painting, and at most it bears on the dating of this work only *qua* object and not *qua* idea. For our historical understanding the scroll's relationship to the Philadelphia picture is far more important. What this relationship suggests is a change of style such as may have been brought about by eighth-century innovators like Wu Tao-tzu and Wang Wei.

The third variation on the theme of *Ming-huang's Journey to Shu* is a relatively small vertical scroll, in the Palace Museum, Taipei (Fig. 40). Its traditional title, *Travellers in the Spring Mountains*, is inscribed above the picture in a hand resembling Emperor Hui Tsung's. We might call it a romanticized version of the preceding work. Highly formalistic, it compresses the three massifs of naked rock into in-ordinately slender pinnacles of evenly faceted, crystalline shapes, rising from a low plateau above an open stretch of uniformly rippled water. Abstract patterns take the place of the infinitely varied, devotedly explored forms of the prototype, where the rendering of the human figures and animals also proves superior. A significant feature of the changed character of this archaistic variant is the replacement of all

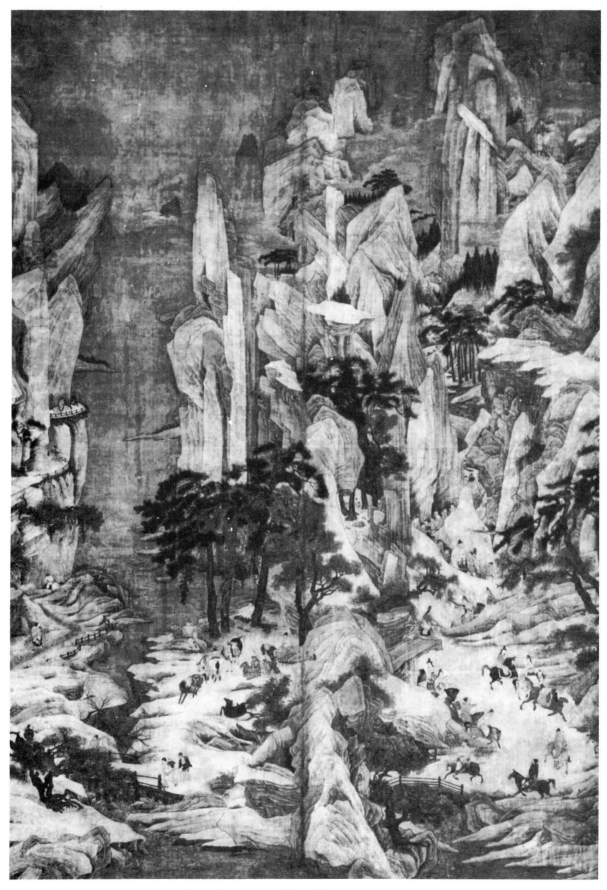

FIG. 38 *Ming-huang's Journey to Shu*. Philadelphia, University Museum.

the individually defined trees on the cliff tops by the dryly repeated unit of a grove of spruce. The effect of those geometricized, patterned, abstract forms is enhanced by the colouring, which, again, reveals a tendency toward the schematic and un-particularized, but contributes toward an almost solemn expression. The historical importance of this work is clear: its very existence presupposes, and thus vouches for the greater antiquity of, the *Journey* in its older versions. The date of the *Travellers* is not, however, safely established. The Palace Museum publications invariably label it 'T'ang', but a post-T'ang date seems more likely. Besides, there is a disturbing discrepancy in the date 1692 of the 'authenticating' inscription written on the mounting by Sun Ch'eng-tse, who had died in 1676.

What little we know of the contribution of **Wu Tao-tzu** (*c*.689–*c*.758) to landscape painting we owe to literary records, which in this case are regrettably unspecific. The 'strange rocks' and 'rushing torrents', mentioned with admiration in *Li-tai ming-hua-chi*,[21] were common motifs even before Wu's time, and the passage from the same source that 'on the road to Shu he drew the landscape [along it] from nature,

FIG. 39 *Ming-huang's Journey to Shu*. Taipei, National Central Museum.

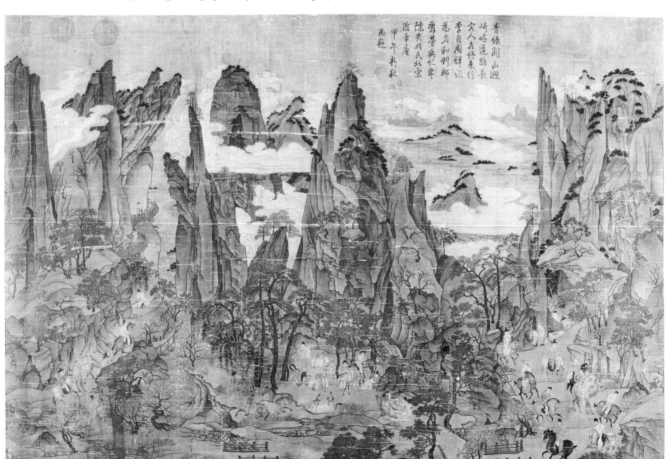

唐李昭道春山行旅圖

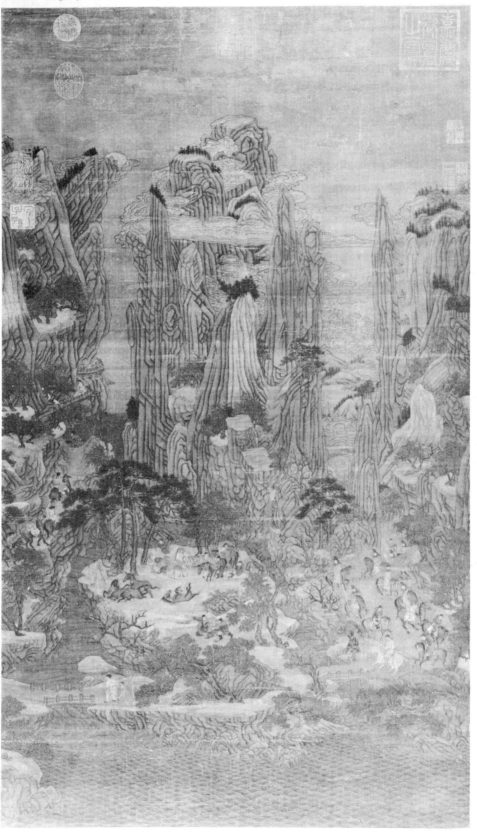

FIG. 40 Attributed to Li Chao-tao, *Travellers in the Spring Mountains*. Taipei, National Palace Museum.

and as a result of this the development of landscape [painting] began with Wu, and was perfected by the two Li', not only remains unexplained but is marred by the chronological incongruity of placing the two Li, Li Ssu-hsün and Li Chao-tao, after Wu. The *T'ang-ch'ao ming-hua-lu*,[22] on the other hand, describes the contrasting manners of Wu Tao-tzu and Li Ssu-hsün in the form of Emperor Minghuang's comment, 'Li Ssu-hsün's achievement of many months, and Wu Tao-tzu's work of a single day both reach the extreme of excellence.' The works in question were murals in the Ta-t'ung-tien, a hall in the Hsing-ch'ing Palace at Ch'ang-an. They represented the scenery of the upper Chia-ling River in Szechwan, which the Emperor loved; he had sent Wu Tao-tzu there to study the landscape some time in the T'ien-pao era (742–55). The Emperor's judgement shows that Wu's work, very unlike Li Ssu-hsün's, must have been rapidly executed, sketchy, without detail, and probably without colour, as was assumed also by Yonezawa.[23] The contrast of the murals, by the way, clearly tells us that the Court did not cling to any established, refined and decorative 'palace style' and reject what obviously was a work of rough and very free style. The two men did not compete with each other, for Li Ssu-hsün had died in 718, a quarter-century or so before Wu's famous mural came into being.

That Wu himself had worked in a meticulous and detailed manner at an earlier stage emerges from an account in Kuo Jo-hsü's *T'u-hua chien-wen-chih*.[24] Wu is mentioned as one of three artists who collaborated on the picture *The Golden Bridge*, which depicted Hsüan Tsung's return from the T'ai-shan, the sacred peak of the east, in 725. Beside the landscape, Wu painted the bridge, the carriages, the figures, plants, trees, hawks, utensils, weapons, and tents—details so finicky as to be amusing when measured by the grand sweep of the Chia-ling mural just mentioned.

None of those passages can bring Wu's style to life. We can only imagine that Wu's contribution was twofold: his forms were more realistic and his technique more transparent than that of his predecessors. His work might thus account in part for the stylistic gap between Figs. 38 and 39.

In **Wang Wei** (699–759) we encounter a personage whose fame is founded on his poetry rather than his painting. Was he an amateur whose pictures were upgraded in accordance with his standing in literature? The question should not be suppressed; the less so because the T'ang critics of the 840s, Chu Ching-hsüan and Chang Yen-yüan, do not reveal any profound enthusiasm for Wang Wei, even though they were writing almost a century later—sufficiently removed in time to give perspective to their judgement. Still, it is possible that the very features that a later writer such as Su Tung-p'o found moving beyond words were the reason for the critics' lack of appreciation. No one could measure up to Wu Tao-tzu. But in Chu's rating, which we have no reason to question, Wang Wei ranked even below Chou Fang, Yen Li-pen, Wei-ch'ih I-seng, Li Ssu-hsün, Han Kan, and Chang Tsao. In technical brilliance or splendour of colour, Wang may not have equalled those masters. But in a less flamboyant, gentle and unostentatious manner he may have contributed something that did not exist in landscape painting before him: an evocative touch, a mood or *Stimmung*, a poetic quality, in short, which our T'ang critics were not prepared to recognize.

Wang Wei was born in the T'ai-yüan district in Shansi. Promoted to *chin-shih* as early as 721, he entered a career that culminated in the position of *Shang-shu Yu-ch'eng*, Right Executive Assistant in the Department of Ministries. When he lost his wife in 730, he became a devout Buddhist. As he was coerced to serve under An Lu-shan in 756, his life was in jeopardy after the return of the Court to Ch'ang-an, where he was confined for some time, together with Chang Tsao and Cheng Ch'ien, to the former residence of the assassinated Yang Kuo-chung in the Hsüan-yang Ward. His younger brother, Chin, succeeded in getting Wang Wei acquitted. Banished from the capital, Wei retired to his estate near Lan-t'ien in Shensi, the Wang-ch'uan Villa, once owned by Sung Chih-wen, a minor poet who was sentenced to death by suicide in 710.[25] 'There he enjoyed the water and the trees, his *ch'in* and his books', says Chang Yen-yüan, continuing thus: 'He was skilled in painting landscapes, in a style linking the past with the present . . . I once saw a landscape [of his] in broken ink, the brushwork strong and brisk.'[26] Except for the new term, 'broken ink', which denotes a technique of shading by graded washes,[27] the passage is not descriptive enough to suggest a distinct style. Rather more specific is Chu Ching-hsüan, who states that, '[Wang Wei's] paintings of landscapes and of pines and rocks were drawn like those of master Wu [Tao-tzu], but were highly individual in their flavour and personal tone.'[28] What Chu presents as a simple fact, namely Wang's close relationship to Wu, who was about ten years older than Wang, is intelligible in historical terms and fully convincing; at the same time he gives recognition to Wang Wei's individual expression. That this individual expression was based in part on the technical innovation of ink wash or broken ink, traditionally ascribed to him, is rather likely. The washes provide tone, hence a suggestion of atmosphere and space and light, and therefore also of time, and ultimately of impermanence. The broken ink was a means of expressiveness outside the range of either colour or ink outline, the media of Li Ssu-hsün and Wu Tao-tzu, respectively, and perhaps not fully exploited until Southern Sung. In Wang Wei's work we must expect no more than the first, groping attempts to come to terms with this new technique, even though it may not have been invented by him. Shimada has observed that it was practised already in the late seventh century by Yin Chung-jung.[29]

By Northern Sung times, Wang Wei's image had become blurred. Kuo Jo-hsü, the historian, considers him a primitive who, were he to return, would no longer be taken seriously as a landscapist.[30] The poet Su Tung-p'o on the contrary, speaks of him with boundless admiration: 'He reaches beyond the shapes.' Mi Fei, the connoisseur, was troubled by the careless attributions common among the collectors in his days. The 126 items listed in the *Hsüan-ho hua-p'u* seem to be symptomatic of Wang's now swollen oeuvre, some 250 years after his time.

No work by his own hand is likely to have survived. One version of his renowned handscroll, *Wang-ch'uan Retreat*, was engraved in stone in 1617 after a copy by Kuo Chung-shu, who is recorded to have died in 977.[31] Though reliable as far as the design is concerned,[32] the engraving, lacking colour and tone, deprives the picture of much of its charm and expressiveness. The meticulous rendering of the wrinkled rocks is reminiscent of Li Ssu-hsün or Li Chao-tao, not of Wu Tao-tzu. Even reduced to a mere outline drawing, this design still conveys some of the

appeal of a truly archaic work with its irresistible blend of naïveté and refinement.

Two copies after a handscroll with the title *Clearing after a Snowfall along the River*, on the other hand, though probably no earlier than Ming, are paintings that answer the T'ang descriptions of Wang Wei's *lavis* technique. One of these copies is in the Ogawa collection,[33] the other, which is longer and perhaps complete, is in the Honolulu Academy of Arts (Fig. 41A–C). The scenery is vast and still. Close-up views alternate with deep recessions. Sharp and crisply silhouetted, leafless, tall trees rise into the grey air, contrasting with groves in full foliage rendered by masses of downy dots. The definition of rock surfaces is precise but less laboured than in the *Wang-ch'uan Retreat*. Compared with the Sasagawa 'Li Chao-tao' (Figs. 36, 37), the rock forms are less fantastic, their textures less arbitrary. It seems that, in proportion as the forms are more soberly seen, their visual impact increases. The greatest intensity of vision in this work may be found in the motif of the snow-bound homestead near the end.

The last part of the composition of the Honolulu scroll, which in Yonezawa's estimate dates back no farther than the sixteenth century, occurs in an older version painted on silk, in the Palace Museum, Taipei. This version, unpublished so far, bears colophons by Shen Chou (1502), Wang Ao, and Tung Ch'i-ch'ang. Certainly of pre-Ming date, it may be as ancient as Sung, perhaps even early Sung, as assumed by Sirén.[33a] While thus testifying to the likely existence of a yet older prototype, it offers no evidence as to Wang Wei's authorship. Its style, moreover, is hard to reconcile with that of the *Wang-ch'uan* engraving. We must not lightly discard an attribution of long standing. But to retain this attribution even tentatively requires us to surmise a considerable transformation of the prototype by the Sung copyist, especially as regards the spatial order. The fact that the three handscrolls in question—the Ogawa, the Honolulu, and the Palace Museum scrolls—are so diversified in technique, brushwork, and likely date is reassuring, however. They seem to be independent of each other, and therefore presuppose an original [or an earlier copy] consistently accepted as a work of Wang Wei, at least since Sung times.

If it is difficult to see the *Wang-ch'uan Retreat* and *Clearing after a Snowfall* as works of the same period, let alone of the same hand, the problem is far more disconcerting if we examine various works of T'ang and later date attributed to Wang Wei. These works hardly resemble each other; they suggest no definite style and no individual oeuvre. All they have in common is an unmistakably antique air. Snowscapes are a favoured theme among them, and they may well be of the variety from Shu or Chiang-nan that it was fashionable to ascribe to Wang Wei in Mi Fei's time (1051–1107). Speaking of this matter repeatedly in his *Hua-shih*, Mi Fei incidentally reveals the high esteem then accorded to Wang Wei.[34]

In the absence of authentic works of the great, the story of the T'ang landscape remains sadly unsubstantial. Much of what has been preserved at Tun-huang and in the Shōsōin to this day makes us only more poignantly aware of the importance of what is lost. It provides a measure of the verve the copies usually fail to transmit. But even poor copies do transmit in visual form something that would else have vanished without trace, as have all visual memories of the works of four of Wang Wei's contemporaries, all celebrated or even ranked above him in their time.

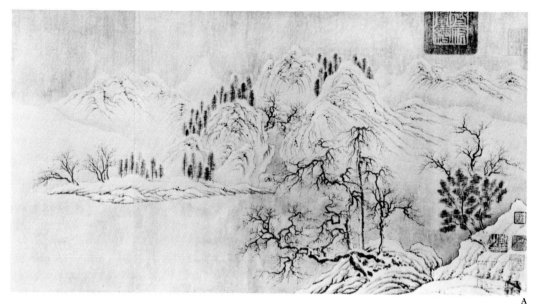

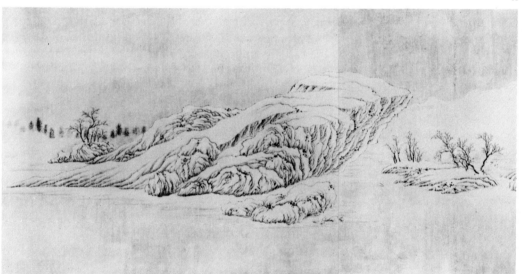

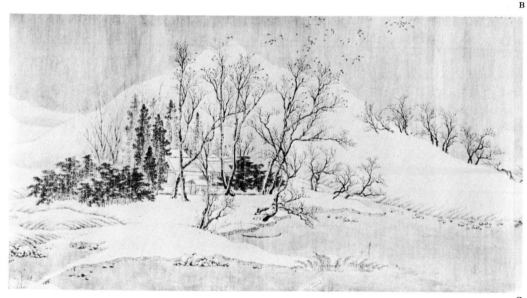

FIG. 41A–C Three Sections of *Clearing after a Snowfall along the River*. Copy after a scroll attributed to Wang Wei. Honolulu, Academy of Arts.

Cheng Ch'ien (*c.* 690–764?) from Cheng-chou in Honan was one of them. A friend of Li T'ai-po and close friend of Tu Fu, in whose poems he is commemorated,[35] he was appointed *Kuang-wen-kuan Po-shih*, Professor of the School of Literature, in 737. Together with Wang Wei and Chang Tsao he was held in confinement after the return of the T'ang Court to Ch'ang-an, and he died in exile at T'ai-chou on the coast of Chekiang. In his better days he, Wang Wei and Pi Hung had each painted a panel in one of the great Buddhist temples of the capital, Tz'u-en-ssu. Once, the Emperor Hsüan Tsung accepted a scroll of his poems with his own illustrations. Eight works of his are listed in the *Hsüan-ho hua-p'u*,[36] including ideal portraits of Kāśyapa Mātaṅga, the earliest of the famed translators of Buddhist texts under the Eastern Han, and of T'ao Yüan-ming (365–427). One of four pictures of the *Tsung-ling Bridge* survived into Yüan. Huang Ch'üan (tenth century) copied one of his landscapes, and Ch'ien Hsüan (thirteenth century), according to *Ch'ing-ho shu-hua-fang*,[37] copied another. The only extant work claiming to be his, a primitivistic and rather crude picture of a cliff with a frightening overhang and a coarsely drawn waterfall in the P'ang Yüan-chi collection,[38] may be no earlier than the seventeenth century.

Pi Hung, from the district of Yen-shih in Honan, who held successively the positions of Policy Adviser, Vice-Prefect of the Capital, and Left Chief Secretary to the Heir-Apparent, may also have been a painter of some importance. The *Li-tai ming-hua-chi*[39] in particular credits him with a new style of tree painting—trees and rocks having been his speciality—praised by his contemporaries and still providing inspiration to tenth-century masters such as Kuan T'ung, as we are told by Mi Fei.[40] Even more remarkable is the fact that Mi Fei chooses none but Pi Hung to establish the relative excellence of Tung Yüan, another of the tenth-century great,[41] and that it was two landscapes of Pi Hung, once in Shen Kua's possession, that he kept seeing in his dreams.[42] Pi Hung's dates are not recorded, but it seems clear that he was older than Chang Tsao and much older than Wei Yen, both of whom are noted for their contributions to the new T'ang *genre* of trees and rocks, of which Pi Hung may have been the first serious exponent. The scantiest hint at the nature of his innovations is given in the *T'ang-ch'ao ming-hua-lu*, which says that 'his pine roots were incomparable'. His new style, therefore, was not a merely technical matter but founded on a deeper conversance with the visual realities of his favourite subject. He discovered an aspect in the life of trees that enlarged their meaning and their symbolic content; one such aspect was 'perseverance', as noted by K. Munakata.[43]

Chang Tsao (still active in 783), a native of the Wu District (Su-chou), who like Wang Wei and Cheng Ch'ien was degraded and exiled for having served under An Lu-shan, was another of the painters concentrating on landscape and on pines and rocks. He was much admired by Chu Ching-hsüan in his *T'ang-ch'ao ming-hua-lu*, where he is not only ranked above Wang and Cheng, Pi Hung and Wei Yen, but singled out for almost extravagant praise: 'In his pines and rocks, he surpassed [all others] from antiquity to the present.' *Li-tai ming-hua-chi* records the anecdote of his encounter with Pi Hung: the latter was so impressed that he gave up painting

for good.[44] Chang also figures prominently in the *Pi-fa-chi*; this text, attributed to the painter Ching Hao (*c*.900), stresses Chang's mastery of the new ink techniques that had arisen in the T'ang period, as well as his subtle and sincere thought. Mi Fei's *Hua-shih* records several of his works without giving any description of stylistic features. While we may thus have to resign ourselves to the improbability of recovering Chang Tsao's style, at least we are given a hint concerning his technique. What Pi Hung found so amazing, according to the account in *Ming-hua-chi*, was the fact that Chang only used worn, blunt brushes or his bare hands to paint. Regardless of the effects, of which we are told nothing but which well may have been in keeping with the fundamentally realistic tendency of the period, Chang Tsao came thus to be regarded as the inventor of 'finger-painting', and a patron saint dear to later adepts of this curious and difficult technique.

The last name in this group of tree painters is that of **Wei Yen**, a native of Ch'ang-an, who left the capital to live in Shu (Szechwan). As a younger contemporary of Tu Fu, with whom he was closely acquainted, he may have lived till about 800 or so. In Tu Fu's verses, though, his name will always live—together with his murals, *Two Horses* and *Two Pine Trees*.[45] It is from the poem about the latter work that we learn about Pi Hung's and Wei's different age:

> How few are those who know how to paint old pines!
> The painter Pi Hung is already too old, but Wei Yen is young.
> When he lays down his brush, the pines look as if their tops were swaying in a
> steady breeze.
>
> Two trunks rise before us; their bark is cracked and covered with moss.
> Their crooked branches strive aloft, intertwined like bent iron rods,
> Showing white ruptures that resemble the rotting bones of dead dragons and
> tigers . . .

While not strictly descriptive, these lines evoke an image sufficiently differentiated to support Chang Yen-yüan's statement that 'the representation of trees and rocks became [really] subtle with Wei Yen. . . .'[46] Recalling Tu Fu's language, Mi Fei's passage on an *Ancient Cypress* ascribed to Wei Yen speaks of 'branches which are twisted and interlaced in a strange manner, like serpents and dragons',[47] and in his usual, sober tone he gives the following account of a *Pine Tree* by Wei Yen: 'A pine with thousand branches and ten thousand needles, which it must have taken at least a year to finish. The scales of the bark, drawn with extreme accuracy, seem like real. The brush strokes are fine, rounded, and unctuous.'[48] Although Tu Fu and Mi Fei may not enable us to visualize Wei Yen's pictures, they leave no doubt whatever as to his expressive power and mental energies. Moreover, Mi Fei's unquestionably persuasive estimate of the time it took Wei Yen to complete his *Pine Tree* supplies an important corrective to the notion of rapidly dashed off conceits. To work with single-minded concentration for a whole year on the image of a tree requires not only skill and sustained inspiration, but also faith, or conviction. He must have been convinced that to explore as thoroughly as he did the appearance of that tree was somehow important. He may have thought of capturing its soul or its vital essence. His thoroughness may well have been prompted by an almost worshipful attitude

toward his subject, an attitude in turn aroused by a strong aesthetic experience. On whatever level of encounter, the painter was sure to be understood by all, for tree worship was practised in China through the ages. In the Sung period, its principle was reaffirmed by Chu Hsi (1130–1200) in a passage quoted in *The Religious System of China* by De Groot: 'Living plants and trees have a *shen* [spirit] of themselves, or else they would, of course, not be able to live.'[49]

None of Wei Yen's legendary *Trees* has survived. A copy of one of Wei's works assumed to be by no less a hand than Li Lung-mien's shows a large herd of horses.[50] An album leaf depicting two men on horseback in the Palace Museum, at best of Sung age, betrays its dubiousness by the preposterous date 'in the Spring of T'ang Chen-kuan (627–50) Wei Yen *pinxit*'—a century or more too early for this painter.[51]

Despite the records and classifications left by the late T'ang writers on whom we have to rely, the history of landscape painting in the later eighth and ninth centuries remains rather obscure. Visual evidence is wanting almost completely. Only here and there do we come across a chronological pointer such as the relationship of master and disciple. Rarely do we get an adequate hint as to a man's style. Most of the names listed remain simply names. Only in a few cases are the records more colourful, attracting, naturally, the attention of later writers up to the present. Occasionally a name that seems inconspicuous in an early record assumes some unexpected importance if it recurs in a different context.

Hsiang Jung (approximately 720–80), for instance, who receives scant mention in the works of Chang Yen-yüan and Chu Ching-hsüan, is virtually resurrected by Ching Hao, who in his *Pi-fa-chi* pays him the high tribute of contrasting his 'most masterly use of ink' with Wu Tao-tzu's brush-work, which 'lacked ink'.[52] This contrast of techniques is restated in lapidary form in the *T'u-hua chien-wen-chih* as forming in combination the basis of Ching Hao's own style.[53] But Ching Hao was not the first to give recognition to Hsiang Jung; Chang Yen-yüan mentions that he was the teacher of the wild Wang Mo, too, so that his influence in late T'ang must have been quite far-reaching. Of his home and career nothing is known except that he is spoken of as the Recluse of T'ien-t'ai (Chekiang), which suggests a southern origin. His handling of the ink, a point of crucial importance, is nowhere sufficiently elucidated. Chang Yen-yüan, unsympathetically, characterizes his work as 'blunt and harsh', while the *Hsüan-ho hua-p'u*, slightly more explicitly, speaks of his brush-work as 'dry and hard, wanting gentleness and moistness, wherefore the ancient critics derided him as "blunt and harsh", although his [images of] steep, precipitous cliffs [alone warrant] placing him in a category of his own'.[54] The description is surprising. Hsiang Jung's mastery of the 'ink' or his 'having ink but no brush' may lead us to imagine that his was a technique rich and wet, using ink in profusion. But, on the contrary, it was dry, or thin, and not moist, harsh and not gentle. Perhaps, therefore, the term 'ink' should not simply be equated with the more or less copious use of ink as such. As a matter of fact, Tung Ch'i-ch'ang (1555–1636) gives a more specific definition of the terms, brush and ink, in his *Hua-yen*, 'The Painter's Eye':

Where the ancients speak of 'having brush and having ink', the two words,

brush and ink, are widely misunderstood. How can it be that, in a painting, there should be no such thing as either brush or ink? Yet, if there is only outline and no texturing (ts'un-fa), they call it 'having no brush'. If there is texturing but no distinction between light and heavy, facing and backing, light and dark, then they call it 'having no ink'.[55]

According to this definition, 'brush' does not mean 'outline' but, rather unexpectedly, 'texture' and the like, whereas 'ink' is a matter of tone contrasts or chiaroscuro. The latter obviously can be brought about by wash or scumble, spatter or splotch, without any visible trace of the brush. But the former, whether we call it texture or pattern or surface design, is done with the brush; and the brush-stroke, while ever visible, may show no variation of tone at all. Applied to the work of Hsiang Jung, then, it must have possessed many of the painterly qualities subsumed under the term 'ink', while wanting in respect of the more purely graphic qualities of the 'brush'.

Hsiang's disciple, **Wang Hsia** (c.740–804), whose dates make it possible to arrive at an estimate of his teacher's life span, was an eccentric southerner, possibly from Chekiang, who was introduced to painting in his early years by Cheng Ch'ien, presumably when the latter lived in exile at T'ai-chou on the Chekiang coast (about 757–64). Assuming Wang to have been about twenty then, he must have been born around 740. His peregrinations in Chiang-nan probably fall into the years after Cheng's death. It may have been no earlier than the 770s that he became Hsiang Jung's follower. Having held a position in the Hua-sheng (that is, Shang-shu-sheng, or Department of Ministries) during the Chen-yüan era (785–804), as noted by Chu and Li in T'ang Sung hua-chia,[56] he died at Jun-chou in Kiangsu at the end of that era, according to Chang Yen-yüan in Li-tai ming-hua-chi.[57]

In both this text and the T'ang-ch'ao ming-hua-lu it is Wang Hsia's extravagantly unconventional method, rather than his finished paintings, that attracted the curiosity and mild indignation of the authors. As they describe it, Wang never painted while sober. When drunk, he would start with spattering ink over his silk, using a brush, or his fingers, or even his hair to bring about accidental and uncontrolled but rhythmic configurations. Inspired by these effects he would then convert them into the intelligible shapes of mountains, rocks, clouds or water, and not a trace of the spatters and splotches would remain undisguised! The outcome, therefore, was less spectacular than the method might make us suspect. Indeed Chang Yen-yüan expressly states that he did not feel Wang's paintings to be so extraordinary. Obviously Wang went further than Chang Tsao and Wei Yen, who too had used their hands instead of brushes for certain effects. But his method was primarily a means of inspiration, a kind of 'automatism', to use a term descriptive of a comparable phenomenon in twentieth-century Western painting, and did not necessarily result in distortion, abstraction, or ambiguity of his images, as has been suggested.

Wang Hsia is the form of his name given in the Hsüan-ho hua-p'u,[58] which further says that he was called Wang P'o-mo (Splash Ink) by his contemporaries; Chang Yen-yüan has Wang Mo (Silent) instead, and Chu Ching-hsüan, Wang Mo

(Ink). It does not seem doubtful, however, that the three sources refer to the same person, whose artistic ranking by the two T'ang writers was none too enviable. In their judgement he stood at the bottom, relegated as he was to the unclassifiable category called *i-p'in*. No work of his survives to testify on his behalf.

If we look back upon the recorded achievements in eighth-century landscape painting, there emerges a succession of dimly perceived styles. Li Ssu-hsün's colour and conceptual design mark him as a precursor. Wu Tao-tzu, all but re-nouncing colour, introduced a new style that was all 'brush', graphic and trans-parent in character, without tonality. Wang Wei, while strongly indebted to Wu, forged a new instrument of expressiveness through his use of 'broken ink' or ink washes, in landscapes more intimate in scale than were those of the older masters. And after Wang Wei we may detect a trend toward far bolder experiments in the use of ink for images of narrower scope but more intense realism, as in the works of Pi Hung, Chang Tsao, and, perhaps, Hsiang Jung. Wang Hsia presumably was too much *sui generis* to count in a telescoped summary of that century, whatever his influence may have been later on.

Though appearing successively, these styles or new techniques did not supersede those existing before them. Rather they might be regarded as additions to an ever widening repertory of means of expression, time after time conceived in response to the demands of new subject-matter. New subject-matter, of course, means new visual discoveries in nature, such as Pi Hung's roots of pine trees or Chang Tsao's famous pines and rocks.

That tendency to explore and study the real appearance of things must have persisted through late T'ang and well into Sung. Its most noteworthy result in the ninth century was the specialization of some painters in the phenomena of water and fire.

Sun Wei (late ninth century) from Kuei-chi in Chekiang, who had moved to Ch'ang-an, fled from there with the court of Emperor Hsi Tsung (reigned 873–88) to Shu when the capital was threatened by the rebel army of Huang Ch'ao in 880. Sun settled in Shu and may have died there. To judge from the titles of his works enumerated in the *Hsüan-ho hua-p'u*, he would seem to have been preeminently a painter of religious and secular figures as well as of mythological subjects.[59] A description of one of his works is given in T'ang Hou's *Hua-chien* of 1329, quoted here in Sirén's translation: 'I have seen Sun Wei's painting representing the fishes and dragons of the Water Palace appearing and disappearing in the billows of the sea, while spirits and ghosts are manifesting themselves in various forms in the Milky Way. It makes the spectator tremble—it is a mighty work.'[60] The passage conveys an air of cosmic grandeur in the close juxtaposition of star spirits and creatures of the deep, of turbulent waves under the nocturnal sky. The subject-matter, moreover, calls to mind such ancient monuments as one of the stone-engravings of the Wu Liang Tz'u from the second century, depicting the monsters of the water in armour. Sun Wei's fame rests mainly on his representations of water. Their importance was recognized in an essay written in 1080 by Su Tung-p'o,[61] who admired the fact that Sun Wei had found unprecedented formulas for torrents and waves, replacing the unexciting, placid patterns current before his

time (cf. Fig. 40); that he understood the 'constant principle' of an element that has no 'constant form'. Perhaps, therefore, Sun Wei can claim to have laid the foundation of the amazingly diversified and precise linear definitions of water in all its many aspects—flowing or swirling, ruffled or heaving, plunging and cascading, breaking, foaming, forming froth and spray—as seen in Sung and Ming painting, and in Japan down to Hokusai. If such was Sun's achievement, it amounted to creating forms of timeless validity, henceforth accepted as the ultimate expression of the nature of water, 'exhausting', as the Chinese texts say, its potentialities.

None of this was possible without intense study of the natural phenomenon itself. Sun Wei, therefore, was a realist, regardless of his rank as the supreme *i-p'in* master of his time, as accorded him in Huang Hsiu-fu's *I-chou ming-hua-lu* (1006) and confirmed in Teng Ch'un's *Hua-chi* (1167).[62] Neither text reveals much of Sun's style, but the earlier and more important one contains a passage saying that 'in his pines and rocks and ink bamboos the brushwork was refined, [the handling of] the ink marvellous, and the atmosphere of virile strength beyond description', which scarcely suggests a rough or wild manner as hinted in *T'u-hua chien-wen-chih* (1074).[63]

Of the famous fire-painter, **Chang Nan-pen**, of unknown origin, the *I-chou ming-hua-lu* records that he lived at Ch'eng-tu, Szechwan, during the Chung-ho era (881–4), which suggests that he, like Sun Wei, his contemporary, got there as a refugee. According to the same source he was a skilful painter of Buddhist images, figures, dragons and spirits, and unexcelled in his representations of fire. Fire, in this context, means the blazing flames that form the aureoles of the wrathful deities in the imagery of esoteric Buddhism, deities such as the terrifying Kings of Knowledge (Sanskrit, *Vidyārāja*, Chinese, *Ming-wang*, Japanese, *Myōō*), of whom he painted a set of eight in the main hall of Chin-hua-ssu in Ch'eng-tu. The inevitable anecdote of the humble pilgrim, who on seeing the flames believed the hall to be on fire, can have only one purpose, that is, to convince the reader of the very realistic, not to say illusionistic, quality of Nan-pen's painted fire. It was regarded as an achievement comparable to, and as lastingly archetypal as, the water patterns of Sun Wei. Referring to both, the compilers of the *Hsüan-ho hua-p'u* added this note: 'Water, which is close to the Tao, and Fire, which reflects the divine, are not easily given form—unless the brush has probed really deeply into the mysteries of their principles.'[64] Evidently more was at stake here than a matter of technical exploits or display of spontaneity. The text leaves little doubt that the two artists had made discoveries in the realm of the visual, and had succeeded in giving them final form.

With the exception of the fire design engraved on the sixth-century stone sarcophagus in Kansas City (Fig. 14) no relevant material has survived in China. Fortunately Japan has much to offer that may give us a hint, specifically the Heian-period images of the awesome protectors of the law introduced by the Shingon Sect. The large and magnificent pictures of the *Godairikikū Bosatsu* in their fiery glories (Pl. IV), National Treasures kept in the Yūshi-Hachimankō group of monasteries on Mount Kōya, Wakayama Prefecture, which are more or less coeval with Chang Nan-pen (late ninth century), apparently typify the stage of Early Heian (784–897),

well before Chang's innovations could have reached the Japanese capital; here the flames are drawn as a fairly regular, ornamental, flat pattern of an even red. The Late Heian (898–1185) image of the *Blue Fudō* of the Shōren-in at Kyoto (Pl. v), by contrast, represents the flames in free, asymmetrical forms and in a chromatic range of red, orange and yellowish white, producing an almost corporeal effect. It is tempting to think that the powerful realism of the fire in this *Blue Fudō*, a work of the mid-ninth century according to Akiyama Terukazu, can tell something about Chang Nan-pen's celebrated contribution.[65]

Reverting after this excursus on late T'ang fire and water painting to the landscape of the same period, I wish to turn to the ninth-century master Li Sheng.

Li Sheng, a native of Szechwan, remains an enigmatic figure, deprived of visual evidence and contradictory in terms of the literary record. To account for his training, there are three different assumptions: first that he was self-taught; second that he began by imitating Li Ssu-hsün; third that having got hold of a Chang Tsao, he felt he might go farther by studying the actual scenery of his native province. In his work, he was compared to Li Ssu-hsün and Li Chao-tao, and like the latter was spoken of as Little General Li; a landscape of his, once owned by Mi Fei, was in fact given a new signature, 'Li Ssu-hsün', by the next owner. Some of his works were mistaken for Wang Wei's. One scroll was adjudged by later critics as very similar to Tung Yüan. Yet another aspect emerges from the descriptions of some particular works seen by Mi Fei, who was an ardent admirer of Li Sheng. From his account of two scrolls given in *Hua-shih* we learn of such features as:

> exquisite refinement; a rocky river bank of heavenly perfection: not a trace of the brush being visible; trees with round and straight trunks showing no trace of the brush; a delicacy and skill never before encountered; despite the enormous density of the foliage, which leaves not a bare spot in the forests, the diversity of leaf shapes is without compare in antiquity and certainly non-existent today.[66]

As in the case of Wei Yen's *Pine Tree*, Mi observes that both works cannot have been completed in less time than years and months, adding that the Li Sheng once in his possession was of the same kind. Thus there were no less than three stylistically consistent works known to Mi Fei, all elaborate in design and exquisitely finished, and the story of the altered signature makes it likely that they were not altogether dissimilar from the manner of Li Ssu-hsün and Li Chao-tao. It seems therefore that Li Sheng's style cannot have resembled the typical style of Wang Wei, not to mention that of Tung Yüan, unless we surmise that his style changed over the years to an unlikely degree. Be that as it may, Li Sheng appears to have been an artist of conservative taste and considerable will-power, whose contribution may have lain in the direction of realistic images based on Li Ssu-hsün's archaic formalism and finished as minutely as miniatures. He seems to have stood at the opposite pole from the great ink-masters, Chang Tsao, Hsiang Jung, and Wang Mo. This position would also be in keeping with the fact that Huang Ch'üan (c.900–65), his fellow-townsman from Ch'eng-tu, chose him as his model for landscapes, bamboos and trees.

Li Sheng's dates are not recorded. But his relationship to Wu-ta Kuo-shih ('Teacher of the Nation' Wu-ta), the priest Chih-hsüan (811–83), with whom he stayed between 881 and 883, permits a guess. He must have attained a reputation by then, have been forty or fifty years of age and therefore been born about 830–40. Of his apparently large oeuvre—fifty-two items being listed in the *Hsüan-ho hua-p'u*—nothing is left.

Before turning to Ching Hao, who 'flourished' in the declining years of the T'ang and was still active in the beginning of the Five Dynasties, we should consider briefly two anonymous mountain pictures of monumental character, which may be as early as the ninth century (antedating Ching Hao). One of them, *Travellers at a Mountain Pass*, in the Palace Museum, is loosely ascribed to Kuan T'ung (Fig. 42); the other, *Landscape with Travellers*, in the Nelson Gallery at Kansas City, bears a signature, Hung-ku-tzu (that is Ching Hao), which was added by a later hand (Fig. 43). Neither of these works, which have much in common as images but differ widely in style, has yet received sufficient attention in modern Eastern or Western literature. The 'Ching Hao', moreover, in contrast to the 'Kuan T'ung', does not seem to be recorded in Chinese sources.

Travellers at a Mountain Pass (Fig. 42) depicts a steeply rising valley, above which towers a colossal, wildly overhanging peak. Though clearly structured and not wanting corporeality, the peak is conceived primarily as a silhouette. Like most of the rest of the scenery, it is sheer rock, vegetation being reduced to an unvarying type of leafless tree or shrub, drawn with gusto. When facing a mountain wall, the shrubs are set off effectively by light, blurred areas of local tone, which remains ineffective and unconvincing as a suggestion of atmosphere. The outlines of the cliffs and slopes are lively and varied, done in jumpy short strokes, which are of a kind we have not encountered so far. Shaded washes of lighter and darker greys enliven and give plasticity to the rocky masses. The spatial layout is quite primitive, as revealed by the unresolved transition from the strongly tilted valley floor to the vertical rise in the upper half of the composition. Although the relative earliness of this work, which bears a seal of Chia Ssu-tao (died 1276),[67] is recognized to some extent by the traditional attribution to an early tenth-century master, it does not seem securely at home in the tenth century at all. In fact, Wang To (1592–1652), in an inscription on the mounting, asks, 'Doesn't this painting evoke such masters as Hsiang Jung and Kuo Chung-shu?', and his reference to the late eighth-century Hsiang Jung is very much to the point. This painting appears to answer nicely the literary characterizations of the ink virtuosi of the eighth and ninth centuries.

The Kansas City scroll (Fig. 43), which too is characterized by the motif of a tall mountain with a savage overhang, differs widely in design and technique. The central massif winds upwards as a coherent, harshly fissured body of rocks, whose contours are heightened by an opaque greyish-white pigment contrasting sharply with the dark clefts and fissures. To the left of the massif a river valley stretches back toward the distant and fairly high horizon; on the right, the peak connects rather abruptly with a range beyond. The sparse vegetation consists of leafless trees and pines silhouetted in greyish white against the darker foil of their surroundings, sky, water, or rock. The many small figures of travellers are treated in like manner, as are the small buildings of a temple, a few bridges and fences. This

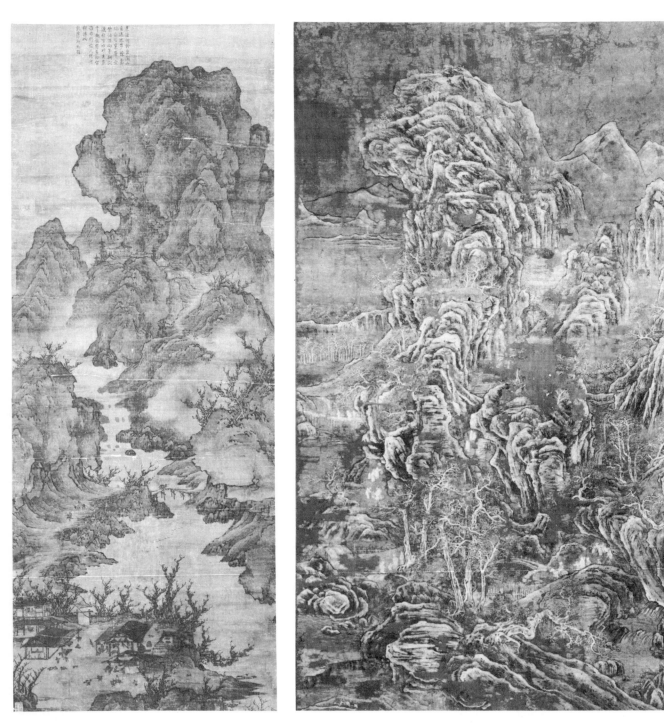

FIG. 42 Attributed to Kuan T'ung, *Travellers at a Mountain Pass*. Taipei, National Palace Museum.

FIG. 43 Attributed to Ching Hao, *Landscape with Travellers*. Kansas City, Nelson Gallery and Atkins Museum.

painting, which has suffered much damage in the course of time, is a work of chaotic grandeur. At first sight it may seem more archaic than the so-called Kuan T'ung (Fig. 42). Yet its composition is more compellingly unified, and the somewhat forced structuring of its huge formation of rock more systematic—prefiguring the graceful and rational solutions that were to appear in the tenth century.

Notes

1. Ch. 10.
2. Ch. 60.
3. Ch. 5, p. 2.
4. *Three Hundred Masterpieces*, vol. 1, pl. 3.
5. *CP*, II, Lists, p. 19.
6. Soper tr., p. 214.
7. p. 21.
8. *Li-tai ming-hua-chi*, ch. 9, p. 285.
9. *KKSHC*, vol. 32.
10. *CP*, III, pl. 81.
11. *Ku Kung*, vol. 29.
12. *Tu Fu's Gedichte*, II, 16.
13. Ibid., XVIII, 46.
14. Ise, *Shina sanzui-gashi*, pls. II, 1–13.
15. Li Lin-ts'an, 'A Study of a Masterpiece'.
16. Ch. 10.
17. *T'ang-shu*, ch. 86; *Hsin T'ang-shu*, ch. 81.
18. Li Lin-ts'an, 'A Study of a Masterpiece', pp. 316–17.
19. Waley, *Po Chü-i*, p. 45.
20. Stein, *Serindia*, IV, pl. 104; Stein, *Thousand Buddhas*, pls. 34, 35; Waley, *Paintings Recovered from Tun-huang*, p. 209; Matsumoto, *Tonkō-ga*, pl. 95a.
21. Ch. 1, pt. 5; Acker, p. 156.
22. *T'ang-ch'ao ming-hua-lu*, Soper tr., p. 209.
23. Yonezawa, *Chūgoku kaigashi kenkyū*, p. 94.
24. Ch. 5; Soper, *Experiences*, p. 76.
25. Giles, *B. D.*, 1829.
26. *Li-tai ming-hua-chi*, ch. 10, p. 301.
27. March, *Technical Terms*, no. 145.
28. *T'ang-ch'ao ming-hua-lu*, Soper tr., p. 218.
29. 'I-p'in Style', Cahill tr., *Oriental Art*, 1961/2.
30. *T'u-hua chien-wen chih*, Soper tr., p. 19.
31. *Sung-shih*, ch. 442.
32. Bachhofer, *A Short History*, p. 105.
33. *CP*, III, pls. 92–3.
33a. *CP*, II, List, p. 21.
34. Vandier-Nicolas, *Le 'Houa-che' de Mi Fou*, ch. 3, paras. 6, 63, 131, 146, 147.
35. *Tu Fu's Gedichte*, II, 57; III, 29; V, 5 and 18; XI, 59.

36. Ch. 5.
37. Ch. 3 : 58.
38. *Ming-pi chi-sheng*, vol. I.
39. Ch. 10.
40. Vandier-Nicolas, *Le 'Houa-che'*, ch. 3, para. 22.
41. Ibid., ch. 3, para. 21.
42. Ibid., ch. 3, para. 184.
43. Munakata, in *Tetsugaku*, no. 53 (1968).
44. Ch. 10.
45. *Tu Fu's Gedichte*, VII, 30 and 32.
46. Acker, *Some T'ang and Pre-T'ang Texts*, p. 156 f.
47. Vandier-Nicolas, *Le 'Houa-che'*, ch. 3, para. 23.
48. Ibid., ch. 3, para. 119.
49. J. J. M. de Groot, *The Religious System of China*, vol. IV, Leiden 1901, p. 272.
50. *Wen Wu*, 1961/6.
51. *Three Hundred Masterpieces*, vol. 1, pl. 17.
52. Sakanishi, *The Spirit of the Brush*, p. 93.
53. Ch. 2 : 8.
54. Ch. 10.
55. *Hua-yen*, in *Mei-shu ts'ung-shu*, 1/3/1.
56. *T'ang Sung hua-chia*, p. 17.
57. Ch. 10, last entry.
58. Ch. 10.
59. Ch. 2.
60. *CP*, I, p. 162.
61. *Tung-p'o ch'üan-chi*, ch. 23.
62. Ch. 9; Maeda, *Two Twelfth Century Texts*, p. 58.
63. Soper, *Experiences*, p. 24, s.v. Sun Yü.
64. Ch. 2, s.v. Chang Nan-pen.
65. Akiyama, *Japanese Painting*, pp. 55, 57.
66. Vandier-Nicolas, *Le 'Houa-che'*, 147 f.; Soper, *Experiences*, p. 145, n. 335.
67. Giles, *B.D.*, no. 326.

Landscape painters of the Five Dynasties *(907–60)*

Ching Hao (*c*.855–915 ?) from Ch'in-shui in Northern Honan was, according to all accounts, the recognized master among the landscape painters active at the end of T'ang. A man of wide learning, who may have been a minor official under Chao Tsung (reigned 889–904), he fled Ch'ang-an during the disturbances of the last T'ang years to live in seclusion in the T'ai-hang Mountains of southern Shansi, not far from his home district. He died before the end of the Liang Dynasty (907–22). Thanks to an extant treatise traditionally ascribed to him, the *Pi-fa-chi*, 'Notes on Brushwork',[1] Ching Hao seems less remote than does many a later artist who left no word for posterity.

The chief message of Ching's treatise concerns value. The ultimate criterion of good painting is truth. Truth is not found in outward likeness but presupposes the presence, in a work of art, of inner reality or spirit. Similarly, Delacroix claimed in his *Journal* that truth is 'the rarest and most beautiful of all qualities', and Konrad Fiedler believed that 'the content of artistic truth alone determines the lasting value of a work, all other qualities being secondary and assuring only ephemeral success'.[2]

The same text offers a modified scheme of the *Six Laws* established by Hsieh Ho, four centuries earlier. Ching Hao's *Six Essentials* are:

> ch'i—spirit, life-breath, vitality, or aliveness,
> yün—harmony, rhythm, or harmonious rhythm,
> ssu—thought, or mental concentration,
> ching—scenery, motif,
> pi—the brush or brushwork,
> mo—the ink, or tonality.

While not so self-explanatory as at sight they seem to be, these rules, according to Sullivan, are terser and rather more logical than Hsieh Ho's *Laws*, which, however, were not displaced by them.[3]

Coming from a painter of his stature, Ching Hao's pronouncements on various T'ang and older masters are of extraordinary historical interest. He makes no secret of his preference for the painters who, beginning in the T'ang period, developed a new ink technique: Wang Wei, Chang Tsao, Hsiang Jung; and even though he expresses admiration for Li Ssu-hsün, and especially for Wu Tao-tzu, he laments their unconcern with 'ink'—much as conversely he takes Hsiang Jung to task for the lack of bone in his brushwork. Ching Hao thereby stakes out his own position: an attempt to synthesize the strengths of Wu's brush and Hsiang's ink.

Ching Hao's theory concerning the opposed aspects of brush and ink is noted by Kuo Jo-hsü, and also in the *Hsüan-ho hua-p'u*, where the two terms are explained as follows: 'To have brush but no ink [means that] the traces of the brush [as such] remain visible throughout, [resulting in] a want of naturalness. To have ink but no brush [means that] "axe and chisel" strokes are discarded [and replaced by] too erratic formations.'[4] If this definition is valid and correctly interpreted, Ching Hao obviously loathed the haphazard effects of ink washes or spatters, the

coarse techniques practised in the ninth century (as in Figs. 42, 43), and would rather have continued the eighth-century fashion of 'axe and chisel' texturing (as in Fig. 40) in linear, clear, and rational patterns. At the same time he found that 'brush' as used by Wu Tao-tzu was an 'unnatural' factor because it did not correspond to the natural objects as he knew them; that it was a superb device but inadequate for the representation of landscape. Ching Hao, it appears, broke the spell of the imposing T'ang traditions—not by wanton experiments, but with a sense of responsibility toward the past. T'ang classic and anti-classic currents were fused and transformed in his work, which became a foundation for the grand conceptions of the tenth-century masters, Kuan T'ung and Fan K'uan.

One element that seems to have taken shape in that process of transformation was to prove immensely fertile. This was Ching Hao's technical innovation of modelling and texturing the rock forms with dabs, the technique called *ts'un-fa*. It was a device yielding both structure (brush) and tone (ink), and it may have been his most important contribution.

The only extant work of surpassing quality attributed to Ching Hao is a tall mountain landscape, known as *The K'uang-lu Mountains* (Fig. 44) in the Palace Museum, Taipei. It is a monumental picture, measuring just over six feet in height, which since Southern Sung has been regarded as a Ching Hao. The ink has faded to a transparent grey on the now greyish-brown silk. A range of peaks towers over lesser cliffs and fissured boulders by the side of a river, which recedes slowly into a haze-obscured depth. The vertical shapes of the peaks dominate, imparting a sense of stately order to the scenery. This order is intensified by the pattern of evenly alternating light edges and dark crevices of the rock formations. There is order also in the gradual increase in size of those formations from the small ones at the bottom of the valley to the big ones above, and in the inverted proportions of the trees. If the design of the rocks with their endlessly varied, jagged contours is complex, the technique used to define them is perfectly lucid. It consists of dots and dabs or short strokes, which remain distinct as small entities of design, only occasionally merging into an area of dark wash. They produce the effect of utmost precision in the definition of shapes and of structural clarity in the whole.

The question of Ching Hao's authorship is, of course, unanswerable. All we can hope for is to arrive at some understanding of the painting's historical position on grounds of style and other internal evidence. Both point to a tenth-century date. The painting stands about midway between the more primitive *Landscape with Travellers* (Fig. 43), in Kansas City, here dated to the ninth century, and the famous Fan K'uan in the Palace Museum, *Travellers among Streams and Mountains* (Fig. 48) from about or soon after the year 1000. As the latter pushes the presumptive Ching Hao far back into the tenth century, so the Ching Hao in turn pushes the Kansas City picture back into the ninth. *Landscape with Travellers* clearly exemplifies a style ancestral to the Ching Hao. In it we find not only the motif of the colossal cliff juxtaposed to a lake or river, but more specifically the relentless fissuring of the rock with its light edges alternating with dark chinks. But its chaotic furor and its harsh technique are transformed, in the Ching Hao, into a solemn order of evenly and rhythmically creviced, perpendicular cliffs, modelled and textured in his transparent, lively and elegant *ts'un-fa* technique.

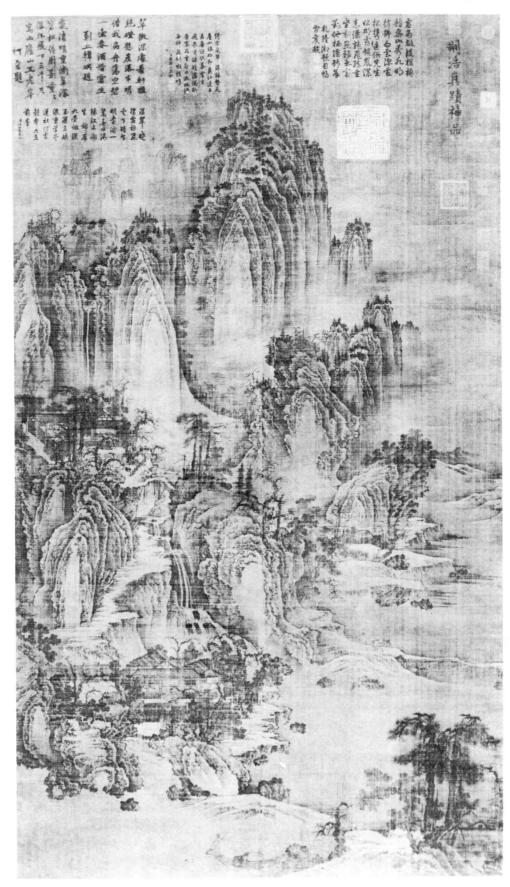

FIG. 44 Attributed to Ching Hao, *The K'uang-lu Mountains*. Taipei, National Palace Museum.

The stylistic position of the *K'uang-lu Mountains* as a tenth-century composition appears to be secure. Its connection with Ching Hao, on the other hand, is not thereby assured but depends on the attribution made by Emperor Kao Tsung (reigned 1127–62) in a short inscription in the upper right corner. If this inscription is authentic, as was maintained in a recent discussion by Fu Shen in *The National Palace Museum Bulletin*,[5] we have no reason to question, and no basis for rejecting, its implications. These would remain valid, moreover, even if the painting were a Northern Sung copy, but it is not very likely that the Emperor was deceived by a work of recent vintage.

What appear to be the most substantial observations regarding Ching Hao's stylistic relationships to the younger tenth-century masters we owe to Mi Fei, in whose *Hua-shih* we find the following passages:

> Fan K'uan had studied Ching Hao. But there were two landscapes in Wang Shen's [*c*.1046–after 1100] possession, which, though arbitrarily designated as works of Kou-lung Shuang [Academy painter, about 1068–85], bore authentic signatures of Ching Hao, yet did not in the least resemble Fan K'uan.

> There was a hanging scroll landscape in a monastery at Tan-t'u, Kiangsu, which was entirely like a Ching Hao. Yet it was signed 'Hua-yüan Fan K'uan'. Hence it was a work of Fan K'uan's early years, and he may truly be called Ching's disciple.

> It is further said that Li Ch'eng studied Ching Hao. I have not seen a single brush-stroke yet that was similar. As for the [possibility of Li's] study of Kuan T'ung, there is [positive evidence in] the similarity in his foliage and trees.[6]

That the Fan K'uan in Tan-t'u was taken as an early work of his, depending on—rather than copying—Ching Hao, shows that the eleventh-century critic must have reasoned in terms of a logically consistent and therefore intelligible stylistic progress in a painter's development.

Kuan T'ung, a native of Ch'ang-an, was a younger contemporary of Ching Hao, whom he recognized as his master; and like the latter he became a subject of the Liang Dynasty (907–23) after the fall of the T'ang. He is a silent and remote figure and left no literary legacy. Nonetheless, he was admired as one of the three greatest landscapists of the tenth century. Condensed into one sentence, a description of his career might run thus: Having studied, in his earlier years, Ching Hao's oeuvre with the ambition to equal or surpass him, Kuan T'ung turned toward older masters such as Wang Wei (701–61) and Pi Hung (later eighth century) in his middle years, while in his late works he arrived at a free, unlaboured, sketchy style of great expressiveness.

What we can learn of his typical style from the descriptions given in literature is little, but a few passages are specific enough to justify their being quoted verbatim. When Kuo Jo-hsü, writing about a century and a half after Kuan T'ung's mature years, undertook to characterize his manner, he may have summed up what then was felt to be distinctive of Kuan's work: 'His rock formations seem hard and solid. The [clumps of] mixed trees are luxuriant and dense . . . When he painted trees, he made the foliage of some as drenched in ink, and let a withered branch stick out

here and there.'[7] Mi Fei, in an oversimplified, peremptory statement in his *Hua-shih*, adds that 'Kuan T'ung's figures are commonplace. His rocks and trees are derived from Pi Hung; [his trees] have branches but no trunks.'[8] Foliage drenched in ink, dead branches, trees without trunks: what is the meaning of these things? Perhaps they were mere idiosyncrasies and came to be regarded as characteristic of Kuan T'ung. More likely, however, they were noted as unfamiliar, novel features. That the trunk of a tree in a dense grove becomes invisible would seem natural enough. But to a person accustomed to seeing trees represented complete even in tangled, confused clusters it might well seem perplexing. The classical tree of antiquity was always represented as a complete organism. The suppression of the trunk is a feature comparable to the discovery that the mountain scrub is a phenomenon of different structure than the tree or the forest. Similarly, the black ink foliage entails the obliteration of the clearly outlined individual leaf, which loses its identity in the larger unity of the inked foliage. Thus Kuan T'ung's treatment of trees and foliage represents a more differentiated mode of perception than was known before him. As for the motif of the withered branches or the dead tree among trees in full foliage, it must be rated another realistic enrichment based on observation. The motif not only meant an innovation of design; it also endowed a scene with sentiment: through the signs of their decay, the trees are individualized and convey the aspect of transience.

The paintings attributed to Kuan T'ung are surprisingly diversified in style, too inconsistent, in fact, to be reconciled with each other. One of the most enchanting pictures ascribed to him is *Waiting for the Ferry* in the Palace Museum (Fig. 45), which shows a soaring cliff dark against a luminous summer sky, with trees in luxuriant foliage. An open foreground is provided by a convex ledge with a fissure and the unruffled water of a stream to the left, where an empty boat is waiting. The mountains are built up in the established sequence of round boulders, high bluffs and a tall central peak, units ever larger and higher as they ascend one behind the other, clearly articulated, compact and solid, their edges darkened by washes. Light peaks emerge beyond the main cliff, giving a sense of greater airiness than in the paintings seen thus far. Short trees and scrub, whose foliage forms coherent patches of dark dots, accentuate the upward movement of the mountain. In the statelier trees below something novel appears: in the dense clumps they form, light foliage is contrasted with dark foliage; some of it is patterned, but most of it is treated simply with stipples and dabs. The colouring is very subdued and has faded so that it only counts as tone.

The silk is of a warm, deep-brown tone and shows many cracks and repairs. While obviously of great age, the picture bears no seals older than the Ming-ch'ang era (1190–5) of the Chin Dynasty. These seals in dark purple appear, however, to have been either retouched or painted. The date of the painting, therefore, depends entirely on its style, a style termed 'lucid and classic in its balance' by Laurence Sickman.[9]

To make the style and chronological position of this magnificent landscape intelligible, we only need to compare it with the 'Ching Hao' of the early tenth century (Fig. 43) and the Fan K'uan of the early eleventh (Fig. 48). A finer estimate is possible, however, as soon as we can recognize some intermediate stages. Fortu-

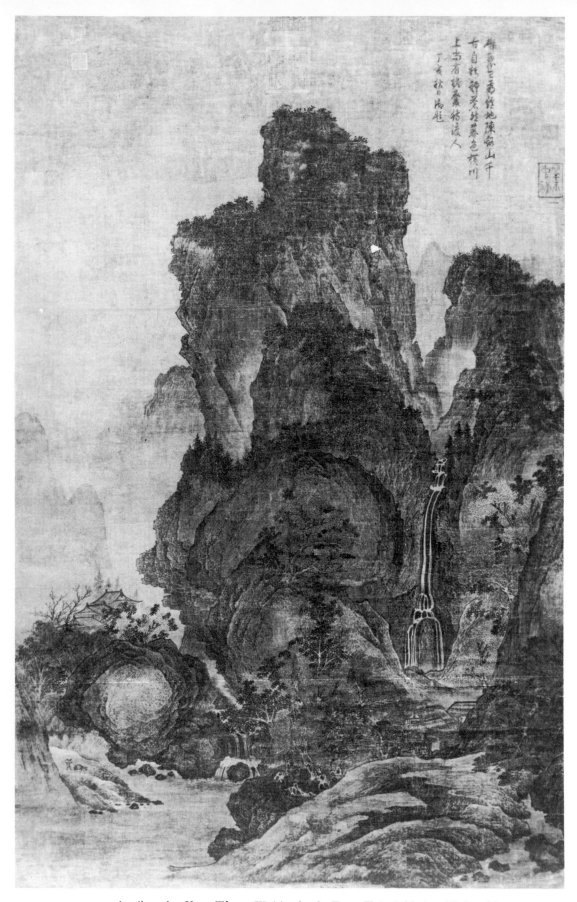

FIG. 45 Attributed to Kuan T'ung, *Waiting for the Ferry*. Taipei, National Palace Museum.

nately such stages are provided by two works that doubtless have to be placed between the 'Ching Hao' and the 'Kuan T'ung' (Fig. 45). These are *Mountains with Palaces in Snow* (Fig. 46) of the Boston Museum of Fine Arts, and *Landscape* in the Princeton University Museum (Fig. 47). Both are anonymous works, and both are linked to the Fan K'uan tradition. In the writer's opinion they antedate not only Fan K'uan's standard work, the *Travellers* (Fig. 48), but also the above described *Waiting for the Ferry* (Fig. 45), attributed to Kuan T'ung.

In the sombre and awesome *Mountains with Palaces in Snow* (Fig. 46) we have an original work in the technical tradition of *The K'uang-lu Mountains* (Fig. 44) but striking out in a new direction. One single mountain of crushing dimensions rises diagonally through the upper two thirds of the picture, its bulging flanks of sheer rock crowding the upper left half. It hangs over a gorge with unobtrusively rendered buildings on a spur at the left edge; on the opposite side is a narrow defile, and a small gate tower guards the access to this secluded corner. In the foreground, where the waters collect between boulders, flat banks, and a tilted bed of rock, lies a ferry-boat waiting for two men approaching over a small bridge.

The trees have shed their leaves; their trunks and limbs and spriggy tops are fully exposed to view. Except for a group of cedars in the lower left corner, the trees seem to be all of one kind; yet they are drawn with such vigour and feeling that each is endowed with individual life. Most of this admirable design, however, is virtually lost in the tangle of the groves, and no effort is made to exhibit it. The same unconcern for effect speaks from the unflinching precision in the structural definition and the pointillistic texturing of the rock surfaces. The minute dabs and dots on the foreground rocks are alike applied on the farthest cliffs. No thought is given to technical economy. Nor is there any concern for atmospheric effects, the only exception being a distant peak that looms above the defile.

The fact that distance modifies both the scale of things and their appearance is realized, however, in the rendering of vegetation. On the central slope, about one third up, we notice a few distinct trees. A little higher up, the trees abruptly cease to be trees. Dissolving into a curious pattern of mainly vertical strokes, they become 'forest' or 'scrub', something less concrete. This carefully handled new pattern is based on a visual discovery of historical importance. There had been nothing comparable in Chinese painting before. Viewed from this particular angle, all earlier landscapes are thereby distinguished from the present one, which marks an irreversible advance. The discovery was formulated in terms of a pattern similar in function to the stipple pattern used in the representation of rock. Like the rock pattern (*ts'un*) it remains constant in itself.

In contrast to the shapes of the rocks and cliffs in *The K'uang-lu Mountains* (Fig. 44), the painter of the Boston picture avoids jagged contours and clear-cut linear themes. His rocks are less geometric; their shapes are more differentiated; their luminescent edges are softly curved. This painter is less concerned with an imposing panorama than with the nature of rock.

Its humble classification as a 'Ming painting in the Fan K'uan tradition' notwithstanding, the Princeton University *Landscape* (Fig. 47) proves to be intimately related to the group under discussion. If indeed this painting cannot be accepted as an original of the tenth century, it would appear to be a meticulously accurate copy

FIG. 46 Attributed to Fan K'uan, *Mountains with Palaces in Snow*. Boston, Museum of Fine Arts.

FIG. 47 *Landscape.* 'In the Fan K'uan tradition'. Princeton University Museum.

after a work that stood somewhere between *The K'uang-lu Mountains* and *Waiting for the Ferry* (Figs. 44, 45). Its design, in other words, is earlier than that of Fan K'uan's *Travellers* (Fig. 48). The attribution to Fan K'uan was only made in 1790 by Feng Min-ch'ang (1747–1806), whose long superscription mounted above the painting is translated in George Rowley's *Principles*.[10] The composition approaches that of *Waiting for the Ferry*: a stream at the left, and a mountain rising above rounded boulders into a light sky, with airy silhouettes of mountains in the distance. But the design of the cliffs with their almost symmetrically drawn fissures and conspicuously jagged contours is more in keeping with *The K'uang-lu Mountains*, while the texturing *ts'un* technique has its closest parallel in the Boston Museum's *Mountains with Palaces in Snow*. But the way large areas of rock are shaded off by washes is again reminiscent of *Waiting for the Ferry*. The painter seems to have been acquainted with the techniques of the three works mentioned—without having gone as far as the master of *Waiting for the Ferry* with regard to variety and freedom of the texture strokes and modelling by sharply darkened contours.

In his rendering of verdure, the painter of the Princeton picture again seems like a precursor of the master of *Waiting for the Ferry*. He knows the effect of chiaroscuro in the foliage, yet renders it in patterns of leaf type throughout (except in the darkest shades). Nor does he seem familiar with the other's intelligent handling of the mountain forests as relatively indistinct dark patches; his trees and shrubs on the peaks are exactly like those in the valley below. A third feature is the crisply drawn boughs jutting out bare over the rich foliage.

Finally, atmospheric effects of the *Landscape* compare well with those of *Waiting for the Ferry*. Particularly striking is the motif of the gorge formed by two inclined, heavily notched cliffs of dark rock, through which the eye travels out into a luminous haze.

The Princeton *Landscape*, then, is tied to designs and techniques of the Ching Hao tradition, and its date should be 'shortly before *Waiting for the Ferry*', suggesting a connection with Kuan T'ung rather than Fan K'uan. At any rate, the stylistic relationships of the Princeton *Landscape* vouch for its validity as a pictorial conception of the period. Whatever the time of its actual execution, the design is not a later invention. It therefore serves in turn to secure the position of *Waiting for the Ferry* as a work from about the middle of the tenth century, and this position is confirmed, again, by the incontrovertible testimony of Fan K'uan's *Travellers among Streams and Mountains* (Fig. 48), half a century later.

Fan K'uan, a native of Hua-yüan in Shensi, was the uncontested master of landscape painting of his time, around 1000. 'Since Sung has come into possession of the empire', says Liu Tao-ch'un in his *Sheng-ch'ao ming-hua-p'ing*, 'the only landscapists deserving absolute praise were Li Ch'eng and Fan K'uan; up to the present there is no one who compares with them.'[11] Mi Fei, who reserved his deepest admiration for Tung Yüan, felt that Fan K'uan surpassed even Li Ch'eng: 'The mysterious nobility with which he invests material things makes him rank unquestionably above Li Ch'eng'.[12] Of his life virtually nothing is known. Kuo Jo-hsü mentions that Fan K'uan was still alive in the T'ien-sheng era (1023–31), so he may have been born around 960—too late for any personal contact with Li Ch'eng, who

had died in 967. His fame rests on his art alone, for apparently he was no scholar, held no office, and did not write. About all that is recorded is that he chose to live in the mountains of the Ts'in-ling range in Shensi, and that he spent whole days or nights, in summer and in winter, contemplating the wild scenery. Alone with nature, he acquired a manner of 'antique severity, approaching indifference and in-urbanity'.[13] A taste for wine he had, but none for company when in low spirits.[14] One utterance of his is transmitted, which, apocryphal or not, appears to fit his austere character and at the same time bespeaks the assurance of the artist who has found his way: 'Those before me made it their rule never to be detached from the things. Rather than learning from other men, therefore, I also should learn from the things themselves or, better still, from their inner nature', as recorded in *Hsüan-ho hua-p'u*.[15] This concept of an inner nature of things will recall Ching Hao's mystical belief in an inner reality—to him a quality of the object, which, if apprehended, would reveal its truth, as distinct from mere resemblance conditioned upon outward form alone. Such concepts, transcending the world of phenomena, cannot be represented but at best may be conveyed through some property of a pictorial structure. That Fan K'uan succeeded in this, that he was able somehow to convey a noumenal presence, is substantiated by Mi Fei's sensitive recognition of his ability to invest matter with a 'mysterious nobility'.

But Fan K'uan's professed reliance on nature rather than men is a conventional phrase, and in fact contradicted by Mi Fei's account of an early painting that could not be told from a Ching Hao. Mi further relates that 'Fan K'uan's snowy mountains are modelled entirely on those which commonly go under the name of Wang Wei.' Other sources such as *Sheng-ch'ao ming-hua-p'ing* and *Hsüan-ho hua-p'u*, however, inform us that Fan K'uan began as a follower of Li Ch'eng. Be that as it may, the Sung writers suggest that Fan K'uan's mature and typical style, while based mainly on Ching Hao and Li Ch'eng, was distinguished by virility, rational order, and structural precision—features quite his own and 'infringing on none of the older schools', as said in *Sheng-ch'ao ming-hua-p'ing*.

The phrase used by Kuo Jo-hsü to describe Fan K'uan's mountains, *hun-hou*, 'massive and substantial', must have been a telling one, as it recurs in writings as late as An Ch'i's *Mo-yüan hui-kuan* of 1742. Chao Hsi-ku, who wrote about 1190, applied the term to Fan's landscapes at large:

> Fan K'uan's Mountains and Rivers, massive and substantial, [manifest] the spirit and image of [the land] north of the [Yellow] River. The mountains, covered with auspicious snow, recede a thousand *li* into the distance. Wintry forests, desolate and dense, stand stalwart, self-sustaining. The things appear stern, frozen, and majestic—bringing the whole winter before our eyes.[16]

The effect of great depth was not usually regarded as typical of Fan K'uan. It was a feature characteristic rather of Li Ch'eng, as explicitly stated in a common saying of Fan K'uan's time transmitted in the *Sheng-ch'ao ming-hua-p'ing*, written about 1048: 'In Li Ch'eng's paintings [even] what is close by seems like a thousand *li* away; in Fan K'uan's paintings [even] what is in the far distance seems to be close at hand.' The contrast of the two men's styles is similarly but more elaborately described in Han Cho's *Shan-shui ch'un-ch'üan-chi* of 1121.[17]

All Sung critics agreed on the point of Fan K'uan's deep realism. None expressed it more succinctly and more poetically than Mi Fei in his *Hua-shih* when saying, 'In Fan K'uan's landscapes you can even hear the water.'[18]

Where in this great painter's oeuvre there might have been 'a slight touch of ordinariness', as charged by no less a writer than Su Tung-p'o, is difficult to imagine. The remark occurs in a colophon written for a landscape by Sung Tzu-fang (born *c*.1000) and recorded in *Tung-p'o t'i-pa*.[19] My assumption is that Su's mild obloquy, which is not an art-historical fact we have to come to terms with, was caused precisely by Fan K'uan's realism, which Su may have found disturbing.

What the Sung sources suggest with regard to Fan K'uan's artistic growth is, that in his earliest phase he depended chiefly on Ching Hao. At some time he must have studied the more differentiated and elusive designs of Li Ch'eng, whose ideas remained essentially foreign to him. A third influence, vouched for only by Mi Fei, was a type of winter landscape, which in Mi's time was ascribed to Wang Wei; it may be noted as a sign of continuing interest in the T'ang master during the tenth century: Kuan T'ung and Li Ch'eng, too, are said to have been students of his work.

Fan K'uan's *Travellers among Streams and Mountains* (Fig. 48) in the Palace Museum, 'a picture of magnificent structure and impressive dimensions' according to Sirén,[20] has the distinction of being the first original, signed work encountered so far. That it bears a signature—hidden between the leaves of the tree farthest to the right—was only recently discovered by Li Lin-ts'an.[21] Stylistically this work marks a turning point in the particular tradition to which it belongs. It possesses one quality by which all critics were struck: simplicity.

Here the time-honoured motif of the big mountain has been restated with incomparable boldness and dignity. The hazy, distant cliffs are eliminated. In proportion to the rest, the mountain is taller and bulkier than ever before, and is shaped with few fissures or notched contours. Its slightly bulging sides are rendered as smooth, bare walls of enormous dimensions, but enlivened by countless vertical dabs of the brush, subtly varied in shade and density. 'It has the appearance of weathered granite and by the plainness of its bulk conveys the impression of an imponderable weight; one deep gorge has been cut by a stream on the right, where the string-like waterfall in its cool, black cleft adds to the verticality that dominates the composition', according to Sickman.[22] The foot of the wall is veiled by a thin mist. Cutting all across, it divides in a lapidary manner all that is above from all that is below. In the region below, a horizontal order reigns. Separated by a gully where the stream splashes down are a densely wooded bluff and a slope, both slanting to the right, forming dark silhouettes against the light mist. They are bounded below by a light strip of sandy ground that slants toward the water at the left. Over this sandy strip move the tiny figures of two men driving their loaded donkeys toward the stream. Close to the lower edge, in the immediate foreground, lies a broad, sharply modelled agglomerate of low boulders, which cuts into the light strip of sand and water without interrupting it at any point (Fig. 49).

The valley zone (Fig. 50) abounds with gems of design. Some of the liveliest accents appear in the briskly drawn fir trees on the bluff above the gully, while most of the deciduous trees forming a dense grove on that bluff are subordinated to the large unit of terrain. Only when seen closely does the maze of leaves—drawn

FIG. 48 Fan K'uan, *Travellers among Streams and Mountains*. Taipei, National Palace Museum.

individually, flawlessly, and with steely precision—reveal its structure and the vigorous rhythm that pulses through it. Another remarkable thing to be noted is the complete identity of the type of brush-stroke used for the trunks and limbs of the trees with that which defines the structure of the rock: a firm, heavy, deliberate line vibrating with life. This unity of form must be counted among the particular achievements of the great master. But throughout this work we sense the presence of a powerful and disciplined intellect, accounting for the exquisite order and the unfailing inspired hand.

Whether Fan K'uan's monumental work still belongs in the tenth century or in the early eleventh is a question that must be left open. If Mi Fei's observation on the murky effect of Fan's late paintings can be regarded as a criterion, the *Travellers* is unlikely to be a late work of the master. It may well date from about 1000 and may be the last tenth-century descendant of the series begun with the *K'uang-lu Mountains* (Fig. 44), whose comparatively archaic character will now be readily seen.

The masters whom Kuo Jo-hsü in his *T'u-hua chien-wen-chih* of c.1074 recognized as supreme were Kuan T'ung, Fan K'uan, and Li Ch'eng. The last artist was compared, as we have seen, with Fan K'uan by the Sung critics—as if all that mattered was the understanding of the dissimilarity of these two men.

Li Ch'eng (919–67?) unquestionably was the foremost among the mid-tenth century landscapists. His fame was such that throughout time he never disappeared from memory. That something of his life is known at all may be due, however, to the circumstance that he came from a family of scholars descended from the T'ang imperial house. We know the names of his grandfather, his father, his son, and his grandson, and a few dates suggesting the years about 860, 890, 920, 950, and 980 for these five generations. Li Ch'eng himself, although regarded as a man of great talents and sufficient learning, never accepted a position. 'His talents and his destiny moved in different planes', the *Hsüan-ho hua-p'u* says with nice detachment, in Giles's translation;[23] and 'he died, drunk, in a guest-house', is the terse account of his end as told in the biography of his son in the *Sung Annals*.[24] His grandson, Yü, who received his doctorate in 1012, bought up all of his grandfather's paintings he was able to get. Paying double the price, he succeeded: sellers were thronging the place, and Li's paintings became rarities.

That the year of Li Ch'eng's death was Ch'ien-te 5, corresponding to 967, is recorded in *T'u-hua chien-wen-chih*, while his age of 49 *sui* [48 years in Western reckoning] is mentioned in Wang Ming-ch'ing's *Hui-chu ch'ien-lu* of 1166.[25] The assumed life-span, 919–67, hinges on these sources, which appear to outweigh contradictory evidence. Unfortunately the text of an epitaph written by Sung Po (936–1012),[26] presumably at the request of Li's son, seems to be lost; it must have contained precise information regarding Li's career, since the author of *Huang-ch'ao lei-yüan* (1145),[27] Chiang Shao-yü, relies on that epitaph to refute Ou-yang Hsiu's assumption that Li held an official position.

As a consequence of the rarity of Li Ch'eng's originals, good copies began to take their place as early as the 1030s to meet a steady demand on the part of fellow-artists, students, and the ever undaunted collectors. With signatures and seals complete, and exact enough to be mistaken for original works,[28] some of these reproductions

FIG. 49 Fan K'uan, *Travellers among Streams and Mountains*. Detail of Fig. 48.

FIG. 50 Fan K'uan, *Travellers among Streams and Mountains*. Detail of Fig. 48.

must soon have acquired the status of authentic works. Emperor Hui Tsung's large collection of 159 items, too, must have contained such copies, to the existence of which the catalogue candidly refers. Still, a copy that preserves reasonably faithfully an original pictorial idea is preferable by far to even the best of descriptions, much as the latter are preferable to general characterizations. What the Sung sources offer is precisely of this kind; all that can be expected from them is a hint at stylistic features that distinguish a Li Ch'eng from all others.

The *Sheng-ch'ao ming-hua p'ing*[29] contains nothing sufficiently specific on Li's style, as the partial translation given in Sirén's *Chinese Painting* shows.[30] Kuo Jo-hsü (1074), by contrast, made an admirable effort to evoke some essential aspect of style in the case of the three masters, Kuan T'ung, Fan K'uan, and Li Ch'eng. Of the latter he says, 'His atmosphere is mournful and thin; his misty forests are pure and desolate. His brush-point is as fine as a needle, his ink, infinitely slight.'[31] The meaning of Kuo's observations becomes clear in the light of some later commentaries. As early as the Yüan period there was a saying that 'Li Ch'eng used ink as sparingly as if it were gold', as noted in *Liu-ju chü-shih hua-p'u*.[32] 'Ink', it will be remembered from our paragraphs on Ching Hao, refers not to the pigment as such but to its application and function in tinting and texturing. This is confirmed in the following description of Li Ch'eng's manner given by Chang Keng in his *T'u-hua ching-i-chih* of 1762: 'The contour strokes are not many, while the shapes are piled up enormously. The texture strokes are very few, yet the inner structure is spontaneously present.' Wang Ming-ch'ing had a still briefer formulation for the same aspect—so brief indeed that we might fail to catch his idea unless we had some notion of its likely implication. Speaking of Li's finest achievements he says in his *Hui-chu ch'ien-lu* that 'it almost seemed as if they were not made with brush and ink.'[33]

What these several passages seem to indicate is a certain amazement about an unprecedented quality in Li's work, namely, the absence of precisely such features as had been wholly indispensable to the older masters: a definite, ideal technique of brush line and ink dab with which to conjure up the myriad phenomena of landscape. In Li Ch'eng's pictures, 'made without ink and brush', there appeared something elusive and unaccountable, a 'next-to-nothing' of technique, intuited by the painter as the things took shape under his hand. Forms came into being as if it were of their own accord. Consequently his work seemed like a more direct manifestation of nature than had been encountered before. 'The phenomena came spontaneously out of him', says the *Hsüan-ho hua-p'u*,[34] echoing the *Sheng-ch'ao ming-hua-p'ing*.

The qualities admired by Mi Fei do not take us far into matters of style. Rather they may be summed up as evidence of Li Ch'eng's character and intelligence, asserting themselves in naturalness and rational order.

On the authority of Wang Lo-yü (b. 1587) we note that Li Ch'eng occasionally, if rarely, painted in colours, a fact which escaped Mi Fei.[35] Wang refers to an album leaf successively owned by Wen P'eng (1498–1573), Hsiang Yüan-pien (1525–90), Tung Ch'i-ch'ang (1555–1636), and himself. This leaf is described in Ch'en Chi-ju's *Ni-ku-lu* as a blue-and-green landscape in the style of Wang Wei.[36] Since the Sung sources are silent on the point of Li Ch'eng's training, that unequivocal statement linking Li Ch'eng with Wang Wei is of some importance. The *Huang-*

ch'ao lei-yüan (1145), it is true, does mention that 'it used to be said that he was a disciple of Wang Wei and Li Ssu-hsün', but implies that it was almost an insult to speak of Li Ch'eng as anybody's disciple.[37] The *T'u-hui pao-chien* (1365), on the other hand, states as a simple fact that 'Li Ch'eng studied Kuan T'ung'.[38] It is noteworthy, therefore, that in a colophon by no less an artist than Wen Cheng-ming the two traditions, those of Wang Wei and Kuan T'ung, are recognized in one and the same painting of Li Ch'eng:

> The brush-line seems to be in the manner of Wang Wei, while the textures and tints seem to be modelled on Ching Hao and Kuan T'ung. Yet the style is so consistent that it is neither Wang Wei's nor Ching's and Kuan's. Li Ch'eng, in fact, is not too far from Tsin and T'ang, and of the famous works of bygone ages all that was good is here collected and at one glance perceived.[39]

In this exceptionally cautious appraisal the reliability of the assumed connection with Wang Wei and Kuan T'ung is both confirmed and qualified. Wen Cheng-ming senses—behind the recognizable style elements—a unique substance, something that demands to be compared with true greatness, irrespective of stylistic filiations. That Li Ch'eng would have to come to terms with Kuan T'ung's ideas was inevitable in his generation. As for Wang Wei, it will be recalled that Kuan himself turned toward the venerable T'ang master in his middle years. There was nothing extraordinary, therefore, in Li Ch'eng's awareness of him. Be that as it may, an affiliation between Li and Wang Wei was so much taken for granted by late Sung times that Chou Mi (1232–1308) in his *Yün-yen kuo-yen-lu* could say, in characterizing a picture attributed to Wang Wei, that 'the hills and old trees were entirely like those done by Li Ch'eng.'

A few indications of Li's contribution to landscape imagery not mentioned so far are given in two Northern Sung texts. *T'u-hua chien-wen-chih*[40] says, 'In misty woods and level distances, the wondrous was first attained by Ying-ch'iu', while the *Hsüan-ho hua-p'u* tells of such themes as 'marshy plains, . . . wind and rain, darkness and light, vapours and clouds, snow and fog'.[41] The implications seem clear. If Li Ch'eng was able to depict the flat recession of a plain, he no longer depended on the archaic conception of landscape as an assemblage of mainly vertical bodies in receding planes, but was aware of space as such. The dramatic vertical shapes give way to the more inconspicuous formations of level land, where the play of atmosphere and light assumes a hitherto unknown importance. Along with it, the painter may have discovered something of a landscape's changeable physiognomy.

Try as we may to wrest a theoretical image from the foregoing commentaries, all that they yield is some insight into Li Ch'eng's technique, which apparently was no longer committed to the characterization of matter or its surface. His thin, sparing, and elusive brush defined as much as was necessary to establish the shapes and dimensions of things, without labouring on formalistic patterns devised to capture reality. This denial of graphic formalism may well have been the result of his sharpened awareness of the spatial continuum in a landscape.

Encountering a work such as *Travellers among Snowy Hills*, a hanging scroll of relatively small size in the Boston Museum (Fig. 51), we cannot fail to notice the strong contrast to the paintings given to Ching Hao and Kuan T'ung. Instead of

elaborate and spectacular vistas, this painting shows an immensely deep space under a high and sombre sky, which soars over the islands and distant banks of a river beyond a formation of boulders rising above the horizon. The solids do not fill the space. They consist of rounded shapes with little of texture to them, and their unlaboured contours are devoid of spikes and notches. They are carefully modelled by shading with some greenish brown colour, and enlivened by thin stipples and heavier dots of ink. Compared with the rocks of Ching Hao and Kuan T'ung, they are of a less conspicuous, almost unsubstantial appearance. Verticality, crevicing, massiveness and jaggedness are features all but omitted. A similar restraint may be observed in the trees and small groves, which are rendered as unobtrusive adjuncts of the scenery. Neither bizarre nor striking, the trees contribute to the slightly melancholy mood of this picture. The group of travellers is about to disappear in a gorge on their way up to a monastery under an overhanging cliff. The figures as well as the architecture are rendered with far greater care than their diminutive scale might demand—very like those in Fan K'uan's *Travellers* (Fig. 48), and in keeping with the traditional manner of handling such details. Despite the great gap between the Boston Li Ch'eng and the Fan K'uan, the fundamental identity of the theme should not be overlooked.

The position of *Travellers among Snowy Hills* becomes fairly distinct through a comparison with the Fan K'uan. The technique of the assumed Li Ch'eng is freer, less predictable, without set texture patterns, and sparing. The definitions are less exact. A rock contour, for instance, may trail off into a series of stipples, which are not descriptive of physical realities but may be read as a rough edge, or as some vegetation, or simply as darkness. Dots, sparse or amassed, hover near a surface without acquiring the appearance of either local tone or scrubby growth. Obviously the painter was not much concerned with the substance of rock. He gives no close-up views such as Fan K'uan's but a detached vista of the scenery as a whole, of the configuration of solids in a vast, open space. The geometric or crystalline shapes of rock and mountain are replaced by irregularly rounded, somewhat nondescript forms, which may possibly correspond to what is described as Li's 'cloud-like rocks'. The painter is averse to display. The fierce and overwhelming aspect of a Kuan T'ung or Fan K'uan gives way to a gentler, unassertive and slightly plaintive air.

This work (Fig. 51) agrees surprisingly well with the descriptions of Li Ch'eng's style given by Sung authors. The fact that it is stylistically incompatible with the Ching Hao school (as envisaged in the preceding pages) would in any case require its being assigned to another school, and this means—if the painting is of the tenth century—either that of Li Ch'eng or that of Tung Yüan and Chü-jan. There can be no doubt as to which of the three schools we recognize here: the Boston picture has nothing whatsoever in common with any work connected with Tung Yüan. Conjecturally, therefore, it should be accepted as a work by Li Ch'eng or one of his early followers, as suggested by the attribution written by, or in the manner of, Emperor Hui Tsung. Sirén, while taking the painting to be of the period, thought its style to be uncharacteristic of Li Ch'eng and rather more closely dependent on that of the previous generation, whereas H. Munsterberg, on the contrary, finds it the most convincing among the Li Ch'engs preserved today.[42] Still, the negative

FIG. 51 Attributed to Li Ch'eng, *Travellers among Snowy Hills*. Boston, Museum of Fine Arts.

FIG 52 Attributed to Li Ch'eng, *Mountain Peaks after a Snowfall*. Taipei, National Palace Museum.

procedure of excluding two schools does not quite settle the case for the third, or Li Ch'eng.

Fortunately there exists another work of comparable style which also goes under the name of Li Ch'eng, namely, *Mountain Peaks after a Snowfall* (Fig. 52) in the Palace Museum. Like the Boston picture it presents a wintry scene under a high, murky sky. In superposed tiers of light rock and dark forests the terrain rises toward a group of pale, soaring pinnacles of naked rock. The formations below are modelled with shallow fissures conforming approximately to the outlines. Patterned texture strokes are avoided. No washes occur, and the sparing, fine, dry and crumbly strokes used in modelling the rocks bring about the same slightly un-substantial air, which we observed in the Boston painting. Reminiscent of the latter, too, are some ink stipples at the tops of the curiously shaped pinnacles.

The trees are drawn with as much restraint as tenderness. They are not drama-tized for effect or expressiveness, and diversity is no concern. Their shapes are of a lovely simplicity and innocence. The image as a whole is free of formalistic elements. There is not one brush-stroke that is important as such, and no contrast of tone that is not objectively motivated. As in the *Travellers among Snowy Hills* (Fig. 51), there is no such thing as atmospheric effects. Both pictures represent the clear air after a snowfall, with all things near and distant sharply defined.

Attributed to Li Ch'eng by Kao Shih-ch'i (1645–1704) in a poem written on the silk frame in the year 1698, the painting is executed in ink only, on a now dark-brown double-woof silk with a greyish overcast of unmistakable age. It agrees closely enough with the *Travellers among Snowy Hills* to make the attribution mean-ingful, much as in turn it supports the older attribution of the *Travellers*.

The two works discussed do not, of course, give a full representation of the styles that go under the name of Li Ch'eng. Connoisseurs and painters of later periods have recognized pictures of rather different cast as Li Ch'engs. To dismiss their attributions as unfounded without trying to understand their reasoning is some-thing which in the present state of uncertainty we can ill afford. It is not likely that Li's oeuvre was perfectly homogeneous. Some attribution may point up one facet that is not found in another attribution, so that both may be valid to some extent. The album leaf discussed next will serve to exemplify the range of dissimilarity tolerated by the critics of old within the same painter's work.

Jasper Peaks and Jade Trees (Fig. 53), in the Palace Museum, is an evidently ancient painting executed in ink and white colour on a now very dark brown silk, mounted as an album leaf and likely to be the remnant of a handscroll. A work of high quality and apparently free of Sung conventions in its design, it is accompanied by a colophon written by Tung Ch'i-ch'ang, which says:

> Mi Yüan-chang [Mi Fei, 1051–1107] thought of writing on the non-existence of paintings by Li Ch'eng. Here we have a genuine Li Ch'eng! Cloud-like peaks, and rocks of an appearance such as can only come from the depth of nature herself, while the brush technique stems straight from Ching Hao: the utmost of antique purity. If venerable Mi had seen it, surely he would have listed it in his *Pao-chang tai-fang-lu*.

The composition of *Jasper Peaks* does not seem to be complete, but apparently

represents a close-up passage from a scroll such as was copied by Wang Hui in 1667 after an original then owned by Wang Shih-min and designated as *Clearing After Snow* by Li Ch'eng, an original that had passed through the hands of Chao Meng-fu and Tung Ch'i-ch'ang,[43] and was copied once more by Wu Li in 1669.[44] The connection of its style with Li Ch'eng, therefore, is one of long standing. But there are features which recall a host of works purporting to represent Wang Wei's manner, for example the rounded cliff contours and their dynamic quality; the use of white pigment; the type of trees in the foreground; the lack of *ts'un* dabs; the soft, blurred crevices and the rugged, extravagantly dissected terrain. One such work is an album leaf by Wang Hui entitled *Snow-Covered Mountains after Wang Wei* in the Palace Museum, executed in a tempera-like technique in cold colours such as grey, bluish grey, dark green, white, and black.[45] Its general character agrees to a surprising degree with *Jasper Peaks*, which in fact does not compare well with any of the tenth-century works examined. It seems that the style of *Jasper Peaks* might be more readily accommodated in the wake of Wang Wei's landscape style, around the ninth century or so, in a pre-Ching-Hao phase.

Jasper Peaks (Fig. 53) cannot stylistically be reconciled with the Boston *Travellers* (Fig. 51). One of the two—but not both—may represent the typical Li Ch'eng

FIG. 53 Attributed to Li Ch'eng, *Jasper Peaks and Jade Trees*. Taipei, National Palace Museum.

style, even though both may be related to the master. In the writer's belief, *Travellers*, as a tenth-century design with a purported eleventh-century attribution, has the greater claim to authenticity, while *Jasper Peaks* may well reflect a secondary Li Ch'eng tradition that grew out of capricious attributions to him of works by anonymous followers of Wang Wei, a tradition which permanently distorted his image.

An important and attractive work that is designated as 'a study after Li Ch'eng' by the eleventh-century master Hsü Tao-ning bears on the problem in hand. Hsü's *Dense Snow on the Mountain Pass* (Fig. 72) in the Palace Museum combines, as it were, three distinct aspects: it is reminiscent of pictures said to follow Wang Wei (eighth century); it agrees fairly well with *Jasper Peaks* (a ninth-century design?); and it is compatible with *Travellers among Snowy Hills* (tenth century). Obviously this work, thoroughly archaistic in character, differs sufficiently from other works that go under Hsü's name to bolster the credibility of its being a study or, possibly, copy after Li Ch'eng. It is a winter landscape in ink and opaque colour, chiefly white and dark green. The mountain forms are rounded, atectonic and dynamic; avoiding verticality, serrated contours and *ts'un* texturing, they resemble those in both *Jasper Peaks* and *Travellers*. The trees, tall and slender, of varied species and swaying motion, have little in common with those of *Travellers*; rather, they evoke T'ang types. But the composition is fundamentally like that of the *Travellers*. The Hsü Tao-ning suggests a model that may have been very close to Li Ch'eng. It certainly reveals no indebtedness to the school of Ching Hao. Yet its testimony is too ambiguous to enable us to decide on the relative reliability of the paintings discussed above. While disappointing, this ambiguity may be a sign that a process of disintegration of the Li Ch'eng 'image' had indeed begun as early as the eleventh century. Mi Fei was convinced that virtually all the Li Ch'engs seen by him were imitations, and Chang Ch'ou, in his *Ch'ing-ho shu-hua-fang* of about 1616, plainly confirms the suspected existence of a secondary tradition when saying that

> much of what later came to be regarded as Li Ch'eng's work was actually the production of three of his followers: Hsü Tao-ning, Li Tsung-ch'eng, and Ti Yüan-shen.[46]

As a consequence we have to resign ourselves to the fact that Li Ch'eng exists today only in the blurred aspect established by his imitators, without whose contribution he might not exist at all. This reduces our stylistic distinctions to the crude level of either similarity to or dissimilarity from the Ching Hao–Kuan T'ung–Fan K'uan and the Tung Yüan–Chü-jan lineages.

Tung Yüan (*c*.900–62) from Chung-ling (Nanking, Kiangsu), although represented with no fewer than seventy-eight items in the *Hsüan-ho hua-p'u*,[47] was not widely known and appreciated in the Sung period. His rise to the status of a leading master dates only from the time of the Yüan Dynasty. Of his life little is known. He was Vice-Commissioner of the North Park at the Nan-T'ang Court in Nanking, and his duties may not seriously have interfered with his artistic inclinations. As he was ordered to make a picture of the *Lu-shan* about 937, he must have established himself as a painter before that year and, we may surmise, have been in his thirties

or so. Again, in 947, he was asked to collaborate with four noted painters on the depiction of a banquet held in celebration of a snowfall on New Year's day. He died in 962, in the second year of the poet-emperor Li Yü's reign, according to an unknown source accessible to Pien Yung-yü (1645–1712) and quoted in his *Shih-ku-t'ang shu-hua-shih* manuscript.[48]

Tung Yüan was not a landscapist exclusively. His oeuvre was surprisingly diversified, as may have been his techniques. But his fame rests on his landscapes, which apparently were unconventional and departed from both tradition and contemporary trends. He was not driven by an *idée fixe* like Ching Hao, or by a passionate will-power like Kuan T'ung, or consumed by the fires of his genius like Li Ch'eng. There may have been ease and playfulness in him. Li Ch'eng, demonic and irritable, might not have had the patience to paint bucolic and anecdotal scenes such as occur among the titles of Tung Yüan's works listed in the *Hsüan-ho hua-p'u*, to wit, herdboys, buffaloes, dragons, the God of Long Life and Lohans, bespeaking a relaxed and convivial temperament.

That Tung worked in both colour and ink, in 'a wet ink manner which resembled Wang Wei's, and a coloured style like that of Li Ssu-hsün', is recorded by Kuo Jo-hsü.[49] Kuo does not say whether the two techniques were used side by side or in successive phases of Tung's career, the latter alternative being favoured by Sirén. The subject of colour looms large in the presentation of the *Hsüan-ho hua-p'u*:

> Yet the painters praised him rather for his coloured landscapes, saying that his rich and lovely vistas have almost the stylistic qualities of Li Ssu-hsün. Judged by Tung Yüan's oeuvre as we know it today [*c*.1120], this certainly seems convincing. For at that time there wasn't much of coloured landscapes done as yet, and few were those who could imitate Li Ssu-hsün. Thus it was specifically on that ground that Tung Yüan gained fame in his days.[50]

That colour was of more than passing interest in Tung's work is an impression we also receive from a paragraph in the Yüan critic T'ang Hou's *Hua-chien* (1329): Tung's landscapes are of two kinds, 'those in wet ink . . . with plains deep and sombre, and mountains and rocks textured with the "hemp fibre stroke"; and those in colour, with little of texture patterns, with colours applied heavily in the ancient manner'. Accordingly it would seem safe to conclude that Tung Yüan did practise both techniques side by side, perhaps from the beginning. Neither was new, of course, and in being conversant with both, Tung had an eminent predecessor in Wang Wei himself.

Regarding Tung Yüan's motifs, it is not surprising that some of his landscapes were done in a traditional vein, 'with lofty and precipitous vistas, piled-up peaks and abrupt walls, giving a sensation of vigour to the beholder, just as his *Dragons* do', while others evidently were more characteristic of the painter's own world: 'rivers and lakes in wind and rain, valleys and ranges in darkness and light, forests in drizzles, vapours and clouds—a thousand cliffs and myriad gorges, layered banks and steep shores'. The above characterizations derive from the *Hsüan-ho hua-p'u* and are conventional in tone. Shen Kua (1030–94), on the contrary, in his *Meng-ch'i pi-t'an*[51] concentrates on Tung's innovations: ' . . . far vistas in autumnal vapours portraying the actual hills of Kiangnan—without any strange cliffs'; and, in a

passage of undeniable importance, he adds, 'the *Sunset*, if viewed closely, seems without merits; but when seen at a distance . . . one comprehends that it is an evening scene, with the summits of the far away mountains rendered as if they were reflecting the light [of the setting sun].' The phenomenon of light, which has been considered as Tung's major contribution,[52] is nowhere more clearly described. It is a factor that has a strongly unifying effect because it denies separateness to the individual object.

To Mi Fei, a younger contemporary of Shen Kua and an ardent admirer of Tung Yüan, the work of the latter was not a matter of cool analysis and objective evaluation, but part and parcel of his artistic creed, and the vindication of Tung's ranking became, as it were, his own apologetic. In his *Hua-shih* he says—without understatement,

> Tung Yüan's plain, insipid naturalness is something that did not exist in T'ang. It is above Pi Hung. The level of what in recent times was classed as 'divine' is nothing to compare with him. His peaks emerging or disappearing, his clouds and mist clearing or thickening, unpretentious and artless, they all have that naturalness. And there is a sense of life in his luxuriant green growth with vapours about it, and in his branches and trunks, so strong and rigid. His streams and bridges, fishing reaches, islets and banks: they are a very slice of Kiangnan.[53]

Despite Mi's admiration, Tung Yüan had no following in Sung, except for the monk, Chü-jan, from Kiangnan. The phenomenon of Tung Yüan's rise to supremacy among the models of antiquity dates only from the Yüan period (1279–1367). The likely reasons for his resurgence, more than three centuries after his death, were first put forth by Chu-tsing Li. In a searching investigation contained in his *Autumn Colors* he recognized that to the Yüan painters in their search for 'prototypes in the literati tradition' the eighth-century Wang Wei and the tenth-century Tung Yüan 'seem gradually to have merged into one single image'.[54]

If such was the case, are the Yüan painters to blame for their indifference to the authentic style of the master? The answer must be that to them the question of authenticity was almost irrelevant. Their object was not historical truth regarding Tung Yüan's style, but their own styles. What mattered to them in the fused images of Wang and Tung was not correctness but effectiveness, that is, effectiveness as archetypal forms in the process of creating a new landscape style. Accordingly, we must not expect much help from any Yüan work when attempting to recognize Tung Yüan's style or, more precisely, traits distinctive of his stylistic innovations. We cannot be sure that any of the now extant works is authentic, but we can expect to discover such traits as consistently distinguish a putative Tung Yüan from other schools. It will not be the whole Tung Yüan by any means. Nor might this whole Tung Yüan—if it were possible to reassemble his oeuvre—be as significant as one single truly characteristic work. For that matter, a fine copy of later date might shed more light on the question of the master's most characteristic manner than does a credibly authenticated painting that happens to be unrevealing as to his mature and typical form. This may sound paradoxical; actually it is perfectly logical that a later artist would imitate the earlier master only in his most original and unmistak-

able aspect. All that did not belong with that essential aspect, therefore, was bound to vanish from memory. An atypical work would then no longer be secure from being misjudged.

A case in point is *The River Bank* (Fig. 54) in the C. C. Wang collection, a large hanging scroll of hoary appearance that, but for a signature that may be Tung Yüan's own, would be most likely to pass for an anonymous work of possibly tenth-century date. There are no features reminiscent of the important, homogeneous group of handscrolls depicting river scenes in the Liao-ning, Peking and Shanghai Museums. It is a work of surpassing quality and readily stands comparison with the masterpieces considered in the foregoing pages, although its condition is such that some passages are no longer clearly legible. Painted in ink and some colour, it depicts a narrow valley zigzagging between steep slopes and widening to a river basin in the foreground. The slopes are not rocky but deeply dissected like eroded soil, and intricately modelled by shading. Sparse groves of pines and firs are scattered over the slopes, diminishing in scale as they recede into the distance. In the valley grow taller deciduous trees, their foliage swaying in a heavy breeze, which ruffles the surface of the water. Partly hidden behind a big rock is a homestead and pavilion on piles. The technique is free of all formalism. There are no dabs or *ts'un* of any kind, such as might remind one of Ching Hao and his followers. The design is full of movement. Regarding space, we note that it is not the mountain masses which dominate but the canyon-like opening between them. This combination of openness and movement is not paralleled among the landscape compositions connected with Ching Hao, Kuan T'ung, Fan K'uan, and Li Ch'eng, where the theme of the mountain was presented with an insistence and a solemnity that are absent here. At the same time, this painting retains several less modern features: a strongly tilted ground plane; fir trees rendered in superposed tiers of a type that at Tun-huang seems to go back as far as the sixth century and to persist through the tenth century; the deeply fissured terrain, which may call a landscape detail in the *Hokke Mandara* of the mid-tenth century in the Boston Museum of Fine Arts to mind; and the rendering of the water ripples comparing, as pointed out by Hsieh Chih-liu, with T'ang designs.[55]

In addition to the signature, *Hou-yüan fu-shih ch'en Tung Yüan hua*, 'Rear Park Assistant Commissioner, servitor Tung Yüan pinxit', the picture bears the early Ming half-seal, *ssu yin* (office seal), which refers to an office named Tien-li Chi-ch'a-ssu between 1374 and 1384, and should warrant a respectable pedigree. In any case, if the *River Bank* (Fig. 54) can be tentatively accepted as a work by Tung Yüan, it would make him seem more unquestionably at home in the tenth century than he does on the basis of most of the other paintings ascribed to him. Their stylistic disparity is a disquieting circumstance. But then, earlier observers too were struck by the phenomenon of Tung Yüan's diversity. Wang Shih-min (1529–1680), for instance, said in one of his colophons that, 'Pei-yüan's paintings vary in the extreme; of those I have seen in my lifetime, not one was like another.'[56] Conceivably, however, *The River Bank* is an early and still atypical work of Tung Yüan's. It is an assumption for which there is no proof, but at least it accounts to some degree for the relatively antique features of this work.

No less important but more widely known is a scroll of imposing size in the

FIG. 54 Tung Yüan, *The River Bank*. New York, C. C. Wang collection.

Palace Museum in Taipei, depicting a vast and inviting scenery of a river, lakes and hills. The picture has been called variously, *Festival in Honour of the Emperor* and *The Dragon Boat Festival*, though neither title is correct, according to L. S. Yang who instead proposes a reading (with the same pronunciation) whose approximate equivalent would be *Genteel Townsfolk at Leisure*.[56a] The painting will be referred to as *Festival at the River* (Fig. 55).

Seen from a great height is a chain of small lakes below tall grassy hills and wooded promontories, which, divided by flat spits of land, wind back into the distance where a big river flows past the hills and disappears in the luminous haze of a shoreless horizon. The eye is drawn irresistibly to that open spot of light where sky and river meet. The hills are solid and massive but do not dominate; the open spaces are equally or even more important. The slopes are not steep, and the crevices do not cut deeply into them. There is no ruggedness. Pliant texture strokes, which run in the direction of the inclines, give a sensation of smoothness as of grassy surfaces. Small groves of leafy trees are scattered over the slopes and the valley ground. The trunks and limbs appear whitish against the rich dark-green foliage. Near the lower left corner we notice two long, narrow boats carrying tiny figures of dancing people dressed in opaque, light-coloured garments. A few others, similarly dressed, are watching from the shore. Nobody is shown working. Something out of the ordinary seems to be going on.

The silk of this picture is dark-brown, old and brittle, the colours dark and heavy. Except for an opaque light-green in the scalloped areas on the hill in front, the slopes are coloured in a more transparent, subdued grey-green. For the few rocks and boulders, bluish and brown hues are used. The foliage is rendered in a blackish green, but there are two trees whose foliage is red.

The attribution to Tung Yüan, made by Tung Ch'i-ch'ang, who acquired the painting in 1597 from a collector in Shanghai, apparently was not questioned by any of the Ming and Ch'ing writers who dealt with it (for example, Chan Ching-feng, Chang Ch'ou, Pien Yung-yü, and the editors of the *Shih-ch'ü pao-chi*). Modern opinions range from diffident acceptance to cautiously worded doubt. Indeed, no clear decision for or against the assumed authorship is possible at present; all that can be expected is a clarification of the stylistic position of this eminent work. Its dissimilarity from the designs connected with Ching Hao and Li Ch'eng and their followers favours its association with the Kiangnan school, as does its affinity with typical works of Tung's follower, Chü-jan (Figs. 63–5), and consequently also with Yüan landscapes based on the Tung–Chü tradition. A good example is Kao K'o-kung's *Cloud-Encircled Mountain*.[57] Some passages in the modelling of the mountain agree so closely that one might feel tempted to place *Festival at the River* itself in the Yüan period, although its total effect as well as its physical condition would seem to favour a pre-Yüan date. In any case, *Festival*, in contrast to the doubtless more ancient *River Bank*, does represent a style reflected in the works of Chü-jan, Mi Fei, Mi Yu-jen, Kao K'o-kung and Wu Chen, and therefore is likely to be a typical work by, or after, Tung Yüan. In his recent study of Tung Yüan entitled *Marriage of the Lord of the River*, Richard Barnhart, too, comes to the conclusion that *Festival* must be regarded as 'the best extant evidence of the painter's "blue and green style in the manner of Li Ssu-hsün" '.[58]

We next turn to three hanging scrolls (Figs. 56–8) also claimed to be Tung Yüan's. The first, *Travellers among Autumn Mountains* (Fig. 56), formerly in the collection of Ch'en Jen-t'ao, appears to be an altered version of an archaic, perhaps tenth-century composition with reminiscences of older elements. Its ancientness is attested by a copy made by Wang Meng (*c.* 1310–85), which in turn was copied by Wu Li (1631–1718), as well as by seals going back as far as Northern Sung, as

FIG. 55 Attributed to Tung Yüan, *Festival at the River*. Taipei, National Palace Museum.

noted in Ch'en Jen-t'ao's *Three Patriarchs*.[59] The silk is dark and worn; ink and colours have faded.

The design is of the utmost grandeur. From a high vantage point the viewer looks down into a valley between cliff-like formations of staggering height. Beyond them flows a wide river lined by low hills. The colossal cliff on the left occupies over two thirds of the height of the picture and has an energetically drawn, expressive outline, which cuts over the lower hills and the horizon. Its edges are light in tone. All along the 'spine' of the cliff there appear 'alum head' lumps and dark vegetation dots, but none of the hovering horizontal blobs seen in other paintings attributed to Tung Yüan. Trees with light stems and finely outlined or dotted foliage grow in the valley and high up on the cliffs—side by side with the vegetation dots, which therefore must be understood as a structural feature of the terrain formation rather than as distant forests; moreover, the same dots are used on distant peaks and in the foreground, where they function merely as accents. The houses, boats and bridges, boatmen and travellers, not actually small in size, virtually disappear among the immense shapes around them.

In some regards this painting, which is closer to the ideals of the Northern masters than any other work connected with Tung Yüan, seems highly archaic; it retains late T'ang elements such as the tilted ground plane, the uniformity of the crevices, and the overhangs and outcrops of the cliffs. Yet the technique of the pliant hemp-fibre strokes used to model and give texture to the piled-up masses is wholly in keeping with all that tradition ascribes to Tung Yüan and Chü-jan. This smooth texture, however, is anomalous when applied to the undercut faces which cannot depict anything but exposed rock. It is an anomaly that renders the substance of the tall cliff ambiguous: where the design suggests rock, the brush technique suggests grassy surfaces. Like the ostensibly structural, actually rather patterning vegetation dots, which are somewhat too obviously and resolutely applied, the illogical uniformity of the surface textures is an unconvincing feature in a work purporting to date from the tenth century.

As to scenery and composition, none of the previously discussed pictures compares more closely than does *The River Bank* (Fig. 54). But technically the two works are so dissimilar that it is impossible to see the same hand in both. *The River Bank*, free of merely formalistic devices, is an altogether more innocent work. Measured by the far more rationally constructed spatial layout and clear articulation of the scene in *Festival at the River* (Fig. 55), the painter of the original version of *Travellers among Autumn Mountains* (Fig. 56) was a more primitive and limited artist. Another hand seems to be responsible for the recklessly formalistic execution of the present version, where the brushwork of *Festival* is adopted—and compromised.

A puzzling work attributed to Tung Yüan by the late Ming connoisseur Wang To (1592–1652) is *Mountain Paradise* (Fig. 57) in the Palace Museum.[60] It is a large scroll in ink and colour on a silk of light yellowish brown tone and has the physical appearance of a Yüan or early Ming rather than a Sung work. It is not signed and bears no ancient seals or inscriptions. Its title, *Tung T'ien Shan T'ang*, is believed to have been written by Yen Sung (1481–1568), a Ming official of unenviable reputation. The only Ch'ing Palace seal is as late as Hsüan-t'ung (1908–11).

A deeply creviced mountain of huge dimensions rises over layers of clouds, which

FIG. 57 Attributed to Tung Yüan, *Mountain Paradise*. Taipei, National Palace Museum.

FIG. 56 Attributed to Tung Yüan, *Travellers among Autumn Mountains*. Hong Kong, collection of the late Ch'en Jen-t'ao.

here and there are pierced by the tops of pine trees and momentarily unveil the roofs of an ensemble of palatial buildings. The colour is quite unusual: a strong cobalt blue, painted over the ink lineament, in the big mountain and in the small peaks to the left and right of it (the latter oddly positioned in front of the far end of the big mountain); greenish greys in the foreground rocks, contrasting with a warm brown in the tree trunks; thin reddish tones in the woodwork of the buildings; and a grey sky, with clouds the tone of the silk.

The painting lacks unity and its quality is uneven. It may be a Ming pastiche in which Sung features (like the beautifully drawn pine trees, the elegant architecture, and the tiny but animated figures) are combined with Yüan elements (the shape and texture of the mountains) in an archaizing composition of pre-Sung character. This lack of unity makes it difficult to evaluate the painting historically; it does not seem to embody an original idea, and its style is unrelated to any of the landscapes mentioned above.

A third picture attributed to Tung Yüan, *River Bank at Dusk* (Fig. 58), was published in *Taifūdō meiseki*.[61] It belongs in an altogether different category. The scenery resembles that of *Festival*, as to some extent does its style. The central hill, which ascends beyond the horizon, is here dwarfed by a peak of spectacular shape, with a perilous overhang and exposed rock in haphazard layers and incongruous cubes. Its lateral face coalesces awkwardly with a rising slope. Beyond this strange peak there towers yet another cliff like an immensely tall apparition in the sky. A relatively narrow space is given to the distant river, thus denying any sense of an immeasurable, open expanse. Wanting here, too, are the beautifully organized contrasts of the gleaming waters and the dark hills and flats that we admire in *Festival*. In the centre grows a group of very tall pine trees that seem quite foreign, as though they had been transferred from a picture of another period. A curious spruce tree at the left edge does not seem at home here either. Between those trees, down by the river bend, stretches a small, very light plateau, which is conspicuously flat and smooth. A group of travellers moves across it, heading toward a bridge and a homestead at a short distance from the river. The respective levels of the plateau, the water, the bridge and the terrain across the water are incongruous. Another disturbing feature is a line of dots, horizontal, slanting, and vertical, that runs down the middle of the light slope of the central hill like a slovenly stitched seam. As these dots do not indicate a dark fissure, they can only be read as vegetation, something which their form denies; hence they represent nothing. If Sirén's discussion of this flawed product leaves any doubt as to his final verdict,[62] the appraisal in his *List* dispels it: the picture is regarded as 'a later copy or free imitation'.

A more convincing case for Tung Yüan can be made from three handscrolls of fairly uniform style (Figs. 59–61). One of them, formerly in Chang Ta-ch'ien's collection and now in Peking, is entitled *Hsiao and Hsiang Rivers* (Fig. 59). The second scroll, which bears the title of *Summer Mountains* (Fig. 60), was in the possession of P'ang Yüan-chi and was acquired by the Shanghai Museum. The third, which is kept at the Liao-ning Provincial Museum in Shen-yang, is a copy based on the now missing part of the Peking scroll; its title, however, is entirely different: *Awaiting the Ferry at the Foot of Summer Mountains* (Fig. 61).

FIG. 58 Attributed to Tung Yüan. *River Bank at Dusk*. Ta-feng-t'ang collection.

The design of the Peking fragment, which depicts a river scene with open water in the lower half, a wooded patch, bare hills and a low sky in the upper half, is of great simplicity. The forms are large and few. The same configuration of broad hills with straight bases is repeated in variations, resulting in a profound repose-fulness (Fig. 59). The tone contrasts are clear and definite, like those in *Festival at the River* (Fig. 55). A masterly hand is evident in the firm and lively modelling of the hills with strokes and dots. The dots are not a stylistic device here but an essential element of design. Disciplined and inspired, they strengthen the impression that *Hsiao and Hsiang Rivers* may be an original work. It contrasts sharply with the imposing, tense and tangled designs of the Northern masters. Its expressive qualities seem to typify what Mi Fei had characterized as 'insipid naturalness' and 'a true slice of Kiangnan'. Motifs, design and technique appear to answer the ancient descriptions of Tung's typical style more fully than do the works considered before, although *Festival* fits these descriptions closely. But assuredly the Peking fragment exemplifies the late Tung Yüan; it must have been preceded by many earlier works in varying styles, nearer to T'ang traditions, and *The River Bank* (Fig. 54) might be one of them.

In *Hsiao and Hsiang Rivers* tiny human figures are scattered along the river: fishermen in the left half, and gentlefolk, whose festive garb and formal behaviour suggest a ceremonial encounter, on the shore and in a boat in the right half. The eighteenth-century collector An Ch'i gave the following description of this group in his *Mo-yüan hui-kuan*:

> At the beginning of the picture, two elegant girls in purple dress are standing together. Ahead of them stands a lady in palace attire who turns her head back. There are five musicians entertaining with their performance. A boat is on the river. A man in a scarlet robe sits stiffly upright, while another holds a parasol. An attendant sits behind them. A kneeling person facing them appears to make an announcement. The man at the bow holds a pole, and the man aft handles the oar. Slowly, slowly the boat comes nearer.[63]

According to the interpretation in *Yün-yen kuo-yen-lu* by Chou Mi (1232–1308), we are witnesses to a ceremonial affair, 'the marriage of the Lord of the River'. Ignored in the title chosen by Tung Ch'i-ch'ang (*Hsiao and Hsiang Rivers*) and rejected by Yao Chi-heng, who owned the scroll after Tung Ch'i-ch'ang, this interpretation refers to an ancient custom of the symbolic marriage of a young girl to the god of the Yellow River, as pointed out by Richard Barnhart in *Marriage of the Lord of the River*.[64] A subject as inauspicious as a human sacrifice, however, was none too likely to be depicted by a painter of this enlightened century. Be that as it may, the connection of the *Hsiao and Hsiang Rivers* fragment with the composition of *Awaiting the Ferry* (Figs. 59 and 61), as observed by Barnhart, cannot be questioned, even though their respective dates may be debated. Sirén, for one, took *Hsiao and Hsiang* to be an authentic work, whereas late Northern Sung and even Ming dates were advocated by Barnhart[65] and Chu-tsing Li,[66] respectively. *Awaiting the Ferry* is an inferior imitation and hardly earlier than Ming.

More important, of course, is the question whether *Hsiao and Hsiang* really represents the late style of Tung Yüan. We find the same style again in the scroll in

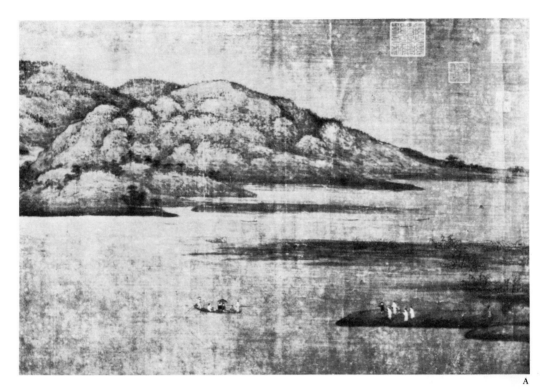

A

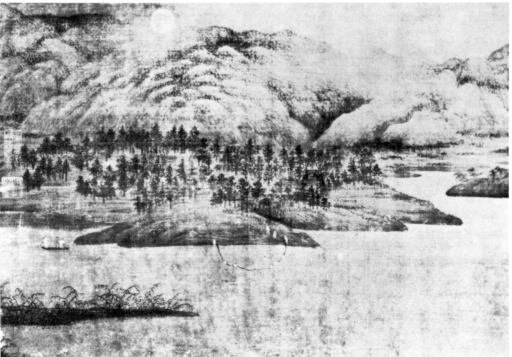

B

FIG. 59A–B Two sections of *Hsiao and Hsiang Rivers*. Peking, Ku Kung Po-wu-yüan. Formerly Chang Ta-ch'ien collection.

Shanghai, *Summer Mountains* (Fig. 60), which exemplifies to perfection the early writers' descriptions of Tung Yüan's vapours and clouds, clearing and thickening mist, deep and sombre plains, and very rough brushwork—with its impressionistic effects.

This scroll, which too is incomplete, opens with a striking passage of mud flats, like so many layers of dark, long drawn-out clouds above trees silhouetted against the water. The flats issue from four ranges of low hills farther left, separated from

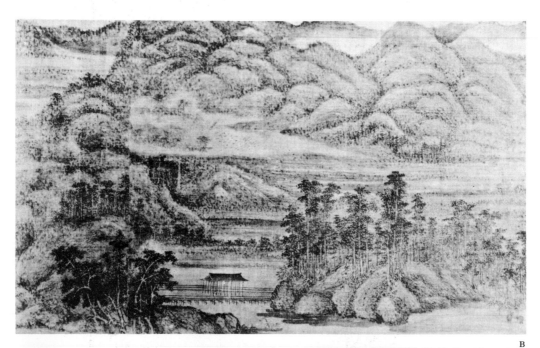

B

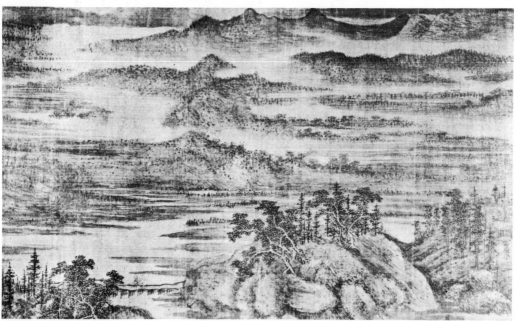

D

each other by mist and water. The second range rises sharply, and soon occupies all of the upper half of the scene, forming a long, undulating ridge with humps and folds almost bare of vegetation. Below it stretches a swamp, while the foreground is occupied by two bluffs overgrown by tall trees and connected by a simply and naïvely drawn bridge. There follows an open, haze-filled depression with rows of indistinctly silhouetted trees, from which the eye travels to the most distant range. Closer to the viewer, beyond a rocky ledge and a stretch of water, are marshy

FIG. 60A–D Four sections of *Summer Mountains*. Shanghai Museum.

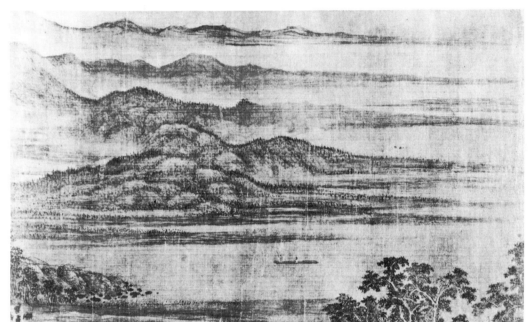

A

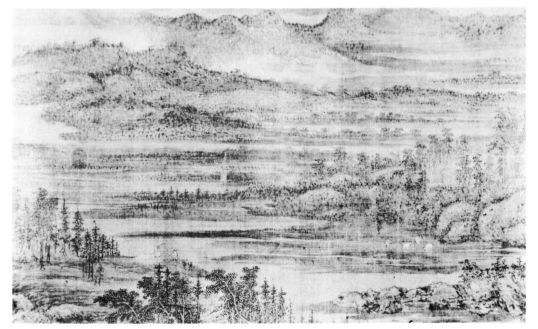

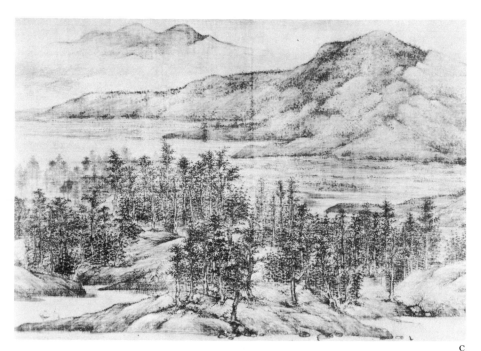

C

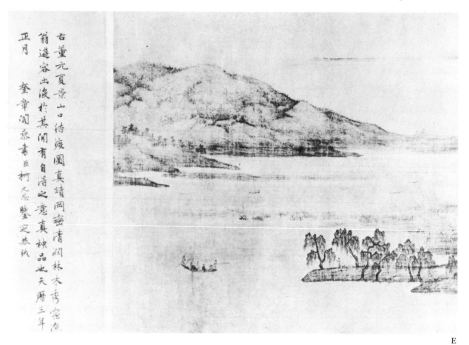

E

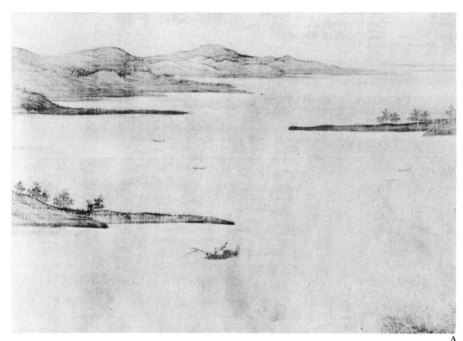

B A

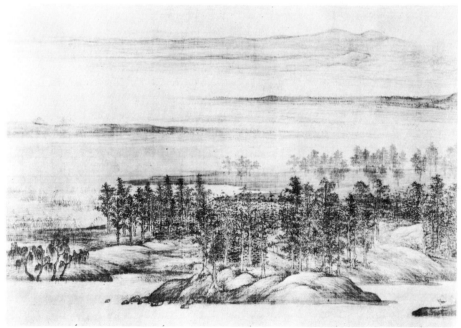

D

FIG. 61A–E Five sections of *Awaiting the Ferry at the Foot of Summer Mountains*. Mukden, Liao-ning Provincial Museum.

flat meadows, where a few buffaloes graze. Farther left, above a close-up copse,
three men carrying what may be oars climb up to a small promontory with a pine
forest. In the last section, the misty marshes stretch further and further, but from
their bottom rise a few hills to interrupt the dizzying horizontals. In the far distance
looms a sharply shaded and outlined range with statelier peaks. Near to the viewer
is a rocky bluff with a variety of trees in a livelier configuration. A long, low bridge
beyond that bluff comes into view briefly, only to disappear again behind the
crisply drawn group of some pines and a leafy tree.

No copyist could hope to capture the lightness, vibrancy and indistinctness of
forms in a design of this kind. It has no predictable elements to hold on to. It is
ultimately patternless, intuited under the brush tip, and in some passages almost
elusive. Yet there is a rhythmic and, so to say, organic coherence in it, something
like a natural order—the 'naturalness' admired by Mi Fei.

If an imitator made the attempt to repeat a design of this kind, he would have to
pick out what is relatively clear, and perhaps exaggerate it; to redefine what is in-
distinct; and to replace by his own inventions all that is wholly blurred. The result
can be imagined: a hardened and lifeless version that distorts the truth. That
distortion might not affect the style as much as the quality of a work. Even a poor
copy may allow us to recognize Tung Yüan's style but convey little of his mental
powers. *Summer Mountains*, if it be a copy, reveals no such weaknesses, and its
attribution to Tung Yüan is supported by the *Hsiao and Hsiang* scroll in Peking,
as well as by the lesser copy in the Liao-ning Museum.

The last work relating to Tung Yüan's oeuvre to be mentioned is an important
and perhaps early copy of a large hanging scroll, a picture called *Wintry Groves and
Layered Banks* (Fig. 62) in the Kurokawa Institute at Nishinomiya. It seems like a
monumentalized version of a typical section of *Summer Mountains*. Painted in ink
only, on a rather rough silk of yellowish grey-brown tone, *Wintry Groves* is an extra-
ordinarily powerful pictorial conception. The lower half shows a wide strip of water,
divided by a sharply shaded islet with a grove of leafless trees and small houses.
Above and below the islet, dark land-spits cut in from the right, contrasting with the
humps of the islet as forms, and with the water by their dark tone. At the farther
shore rise two bleak hills of congruent shapes, falling off steeply to the right and
imparting a sense of movement to the severely static composition. Beyond these
hills there stretches to the upper edge of the picture a marshy plain, flat, sombre and
skyless, and rendered in wavering horizontal lines of lighter and darker tones, with
nothing but a few trees in rows to enliven its empty vastness.

This plain is a bold new image. In its shapeless immensity it greatly contrasts
with the older images of the Big Mountain, conceived in terms of a tall and intricate
piece of sculpture, an object meaningful in itself. Here, where interesting picturesque
forms have vanished, the meaning lies entirely in the relationship of the eventless
area of the plain to the rest of the design. The total pictorial structure, in other
words, has become more important than the structure of individual objects. This
would explain the apparent indifference in Tung's landscapes toward individual,
exact definitions of things. The odd association in the present work of leafless
trees in the foreground with trees in their foliage at the far shore and in the plain is a
case in point. And does not Tung's hallmark, his celebrated hemp-fibre stroke,

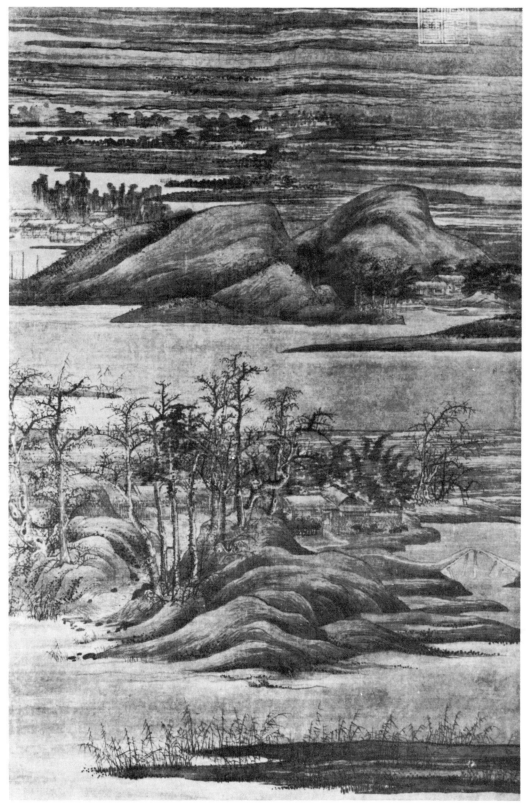

FIG. 62 Attributed to Tung Yüan, *Wintry Groves and Layered Banks*. Nishinomiya, Kurokawa Institute of Ancient Cultures.

illustrate the same principle in as far as its application, regardless of the physical nature of the terrain, amounts to a denial of actual textures?

Though doubtless closely modelled on some work of Tung Yüan, *Wintry Groves* (Fig. 62) exhibits the copyist's predicament, especially in the hard contours of the hills and in the failure to integrate the dabs and dots with contours and modelling. The dots do not build up the forms but are non-essential additions. Lacking the lightness and vigour of *Summer Mountains*, this painting represents a frozen Tung Yüan style, albeit on an impressive level. Two apparently old imperial seals, one in use after 1233 ('*Ch'i-hsi chih pao*'), and the other between 1341 and 1367 ('*Hsüan-wen-ko pao*'), suggest that this copy may go back as far as the twelfth century or so—a period when it was oddly out of tune with the prevailing taste. To disregard these seals as spurious in order to uphold a later date, however, would be arbitrary; to rely on them for an early date would be naïve. Seals are a much abused means of establishing make-believe pedigrees.

Tung Yüan's artistic development may never be adequately known. Still, the works here assembled allow us to theorize about it. If the Shanghai and Peking scrolls (Figs. 59, 60) are genuine works, which we have no reason to doubt, they cannot but be late works, standing farthest from the traditions up to the painter's time. *Festival at the River* (Fig. 55) may have preceded the *River* scrolls (Figs. 59–61). It seems to represent Tung's mature, rather than late, style. Its design, unlikely to be a Sung or Yüan invention, ultimately must have originated with Tung Yüan, even though the extant version may not be Tung's own, or may have been subject to retouching, as assumed by Sirén.[67] Least likely to be recognized as a work of his is the only known signed picture, *The River Bank* (Fig. 54), which happens to be the most convincing as a tenth-century picture. Accepting it would mean to envisage an imposing developmental span in Tung's oeuvre, which of itself is not incompatible with his reputation; for if indeed it were from his hand, it would have to be an early work, based on prototypes long since lost to view. But nothing in this work foreshadows the typical Tung Yüan, and as it cannot be claimed for Tung Yüan on stylistic grounds, its acceptance is a matter of faith in the genuineness of the signature.

For Tung Yüan's style generally, we might expect to find some clues in the oeuvre of his follower, Chü-jan.

Chü-jan, a Buddhist priest from Chiang-ning (Nanking), whose secular name is never mentioned, seems to have led an uneventful life. No anecdotes about him are remembered, and no word of his has come down to us. All we are told is that he received his instruction at the K'ai-yüan Monastery of his native district; that he was a pupil or follower of Tung Yüan; that in 975 or shortly thereafter he followed Li Hou-chu, the deposed lord of Nan-T'ang, to the Sung capital (Pien-liang), where he lived at the K'ai-pao-ssu; and that, having presented himself at court, he gradually gained reputation as a painter. His lifespan is not known. Assuming that he must have been at least thirty or thirty-five when ordered to go to Pien-liang, he may have been born about 940, and lived till about 1000, Giles, in his *Intro-duction*,[68] mentions that Chü-jan 'finally settled down at Loyang', but does not

indicate his source, which apparently was not the *Sheng-ch'ao ming-hua-p'ing*[69] on which our meagre information is based.

The accounts of his artistic achievements are rather colourless and reveal no great excitement on the part of the writers. He appears to have distinguished himself chiefly as a muralist. But his murals did not survive for long. As early as 1067, when Ou-yang Hsiu (1007–72) wrote his *Kuei-t'ien-lu*, nothing was left except a painting in the Jade Hall of the Academy.[70] But from other sources we learn that in the late eleventh and early twelfth centuries many of his scrolls were still in existence.[71] What information about his style may be gleaned from Northern Sung writings appears to be based on the scroll-paintings. It consists of descriptions of subjects and motifs rather than of his formal qualities, which are not clearly distinguished from Tung Yüan's.

Taken as a whole, Chü-jan's oeuvre—in contrast to that of his master—is surprisingly uniform. It is for this reason that we may expect it to guide us in matters of Tung Yüan's late style, which seems to agree in some aspects with the younger man's oeuvre. The agreement was such that in the perspective of later centuries their styles became as one: the Tung–Chü tradition.

The painting that best exemplifies what is widely taken to be the typical Chü-jan is *Seeking the Tao in the Autumn Mountains* in the Palace Museum, Taipei (Fig. 63). A massive mountain constructed of steep, convex, evenly creviced, smooth slopes rises in the centre. Groves of tortuously grown pines are scattered about its humps and recesses. The slopes are textured with nearly parallel curved strokes conforming to the contours, which are accentuated and to a degree enlivened by sparsely applied dots. Sky and water are set off from the brownish tints of the mountain by a light blue wash. In one of the huts clustered in the valley we detect the tiny figures of two men conversing: the seekers of Truth, to whose presence the title refers. The forms of the hills and trees are obviously derived from Tung Yüan. Their arrangement in deliberately repeated and uniform shapes, however, has a surprisingly conventionalized, nay almost abstract quality. This abstractness sets the picture apart from both Chü-jan's contemporaries and some of his works in a different style (Figs. 64, 65). If for that reason a later date were considered, it would be contradicted by the evidence of a seal purporting to be that of Ts'ai Ching (1046–1126), the 'Chief of the Six Traitors' in Hui Tsung's reign. If this seal is accepted as genuine, as in Fu Shen's recent *Preliminary Study*,[72] the painting cannot be later than the eleventh century. According to Fu Shen's appraisal, the painting, while not necessarily from Chü-jan's hand, may be close in time and style. When compared with a work such as *Festival at the River* (Fig. 55) attributed to Tung Yüan, a lack of visual knowledge and imagination becomes clearly apparent, especially in the terrain forms. What is impeccably structured there, for example the creviced slopes topped by scalloped plateaus, is here formularized, patterned, and flattened. As a result, *Seeking the Tao* has an archaic flavour quite its own, not to the detriment of its gentle lyricism.

A different Chü-jan appears in a scroll that depicts a monastery in a remote valley, the setting of the T'ang Dynasty story of *Hsiao I Seizing the Lan-t'ing [Manuscript]* (Fig. 64). This work, also in the Palace Museum, has a far more individual character than the preceding one. The form of the mountains in particular, soaring

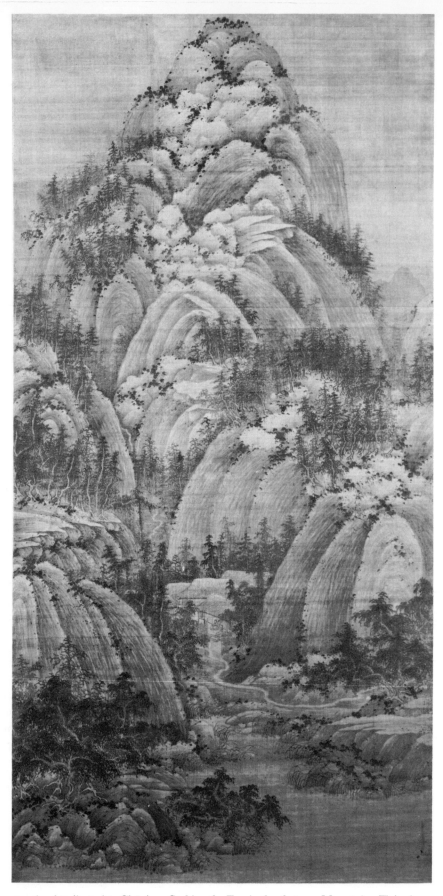

FIG. 63 Attributed to Chü-jan, *Seeking the Tao in the Autumn Mountains*. Taipei, National Palace Museum.

pinnacles with slightly concave flanks and angular tops, is wholly *sui generis*. Diversified in shape and energetically articulated, these mountains contrast greatly with the uniformity seen in *Seeking the Tao*. The forests are more organically adapted to the terrain formations than in the latter work, and the tree trunks on the whole are straight or at any rate less obtrusively crooked. The smooth, sloping banks in the foreground are drawn like those in Tung Yüan's river scrolls; but the long, weaving hemp-fibre strokes (*p'i-ma-ts'un*) are replaced by shorter and straighter strokes. The contours of these slopes and of the big mountains are broad and softly rubbed or scumbled. Even the small lumps, called alum heads (*fan-t'ou*) by the Chinese—a feature never missing in a Chü-jan—are treated quite distinctly in the two paintings. The only characteristic motif wanting here are the wind-blown reeds along the banks of the stream, which in *Seeking the Tao* are very delicately executed; their absence may account for the undeniable baldness of the foreground. In sum, it seems inconceivable that the same hand was responsible for the two works assigned to Chü-jan. Nor can we be at all certain that either hand was his. But *Seeking the Tao* (Fig. 63) is a strangely impersonal and mannered work when measured by the refreshingly personal qualities of *Hsiao I Seizing the Lan-t'ing* (Fig. 64).

The diminutive figure on horseback dashing across the bridge on the way to the monastery far back in the valley represents Hsiao I, a greatgrandson of the Liang Emperor, Yüan Ti, and Investigating Censor during the reign of T'ang T'ai Tsung (627–49). He comes as an emissary of the emperor, in search of Wang Hsi-chih's calligraphic masterpiece, the *Lan-t'ing Preface* (see Chapter 2, page 15, above), rumoured to be in the possession of the Buddhist abbot, Pien-ts'ai. Posing as a collector of ancient calligraphies, Hsiao I is received by the abbot. As the visitor boasts of his mediocre possessions, the abbot cannot restrain himself and displays the *Lan-t'ing*. To his dismay the visitor now discloses his identity and departs with the treasure.

Precisely the same style as that of *Hsiao I*, if not necessarily the same hand, is encountered once more in the Palace Museum's *Mountains and Woods* (Fig. 65). Attributed to Chü-jan by Tung Ch'i-ch'ang, this work relieves *Hsiao I* of its otherwise disquieting isolation. The scenery is less complex here, but animated by a luminous haze that blurs the more distant forest and all but blots out the farthest range. Instead of the imposing pinnacles in the other work there are here two moderately tall, treeless cliffs, whose jagged silhouettes and concave flanks are echoing each other. A curious anomaly is the extremely pale ink used for trees and terrain in the foreground, which possibly was left in an unfinished state. The way this landscape differs from both *Seeking the Tao* and *Hsiao I* is—in addition to its airiness—the wide space given to the sky. It is a feature we noticed before in the Li Ch'eng of the Boston Museum (Fig. 51), where the vast expanse of the sky only intensified the feeling of immensity, while in the Chü-jan the sky becomes part of a serene and accessible world.

The likely age of these two closely related works, *Hsiao I* and *Mountains and Woods*, is Northern and Southern Sung, respectively, in Fu Shen's opinion, which is based on a careful evaluation of the seals, the silk, and the physical condition of the two; he would not however deny the possibility of a Northern Sung date in the case of *Mountains and Woods*, too, though it would be later than *Hsiao I*. More

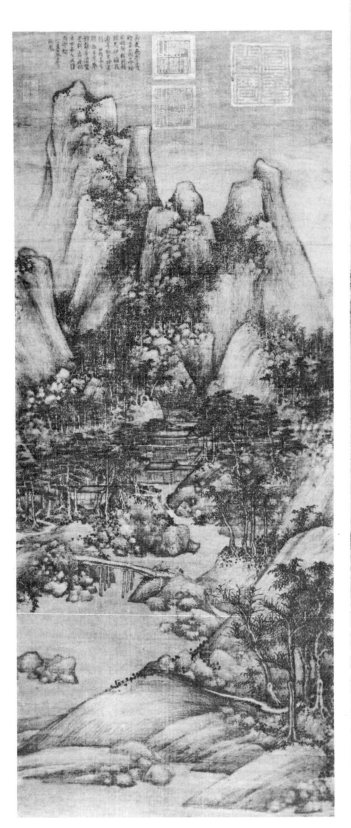

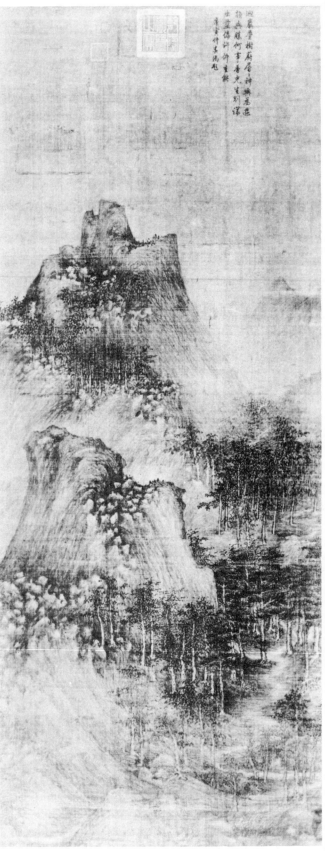

FIG. 64 Attributed to Chü-jan, *Hsiao I Seizing the Lan-t'ing*. Taipei, National Palace Museum.

FIG. 65 Attributed to Chü-jan. *Mountains and Woods*. Taipei, National Palace Museum.

important, of course, is the question of whether their style originated with Chü-jan. More cautious than Chang Ch'ou and Tung Ch'i-ch'ang, who were responsible for the specific attributions, Fu Shen accepts the works as being in the Chü-jan tradition.

Notes

1. Translated in Sirén, *The Chinese on the Art of Painting*; Sakanishi, *The Spirit of the Brush*, ch. 9; and Munakata, *Ching Hao's Pi-fa-chi*.
2. Delacroix quoted in E. Gilson, *Painting and Reality*, 1957; *Konrad Fiedler's Schriften über Kunst*, ed. Hermann Konnerth, vol. 2, Munich 1914, Aphorisms, no. 147.
3. Sullivan, *Introduction*, 1961, p. 142.
4. *Hsüan-ho hua-p'u*, ch. 10.
5. Vol. 2, no. 6 and vol. 3, no. 1 (1968).
6. Vandier-Nicolas, paras, 51, 52.
7. *T'u-hua chien-wen-chih*, chs. 1 and 2.
8. Vandier-Nicolas, *Le 'Houa-che'*, p. 37.
9. Sickman and Soper, p. 105.
10. First edition, pp. 99–101.
11. Ch. 2.
12. Soper, *Experiences*, p. 172, n. 498.
13. *T'u-hua chien-wen-chih*, ch. 4.
14. *Hsüan-ho hua-p'u*, ch. 11; cf. Giles, *Pictorial Art*, p. 97.
15. Ch. 11; Giles, *ibidem*, reverses the meaning of the first sentence.
16. *Tung-t'ien ch'ing-lu-chi*.
17. *CP*, I, p. 206; *Experiences*, p. 172, n. 498; Maeda, *Two Twelfth Century Texts*, p. 39.
18. *CP*, I, p. 203; Vandier-Nicolas, *Le 'Houa-che'*, p. 116.
19. Ch. 5.
20. *CP*, I, p. 204.
21. Li Lin-ts'an, 'Fan K'uan, *Ch'i-shan hsing-lü t'u*'.
22. Sickman and Soper, p. 109.
23. Ch. 11; Giles, *Pictorial Art*, p. 97.
24. Ch. 431.
25. Ch. 3, end.
26. *Sung-shih*, ch. 439.
27. Ch. 51:8.
28. Cf. *Hsüan-ho hua-p'u*, Ch. 11.
29. Ch. 2.
30. Vol. I, p. 197.
31. *T'u-hua chien-wen-chih*, ch. 3.
32. Ch. 3, section on 'the application of ink'.
33. Ch. 3.
34. Ch. 11.
35. See *Shan-hu-wang hua-lu*, ch. 19: 1b.
36. *Ni-ku-lu*, ch. 4:2.
37. Ch. 51:8.
38. *T'u-hui pao-chien*, ch. 3.
39. Chu and Li, *T'ang Sung hua-chia*, p. 99.3.
40. Soper, *Experiences*, p. 19.
41. Ch. 11.

42. *CP*, I, 199; Munsterberg, *Landscape Painting*, p. 35.
43. *Shi Ō Go Un*, pls. 11, 12.
44. M. Tchang and P. de Prunélé, *Le Père Simon A. Cunha, S.J.*, no. 30.
45. *Three Hundred Masterpieces*, vol. 6, pl. 272.
46. *Ch'ing-ho shu-hua-fang*, ch. 6.
47. Ch. 11.
48. *Teste* Yao Ta-jung, quoted in Ch'en Jen-tao (1956).
49. *T'u-hua chien-wen-chih*, ch. 3; Soper, *Experiences*, p. 46.
50. *Hsüan-ho hua-p'u*, ch. 11.
51. Ch. 17; ed. Hu Tao-ching, vol. 1, p. 565.
52. Chu and Li, *T'ang Sung hua-chia*, p. 289.1–2.
53. Vandier-Nicolas, *Le 'Houa-che'*, p. 36.
54. Li Chu-tsing, *The Autumn Colors*, ch. 7.
55. *T'ang Wu-tai Sung Yüan ming-chi*, pl. 2.
56. *Yen-k'o t'i-pa, shang*, 16b.
56a. Yang Lien-sheng, 'An Explanation of the Term "Lung Su Chiao Min"', Bulletin, Institute of History and Philology, extra vol. 4, Taipei (1960), pp. 53–6.
57. *CP*, VI, pl. 57.
58. Barnhart, *Marriage*, p. 40.
59. Ch'en Jen-t'ao, *Three Patriarchs*, pl. 1.
60. See *Three Hundred Masterpieces*, vol. 1, colour plate 43.
61. Vol. 1, 3.
62. *CP*, I, p. 211.
63. *Mo-yüan hui-kuan*, ch. 3.
64. Barnhart, *Marriage*, pp. 11 ff.
65. Ibidem, p. 38, agreeing with K. Suzuki and S. Shimada.
66. Li Chu-tsing, *The Autumn Colors*, p. 63.
67. *CP*, I, p. 210.
68. *Pictorial Art*, p. 150.
69. Ch. 2.
70. *Ou-yang Hsiu ch'üan-chi*, vol. 2, p. 1024.
71. Kuo Jo-hsü; Mi Fei; *Hsüan-ho hua-p'u*, ch. 12, listing no fewer than 136 scrolls.
72. Fu Shen, 'A Preliminary Study to the Extant Works of Chü-jan', nos. 6 and 7 in the Chinese text, nos. 8 and 6 in the English summary.

Landscape painters of Northern Sung
(960–1126)

Yen Wen-kuei (967–1044) from Wu-hsing in Chekiang came to the Sung capital during T'ai Tsung's reign (976–97). At that time Chü-jan was active there and Fan K'uan's presence may already have been felt. These were names hardly to be matched by that of the obscure Hao Hui from Shansi whom Yen acknowledged as his first master. Nevertheless, as early as 989 the young painter was advanced enough to submit to the Court a picture on the subject of 'A Market Scene on the Seventh Night';[1] and under the third Sung emperor, Chen Tsung (reigned 998–1022), he was appointed to the Academy as painter-in-waiting (*chih-hou*). He had been recommended by Kao I, a Khitan refugee and himself a member of the Academy, who had recognized Yen's abilities.

For the first time it happens that from among the extant attributions there emerges a small body of works so consistent in style that it would seem arbitrary to question their validity. One of these works is a short handscroll from the Abe collection in the Osaka Municipal Museum (Fig. 66); another, a vertical scroll painted on silk, depicting a majestic mountain by a river, is in the Palace Museum (Fig. 67); a third, again in a handscroll, reproduced in Hsieh Chih-liu's *T'ang Wu-tai Sung Yüan ming-chi*,[2] is a variation on the theme of the Osaka scroll.

The Osaka work, entitled *Temples in the Mountains by a River*, is painted in ink and very light, faded colours on paper that has become dark grey with age. The beginning of the composition is reminiscent of Tung Yüan's river scrolls with their open vistas of water and mud-flats. But the section that follows shows a turbulent array of precipitous tors—a far cry from Tung Yüan's peaceful and unexciting ranges of low hills (as in Fig. 60). The silhouette of the distant massif at the left side compares instead with Chü-jan (as in Figs. 64, 65), as does the design of some of the

FIG. 66 Yen Wen-kuei, *Temples in the Mountains by a River*. Osaka, Osaka Municipal Museum, Abe collection.

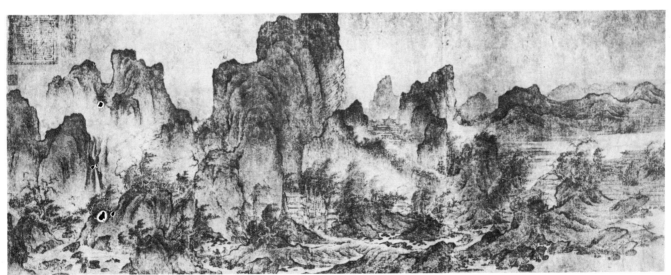

tree roots, which resemble the odd and stilted shapes seen in *Seeking the Tao* (Fig. 63). Yen doubtless was familiar with some of Chü-jan's works. Yet the characterization of the mountains as sheer rock links him firmly to the tradition of Ching Hao and his successors up to Fan K'uan, who was contemporary with, and presumably had a profound influence on, Yen Wen-kuei. The vertical streaking of his rock surfaces in the Palace Museum picture, *Temples among Streams and Mountains* (Fig. 67), seems directly related to Fan K'uan's raindrop *ts'un*. In the Osaka scroll this feature is less pronounced, and it is further obscured by retouches in the form of slanting sharp flicks on the flank of the tallest peak.

In their effect, however, the two landscapes are distinct from the Fan K'uan we know by his *Travellers* (Fig. 48). His awesome precision, the grand simplicity of his design, and his mysterious directness are beyond the reach of Yen Wen-kuei's art. Yen dramatizes; he loves profusion and turbulent movement; his forms are not free of conceits. His contrasts of light and dark, of shaded peaks set against luminous mists, have a flickering suddenness. The trees in the Osaka scroll are swept by fierce gusts of wind. Scattered in clumps all across, they compete with the terrain forms in diversity and jerkiness of rhythm. The dead branches that hover above the clumps are an 'invention' of Kuan T'ung which now seems a bit old-fashioned. But this does not detract from the fact that, on the whole, the trees are free of traditional foliage patterns and are treated in a rather spontaneous and impressionistic manner. The dynamic character of all this is enhanced, finally, by the heavy, sudden accents in the outlines of the hillocks and boulders, mountains and cliffs. These accents are scarcely necessary for objective definition; they are graphic in nature, frills, conceits.

If the reading of the large seal at the end of the Osaka scroll as stated in a colophon of 1910 is correct, the seal was that of one Chao Tzu-hua (1089–1141), providing a credible *terminus ante quem*. Moreover, the scroll is signed at the end. The fact that the Palace Museum scroll, too, bears a signature was overlooked in *Shih-ch'ü pao-chi* (*Hsü-pien, Ning-shou-kung*) as well as *Ku Kung shu-hua-lu*,[3] although it is mentioned in An Ch'i's *Mo-yüan hui-kuan* of 1743 and the recent *Three Hundred Masterpieces*.[4] In addition, there is the early Ming half-seal of the years 1374–84, securing a pre-Ming date.

In the triad representing the first decades of Sung three temperaments are clearly distinguishable: the placid and somewhat formalistic Chü-jan; the monumental, rational and classic Fan K'uan; and the dynamic and impetuous Yen Wen-Kuei. The masters who followed, Hsü Tao-ning and Kuo Hsi, turned to the older Li Ch'eng for inspiration, although Yen Wen-kuei may have remained influential in the case of Hsü Tao-ning to some extent.

Hsü Tao-ning, who was born in Ho-chien, Hopei, received his first instruction from Ch'ü Ting. Ch'ü Ting, according to Su Tung-p'o,[5] was an Academy painter in the reign of Jen Tsung (1023–63), and had modelled himself on Yen Wen-kuei. Hsü, who went to live at Ch'ang-an, apparently never joined the Academy. His attachment to the Li Ch'eng tradition is a fact recorded in all the relevant sources. What is more, they pay him the tribute of acknowledging that in the end he found his own style. Kuo Jo-hsü says: 'Early [in his career] he set great store by a meticulous

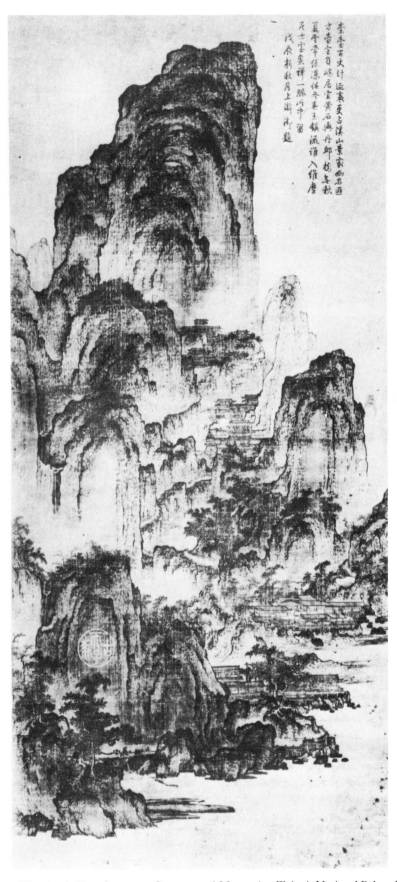

FIG. 67 Yen Wen-kuei, *Temples among Streams and Mountains*. Taipei, National Palace Museum.

B

D

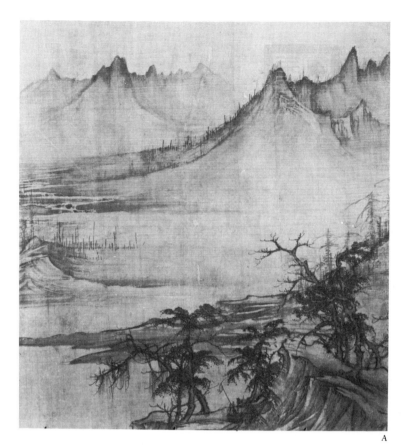

A

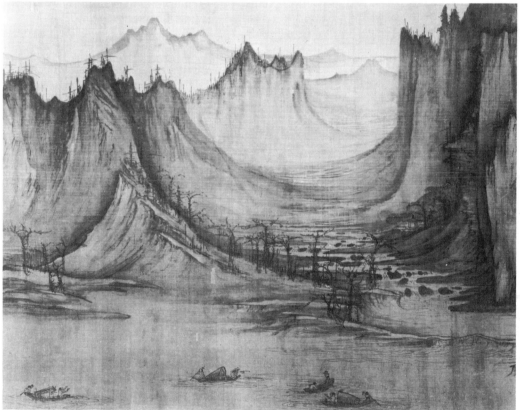

C

FIG. 68A–D Hsü Tao-ning, *Fishing in a Mountain Stream*. Kansas City, Nelson Gallery and Atkins Museum.

precision; but as an old man he cared only for simplicity and swiftness of drawing. With peaks that were abrupt and sheer, and forest trees that were strong and un-yielding, he created a special school and form of his own.'[6] Neither this poetic description nor the attributed works give us a clear concept of Hsü Tao-ning's style. In contrast to that of Yen Wen-kuei, there is no consistency in his attributed oeuvre. Each work stands alone. A handscroll in the Nelson Gallery, *Fishing in a Mountain Stream* (Fig. 68), however, is widely regarded as a possibly authentic work of the master. It answers the description of his late style and may be of the period. What it depicts is not the big mountains as such, their awesome presence or their almost oppressive literalness, but the grand rhythm that pervades the layered ranges and deep valleys—'range behind range of bleak and shattered peaks, soaring above marshy valleys where the wintry fog hangs low', in Sickman's description.[7] The composition is organized like a mighty polyphonic chorale. Physical pro-perties of things count for little. What matters is the contrasts of solids and space, of movement and arrest, of light and dark. The trees are rendered in a sketchy manner. Those close to the viewer are full of vigorous movement, whereas the ones in the distance are reduced to vertical strokes, or mere symptoms of a vegetation. Still smaller in scale are the human figures, fishermen and travellers.

The Nelson scroll stands about midway between the Yen Wen-kuei (Fig. 66) and the Kuo Hsi scroll in Toledo, Ohio (Fig. 75). In its rhythmic sweep it has dis-engaged itself from the heavy literalness of the former, while compared with the pure musicality of the latter it still seems descriptive and earth-bound.

A painting of surpassing quality and imposing size in the Palace Museum, *The Crooked Trees* (Fig. 69), is another work attributed to Hsü Tao-ning. Its design and physical appearance suggest a date as early as Northern Sung. But this painting is without pedigree and the only seal it bears is that of the last Ch'ing emperor Hsüan-t'ung (1908–11). It is a work of which any Sung painter would have been proud—except, perhaps, Mi Fei. It shows a group of five leafless, old, tortuously grown trees of exceedingly complex shapes and astonishing formal perfection. There is an air of mystery and sadness about these trees, deepened rather than lessened by the elegance of form given to their hoary shapes. Possibly the most eminent of all tree pictures in existence, its expressiveness seems to depend on the combined effect of a compassionate feeling and the excitement of visual discoveries. It is a work of such power and subtleness that it cannot but enlarge the viewer's inner world. A comparably intense feeling for the subject of the tree was noted before in the case of the T'ang painter, Wei Yen (chapter 4, page 79), who is known to us only through literary records. A yardstick by which to measure the degree of sophistication encountered in *The Crooked Trees* is supplied by the much older picture of a shattered plum-tree in the Metropolitan Museum, *Landscape with a Broken Tree* (Fig. 70). Although the signature, 'brush of Yang Sheng', referring to an eighth-century master, must be discounted, the painting itself may well go back as far as late T'ang. Its symbolism is obvious; its form, touchingly direct. The absence of 'brushwork' and the seemingly very ancient manner of colouring[8] are features that make the relative modernness of the 'Hsü Tao-ning' quite apparent—without providing any justification of the attribution. If *The Crooked Trees* were in fact from the hand of Hsü Tao-ning, it would have to be an earlier work than *Fishing*

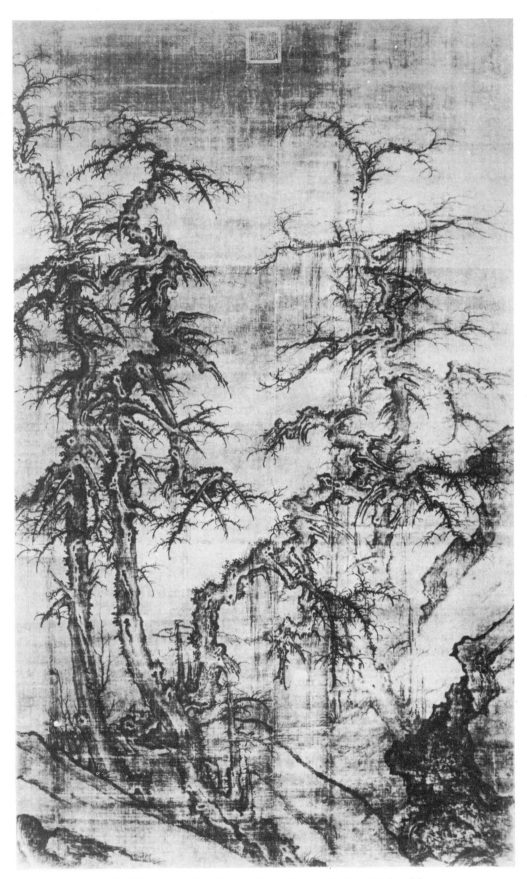

FIG. 69 Hsü Tao-ning, *The Crooked Trees*. Taipei, National Palace Museum.

in a Mountain Stream, for it shows neither 'simplicity' nor 'swiftness', characteristic of his late works, but elaborate, almost mannered, refinement. The gap between these works seems too wide to sustain their attribution to the same master.

The case of Hsü Tao-ning becomes even more puzzling when we look at two other paintings that carry his signature and, moreover, appear to be acceptable as eleventh-century works. Both are in the Palace Museum. *Fishing on a Snowy River* (Fig. 71), in ink and nearly without colour on a brown, glossy, old silk with many defects, is a painting of marvellous qualities. In design and technique it is evidently linked to the tradition of Ching Hao–Fan K'uan–Yen Wen-kuei. But its spatial vastness, the mist enfolding the solids, the fluency of the texture of the rocks, and a novel use of broad, modulated and not merely descriptive contours of the cliffs, boulders and banks are features that go beyond the concepts of those masters. So does the treatment of the trees: tall, sparse, leafless trees of a mildly pathetic character at the bottom; a forest of firs, drawn crisply in horizontal and vertical strokes, on the promontory in the centre; and, as a third variety, the witty ciphers of geometricized scrub in endless variations on the tallest peaks. The particular characteristics of this work are evident without further description: a much advanced vision of the spatial continuum, and a certain detachment from the definition of matter in favour of an expressive interpretation of the whole. The picture is signed and dated, 'Ching-yu (1034–37) *chia-shen* (1044), first [month of] winter, tenth moon, Tao-ning *fecit* . . .' Flawed by an inexplicable discrepancy of the years of era and cycle, the date does not make sense and has to be disregarded— along with the signature, which under the circumstances is irreparably discredited. While the painting may well date from about the middle of the eleventh century, the question of its authorship must be left entirely open. The other work in the Palace Museum, *Dense Snow on the Mountain Pass* (Fig. 72),[9] is designated as a study after Li Ch'eng in an inscription that may well be from Hsü Tao-ning's own hand. Imperial seals of the eras of Cheng-ho (1111–17) and Ming-ch'ang (Chin Dynasty, 1190–95) provide an apparently reliable pedigree. This painting is not wholly in tune with the period, but it has a late T'ang flavour that accords with its declared dependence on Li Ch'eng. (It will be recalled that in the judgement of eleventh-century would-be connoisseurs the styles of Li Ch'eng and Wang Wei had all but merged.) Certain features—the types of the trees, the shapes of the boulders, and the dynamic, grandly soaring cliffs whose height contrasts with the vast depth of the valley as defined by an endless succession of dark, layered banks— differ greatly from the corresponding solutions of the preceding three works. Sirén, in fact, found that the composition in principle was comparable to that of the Li Ch'eng in Boston (Fig. 51). Consequently, *Dense Snow on the Mountain Pass*, even though it may be an authentic work of Hsü Tao-ning, is unlikely to offer a clue to his typical style. For the latter we still depend on the doubtless late, masterly creation of *Fishing in a Mountain Stream* (Fig. 68), whose likely historical position admits of the attribution to Hsü—it is after Yen Wen-kuei but before Kuo Hsi.

Kuo Hsi (*c.*1020–90) from the District of Wen in Northern Honan was, according to the (contemporaneous) *T'u-hua chien-wen-chih*,[10] the supreme figure among the landscape painters of the time. In contrast to Hsü Tao-ning, he was a member of the

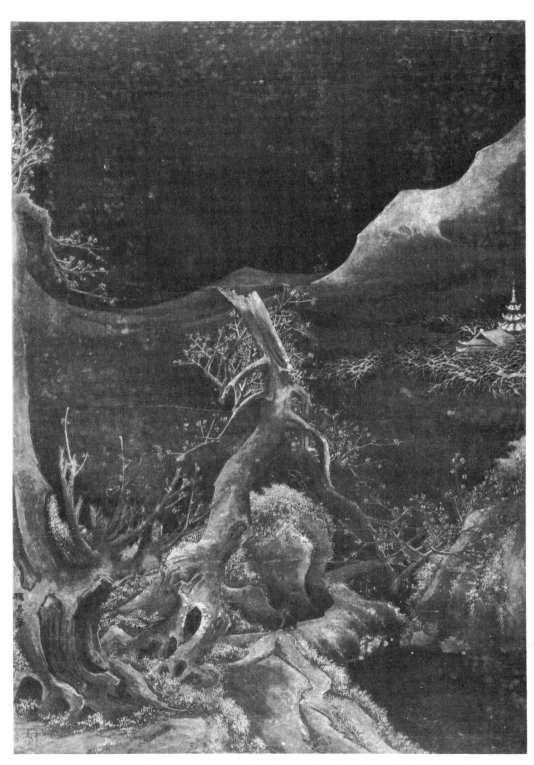

FIG. 70 Anonymous, late T'ang? *Landscape with a Broken Tree*. New York, The Metropolitan Museum of Art.

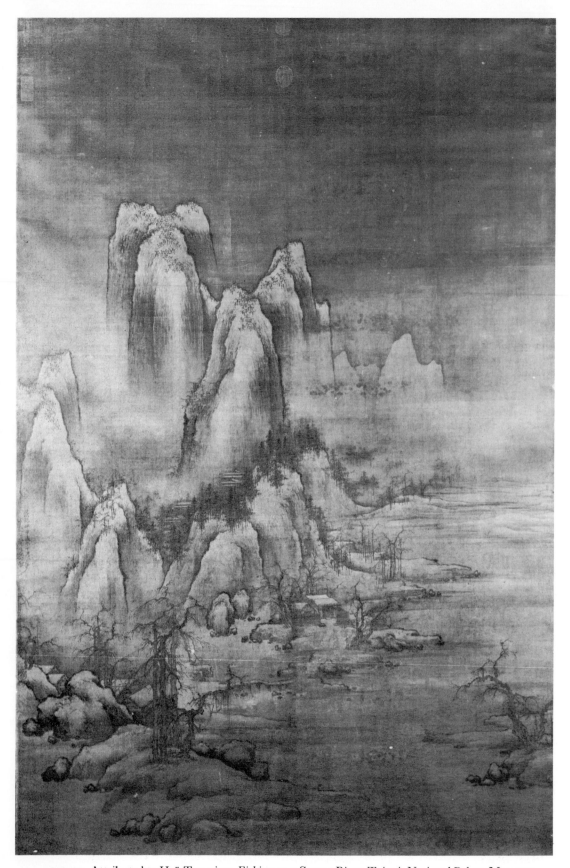

FIG. 71 Attributed to Hsü Tao-ning, *Fishing on a Snowy River*. Taipei, National Palace Museum.

Imperial Academy, and his tenure of office spanned part of the reign of Jen Tsung (1023–63) and the reigns of Ying Tsung (1064–7) and Shen Tsung (1068–85). That he was still active by 1085 can be inferred from a colophon written by Huang T'ing-chien (1050–1110) in the year 1100. Recorded in Huang's *Shan-ku t'i-pa*,[11] the colophon said that toward the end of the Yüan-feng era (1078–85) Kuo Hsi had painted twelve screen panels for a priest of the Hsien-sheng-ssu, one of the leading Buddhist monasteries in the capital. Three years earlier, in 1082, Kuo Hsi's son, Kuo Ssu, who collected and edited his father's pronouncements on landscape painting under the title of *Lin ch'üan kao chih*, 'Lofty Messages of Forests and Springs', had received his doctoral degree. While Ssu sat for the examinations, Kuo Hsi painted what he himself regarded as his ultimate achievement: four murals of landscapes and eroded rocks, commissioned for the Confucian temple of his native Wen-hsien.[12] The murals are lost, as are the panels of 1085 and most of the rest of Kuo's oeuvre. Still extant, however, are a few works that are convincing.

The signed and dated *Early Spring* of 1072 in the Palace Museum (Fig. 73), which is generally accepted as an original work, should, in view of its chronological position, be regarded as an example of Kuo's mature, rather than late, style. In addition it is the foremost single chronological landmark for the history of landscape painting down to the late eleventh century. *Early Spring* is the last of the heroic mountain images that we encountered in groping formulations of the ninth century (Figs. 42, 43) and in the awesome perfection of Fan K'uan's *Travellers* soon after the year 1000 (Fig. 48). In Kuo Hsi's solution, movement is stressed—at the expense of substantiality and precise definitions. The solids are eroded by the fitfully intruding element of the atmosphere, resulting—without loss of expressiveness—in spatial ambiguities. The rock shapes are rounded and never angular, slanting rather than vertical. Their outlines are so broad that their descriptiveness is compromised. The ink is rich, deep, and fluid, concentrated in flickering darks. Washes take the place of the elaborate *ts'un* textures: a change of technique that gives the impression of rapid execution, even sketchiness. Actually this painting is carefully, almost meticulously executed, and it is the combination of washes with a design of variable distinctness that would appear to account for its less finished look. Some parts seem out of focus, blurred, or blotted out. In the earlier works every part is in focus, and every part shares the same, diffuse light with the rest; nothing indicates the possibility of change; the world appears to be static and timeless. In the Kuo Hsi there is restlessness. The heaving masses of rock and cliffs are broken up by atmospheric blurs, by the erratic shifts of focus, and by unpredictably placed contrasts of light and dark. Emphasizing here, suppressing there, the painter in depicting his scenery apparently cares less for the semblance of completeness than for a new, dynamic, interpretation such as, say, 'nature's awakening from winter-sleep'.

Works likely to approximate Kuo Hsi's early and late styles, respectively, are two handscrolls: *Clearing Autumn Skies over Mountains and Valleys* in the Freer Gallery (Fig. 74) and *River and Mountains after a Snowfall* in the Toledo Museum of Art (Fig. 75).

The Freer scroll, which according to a colophon of 1579 by Wen Chia (1501–83) had carried a label from the hand of Ni Tsan (1301–74) naming Kuo Hsi as the author, was generally accepted as an authentic work of the Northern Sung master.

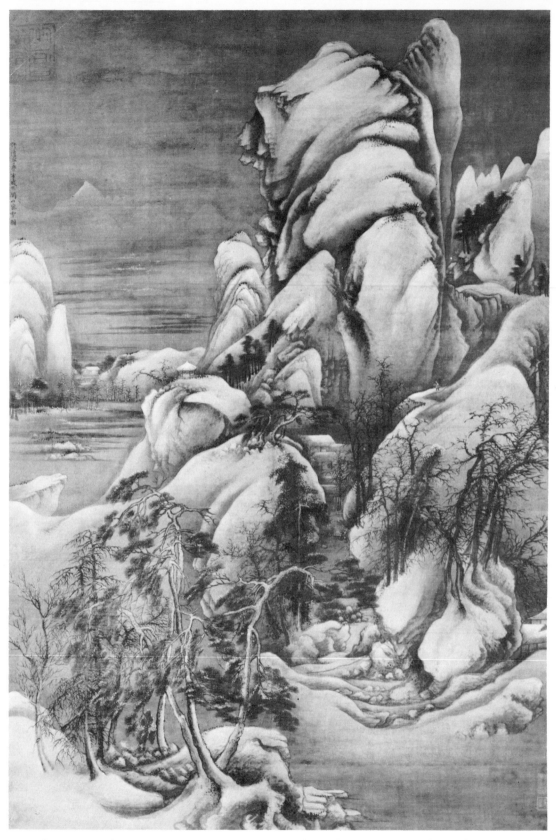

FIG. 72 Attributed to Hsü Tao-ning, *Dense Snow on the Mountain Pass*. Taipei, National Palace Museum.

The only voice of dissent is that of Hsieh Chih-liu, who favours a reattribution to Wang Shen.[13] But the oeuvre of Wang Shen, who was somewhat younger than Kuo Hsi, is rather obscure and discouragingly heterogeneous. Should he in fact have painted the Freer scroll, it would only prove his close dependence on Kuo Hsi in this particular case. Stylistically *Clearing Autumn Skies* belongs with Kuo Hsi. A similar claim can no doubt also be made for the Toledo scroll. Again unsigned, and moreover unsupported by colophons, the scroll bears a short inscription telling that it is recorded as a work of Kuo Hsi in a catalogue compiled by Miao Yüeh-tsao, the *Yü-i-lu* (whose preface is dated 1733). Though inconclusive as to Kuo's authorship, the entry gives evidence that the scroll existed in the early eighteenth century and that its appearance was such as to allow, or at least not to deny, a Sung date.

Clearing Autumn Skies agrees closely with *Early Spring* (Fig. 73) as regards technique and type forms, while lacking its forceful dynamic. In the topographic layout and the sequence of deep, open vistas and compact solids, on the other hand, *Clearing* is certainly also reminiscent of the Hsü Tao-ning in Kansas City, although wanting its linear energy (Fig. 68). The formidable configurations of perpendicular cliffs in layered ranges in the Hsü Tao-ning are replaced by less forbidding formations, rounded, softer, and more corporeal. Very different from the Hsü Tao-ning is the treatment of the trees seen close-up along the lower edge of the scroll. Nothing in the Hsü Tao-ning or in the Kuo Hsi of 1072 quite equals the technical perfection and charm of these trees, which involve the viewer more intimately than do the uniformly distant trees of the Hsü Tao-ning.

Kuo Hsi's late style is a matter of conjecture. His latest dated picture now known, *A Plain with Eroded Rocks* of 1078, admirably reproduced in *Wen-wu ching-hua*,[14] indicates a tendency toward terse statement, a sparing and precise definition of forms, and a pervasive, wondrously musical rhythm that binds each detail to the whole. The horizon is low. Distant hills emerge dimly from a haze that serves as a foil to the dominating motif of two tall trees forming a graceful silhouette. Around these trees the rocks lie in a radial order. There is a touch of abstractness about this marvellously polished design. To say, however, that its style brings us closer to the Toledo scroll (Fig. 75) would be an exaggeration. Here taken to 'approximate' Kuo Hsi's late style, the Toledo scroll goes much further toward abstractness. Its bleak, sombre and austere scenery is done in a less ingratiating, harsher, almost impetuous manner. The mountains in the distance are reduced to occasional crests in the endlessly stretching horizon. Differentiating textures are avoided. The terrain in the foreground, islets, mountains and rocks all seem to consist of the same undefined homogeneous matter, taking shape momentarily, spontaneously—nowhere so striking as in the brilliant finale: a phantasmagoria of bubbling, rock-like formations. The trees, too, are without individuality and of little interest in themselves. In the main they function either as vertical accents or as dark values. Like the other elements they are subject to a grand design which is organized like a sequence of *tempi* or movements in a sonata: *largo, poco animato, vivace*, to venture specific equations. In this manner the dimension of time, essential in a handscroll composition, is realized in a quasi-musical graphic form.

The painter's interest thus lay in the rhythmic flow of his design, the sequence of contrasting movements, or passages of variform structure (open, flat and monoto-

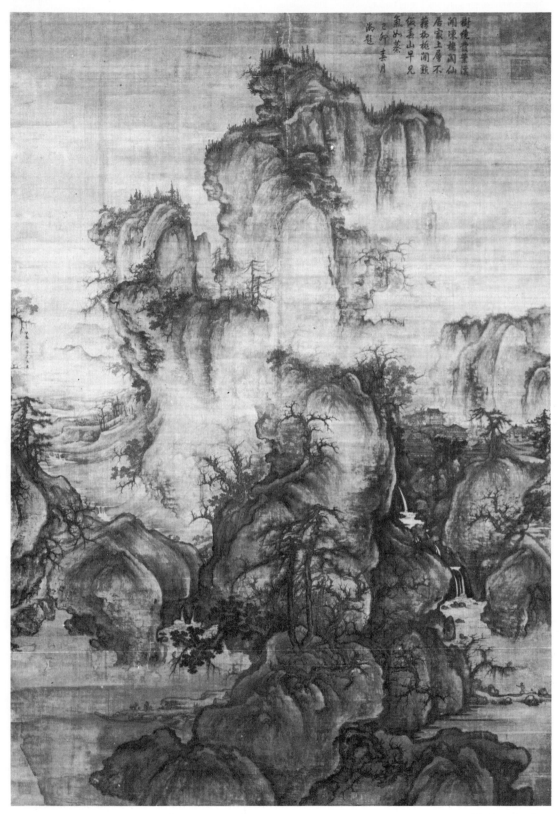

FIG. 73 Kuo Hsi, *Early Spring*. Signed and dated in accordance with 1072. Taipei, National Palace Museum.

nous, or densely packed with upright shapes). The single object has lost its importance. It is reduced to the role of a mere symptom and exists only for the sake of the larger context. A landscape scroll such as *River and Mountains after a Snowfall* (Fig. 75), therefore, reveals a broad and detached vision that presupposes a great deal of experience on the part of the artist, who must have been advanced in years when conceiving this work. It is the last work in the tradition of the heroic landscapes of the tenth and eleventh centuries, a tradition that seems to have ended abruptly with Kuo Hsi, who had no successor. His style, however, was not forgotten but remained a source of inspiration to later followers from the fourteenth century onward.

THE LAST QUARTER OF THE ELEVENTH CENTURY

This was a period of far-reaching changes, observable in styles and subject-matter, in the appearance of a scholarly antiquarianism, and in new theories proclaiming the value of art produced by men of culture. The amateur status of the scholars, or literati, would ban all vulgarity of professional skill but not impede expression, or the manifestation of individuality. When measured by the hitherto almost unquestioned acceptance of a tradition of objective realism, these innovations may seem startling enough. But both Hsü Tao-ning and Kuo Hsi had gone far in advancing subjective interpretation at the expense of objective statement—notwithstanding their professional status. Wholly new positions, therefore, were those of the antiquarian or archaist and, of course, of the genuine innovator, whatever his place in the social hierarchy.

Chao Ling-jang, better known as **Chao Ta-nien** (active *c*.1080–1100), a fifth-generation descendant of the founder of the Sung Dynasty, emerges from among the leading painters of his time as perhaps the most approachable. Not that he was the most eminent among them, but his talents, upbringing and wealth, allowing him to engage in the pursuits of learning and elegance, make him an almost perfect example of the independent gentleman-artist. What is more, none of his contemporaries' oeuvres have fared so well as his—combining as it does a few authentic specimens with a series of consistent attributions, works which together represent an artistic legacy of unmistakable character. And it is this character, so strikingly different from that of the earlier Northern Sung tradition up to Kuo Hsi, which proves Chao Ta-nien's seriousness and importance as a painter. There is, further, literary evidence of his artistic quest. In Teng Ch'un's *Hua-chi* of 1167[15] we are told that Ta-nien studied such T'ang masters as Pi Hung and Wei Yen (the founders of the *Pine Tree and Rock* theme), the snowscapes attributed to Wang Wei, as well as Su Tung-p'o's *Bamboos* and *Little Mountains*, works either very recent or far removed in time. He was also, according to *Hsüan-ho hua-p'u*,[16] a keen collector of ancient autographs and pictures; he owned a Fan K'uan,[17] whom he resembled so little, and even a Wu Tao-tzu (as mentioned in Mi Fei's *Hua-shih*); and he familiarized himself with Tung Yüan without becoming Tung's bondsman. (His *Autumn Morning* [lost] in the manner of Tung Yüan was very unlike his ordinary works, according to Wu Ch'i-chen.[18]) Evidently Chao was no naïve amateur at all, and it is

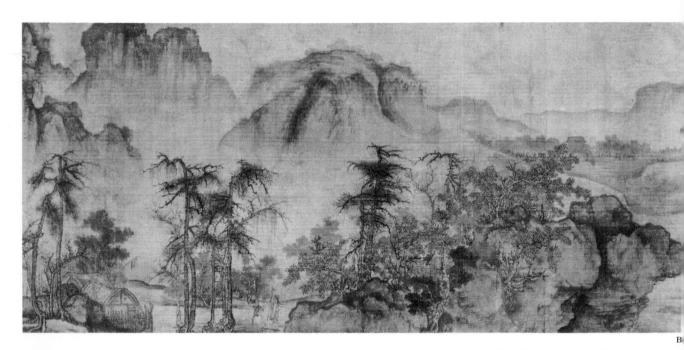

B

D

A

C

FIG. 74A–D Attributed to Kuo Hsi, *Clearing Autumn Skies over Mountains and Valleys*. Washington, D.C., Freer Gallery of Art.

B

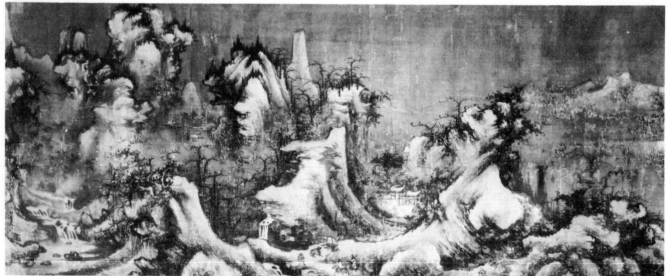

D

not likely that contemporary critics as forthright as Huang T'ing-chien and Mi Fei would have praised the works of a mere amateur whom they did not take seriously as a painter. Still, Chao Ta-nien's most valid justification is his oeuvre.

His *River Village in Clear Summer* in the Boston Museum, a handscroll signed and dated in accordance with 1100, represents Chao's achievement well-nigh perfectly (Fig. 76). The contrast to the Kuo Hsi and Hsü Tao-ning scrolls (Figs. 75 and 68) could not be more extreme. The world has suddenly become small. There

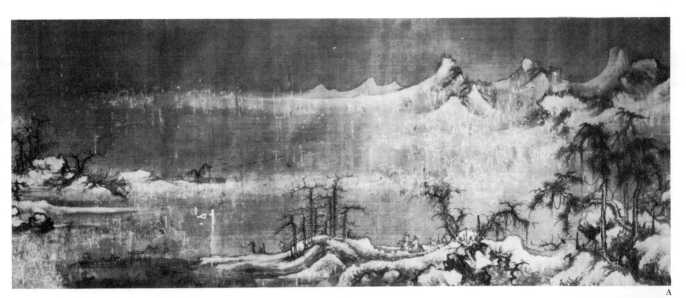

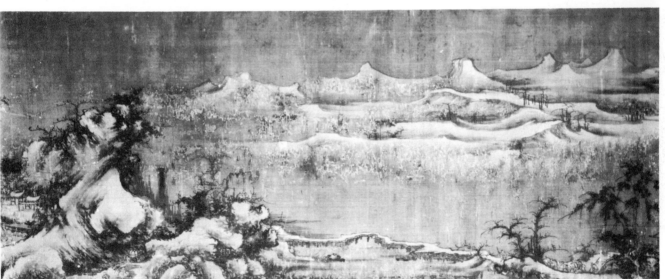

FIG. 75A–D Attributed to Kuo Hsi, *River and Mountains after a Snowfall*. Toledo, Ohio, Toledo Museum of Art.

is no vastness; everything is near at hand. Rocks and cliffs and mountains have disappeared, as have the waterfalls, the pathetic trees with clawing roots, and the heaving, dissected terrain. The scenery is restful and gentle, not heroic but homely and intimate and protected. Not only the motifs have changed; the technique has too, especially in the brushwork used in rendering the foliage with downy dabs, feathery strokes, and beautifully intuited blurs. The tree trunks, by contrast, are completely uniform and without individual interest whatsoever, as if in revolt

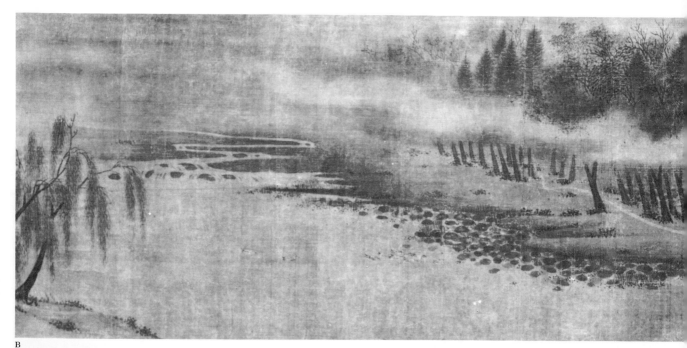

B

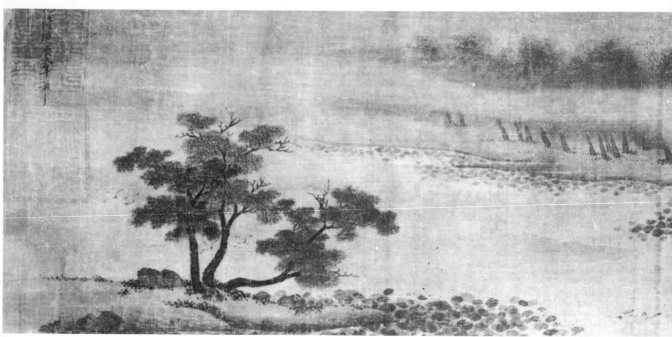

D

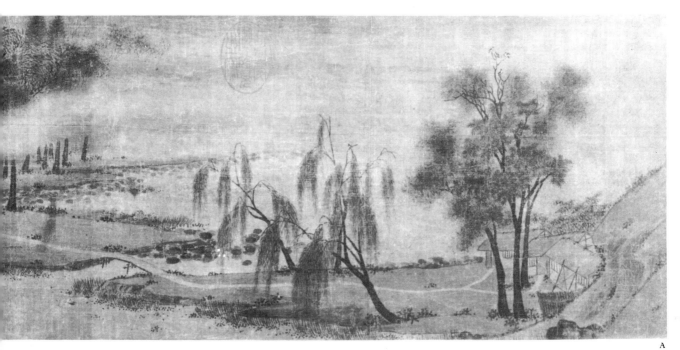

A

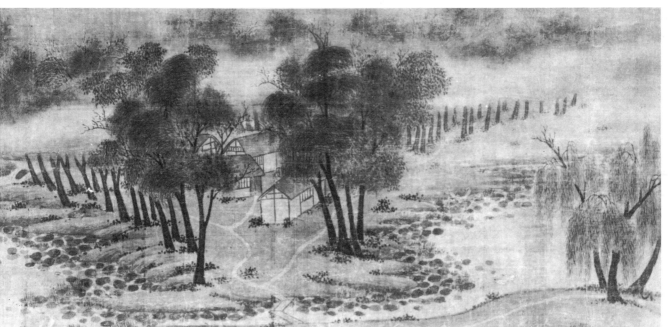

C

FIG. 76A–D Chao Ta-nien, *River Village in Clear Summer*. Signed and dated in accordance with 1100. Boston, Museum of Fine Arts, Keith McLeod Fund.

against the dramatically battered, bent and twisted trees of the past. An element given much importance is the atmosphere. A dense morning mist shrouds the open stretches at the beginning, in the middle, and at the end of the scroll, shutting out what is far away; and in the form of long bands hugging the groves along the water it moves now forward and now back, as the shoreline does. 'For the first time in Chinese landscape painting, one is fully aware of a particular moment in time—the stillness of a misty morning.'[19] 'Time' as understood in this observation is not a dimensional factor (one that can be organized in sequential rhythms) but an expressive factor, indicating a deepened realism with a new content—the awareness of transient states in nature. This new realism, which also manifests itself in the humble motifs, in the elimination of deep distances and in the simplicity of the design, separates Chao Ta-nien irrevocably from the grander idioms of the past.

That this gentle revolutionary did have a following is evident, for instance, from a lovely small album leaf by Li An-chung in the Cleveland Museum, signed and dated in accordance with 1117 (Fig. 77). But for its signature, this work would surely be assigned to Chao.

Mi Fei (1052–1107), Chao's contemporary from Hsiang-yang in Hupei, an intellectual who through his writing, his calligraphy, and especially his critical connoisseurship in matters of painting is better known to us today than Chao, remains deplorably obscure as a painter. While there is little doubt as to his style in general, not a single example of his work is generally accepted as authentic. Our knowledge of his style depends mainly on later imitations of a certain type of mountain landscape that seems to have originated with him and at any rate was perpetuated in the work of his son, Mi Yu-jen (1086–1165). It was a type of mountainscape characterized by extreme simplification of both design and technique. Not altogether unlike Chao Ta-nien's, therefore, Mi Fei's small ink pictures nevertheless appear to have been motivated by aesthetic inclinations rather than visual discoveries. For Mi, to paint was to assert his taste and his character.

The pre-eminent quality in a work of art was, in Mi Fei's view, the quality of 'naturalness' (t'ien-chen). It has nothing to do with naturalism or realism but denotes artlessness, ease, and innocence, the absence of cleverness or beguiling skill. This quality he found in the masters of antiquity, such as Ku K'ai-chih and Wang Wei of T'ang, as well as in the more recent Tung Yüan and his disciple, Chü-jan, all of whom he deeply admired. He had less sympathy for Kuan T'ung, Li Ch'eng and Kuo Hsi. He scorned even the great Wu Tao-tzu, asserting in his *Hua-shih* that not one brush stroke of his was in Wu's manner. Mi thereby took a stand in opposition to the boundless admiration for Wu as expressed by Chang Yen-yüan (847) and implied in the work of Li Lung-mien (1049–1106), who had completely succumbed to the Wu style.

Mi's verdicts are not based on form or style alone, but coloured by his apprehension of a moral content. This stress on *ethos* in the ranking of a work was wholly in keeping with the tenets of the Sung literati or scholar-artists. They held that a man's character is revealed in his painting, and that this was possible because of the fact that he did not copy, but instead interpreted reality. 'Art presents a convincing image of the visible world; this image, when filtered through the mind of an excep-

tional person, can be truer than nature uninterpreted. This seems to be the message of the Sung critics,' as summed up by Susan Bush, *The Chinese Literati on Painting*.[20]

A superior example among the none too numerous works attributed to Mi Fei is a silk painting in the Freer Gallery, *Misty Hills* (Fig. 78). Of great simplicity as regards the design, the picture shows three ranges of bare, rounded hills separated

FIG. 77 Li An-chung, *Cottages in a Misty Grove in Autumn*. Album leaf. Signed and dated in accordance with 1117. Cleveland, Cleveland Museum of Art.

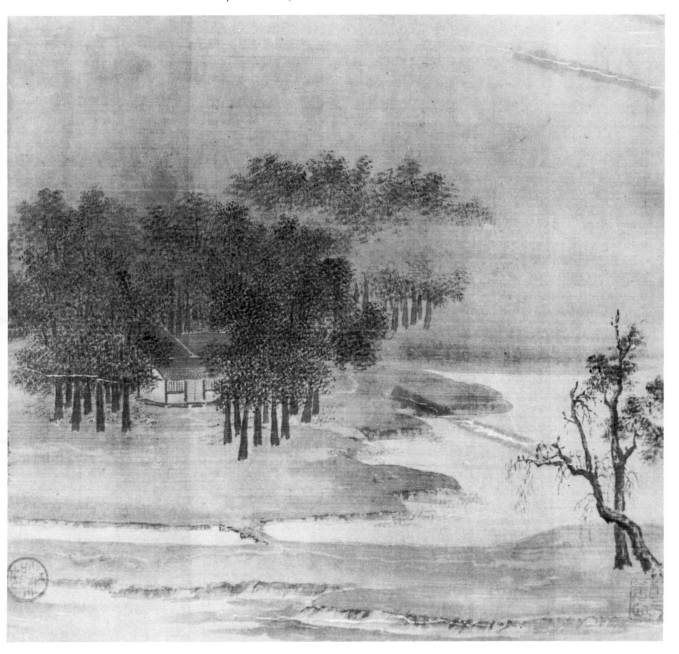

FIG. 78 Attributed to Mi Fei, *Misty Hills*. Washington, D.C., Freer Gallery of Art.

by mist-filled depressions, and two rows of trees in dark foliage below. The same shapes are repeated throughout. Emerging from and disappearing again in the mist, the hills form gently swinging curves in slightly varying arcs and tones. No angularity disturbs their harmonious interplay. The trees appear as silhouettes of a peculiar form, reminiscent of the trees in Tung Yüan's *Festival* (Fig. 55). The technique is soft, almost furry; there are no distinct outlines. But the horizontal blobs of the brush that create this furry effect are subservient to the definition of form. To give a sweeping appraisal, this painting seems like a sophisticated variation on a theme by Tung Yüan, while in turn it offers a model for Kao K'o-kung (1248–1310), an early Yüan follower of Mi Fei, whose works constitute an early landmark in the Mi tradition.[21] The pre-Yüan date of the Freer picture, suggested here, is supported also by the similarity of this painting to a handscroll in the Cleveland Museum, the *Clouded Mountains* of 1130, in ink and colour, by Mi Fei's son, Mi Yu-jen. While the Freer picture lacks an inscription such as virtually authenticates the Cleveland scroll, on stylistic grounds it would assuredly always be connected with Mi Fei.

Li Kung-lin (1049–1106), whose *hao* was Lung-mien, was a contemporary, friend, and antipode of Mi Fei. The son of a collector of calligraphy and paintings from Shu-ch'eng, Anhui, Li Lung-mien received his *chin-shih* degree in the Hsining era (1068–77). He was a man of antiquarian learning, a painter of extraordinary skill, and the first great archaist in figure painting. His literary style, according to the *Hsüan-ho hua-p'u*, was modelled on that of the Chien-an era (196–220); his calligraphy, on that of Chin and Sung (265–477); and his painting style went back to Ku K'ai-chih and Lu T'an-wei.[22] To these names must be added those of Chang Seng-yu and, especially, Wu Tao-tzu, to mention only the most important ones. The catalogue of the 107 works of Li Kung-lin listed in the *Hsüan-ho hua-p'u* reads, in fact, like a survey of pre-Sung painting. Buddhist subjects such as Śākyamuni, Queen Māyā, an Amitābha Triad, Amitāyus, Acala, Brahmā, Avalokiteśvara, Vimalakīrti, and illustrations to the *Avataṃsaka* and *Diamond sūtras* are followed by portrayals of eminent scholars of the past, by classical narratives, and by many paintings of horses, while copies after Li Chao-tao (*Picking Melons*), Han Kan and Wu Tao-tzu of the T'ang period and one after Hsü Hsi (*Peonies Seen from Four Sides*) of the Southern T'ang comprise the rest. But, even though 'his manner was not inferior to that of the ancients,' in the estimate of Huang T'ing-chien (1045–1105),[23] the world of his paintings was an impersonal one—only re-created by 'historical appreciation', founding 'no new traditions . . . that followers could develop,' and leaving 'not even so much as a clear echo'.[24]

A noble work attributed to Li Kung-lin is the *Vimalakīrti* of the Victor Hauge collection (Fig. 79). The fictional layman from Vaiśālī has become the very image of a Chinese aristocrat. Seated in *līlāsana* posture on a kind of *k'ang*, the fastidiously attired figure is drawn with immense skill, in a style derived from T'ang but psychologically unlike T'ang: he is presented with a knowing, scrutinizing gaze, such as may be seen in some examples of superior Sung Buddhist sculpture. If any proof of the high level of this work were needed, it is furnished by an anonymous Sung painting representing the same subject in the Palace Museum.[24a] The gap in

FIG. 79 Attributed to Li Lung-mien, *Vimalakīrti*. Japan, Victor Hauge collection.

quality is such that no attribution short of that to Li Kung-lin can do justice to the Hauge picture.

While none of the known paintings attributed to Li Kung-lin quite attains the dignity of the *Vimalakīrti*, some of them merit consideration as possibly authentic.

In particular, we should think of the *Five Tribute Horses*, a handscroll formerly in the Peking Palace (afterwards in Japan and believed to have been lost during the Second World War). The section illustrated here depicts a horse with its Khotanese groom (Fig. 80). The brief inscription explains that the steed was presented as tribute on January 23, 1087. The groom, clearly a foreigner, is portrayed as a proud and earnest man with convincingly individual, vivid features. His attire is rendered in fine outlines, which are comparable to those in the *Vimalakīrti*, though thinner and sparser. In 1347 Chao Yung made a close copy of this group, adding bright colour however. This copy, now in the Freer Gallery (Fig. 81), supports Li's authorship of the original but at the same time enables us to gauge, once more, the far superior level of the original. As described by Thomas Lawton, 'Chao Yung's portraits of horse and groom lack the extraordinary degree of individuality and solidity that are so important in Li Kung-lin's painting.'[25]

Compared with a work of the first quarter of the twelfth century such as *Ch'ing-ming shang-ho t'u* by **Chang Tse-tuan** in the Peking Palace Museum, the realism achieved by Chao Ta-nien might well seem slight, tempered by a lyrical mode, and restricted to rustic motifs. This marvellous work is a handscroll depicting scenery and life along the river and in the Northern Sung capital of Pien-liang (modern K'ai-feng in Honan) on the day of Ch'ing-ming Festival (in early April). It was painted some time between 1111 and 1126 by a virtually unknown Academy painter. Although the scroll, rediscovered in Manchuria as recently as 1954, is not signed, it is authenticated by a series of fourteen colophons from the hands of Chin, Yüan and Ming writers. The earliest of the colophons, dated in accordance with 1186, provides both the attribution to Chang Tse-tuan and all we know about his origin and career: he was born in Shantung; having read much in his youth, he came to the capital for study; he became a member of the Han-lin Academy; and finally was acknowledged as a master painter who specialized in such subjects as boats, carts, markets, bridges, city walls and streets. To these subjects we should add trees, water, landscape, and human figures, implying his thorough conversance with an even broader range of specific traditions.

Painted in ink and light colour on silk, the *Ch'ing-ming* scroll (which measures 5.25 metres in length) is composed of three sections, which differ in topography and time of day (Fig. 82A-D). In the early morning we find ourselves in the flat country-side and its foggy air, with farmyards almost deserted (Fig. 82A). Next we are watching big barges on their moorings along the river (Fig. 82B) and the excitement created when one of them swings out to pass under the Rainbow Bridge (Fig. 82C), where a fascinated throng of idlers follows the crew's manoeuvres. Then leaving the riverside, we enter the city through one of its imposing gates (Fig. 82D). It may be noon by now, or early afternoon—there are no shadows telling us the hour, but in a way the ambience does.

All through its length, the scroll is full of surprising detail, revealing not only an awesome power of observation but, what is more, a deep familiarity with all the things depicted. The painter knows the atmosphere, the configurations of flowing water, deep or shallow; he knows the shape of the hulls of his barges and how to render them, laden, foreshortened; he becomes an engineer when drawing the

wooden bridge, and a gardener when giving shape to his trees and pollarded willows; he has a feeling for his dogs and camels and donkeys; and he is secure in characterizing, rather than merely depicting, the many types of human beings appearing throughout his scroll. When towed upstream, a boat as drawn by Chang Tse-tuan would show the backstays properly taut and the forestays slack on the tow-mast; when drifting downstream, his barges would be steered not with the rudder but with long oars or sweeps, one at the bow and one at the stern, each of them operated by a team of as many as eight men. In his thorough investigation of this work, Roderick Whitfield further noted 'how every barge at its moorings lies according to the current, slightly downstream from the mooring post. The contrast here with the later copies is most marked: in the latter the barges around the bridge are moored with their bows converging on the bridge, so that the sterns of some of

FIG. 80 Li Lung-mien, *Horse and Khotanese Groom*. Detail from the scroll *Five Tribute Horses*. Now lost.

them face upstream, a situation that would be impossible in the presence of any current.'[26] Of such later versions (none of them true copies) Whitfield was able to assemble no fewer than thirty-seven items of three distinct varieties.

There seems to be no other Sung painting of such intense realism, so given to full and accurate description and so sovereignly indifferent to formalistic concerns. In Chang Tse-tuan's knowing and loving representation of nature, of people and man-made things, the object and its form coincide. Style and technique are inseparable from the specific subject-matter. Chang can be copied but he cannot be imitated. He left no school manner. All of this means that this scroll emerges as the supreme instance of realism in Chinese painting generally. For even though there never was to be any downright rejection of reality, or nature, realism began to decline or to take different forms from here on.

FIG. 81 Chao Yung, *Horse*. Copy after Li Lung-mien. 1347. Washington, D.C., Freer Gallery of Art.

B

D

A

C

FIG. 82A–D Chang Tse-tuan. Four sections of *Ch'ing Ming Shang Ho* (Up the River on Ch'ing Ming Day). Handscroll. Datable between 1111 and 1126. Peking, Ku Kung Po-wu-yüan.

Li T'ang from San-ch'eng, Ho-yang, Northern Honan, may have been a slightly older contemporary of Chang Tse-tuan. According to *Hua-chi*,[27] he was already eighty when he left Pien-liang after its sack by the Chin Tatars and took up residence at Lin-an (Hang-chou), the new Southern Sung (1127–1278) capital. His life may have spanned the fourscore years from about 1050 to 1130. In any case, having entered the Academy under Hui Tsung, he was promoted to higher office during the Chien-yen era (1127–30), the early years of Kao Tsung's long reign. If today Li T'ang is classified as a realist,[28] no mistake is made. Yet, on the evidence of the large and imposing hanging scroll of 1124, *Whispering Pines in the Gorges*, in the Palace Museum, Taipei (Fig. 83), his realism is far removed from that of Chao Ta-nien and Chang Tse-tuan, being neither intimate and lyrical nor joyously worldly. Instead we find here a composition of sublime character, reminiscent of Fan K'uan (Fig. 48). A grove of tangled pines is enclosed by walls of rock. Beyond this hollow there rises a tall cliff, beautifully textured by slanting, parallel, 'chipped' bands as neat as the flaked surface of a Solutrean flint dagger. The cliff is topped by lush vegetation, derived from, but rather unlike, Fan K'uan's scraggy scrub. Thin threads of waterfalls plunge from dark recesses into the gorge, somehow feeding the trees that grow here without soil. The varying rock formations and textures are defined by a disciplined and unflaggingly vigorous brush, again dissimilar from Fan K'uan's more austere uniformity. Exquisitely drawn are the waters of a small stream that gurgles over its boulder-strewn course. On a distant pinnacle to the left of the big cliff the painter has inscribed the date (corresponding to 1124) and his name in clerical script (*li-shu*), adding a touch of antiquarian learning to this monumental work. The placement of the signature, moreover, would seem to speak in favour of its authenticity, and the physical condition of the much darkened silk leaves little doubt as to the great age of the picture. Stylistically, however, it stands apart from both Chao Ta-nien and Chang Tse-tuan, representing instead a clear revival of the heroic landscape in the manner of Fan K'uan.

That Li T'ang during his few remaining years in the South should have discarded the style on which his fame rested is not very likely. Yet this is the conclusion that has been drawn from Shimada Shūjirō's discovery of an effaced 'Li T'ang' signature on one of the two landscapes in the Kōtōin at the Daitokuji Monastery in Kyoto (Fig. 85).[29] This pair of landscapes is done in broad, graded washes typical of the late twelfth-century Ma-Hsia school, and they therefore are not easily reconciled with the style of a painter whose activity ended a half century earlier. Shimada, in fact, rejects the *Whispering Pines* of 1124 as a Li T'ang, basing his concept of Li T'ang's oeuvre on the more advanced style of the Kōtōin pictures. Sirén, accepting both the Kōtōin pair and the *Whispering Pines*, struggles with the problem of how to account for a stylistic jump that would have had to occur during the last few years in the life of an octogenarian.[30] Both theories have one and the same disturbing consequence, however. If Li T'ang had indeed created the style embodied in the Kōtōin landscapes, it was in a sweeping anticipation of what was to be the chief contribution of the following two generations of landscape painters: the perfection of the technique of graded washes.

The agreement of Chinese literary sources on Li T'ang's lasting influence in the Southern Sung Academy need not be construed to mean that during the next 150

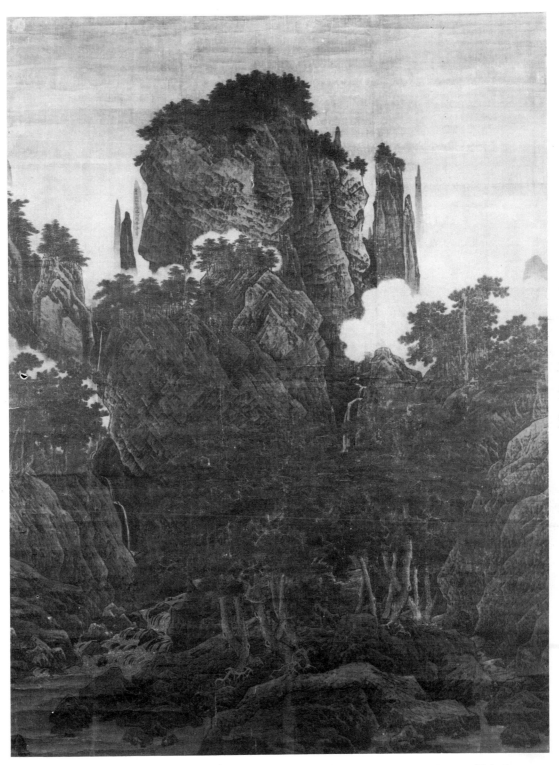

FIG. 83 Li T'ang, *Whispering Pines in the Gorges*. Signed and dated in accordance with 1124. Taipei. National Palace Museum.

years there were no innovations at all. What I believe it means is that the innovations that did occur were tied to Li T'ang's style. In other words, what became the main-stream of Southern Sung landscape painting originated with Li T'ang—and not with Kuo Hsi, Mi Fei, Chang Tse-tuan, or even Chao Ta-nien, not to mention Li Lung-mien. In hindsight, therefore, the stature of Fan K'uan, to whom Li T'ang owed so much, becomes awesome.

Li T'ang's persistent dependence on Fan K'uan still shows in a few works that go under the name of his pupil and son-in-law, Hsiao Chao (active *c.*1130–60). Hsiao's *Temple on a Mountain Flank* (Fig. 84) is a case in point, although the stress on a misty, open distance and a sharper separation of the large units of the design are evidence of its Southern Sung date.

In order to give some indication of the wide diversity of individual achievements during Hui Tsung's time (1101–25), one might mention the dated works of two or three men of lesser stature. An outstanding example of the T'ang blue-and-green style applied to a vast panorama of land and sea distinctly Sung in design is the scroll entitled *A Thousand Li of Rivers and Mountains* in the Peking Palace Museum. The work is by the otherwise unknown **Wang Hsi-meng**. An inscription of May 17, 1113 by the notorious political manipulator Ts'ai Ching (1046–1126), who had received this scroll as a gift from the Emperor, supplies both the date and the name of the painter. It also informs us that Wang was only eighteen at the time, a student at the Academy, and favoured by the Emperor, who personally instructed him; he died at the age of twenty. The colouring of this work in bright blue, turquoise and green 'has the radiance of precious stones' (Hsü Pang-ta). Traditionally linked to Li Ssu-hsün and Li Chao-tao, the blue and green technique was practised by Li T'ang, too, in his early years.

Another dated work of the period is an unassuming short handscroll of 1122. It was painted by **Hu Shun-ch'en** from Chekiang, who is said to have been a follower of Kuo Hsi. It was done in ink on silk as a parting gift to a gentleman who was sent as an envoy into Liao territory (Fig. 86). A sparsely wooded, mountainous terrain slopes down to a valley enclosed by receding low hills. At some distance a village is nestled among trees by a stream. The scenery is unspectacular, the atmosphere misty and still, with a touch of melancholy about it. There is no grand brush stroke or bold wash. The hand seems to have moved cautiously, and the outcome is compatible with the gentle tone of Chao Ta-nien's landscapes.

A third instance, again a handscroll, though done in ink on paper, illustrates Su Tung-p'o's *Second Ode on the Red Cliff*, a piece of rhythmic prose that soon took its place in the repertoire of classic literary themes in Chinese painting. The scroll which is attributed to **Ch'iao Chung-ch'ang** and purports to date from 1123 at the latest, is in the Crawford collection, New York (one section in Fig. 87).[31] Of Ch'iao's life nothing is recorded except that he was a native of Ho-chung, Shansi, and was staying in the Northern Sung capital (Pien-liang) when it was besieged by the Chin Tatars. Why he was counted among the followers of Li Kung-lin is not obvious from this scroll. The human figures are none too interesting. But the landscape

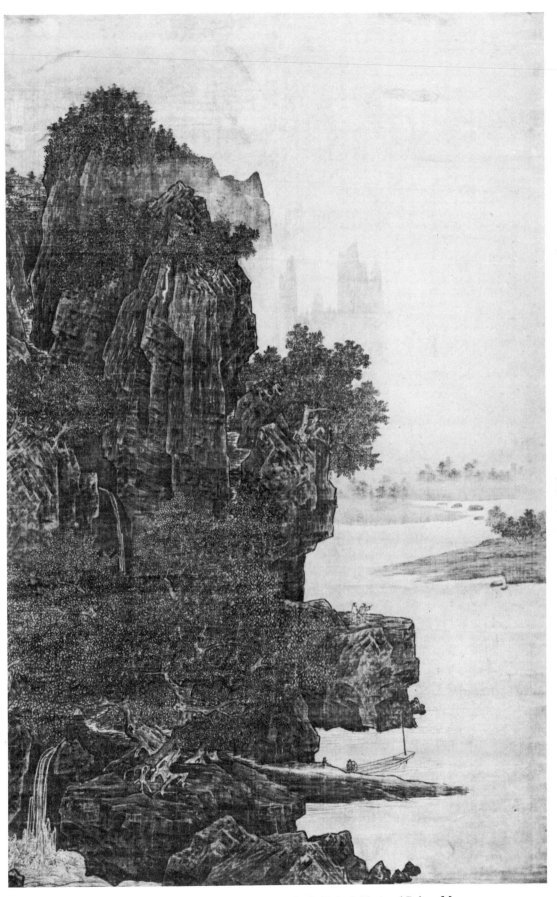

FIG. 84 Hsiao Chao, *Temple on a Mountain Flank*. Taipei, National Palace Museum.

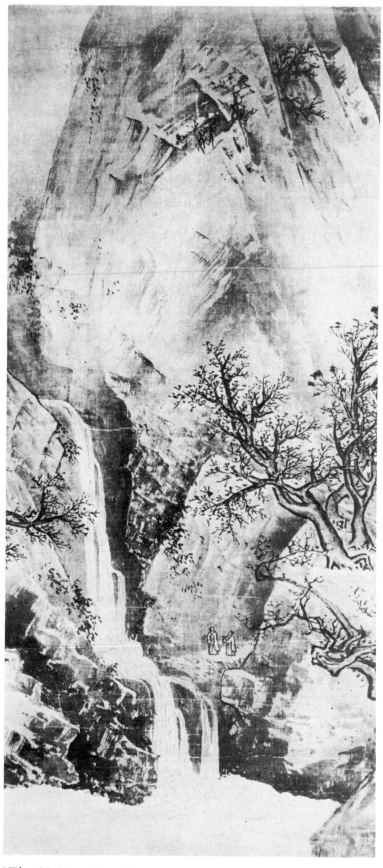

FIG. 85 'Li T'ang' (with an effaced signature), *Landscape*. Probably late Southern Sung. Kyoto, Kōtōin of Daitokuji Monastery.

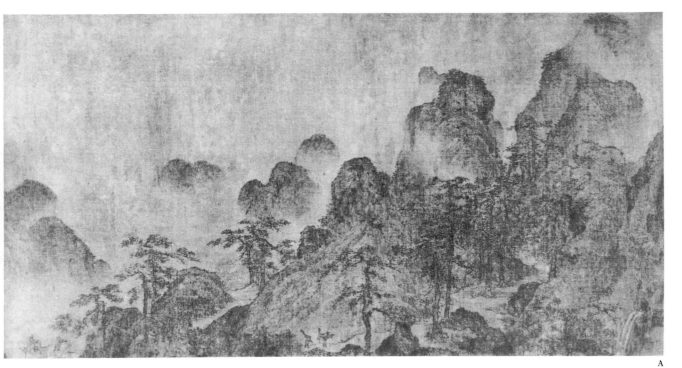

A

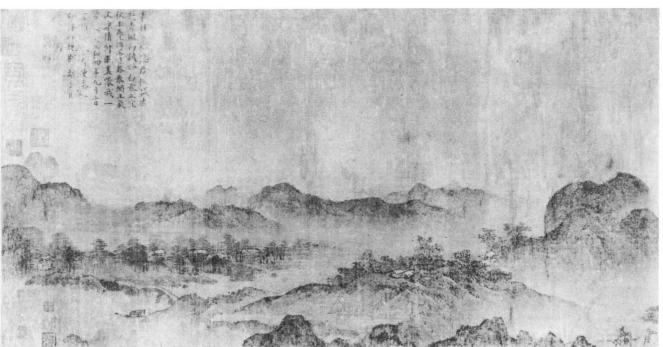

B

FIG. 86A–B Hu Shun-ch'en, A Landscape Scroll Painted for Ho Hsüan-ming. Dated in accordance with 1122. Osaka, Osaka Municipal Museum, Abe collection.

design, especially the rock formations, is exciting and unique. Twisted masses of worn rock are contrasted with tilted layers of ancient sediments, done in a dry, sharp, and sparing technique, as are the largely leafless trees. The rocks are unshaded, like graphic notations about their placement, contours, and structure.

Some of the rock formations are reminiscent of T'ang design. The likelihood of 'archaism, with T'ang antecedents' was noted by James Cahill, who saw, further, that the painter intended 'to evoke an air of antiquity' in his 'square-cut, formalized drawing of fractured rock strata'.[32] Its style, archaistic allusions and subject-matter suggest that this scroll represents an instance of Sung literati-painting, an art form initiated by a group of scholar-amateurs whose first theorist was none other than Su Tung-p'o, the very author of the *Red Cliff Odes*.

B

D

Surprisingly, what may be the only painting attributed to Su, showing an old tree and rock (Fig. 88) rather than bamboo, is closely akin to Ch'iao Chung-ch'ang's manner of drawing rocks and trees. Still, the scholar-painters' contribution to Sung painting remained peripheral. Nor is it always possible to draw the line between the works of scholar-officials, academicians, and the aristocracy.

FIG. 87A–D Ch'iao Chung-ch'ang. Detail from *Second Ode on the Red Cliff*. New York, John M. Crawford, Jr., collection.

A

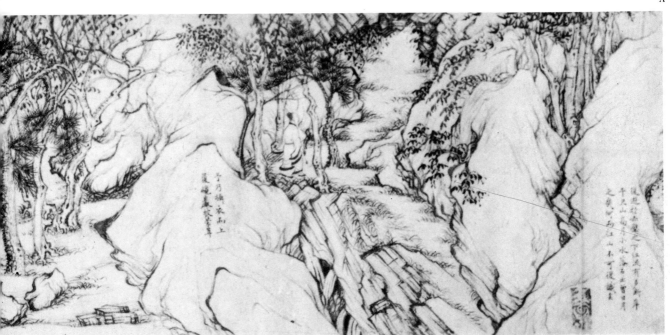

C

To what extent an eminent painter and calligrapher, Prince Chao Chi (1082–1135), Shen Tsung's eleventh son, who was to rule China as Emperor **Hui Tsung** (reigned 1101–25), can be considered as a focal figure in the arts of his time is no easy question to answer. Enthroned when he was only nineteen, he seems to have remained indifferent to political realities until he was taken captive by the Chin Tatars on 21 March 1127. His exalted position may account for the exaggerated praise of his work in some of the records. But these records cannot very well be mistaken in noting his associates. The three men closest to him were Wang Shen, Chao Ta-nien, and Wu Yüan-yü, all of them painters and of high social rank. Wang introduced the prince to the calligraphic style of Huang T'ing-chien (1045–1105); Chao Ta-nien may have shared with him the joys of his artistic discoveries in the country around the capital; and Wu, a disciple of the famous Ts'ui Po, was the prince's instructor in painting. We might think of the three as archetypes of the connoisseur and collector (Wang), the innovator (Chao), and the conservative academician (Wu). Hui Tsung's artistic range thus becomes understandable. Though best known for his flower-and-bird pictures, he tried his hand at landscapes and figures; and in taking up ancient styles and ink bamboo he competed with the scholar-painters of his time. An encounter with the late eleventh century Sung Ti's *Eight Views of Hsiao and Hsiang Rivers* inspired Hui Tsung to paint a series of *Twelve Views*, on Kuan-yin paper, 'with a playful brush'.[33] 'Playful brush' was, or became, a standard phrase in the jargon of the scholar-painters, who preferred paper to paint on rather than silk. Behind Hui Tsung's interest in the ancients, as well as in the modern topic of bamboo stood, no doubt, Wang Shen, who had studied the bamboo pictures of Wen T'ung (?1019–79), and who was familiar with the 'ink plays' of Su Tung-p'o and Mi Fei. While Wang Shen's learned eclecticism, which also included studies after Li Chao-tao, Wang Wei and Li Ch'eng, resulted in a style that seemed 'neither ancient nor modern' according to T'ang Hou in 1329, the oeuvre of Hui Tsung appears to have been less diffuse in

FIG. 88 Attributed to Su Tung-p'o, *Old Tree and Rock*. Whereabouts unknown.

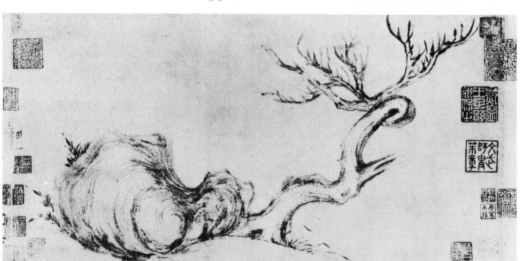

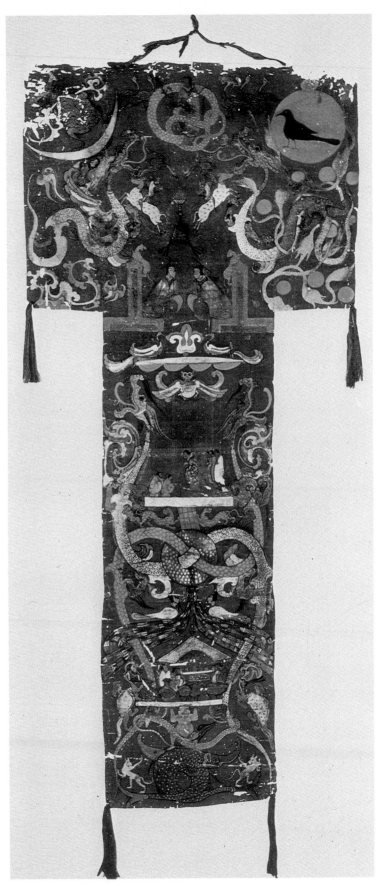

PLATE I Painted banner from the Ma-wang-tui, Ch'ang-sha, Hunan. First half second century B.C.
Ch'ang-sha Museum.

故曰翼翼矜矜福所以興靜恭自思榮顯所期

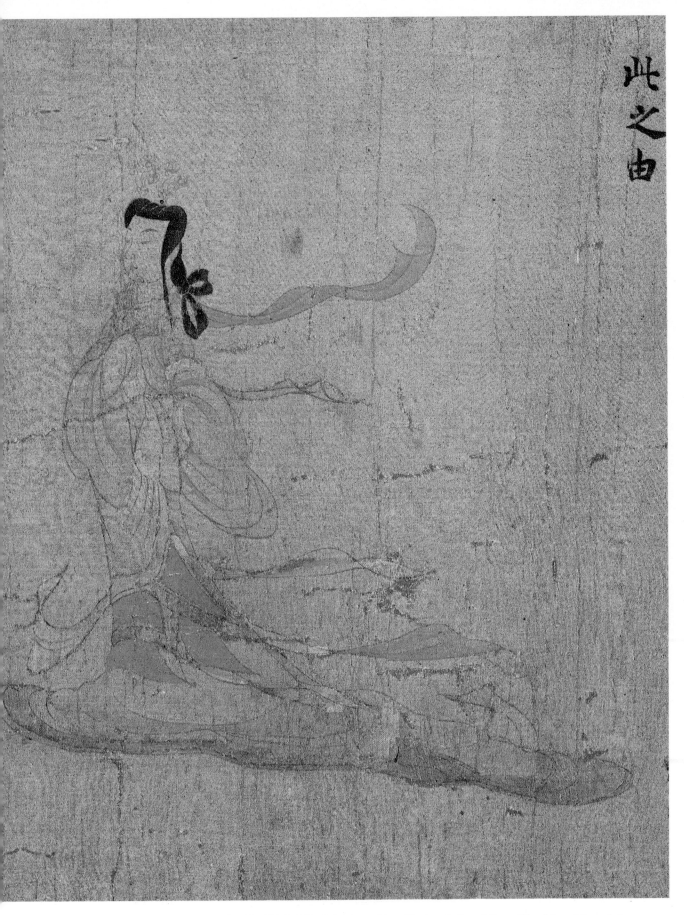

此
之
由

PLATE II Attributed to Ku Kʻai-chih, A Lady and her Husband. Detail from *The Admonitions of the Instructress to the Palace Ladies*. London, British Museum.

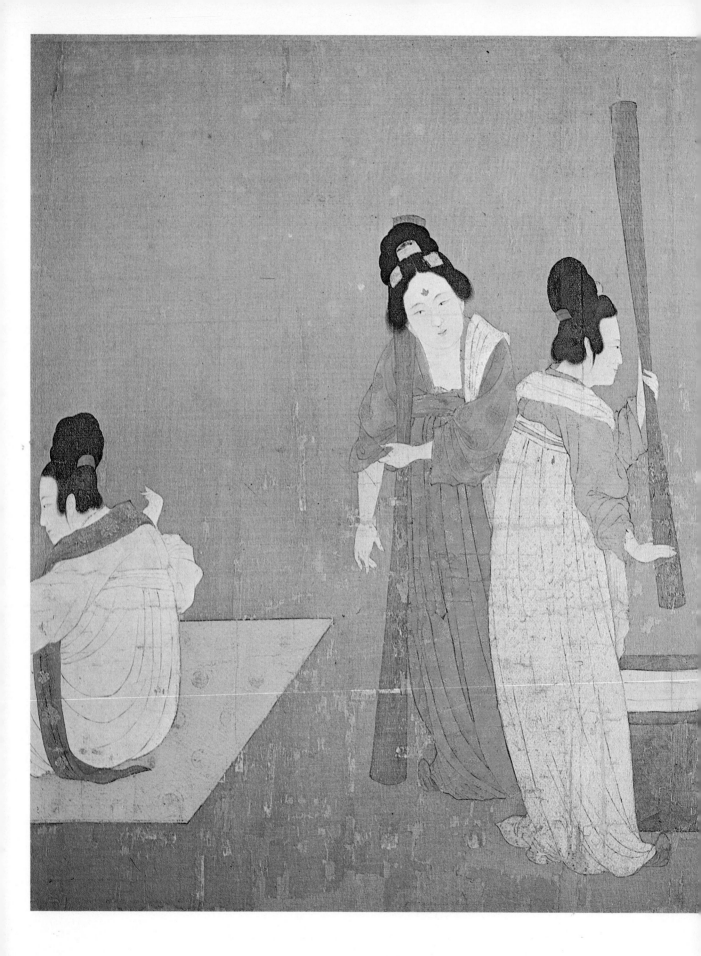

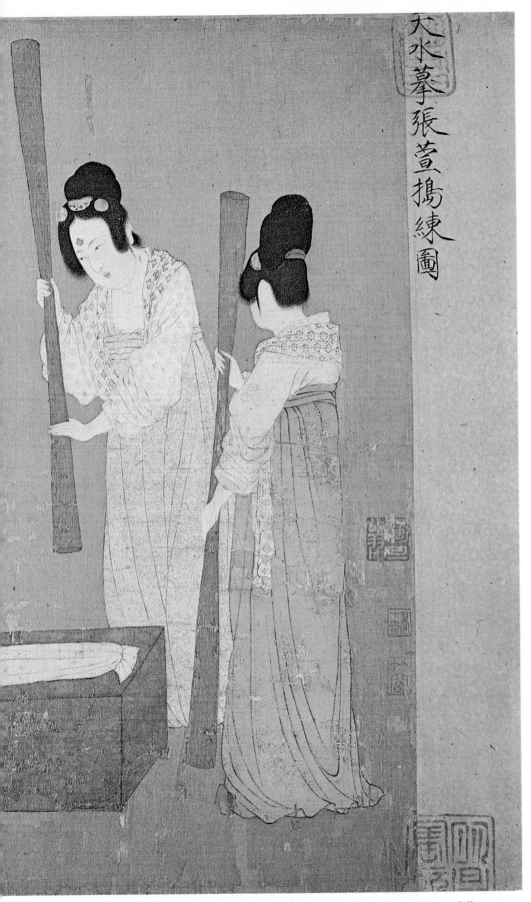

PLATE III Emperor Hui Tsung, *Ladies Preparing Newly Woven Silk.*
Right section. Boston, Museum of Fine Arts. See also Fig. 25A–C.

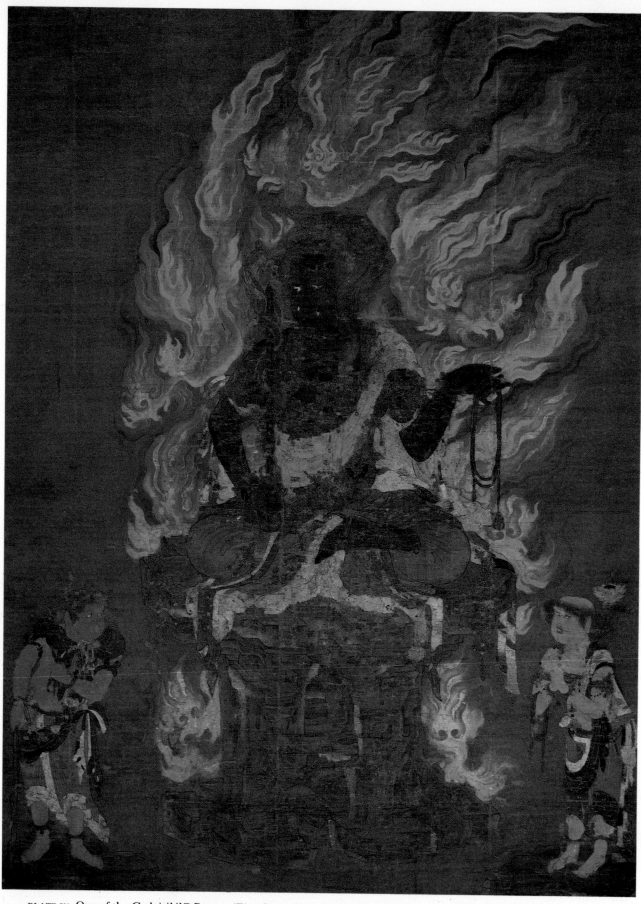

PLATE IV One of the *Godairikikū Bosatsu* (Five Great Power-howl Bodhisattva). 9th century. Yūshi-Hachimankō, Mt. Kōya, Wakayama Prefecture, Japan.

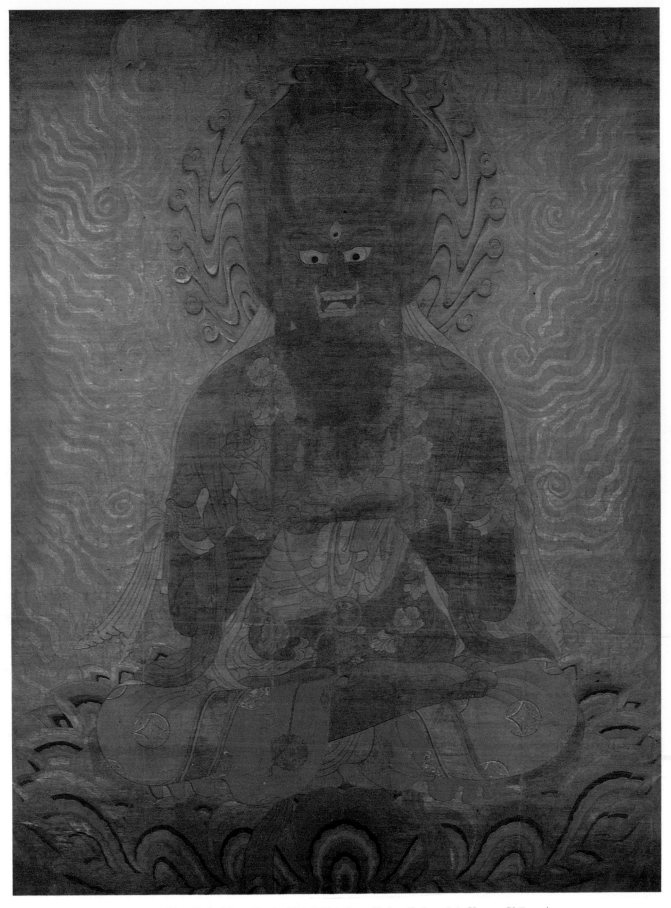

PLATE V *Blue Fudō Myōō* (Acala-Vidyārāja). Late Heian (898–1185). Kyoto, Shōren-in.

PLATE VI Emperor Hui Tsung, *Finches and Bamboo*. New York, John M. Crawford, Jr., collection.

PLATE VII Chao Meng-fu, *The Joys of Fishing at a River Village*. Fan-shaped album leaf. New York, C. C. Wang collection.

PLATE VIII Chao Meng-fu. Detail of *Autumn Colours at the Ch'iao and Hua Mountains*. Handscroll, dated in accordance with 1296. Taipei, National Palace Museum. See also Fig. 118.

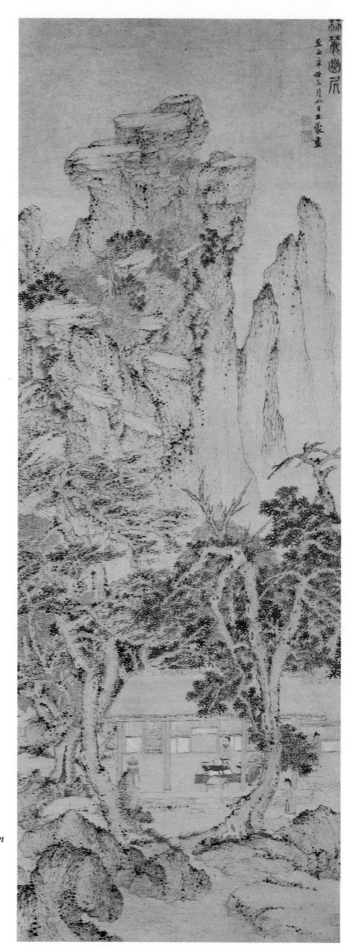

PLATE IX Wang Meng, *Secluded Home in a Wooded Glen*. Dated in accordance with 1361. Chicago, Art Institute of Chicago.

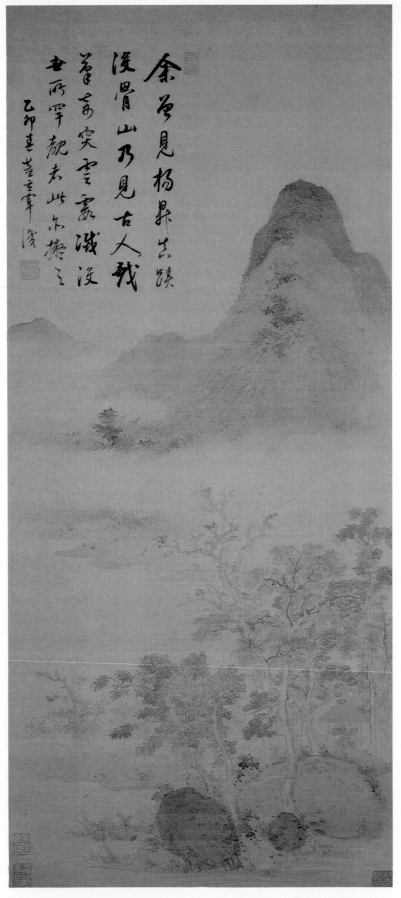

余嘗見楊昇畫蹟
後骨山乃見古人我
筆意高突雲露淡沒
世所罕觀表此不揽之
乙卯春菩玄宰淺

PLATE X Tung Ch'i-ch'ang (?), *Mountain Landscape in the 'Boneless' Manner*. Kansas City, Nelson Gallery and Atkins Museum.

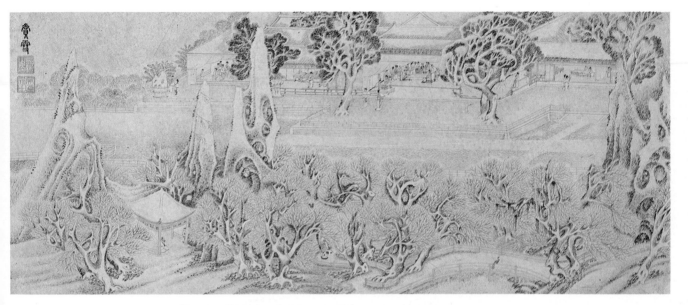

PLATE XI Wu Pin, *Admiring the [Fresh-Fallen] Snow*. Album Leaf. Taipei, National Palace Museum.

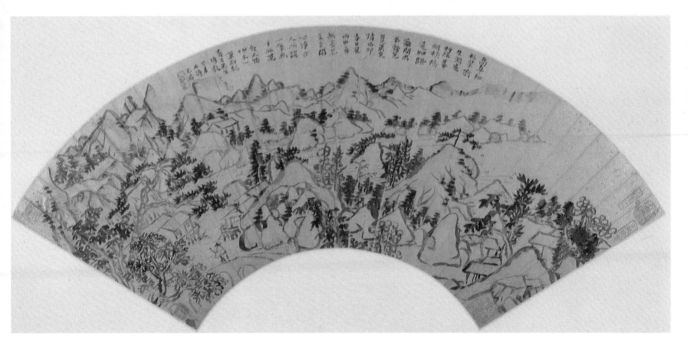

PLATE XII Tao-chi, *Landscape*. A folding fan. New York, John M. Crawford, Jr., collection.

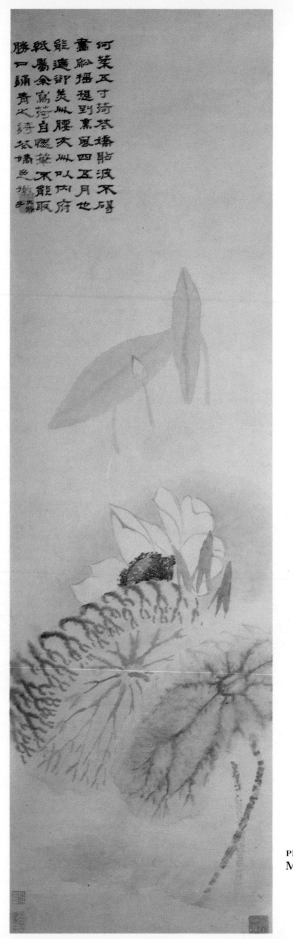

荷葉五寸荷花嬌貼波不礙

畫船搖擺提到熏風四五月也

能邀邻美州腰大州以内府

纸為余寫荷自隄葉不能取

勝一誦青火詩玫瑰色滌子

PLATE XIII Tao-chi, *Lotus*. Toronto,
Mr and Mrs R. W. Finlayson collection.

PLATE XIV Fan Ch'i, *A Garden Scene*. From an album dated 1646. New York, The Metropolitan Museum of Art.

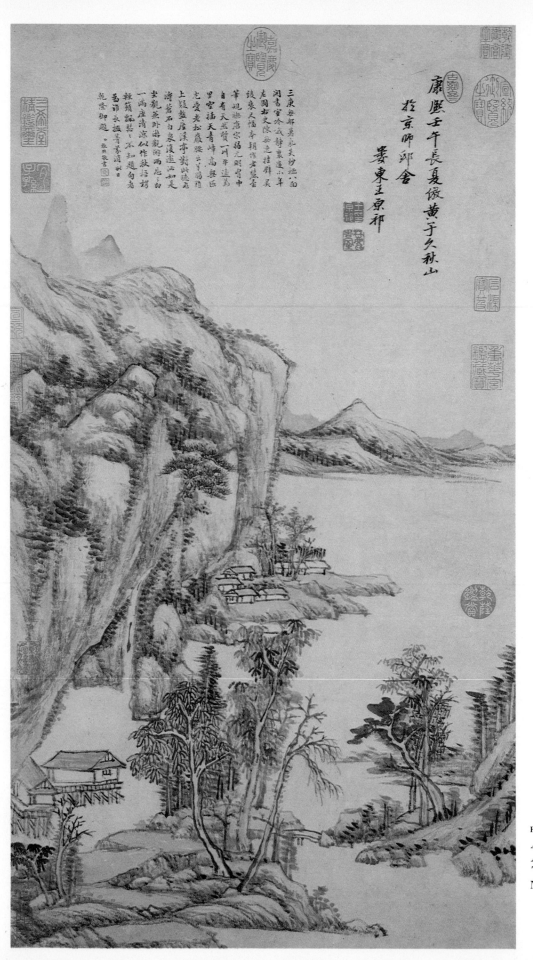

PLATE XV Wang Yüan-ch'i,
*Autumn Mountains after
Huang Kung-wang*. 1702
Taipei, National Palace
Museum.

FIG. 89 Emperor Hui Tsung, *Dove in a Peach Tree*. Dated 1107. Tokyo, Setsu Gatōdō.

character, at least when judged from his extant works. Which of these, however, should be accepted as genuine is a matter of debate. A clearer measure of his artistic personality is afforded by his marvellous calligraphy—quite unlike Huang T'ing-chien's, and possibly the most enduring of his achievements. His characters are formed with a buoyant, elastic strength; they are lucid in structure, yet joyously unpedantic and, in a word, the ultimate of elegance (see Pl. VI, Figs. 89–91).

In view of the ever asserted identity of the arts of painting and calligraphy it may be noted that the designs of the flower-and-bird pictures credibly attributed to the Emperor, though lucid and elegant, are meticulously worked out and static, and not at all partaking of the dynamic sweep of his calligraphy. In their perfection and finality of statement, the Emperor's paintings seem almost impersonal (Figs. 89–91). This discrepancy between impersonal perfection and the spirited, highly personal calligraphy accounts in large measure for the difficulties encountered in any serious attempt to decide on matters of authenticity. The same paintings are interpreted in opposite terms depending on whether the Emperor was seen as a true artist or as a mere dilettante. Sirén, inclining toward the latter assumption, dismissed virtually all of Hui Tsung's usually accepted works in the flower-and-bird category, except the *Mountain Birds on an Allspice Tree* in the Palace Museum in Taipei.[34] Rowland, who took Hui Tsung's inscriptions as a positive criterion, accepted also *Dove in a*

Peach Tree, in the Setsu Gatōdō, Tokyo (Fig. 89), the *Quail* of the Asano collection,[35] the *Five-Coloured Parakeet* of the Boston Museum (Fig. 90), and a *Landscape* in the Palace Museum collection, Taipei.[36] All of these paintings are of high quality and carry convincing imperial inscriptions.[37] To the same list should be added *Hibiscus and Golden Pheasant* in the Peking Palace[38] and *Finches and Bamboo* in the Crawford collection (Pl. VI). To deny Hui Tsung's authorship of these paintings, which are apparently from the same hand throughout, would be arbitrary, while to accept his authorship would have no worse consequence than the recognition of his quasi-professional standing. All these works, moreover, are signed with Hui Tsung's peculiar monogram (believed to signify either T'ienshui, his birthplace, or *T'ien-hsia i-jen*, 'first man under Heaven') in a perfectly convincing form, taut, crisp, and elegant.

FIG. 90 Emperor Hui Tsung, *The Five-Coloured Parakeet*. Boston, Museum of Fine Arts.

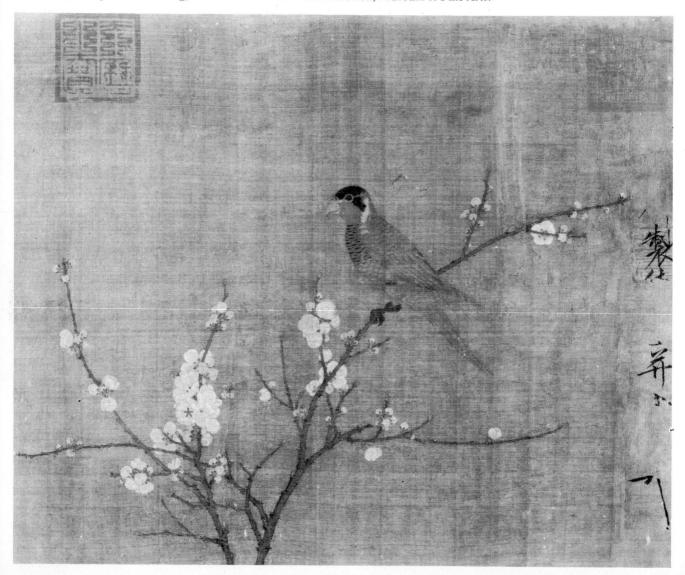

What all these flower-and-bird pictures demonstrate is a complete balance of form and feeling, of descriptive rigour and decorative charm. Their technique, renouncing the use of ink outline and relying on colour alone (*mu-ku*, 'boneless'), is inherited from Wu Yüan-yü, Wu's teacher Ts'ui Po, and Ts'ui's teacher Hsü Ch'ung-ssu from Nanking, grandson of the famous Hsü Hsi, whose works have perished. The designs too, no doubt, were a matter of tradition, perhaps raised to an incomparable level in Hui Tsung's faultless spacing that may in turn have set a standard for the flower-and-bird painters of the Southern Sung Academy. Landscape, by contrast, was a subject-matter in which Hui Tsung apparently took scant interest. A landscape does not lend itself to an exact portrayal of the kind preferred by the Emperor, the portrayal of finite objects, neatly observed, drawn from life (*hsieh-sheng*), and impeccably delineated.

FIG. 91 Emperor Hui Tsung, Calligraphy of *The Five-Coloured Parakeet*.

Notes

1. *Sekai Bijutsu Zenshū*, vol. 14, p. 304.
2. Pls. 10–12.
3. Ch. 5, 40.
4. Vol. 2, pl. 71.
5. *Tung-p'o t'i-pa*, ch. 5.
6. Soper, *Experiences*, p. 58.
7. Sickman and Soper, p. 209.
8. Sirén, *Bahr Collection*, pl. 3.
9. Reproduced in colour in *Three Hundred Masterpieces*, vol. 2, pl. 75.
10. Ch. 4.
11. Ch. 4.
12. Cf. Chu and Li, *T'ang Sung*, p. 219; Chang An-chih, *Kuo Hsi*, p. 2.
13. Hsieh Chih-liu, *T'ang Wu-tai*, no. 9.
14. No. 3 (1964).
15. Ch. 2.
16. Ch. 20.
17. *Kuang-ch'uan hua-pa*, ch. 6.
18. Wu Ch'i-chen, *Shu-hua-chi*, ch. 5, p. 539.
19. Maeda, 'The Chao Ta-nien Tradition', p. 247.
20. Bush, *Chinese Literati on Painting*, p. 22.
21. *CP*, VI, pls. 57–60.
22. *Hsüan-ho hua-p'u*, ch. 7.
23. Quoted in *Sung-shih*, ch. 444, s.v. Li Kung-lin.
24. Meyer, *Li Lung-mien*, p. 228.
24a. *Three Hundred Masterpieces*, pl. 141.
25. Lawton, *Chinese Figure Painting*, pp. 174 ff.
26. Whitfield, *Ch'ing-ming shang-ho t'u*, p. 131.
27. Ch. 6.
28. Chu and Li, *T'ang Sung*, pp. 114 ff.
29. Shimada, *Bijutsu Kenkyū*, no. 165.
30. *CP*, II, pp. 93–4.
31. Sickman, ed., *Crawford Catalogue*, no. 14; completely reproduced in Hsieh Chih-lu, *T'ang Wu-tai*, pls. 23–33.
32. Sickman, ed., *Crawford Catalogue*, p. 75.
33. Chang Ch'eng, *Hua-lu kuang-i*, quoted in Teng Po, *Chao Chi*, p. 9.
34. *CP*, III, pl. 234.
35. *CP*, III, pl. 238.
36. *CP*, III, pl. 240.
37. Rowland, 'The Problem of Hui-tsung'.
38. *CP*, III, pl. 230.

Painters of Southern Sung
(1127–1278)

Officially the story of the Southern Sung began in 1127, when Hui Tsung's ninth son, Chao Kou, was enthroned as Kao Tsung (reigned 1127–62). Yet 'the migration of the Court to the south was a complicated series of wanderings which filled eleven years'.[1] Only in 1138 was the new capital fixed at Lin-an (Hang-chou). Although the dynasty came to an end in 1279, the Mongols had made Yen-ching (Peking) their capital as early as 1264, and had occupied Lin-an in 1276, receiving the submission of the third to last Sung emperor, then a child of six, in the same year. Those 138 years of Southern Sung rule were troubled by conflicts with Chin Tatars and their more fearsome successors, the Mongols; by heaven-sent calamities such as earthquakes, floods, fires, locusts, and famines; and by the misdeeds of disloyal ministers, such as Chia Ssu-tao (assassinated in 1275), who in art-history is remembered for his less nefarious activity as a collector.[2]

As far as can be told from the extant works of Southern Sung painters, there seems to have taken place a process of increasing uniformity or standardization, contrasting with the almost breathtaking diversity of the preceding period. For the first time it seems possible to characterize the art of an historical time span in fairly specific terms.

The subjects reveal a retreat from the stark realism encountered in some works before. The world that invites us is idealized, freed from the gross concerns of existence, where man does not act but contemplates, aware of his own being. His surroundings are no longer described in full but suggested. In a refined simplification of the ink technique, modulated washes do away with the *ts'un* textures of rocks and cliffs. Volumes give way to almost incorporeal silhouettes. Ultimately the solids are so reduced that a landscape consists mainly of empty space. The atmosphere becomes accordingly important. It is observed and rendered with such mastery as to evoke some particular moment in time. Instead of the changeless and therefore timeless aspect of nature in earlier painting, there now appears a sense of transitoriness, of impermanence. A new 'image time' was created, with time subtly, and poignantly, condensed into a brief, intensely experienced moment. In painting, such condensed moments were expressed in events like sunset, dusk, and nightfall; a breeze, gusts of wind, or squalls; a sudden shower, a gentle rain, or clearing skies; the luminous haze of a summer morning, or the brewing fog in the early evening. All of this was realized with a few brush strokes and some more or less diluted patches of ink, in pictures of relatively small size, such as round fans, album leaves, and hanging scrolls. This technical mastery went hand in hand with terse and elegant form, in styles that stayed alive and fresh as long as they were sustained by discoveries in the visual world.

In this phase we are still at the mercy of traditional attributions, especially as regards the important Southern Sung holdings in Japan. It may to some extent be helpful, therefore, to know that in China there was some agreement as to the four great painters of that period: Li T'ang, Liu Sung-nien, Ma Yüan, and Hsia Kuei.

FIG. 92 Liu Sung-nien, *A Lo-han*. Dated in accordance with 1207. Taipei, National Palace Museum.

We are acquainted with Li T'ang (Fig. 83). **Liu Sung-nien**, a native of Ch'ien-t'ang (Hang-chou), entered the Academy as a student some time between 1174 and 1189; was promoted to painter-in-attendance after 1190; and was honoured with the award of the golden girdle after 1195, when he submitted to the Court his opus of *Pictures of Ploughing and Weaving*. Apparently his strength lay in genre and figure painting, and he seems to have cultivated a very elaborate, somewhat anti-quated style. When, for instance, Tung Ch'i-ch'ang (d. 1636) saw his scroll, *Returning Home in Wind and Rain*, he thought it to be a work of Fan K'uan (c.1000). Of another work of Liu Sung-nien's, *Ch'eng Wang Enquiring About the Tao*, Sun Ch'eng-tse (d. 1676) said, even more pointedly, that it was 'neither in the manner of Southern Sung nor of the Academy'.[3] This surprising judgement is borne out by a few works credibly attributed to Liu Sung-nien, such as the *Lo-han* of 1207 in the National Palace Museum, Taipei (Fig. 92), and *The Drunken Priest* of 1210 in the same collection.[4] They are pictures that overwhelm by multitudinous detail, meticulous execution and sheer skill, but lack expressiveness and warmth. Another hanging scroll in Taipei, *Conversation with a Guest in a River Pavilion*,[5] which Sirén was inclined to accept as an original work of Liu's, is provided with a signature that may not be genuine but at any rate tells what kind of picture was likely to be taken as his at some later date. This scroll, whose orange-tan silk seems rather too well preserved for its presumed age, parades Southern Sung motifs and romanticism in the obtrusive manner of the fifteenth-century academicians, such as Tai Chin (see Fig. 93). The charm of its motifs is worn, its precision purposeless, not to say destructive. How contrived is the rock in the lower right corner, a scrag, smallishly defined, whence rises—not scrubby brush, but a majestic pine. The prunus tree in the opposite corner, lifted perhaps from Ma Yüan, harmonizes with nothing else in this picture. We need not speak of the disquieting shape of the over-hanging cliff and its absurdly lush vegetation. No Sung master ought to be held responsible for a jumble of this kind, while some of the Ming followers might, for there is no reason to doubt Liu Sung-nien's Sung rationality.

Still, judged by whatever acceptable work of his, Liu is dwarfed by virtually any of the works that go under the names of Ma Yüan and Hsia Kuei, his contemporaries and fellow academicians.

Ma Yüan (active c.1200) was a fourth-generation descendant of a veritable dynasty of Academy painters from Ho-chung (Shensi), whose genealogy is given here:

Ma Fen (c.1100)
|
Ma Hsing-tsu (c.1130)

Ma Kung-hsien (c.1160) Ma Shih-jung (c.1160)
|
Ma K'uei (c.1190) Ma Yüan (c.1200)
|
Ma Lin (c.1230)

FIG. 93 Attributed to Liu Sung-nien, *Conversation with a Guest in a River Pavilion*. Taipei, National Palace Museum.

Ma Yüan, who was active under the emperors Kuang Tsung (reigned 1190–4) and Ning Tsung (reigned 1195–1224), may possibly rank as the foremost Southern Sung painter—not despite but rather because of a certain limitation of his pictorial world, a limitation that somehow seems to make his works so readily identifiable. The works attributed to him are many, however, and far from uniform. Rarely direct or simple, they range from an icy formalism as in *Tall Pines by a Mountain Lodge in Snow* (Fig. 94) to the profound feeling in the small fan picture of *Bare Willows and Distant Mountains* in Boston (Fig. 95). The former, a narrow hanging scroll, is a painting of great elegance, exhibiting every feature typical of the Ma style and done with a knowing delight in formal problems; its authenticity, however, is by no means certain and was rightly questioned by Sirén. *Bare Willows and Distant Mountains*, which carries a convincing signature of Ma Yüan, takes us onto a higher plane. The forms are few and large, and they stand out with intensity. Tone and contours coincide, and the tone creates space and specific time and mood, while the lineament, or brush, is beautifully descriptive, crisp and natural—that is, unlaboured and spontaneous. The drooping curves of the boughs supply a kind of *leitmotiv*, echoed in the silhouette of the mountain and creating the sensation of a gentle touch of lament in this reposeful setting. Measured by this small fan picture, *Tall Pines* sinks to the level of affectation.

Another important work, ascribed to Ma Yüan by Kanō Tanyū (1602–74), is the unsigned *Landscape in Wind and Rain* of the Seikadō collection (Fig. 96), which, if the attribution stands, at once establishes Ma Yüan's place in the tradition of the heroic landscape as conceived by Fan K'uan (Fig. 48) and Li T'ang (Fig. 83). Much has changed here. The scenery is open and airy, and the atmosphere pervades the whole. As regards the motif, Ma Yüan is more selective and clear. A dark clump of windswept trees contrasts with the light, almost textureless cliffs rising in the distance. Although each leaf is outlined exactly in the manner of the earlier masters, the foliage is not dense and tangled; each kind of tree is neatly and expressively silhouetted. Gone is the painstaking *ts'un* technique of texturing and modelling the mountain surfaces. It is replaced by a few light washes applied to mountains of straight contours and flattened appearance. But the shapes of the rocks on the near slope are diversified and strong, unlike the neat crystalline shapes customarily seen in a 'typical' Ma Yüan. The wind and the rain are unobtrusively but unmistakably indicated by the tree silhouettes and light diagonal washes respectively; they are the elements that determine to a large extent the painting's mood and sense of time, which is momentariness within a stable world.

That feeling of transience is even more poignantly present in a vertical scroll entitled *Banquet by Lantern-Light* in the Palace Museum at Taipei (Fig. 97). It is a garden-like landscape composition in horizontal layers, suggestive of the last dim light of dusk. A row of weirdly gesturing prunus trees in the foreground separates us from a courtyard, upon which opens a stately hall. Behind the hall is a darkish bamboo grove shrouded in mist. A faintly luminous haze above the grove is in turn overlaid by a dark mist, from whence there emerge distant, steep crags, which gather the fading light. Two very tall pine trees rising over the bamboo grove closely resemble the pines of the Seikadō landscape (Fig. 96). 'Every detail of style and composition points to the hand of Ma Yüan', in the judgement of the authors of the

FIG. 94 Ma Yüan, *Tall Pines by a Mountain Lodge in Snow*. Taipei National Palace Museum.

1961 exhibition catalogue, *Chinese Art Treasures*, a judgement I concur with un-reservedly—implying as it does the rejection of another version of this composition, also in the Palace Museum.[6] This latter version distorts the design by the addition of trees and buildings, and is marred by a forged double-dragon seal purporting to be of the reign of Hui Tsung and thus anachronistic.

FIG. 95 Ma Yüan, *Bare Willows and Distant Mountains*. Fan painting. Boston, Museum of Fine Arts.

FIG. 96 Attributed to Ma Yüan, *Landscape in Wind and Rain*. Tokyo, Seikadō collection.

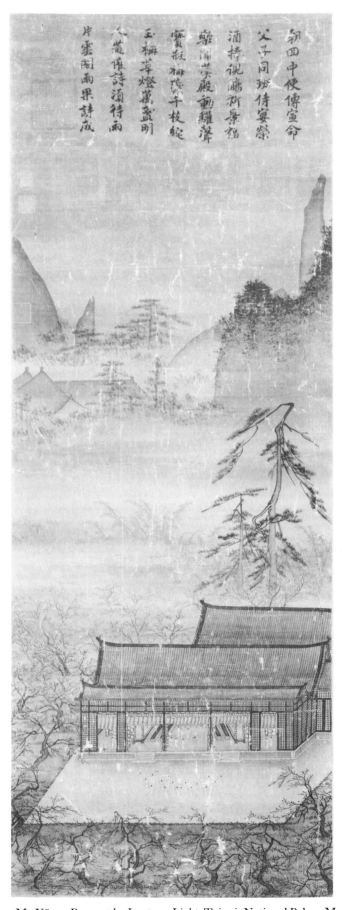

FIG. 97 Ma Yüan, *Banquet by Lantern-Light*. Taipei, National Palace Museum.

As recently as 1958 the Peking Palace Museum published a previously unknown album of *Twelve Views of Water* with titles and short dedications inscribed on each leaf by Lady Yang Mei-tzu (second consort of Ning Tsung, reigned 1195–1224) and provided with colophons of Ming writers, who are agreed on Ma Yüan's authorship. The theme of water, which had fascinated some painters as far back as the tenth century (Sun Chih-wei) and was fully mastered by the early twelfth (Chang Tse-tuan, Fig. 82), was now seen and recognized as a pictorial motif all by itself. Capturing the forms that water takes in streams and rivers, lakes and oceans, Ma Yüan ties them to light and atmosphere, to space and infinity. There are the sharply observed images of choppy water with patches of fog on a breezy morning; of the eddies forming around a shoal; of big swells and the froth of breakers; of the turmoil of counter-currents in the Yellow River; and of the dizzying expanse of evenly rippled lake waters. The formulation of small ripples on a lightly heaving surface has an almost hypnotic effect, as in *A Gentle Breeze on Lake Tung-t'ing* (Fig. 98). The series is presented quite unpretentiously, in ink on silk, and with a sketchy freshness; 'the versatility of the brushwork is extraordinary', in the judgement of Robert J. Maeda,[7] who concludes his discussion with the following quotation from the colophon by Li Jih-hua (1565–1635): 'Ma Yüan had obtained the essence of water by capturing its sense of momentum (*shih*).'

The fact that there exists no monograph on Ma Yüan in a Western language so far is only in part explained by the fortuitous state of our researches. A weightier factor seems to be the current disinclination among Western scholars to recognize the values at stake. As recently formulated, 'Japanese critics have always admired the works of Li T'ang, Ma Yüan and Hsia Kuei, and they have been widely appreciated by critics in the past. But more recently there has been a tendency, for the most part as unwarranted as it is unfortunate, to deprecate their achievement and minimize their value.'[8] Dealing with this matter earlier, Sherman E. Lee, in defence of what he called the 'great collective contribution' of the Ma school, had already explained that this tendency had arisen precisely because the admiring critics were not Chinese nor of the present generation.[9] Be that as it may, until the task of sifting Ma Yüan's oeuvre is done, an appraisal of his art is bound to remain tentative and subjective.

With this caveat duly stated, we may posit that the early Ma Yüan must to some extent have resembled Li T'ang (minus his descriptive profuseness), while the late Ma Yüan may have come close to Hsia Kuei (if lacking his ease and naturalness). The record of Ma Yüan's elders is hardly more than a blank, and there are no dated works of his to go by. Another difficulty: he is said to have signed some of his paintings with the name of his son, Ma Lin, intending to contribute to his son's success. To try and separate his personal contribution from all that he had inherited from either family or academic tradition is an almost hopeless undertaking. Still, relying on the stylistically consistent works, we feel time and again the presence of a strong artistic intellect that asserts itself in compelling images. Though terse and selective, they are complete; lyrical and tender, they have a severe overtone and virile form; while capturing the sensation of infinity, they forcefully suggest also change, impermanence, and finiteness, the finiteness not of space but of life. It seems as if these deeply tranquil landscape harmonies carried a message, intimating

that we serenely accept the transitoriness of existence. Ma Yüan's forms posses
grandeur, and his human figures dignity, however humble their station.

The presumably somewhat younger **Hsia Kuei** from Ch'ien-t'ang (Hang-chou
Chekiang), an Academy member under Ning Tsung, was rated peerless among the
academicians after Li T'ang, much as Ma Yüan was praised as one who walked
alone. Obviously the two men were almost equally esteemed. The early Ming *Ko-ku
yao-lun* (1387), however, makes a fine distinction between them when saying that
'in composition and the texturing [of rocks], Hsia Kuei's landscapes are no different
from Ma Yüan's. But, in their conception there is a flair for ancientness and sim-
plicity . . .'[10] A few years earlier the venerable Doctor Wang Li (b. 1332), to whom
we shall return later on, had written in praise of Hsia Kuei's paintings that 'if
rough, they did not drift into vulgarity; if delicate, they did not drift into pretti-
ness.'[11] Though brief and simple, these appraisals by fourteenth-century writers
point to an essential, and lovable, quality of Hsia Kuei's paintings, a quality that
sets him apart from the formidable Ma Yüan: there is no effort toward elegance, no

FIG. 98 Ma Yüan, *A Gentle Breeze on Lake Tung-t'ing*. Album leaf. Peking, Ku Kung Po-wu-yüan.

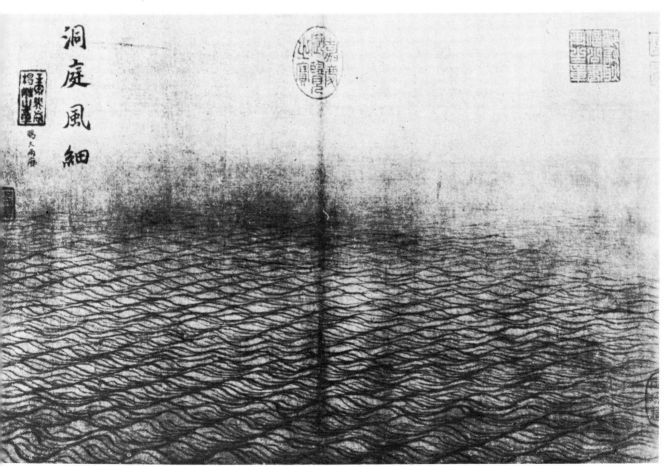

exhibition of skill, no trait of vanity. The dramatically bent and twisted pines of the
Ma school are replaced by less conspicuous types of deciduous trees; the sometimes
forbidding precision of Ma's architecture gives way to rustic abodes drawn with a
free hand and blending into their surroundings as if they were part of nature.
Even Hsia Kuei's figures appear to be humbler folk than Ma's aristocratic types,
although he may simply have been less interested in the human figure than Ma
Yüan and therefore indifferent toward specific characterization.

Of the many works attributed to Hsia Kuei, perhaps no more than six or eight
are likely to be nearly generally accepted. One of them, a leaf in a famous album in
Japan, where it is known as *Hikkōen*, 'A Brush-Tilled Garden', states the case for
Hsia Kuei convincingly. What it shows is a landscape in rain and fog (Fig. 99). In
the middle foreground rises a low hillock with tall trees in wet foliage, half hiding a
house that looks toward a mist-shrouded lowland on the left side, where we notice
the faint gleam of a meandering stream. At some distance there descends diagonally
from the right a slope, marked by the blurred silhouettes of trees at the top and with

FIG. 99 Hsia Kuei, *Rainy Landscape*. A leaf from the album known as *Hikkōen* (*The Brush-Tilled Garden*). Japan, formerly in Marquis Kuroda's collection.

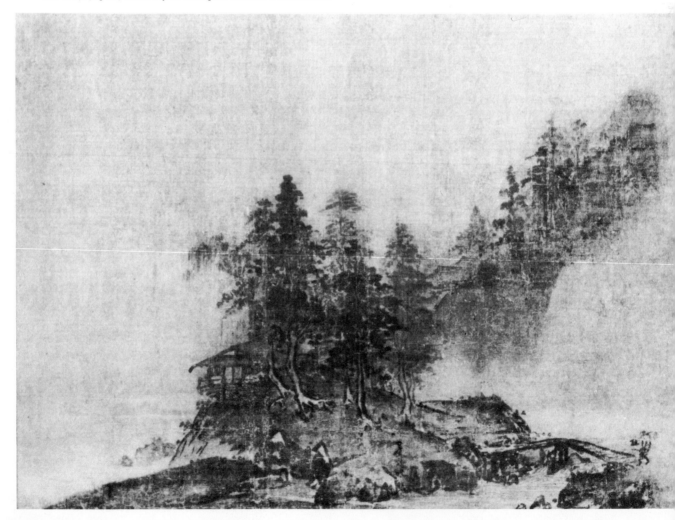

drifting fog concealing its base. A man carrying a load on his shoulders approaches the hillock over a bridge from the right; his very unobtrusive figure is given weight by his isolation against the large empty area of fog beneath the slope. The forms of the terrain, the tree trunks and the architecture are defined by carefully placed, crumbly lines and washes. Blurred dabs of darker or lighter ink define the varied foliage of the trees, their position in space, as well as the atmosphere. The motif is simple, indeed commonplace, and wanting the beauty and grandeur of such works as the *Landscape in Wind and Rain* by Ma Yüan (Fig. 96) or the Palace Museum Li T'ang, *Whispering Pines in the Gorges*, of 1124 (Fig. 83). There is no technical elegance, no display of skill. Instead, we are faced with something more profound, as if it were nature itself. The painter's partly effaced signature is placed prominently below the tree farthest to the right on the hillock.

Of another work of Hsia Kuei's, a handscroll entitled *Twelve Views from a Thatched Cottage*, there exist several versions. Their combined testimony leaves no doubt that an incomplete version of no more than four of the *Views* in the Nelson

FIG. 100 Hsia Kuei, *Boats Returning to the Mist-Shrouded Village*. Section from the handscroll *Twelve Views from a Thatched Cottage*. Kansas City, Nelson Gallery and Atkins Museum.

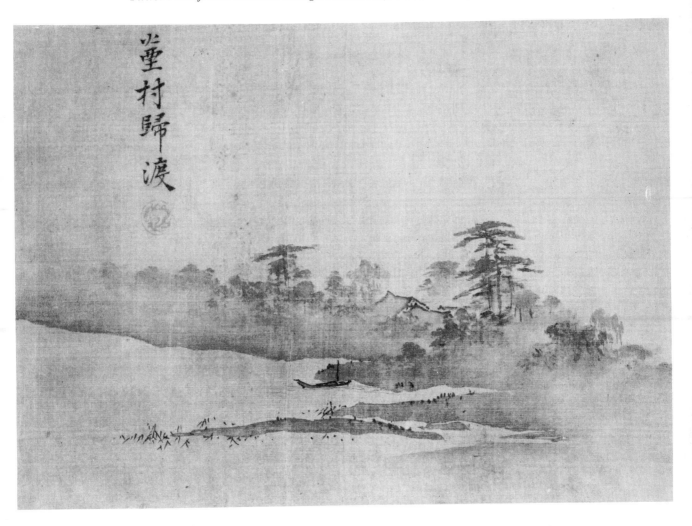

Gallery at Kansas City can alone claim to be the original. Establishing as they do the existence of a Hsia Kuei scroll that they imitate with great skill, the copies, among which Sheng Mou's of 1343 at the Metropolitan Museum appears to be the earliest, are valuable evidence indeed. Admirable in its technical perfection and poignantly nostalgic mood is the passage of *Boats Returning to the Mist-Shrouded Village* (Fig. 100). The village is suggested by two roofs surrounded by mist-enveloped bushes and a few tall pines along the near portion of a drawn-out shore-line. The whole of this vista, executed in extremely fluid ink, forms a coherent unit in which no part can be separated from the rest. Only a few boats stand out as sharply defined and isolated elements, and they intensify the viewer's feeling of the atmosphere and the sinking light. The following two scenes, designated as 'A Fisherman's Flute, Clear and Remote' and 'Mooring at Night by a Misty Bank'—in the handwriting of Emperor Li Tsung (reigned 1225–64), according to the colophon of 19 March 1562 by Wang Ku-hsiang—are slightly more descriptive than the preceding passage, more in keeping with the Ma–Hsia tradition at large.

A third example of this master's hand agrees closely with the *Rainy Landscape* (Fig. 99) and like the latter presents his mature or possibly late style: the *River-scape on a Breezy Day* in the Museum of Fine Arts, Boston (Fig. 101). A fan picture that has somewhat suffered with age, it is painted in ink on silk, with a joyous bravura, fresh, rough, and dynamic. The marvellous windswept trees on a rugged promontory take us well beyond the stage of the Seikadō Ma Yüan, *Landscape in Wind and Rain* (Fig. 96), where foliage still was the sum of precisely drawn leaves, while here it is suggested by a mass of blunt yet expressively ordered dabs. The rocks are coarsely drawn, unlike the neat geometric formations typical of so many Ma–Hsia school pictures. A noteworthy feature is the clear correspondence between the silhouettes of the terrain to the left of the trees and of the mountain emerging from the dense haze beyond the river, the presence of which is only revealed by the sailboat on its down-wind course.

Time and again we become aware of the importance of light and darkness and the atmosphere in these landscapes of Hsia Kuei and Ma Yüan. It is the importance of such phenomena as are apt to evoke a particular moment in time, an 'image time', contrasting with the 'timelessness' of earlier landscapes. Apparently this concern with the fleeting aspects of the landscape image did not escape the contemporary· critics. The author of an essay on painting entitled *Tzu-yen lun-hua* written toward the end of the twelfth century in fact presents what amounts almost to a theory about the efforts of the leading landscapists of that period. He writes:

> Mountains in rain, mountains in sunshine: the painters have no difficulty in depicting them. But [phenomena like] fair weather turning to rain; or rain about to cease; the fog at night; the mist at evening as it parts and then closes again; a vista obscured, appearing no sooner than being submerged into nothingness: these are difficult to depict. Unless it be an artist of marvellous ability [recognized] in the world, one whose concepts transcend the ordinariness of things, he certainly cannot attain it.[12]

The kind of subject-matter here outlined appears to have preoccupied the landscapists in and around the Academy almost till the end of Sung. There was a price

to pay, however. The more intense their images of mist-filled space, of breezy mornings or quiet dusks became, the less they contained of clearly defined solids. It was as if the substance had been eaten away by the vibrant void.

FIG. 101 Hsia Kuei, *Riverscape on a Breezy Day*. Album leaf. Boston, Museum of Fine Arts.

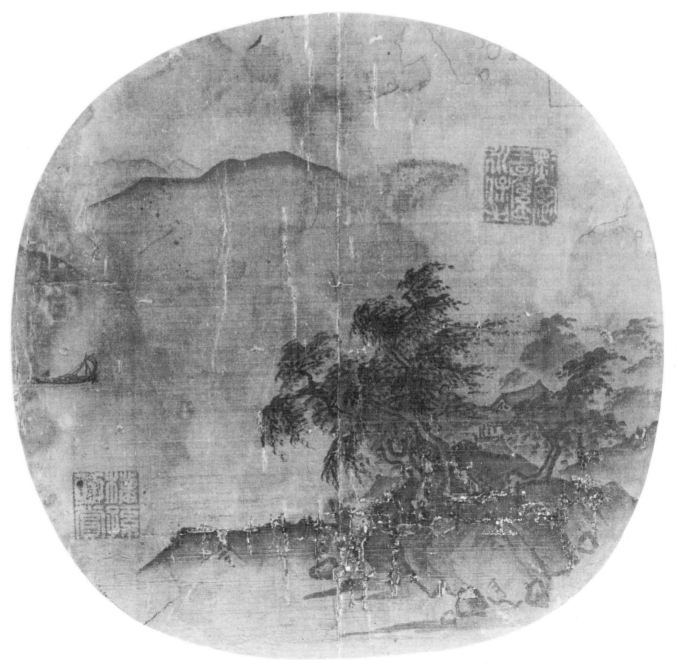

Ma Lin, the son of Ma Yüan and a fifth-generation descendant of Ma Fen, who probably was born about 1180/90, has left one of the most memorable and representative late Sung landscapes, which in its drastic reduction of solid matter clearly points in the direction of the development just described. *The Evening Sun* in the Nezu Museum, Tokyo (Fig. 102), is a painting of moderate size in ink and some colour on silk, which has become grey with age. Two staggered slopes in graded ink tones cut into the picture plane from the right at some distance. Further away a bluish grey rock rises up as a faint silhouette with a clear obtuse-angled contour. Streaks of reddish clouds above it indicate the hour of sunset. There is no foreground proper, but four swallows fluttering near the lower edge function effectively in its stead. The signature in the lower right corner reads '*ch'en* Ma Lin', indicating that the picture was submitted to the Court. Indeed, the monumental ten characters filling the immense expanse of the sky were inscribed by the Emperor Li Tsung. His couplet,

> The mountains hold the colours of approaching autumn,
> The swallows flit about in the late evening sun,

is followed by two small seals reading *chia-yin*, a cyclical year corresponding to 1254; three small, written characters saying 'presented to the Princess'; and a large seal that reads *yü shu*, 'Imperial writing'. The year 1254 provides a safe *terminus ante quem* or, even more likely, *ad quem*, on the assumption that Li Tsung added his couplet and brief dedication to the Princess when the painting was new, perhaps commissioned by him as a gift for his daughter and only child, who then was ten years old.

Being dated, the place of this exquisite work in Ma Lin's oeuvre is certain. It is a late work, done in his sixties if not seventies, with the masterly economy and precision of an experienced hand. There exists another dated work that offers a glimpse of what Ma Lin had accomplished nearly four decades earlier. It is a work entitled *Plum Blossoms*, which is accompanied by a quatrain written by the empress of Ning Tsung (reigned 1195–1224), Lady Yang Mei-tzu (d. 18 January 1233), and dated by a seal that gives the cyclical year *ping-tzu*, corresponding to 1216 (Fig. 103). Kept in the Peking Palace Museum, the painting shows a most sparing design of two boughs, meticulously drawn and fastidiously placed on a wide, empty plane. It might almost have been inspired by a Hui Tsung. Both descriptive and lyrical, it is quite dissimilar from the style of his *Sunset* of 1254. One may feel tempted to think that in his early years Ma Lin made a serious effort to broaden his stylistic basis beyond that of his family tradition, with which he had to, and did, come to terms in his mature years. Perhaps it was in apprehension of his son's straying from the family style that Ma Yüan bethought himself of signing works of his own with the name of Ma Lin. Since Ma Lin could not well disown his father's well-meant frauds, he unavoidably became committed to the Ma style. Most of the Chinese texts intimate that Ma Yüan meant to insure his son's success; a few are more critical, however, demanding recognition of Ma Lin's excellence or even of his superiority to his father.[13].

The examples of 1216 and 1254 do not exhaust the store of dated works by, or attributed to, Ma Lin, not to mention the larger body of undated ones. None of the

former category seems fully convincing, except perhaps a set of eight flower studies again of 1216 ('1276' in Sirén's *List*), which is a work of small import, however. Among the undated paintings, *Fragrant Spring: Clearing after Rain* in the Palace Museum, Taipei, stands out as an unconventional, strongly personal statement (Fig. 104). Though technically concordant with the Ma-Hsia style, its composition focusing on the middle ground, its emphasis on a tangled and twisted design of the

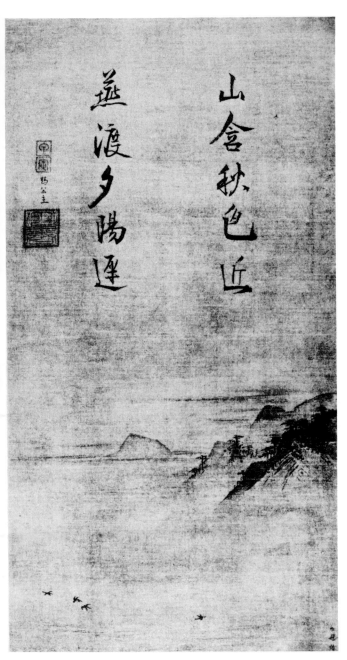

FIG. 102 Ma Lin, *The Evening Sun*. 1254. Tokyo, Nezu Museum.

FIG. 103 Ma Lin, *Plum Blossoms*. 1216. Peking, Ku Kung Po-wu-yüan.

trees and its pathetic expression are features that separate it from the ideal of perfect clarity and harmony of that style, typified by Ma Yüan's *Bare Willows and Distant Mountains* (Fig. 95). Ma Lin's forms are so tortuous and restless that they convey a feeling of suffering. The title was written by Lady Yang Mei-tzu, providing a *terminus ante* 1233.

More puzzling is a recently published large hanging scroll in colour on silk, signed Ma Lin, and titled *Hibiscus at Dawn*.[14] Contrary to common Sung practice and contrasting utterly with the *Plum Blossoms* (Fig. 103), the picture does not isolate a sprig or two on empty ground but instead is filled with a large, profusely flowering shrub that grows by a water where the disk of the sun is reflected. With astonishing realism the painter has depicted the fog that hangs in the plant and over the water, blurs or blots out portions of the foliage and the flowers, and dims the atmosphere. No ink is used, only colour, in subtle chromatic values: a technique of long standing called *mu-ku* or 'boneless', and applied particularly in flower painting. *Hibiscus at Dawn* has not been discussed or subjected to any test thus far; if found acceptable it would much enlarge Ma Lin's range, and that of Southern Sung as well.

FIG. 104 Ma Lin, *Fragrant Spring : Clearing after Rain*. Taipei, National Palace Museum.

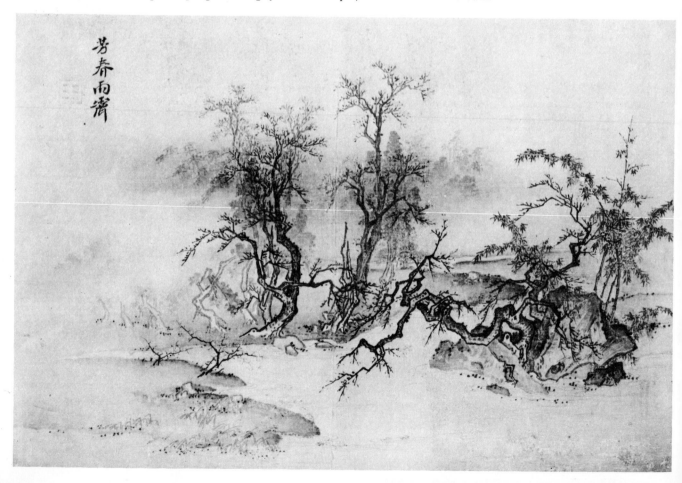

Liang K'ai, from Tung-p'ing in Shantung, presumably was slightly older than Ma Lin since he was appointed *tai-chao* or painter-in-attendance as early as the Chia-t'ai years (1201–4) in Ning Tsung's reign. He stands clearly apart from the Ma–Hsia school. The *T'u-hui pao-chien* of 1365[15] speaks of him as a painter of figures, landscapes, Taoist and Buddhist subjects as well as of supernatural beings, relating that he was a pupil of Chia Shih-ku, himself a follower of Li Lung-mien's technique of outline drawing or *pai-miao*, 'blank drawings'. From the same source we learn that Liang K'ai, having been honoured by the award of the Golden Belt, left the Academy; that he was fond of liquor; and that he liked to speak of himself as Liang the Fool. And further, that although he was generally admired by his fellow academicians for the exquisiteness of his works, what is now left of them is coarse—spoken of as 'abbreviated brush'. Free from official obligations, Liang K'ai apparently became associated with the Ch'an Buddhist monasteries around Lin-an. Much of the subject-matter of his extant or recorded paintings is Ch'an-oriented, and some of them bear eulogies (*ts'an*) written by Ch'an priests. Consequently he is regarded as one of the foremost Ch'an artists of Southern Sung, notwithstanding his status of layman and ex-academician.

Attempts to trace his stylistic range are not wanting,[16] but they were hampered by the lack of a convincingly early work. What was taken to represent the early Liang K'ai because of the wording of his signature, 'painted in the presence of His Majesty', is the famous *Buddha Leaving the Mountains* in the Shima Eiichi collection, Tokyo (Fig. 105), which is a mature, possibly even a late work, in the estimate of Dietrich Seckel.[17] Although the phrasing of the signature indicates that this noble and doubtless authentic work antedates Liang's abrupt withdrawal from the Academy, there is no reason to assume that this happened in his early years; the rank of *tai-chao* presupposes maturity, as borne out by the painting itself.

'The mountains' are conceived as a sphere of terrifying loneliness. Slanting walls of bleak untextured rock form a narrow defile, from whence the strangely motionless figure of the ascetic Sākyamuni emerges, not walking but floating, as it were. His haggard, bearded face, Indian rather than Chinese in appearance, is so intensely introspective that we may feel that our eyes must not rest on it. His hands meet at the chest but are hidden under the robe—hiding, in Seckel's interpretation, the treasure of the truth. There is no sky and no depth and the atmosphere is sombre. The only sign of life is an old tree with leafless, prickly twigs. Its trunk, which cuts across the left edge of the picture, arrests the diagonally falling contour of the colossal wall of rock that passes closely behind the figure of the Buddha. Slightly higher up the tree returns again, spreading its shadowy silhouette against the foil of the pale wall. That enormous diagonal contour is treated with a downy softness, however, so that it resembles the edge of a curtain rather than that of a rock. Whether just opening or about to close, that 'curtain' seems to symbolize the beginning of a new phase in Siddhārtha's career: he who came here six long years earlier as a seeker of truth has found the truth; secure in his self-won knowledge of the human condition he returns to the world. It is hard to imagine that Chinese humanism produced any document of deeper sympathy toward Buddha.

The question of Liang's early style is settled, in my opinion, by the barely known scroll depicting the poet T'ao Yüan-ming (365–427) in the Palace Museum in

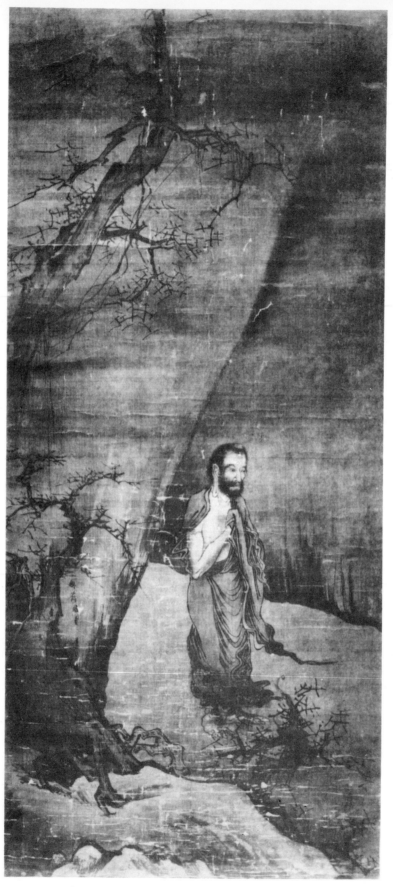

FIG. 105 Liang K'ai, *Buddha Leaving the Mountains*. Tokyo, Shima Eiichi collection.

Taipei. Entitled *The Scholar of the Eastern Fence* (Fig. 106), this scroll possesses the marks of an early work of Liang K'ai while at the same time it is clearly compatible with his *Buddha Leaving the Mountains*. The type forms agree with academic conventions not far removed from the Ma–Hsia style; the execution is elaborate and descriptive, wanting the strongly personal touch that distinguishes the later work; and the figure of T'ao Yüan-ming in particular is drawn in an orthodox manner, with an appropriate Six Dynasties flavour in costume and design. An imposing, tall pine tree of almost Northern Sung complexity, silhouetted against the misty open space, is the largest element in the composition and determines its character to a large extent. Liang K'ai's signature in the lower right corner looks convincing, and the painting was in such eminent collections as those of Hsiang Yüan-pien (1525–90) and Liang Ch'ing-piao (1620–91), to mention that much as to its pedigree. But for his signature we might be entirely in the dark as to Liang's authorship. It is only in hindsight that we are able to see a connection with his mature style.

A fan-shaped album leaf entitled *Strolling on a Marshy Bank* in the Crawford collection, by contrast, agrees readily with the style of *Buddha Leaving the Mountains*, going perhaps even further in reducing scenery to a few bleak components (Fig. 107). In this dismally bare and uninviting world, virtually without vegetation, an oppressively overhanging rock of gigantic dimensions dominates; it is untextured save for an area at the top, above darkish layers of cloud streaking straight across the rocky mass. A body of water is defined by very dark, narrow spits of land darting forth from underneath the big rock. On the 'marshy bank' in the foreground a lonely figure walks past the viewer. Small, erect, and crisply drawn, it holds the entire design together. The picture is signed, but there are no ancient seals providing a pedigree. Proof of its existence by the fourteenth century is provided, however, by a copy of sorts made by no less a painter than Fang Ts'ung-i of the late Yüan to early Ming period.[18]

A famous pair of figure paintings may date from the time when Liang K'ai was no longer connected with the Academy: *Chopping Bamboo* in the Tokyo National Museum and *Tearing Up a Sūtra* in the Mitsui Takanaru collection. Often reproduced,[19] these paintings represent, according to a Japanese tradition, Hui-neng (638–713), the sixth patriarch of the Zen Sect in China. Yet neither Tanaka nor Fontein insists on this identification. The figures may portray two nameless archetypes of the Zen monk who has attained enlightenment. Their garments are not rendered descriptively but symbolically, in flashing strokes of great energy that express quiet concentration in the case of the one who wields his knife and a furious outburst in the case of the other. Their acts, themselves, are symbolic: submitting to a workaday task, or displaying the final independence from scripture, both are typical acts and may apply in more than one instance to the lives of the Zen masters. The two paintings were in the collection of the Shōgun Ashikaga Yoshimitsu (1358–1408), and thus must have come to Japan around 1400 at the latest. The fact that the pair became separated long since may account for their unequal state of preservation.[20]

Liang K'ai's famous portrait of the poet Li T'ai-po (701–62), again in Japan (formerly Count Matsudaira), may be a very late creation of his (Fig. 108). The drawing is extremely simplified, yet, except for the fully defined head, surprisingly

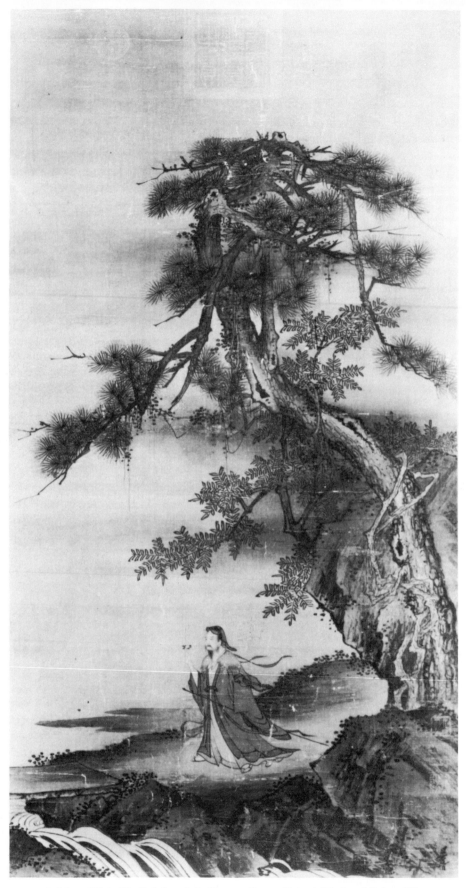

FIG. 106 Liang K'ai, *The Scholar of the Eastern Fence*. Taipei, National Palace Museum.

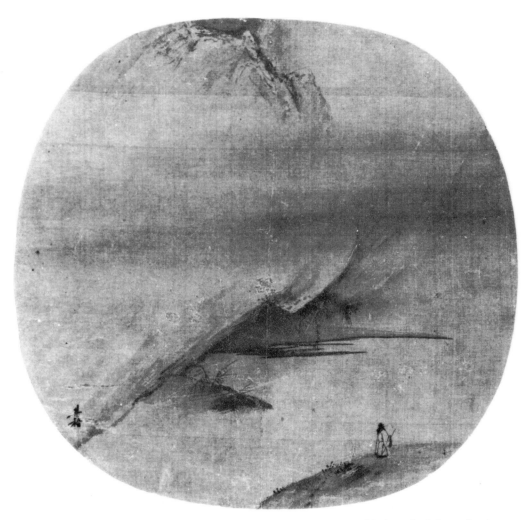

FIG. 107 Liang K'ai, *Strolling on a Marshy Bank*. New York, John M. Crawford, Jr., collection.

vague; by Sung standards, the outlines of the cloak are shapeless, and what corresponds to the hem and feet is unreadable. But the slightly raised head has a beatific aura about it that is unforgettable—and enough for a contemporary Western critic to feel that here we have one of the great images of man in world art.[21] The large seal has never been deciphered. Even so, being written in the Mongol square script devised by the Tibetan monk hPhags-pa (1239–80) about 1269, during the reign of Kublai Khan, its presence vouches for the painting's ancientness.

Fa-ch'ang, better known as **Mu-ch'i**, who came from Szechwan to Lin-an, presumably was the most eminent of the Zen monk painters at the end of Southern Sung. His lifetime spanned approximately the years from 1200 to 1270. This may be inferred from the likely difference in age from that of his ecclesiastical mentor,

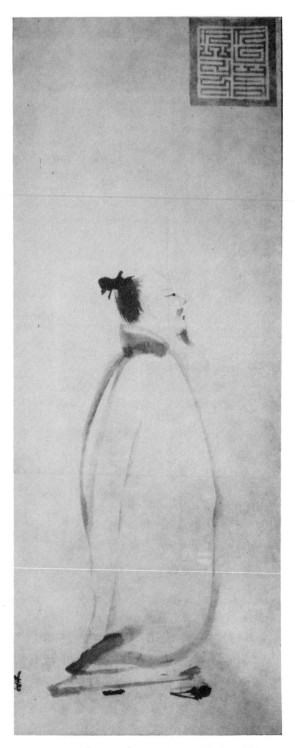

FIG. 108 Liang K'ai, *Li T'ai-po*. Tokyo, National Museum.

the Zen master Wu-chun (c.1175–1249), and from the fact that his *Tiger* picture at the Daitokuji in Kyoto bears a date corresponding to 1269. The assumed life span accords well with that of the Japanese priest Shōichi Kokushi (1202–80), who during a sojourn in China between 1235 and 1241 became Mu-chʻi's co-disciple under Wu-chun, then the abbot of Ching-shan-ssu at the West Lake and a painter of modest achievement himself. A few of Wu-chun's works left today such as a triptych in the Tokugawa Art Museum, Nagoya,[22] and a scroll in the Crawford collection, New York[23] appear to be modelled on the late Liang Kʻai, who doubtless also influenced Mu-chʻi to some extent. (The assumption that Liang Kʻai, on the contrary, was a follower of Mu-chʻi is erroneous on chronological grounds. According to Wang Chih-teng's *Kuo-chʻao Wu-chün tan-chʻing-chih*, Mu-chʻi died in 1239, aged 63, which is incompatible with the 1269 date of the Daitokuji *Tiger* and not likely in view of the older Wu-chun's demise in 1249. Sun Ta-kung, on the other hand, takes Mu-chʻi to be identical with one Fa-chʻang from Kʻai-feng whose family name was Hsieh, and who was a priest at Wan-nien-ssu in the Tʻien-tʻai Mountains and died, according to Chʻen Yüan, in 1180.)[24]

As in the case of Liang Kʻai, all the important works of this painter are in Japan. Foremost among them is a triptych of *Kuan-yin* flanked by a *Crane* on the left hand side and a *Monkey* with her young on the right (Figs. 109–11), a set that bears the seals of Ashikaga Yoshimitsu (1358–1408).

The Kuan-yin is seated on a rock by a stream. Her posture and unseeing eyes reveal a state of deep meditation. An overhanging rock suggests a cavernous recess, whose depth is obscured by a mist. From the variegated greys of this setting stands out the lighter tone of the Bodhisattva's 'white robe'. Draped all around the body, hands and feet, it forms a kind of mantilla over the diadem and high chignon, leaving little beside the face exposed. Iconographically the subject represented is that of the White-Robed Kuan-yin (Japanese Byakue Kannon), one form of Avalokitesvara related to the Water-and-Moon Kuan-yin (Japanese Suigetsu Kannon) and the Willow-Branch Kuan-yin (Japanese Yōryū Kannon) of the esoteric sects, all of which forms existed as early as Tʻang.[25] A resplendent image of the Water-and-Moon Kuan-yin in late Tʻang style, also kept in the Daitokuji, reminds us of the fact that the ninth-century Chou Fang was credited with the creation of this type of image (Fig. 112).[26] Clearly reminiscent of Chou Fang's *Court Ladies Adorning Their Hair with Flowers* (Fig. 27), especially as regards the diaphanous draperies, that image, whatever the date of its actual execution, makes us aware of a profound shift in content between late Tʻang and late Southern Sung. The Tʻang type, male, exotically attired and gorgeously coloured, is an icon of decorative splendour but wanting inwardness; the face, a detail almost submerged in the design of the whole, has no memorable expression. Mu-chʻi's Kuan-yin, by contrast, is represented as a woman, in monochrome, and the greatly simplified composition concentrates on her face, which is of indescribable dignity, sweetness and composure. Her flowing robe, in diluted ink strokes of 'orchid-leaf' type—a fitting if trivial classification—seems to symbolize her mental powers, those of an almost divine being whose compassion equals the sufferings of the world. Among the extant images of the White-Robed Kuan-yin the present one is the oldest, according to E. Matsumoto.[27] It also is the best-documented work of Mu-chʻi, being both

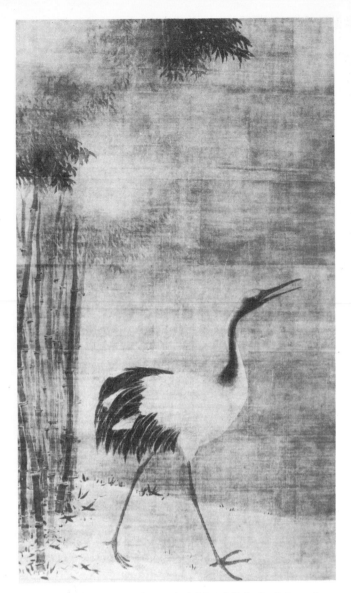
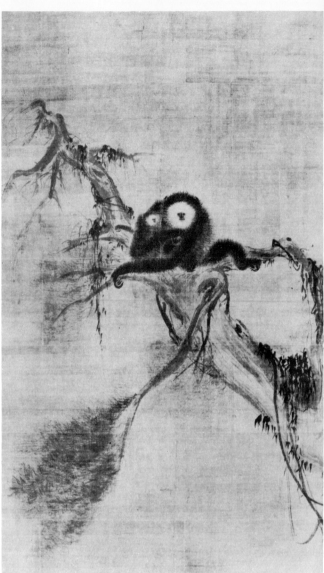

FIGS. 109, 110, 111 (opposite) Mu-ch'i. Left, right and centre hanging scrolls of a triptych. *Kuan-yin* is flanked by a Crane on the left and a Monkey with her Young on the right. Kyoto, Daitokuji.

signed by him and stamped with a seal of his, and is widely regarded as his most representative work. And, what must not be overlooked, it reveals a personality strikingly unlike Liang K'ai's: calm, objective, engaging, and seraphic.

Whether the companion pieces of *Monkey* and *Crane* (Figs. 109, 110) were painted to form a triptych with the *Kuan-yin* is an unresolved question. Nor do we know their meaning. It should be noted, however, that the theme of monkeys and cranes in contraposition was already established by the twelfth century, one case being recorded in a secular, another in a monastic setting. (The *Hua-chi* of 1167, tells of a mural of *The Hundred Monkeys* matched by one showing *The Hundred Cranes* in a pavilion built for a concubine of Emperor Hui Tsung.[28] A text of c.1190, *Tung-t'ien ch'ing-lu-chi*, mentions monkeys and cranes on the Lo-han Wall of a Buddhist monastery in Chekiang.[29]) What on purely formal grounds seems to tie the three paintings together is the presumably intended differentiation of the

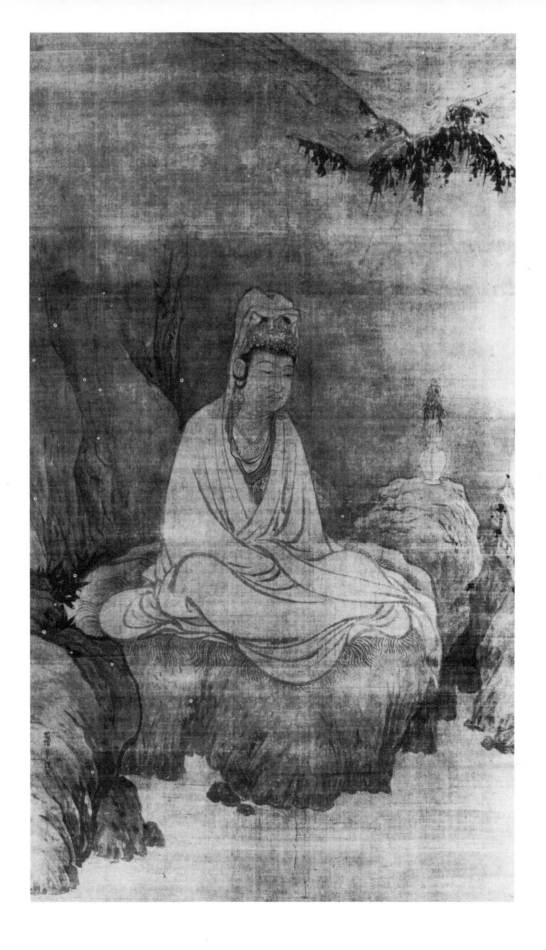

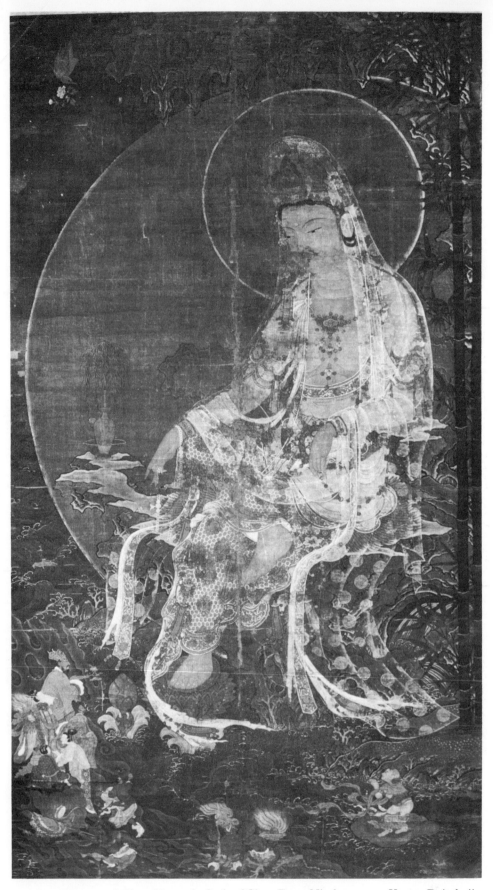

FIG. 112 *Water-and-Moon Kuan-yin*. Style of Chou Fang. Ninth century. Kyoto, Daitokuji.

position of the heads: the monkey's is *en-face*, the Kuan-yin's in half-profile, the crane's in profile. As paintings, these non-human creatures are no less admirably conceived and executed than the Kuan-yin. Most noteworthy are such details as the feet of the crane and the gracile, furry limbs of the monkey and her mysteriously geometricized features. The inexpressiveness of the monkey's face compared to that of the Kuan-yin might also indicate meaningful relationships between the three panels, but there is no clear-cut correspondence as far as the crane is concerned.

The *Lo-han* of the Seikadō Foundation, the *Tiger* and *Dragon* of 1269 at Daito-kuji, and the *Six Persimmons* in the same temple are paintings worthy of Mu-ch'i, as may be the *Shrike* in the Matsudaira collection and the *Sparrows* in the Nezu Museum.[30] Other works attributed to Mu-ch'i, figures, flowers and the like, are too coarse and superficial to be acceptable. Some of them may be from the hand of Moku'an, the Japanese follower of the master who travelled to China in 1326–8, where he was hailed as a second Mu-ch'i and given some original seal or seals of Mu-ch'i. The only landscapes that go under Mu-ch'i's name are four scenes from a handscroll depicting the *Eight Views of Hsiao and Hsiang*, a scroll that was cut into single scenes as early as the time of Yoshimitsu, whose *Dōyū* seal is affixed to each of the remaining four. There is, however, no seal or signature of the painter on any of them. Indeed, the Japanese scholars invariably designate these scenes as works not by, but attributed to, Mu-ch'i. Although of long standing, these attributions are not unequivocally supported by the style of these landscapes. In fact, someone ignorant of the attribution might see no connexion at all between the *Eight Views* and the works generally accepted as authentic. Some traits encountered in that series are foreign to the always precise and completely unambiguous definitions typical of the authentic works, on which Mu-ch'i's greatness rests.

The subject of the *Eight Views of Hsiao and Hsiang* is said to have been depicted first by the Northern Sung master **Sung Ti** from Lo-yang,[31] and two relevant titles are listed among his works in the catalogue of Emperor Hui Tsung's collection, namely *Autumn Evening at Hsiao and Hsiang* and *Eight Views*.[32] It is likely, however, that the Hsiao and Hsiang theme as such is far older since it is named in one of Tu Fu's (712–70) poems as the possible subject-matter of a landscape screen done by a contemporary official and amateur painter.[33] Today there seems to exist no earlier version of the *Eight Views* than the four scenes attributed to Mu-ch'i in Japan, of which *The Evening Bell of a Temple in Fog* is illustrated (Fig. 113). The title is one of the eight recorded by Shen Kua in his passage on Sung Ti. Remarkable not only for their poetic touch but also as testimony of an intense concern with atmospheric phenomena as early as late Northern Sung, these titles are as follows:

1. Wild-Geese Alighting on a Sand-Bar
2. Boats Returning from a Distant Shore
3. Mountain Village in Clearing Vapours
4. Snow at Dusk over Streams and Mountains
5. The Autumn Moon above Lake Tung-T'ing
6. Hsiao and Hsiang in Rain at Night
7. The Evening Bell of a Temple in Fog
8. Fishing Village in the Glow of Sunset.

FIG. 113 Attributed to Mu-ch'i, *The Evening Bell of a Temple in Fog*. Section of a handscroll *Eight Views of Hsiao and Hsiang*. Tokyo.

If for want of an earlier scroll of identical subject-matter we compare *The Evening Bell* with Hsia Kuei's thematically similar *Twelve Views from a Thatched Cottage* (Fig. 100), we notice these particulars: Mu-ch'i goes farther in blurring his forms— even in the foreground; his type-forms are unlike those of Hsia Kuei, being reminiscent rather of Mi Yu-jen's;[34] his technique, though relying on washes no less than did Hsia Kuei's, is wetter, faster, more random. There is no wide gap between the two works, but the later one seems to gain in expressiveness to the extent that it renounces descriptiveness.

The only instance of a later scroll on the topic of *Eight Views of Hsiao and Hsiang* is the work of one **Yü-chien**, three sections of which have survived in Japan.[35] *Boats Returning from a Distant Shore* (Fig. 114) in the Tokugawa Art Museum at Nagoya is one of them. The sail-boats, which account for the title, can be made out by two masts capriciously placed in the distance beyond a softly and hazily brushed-in bank and a stretch of open water that is characterized as such by the presence of a row-boat. To the right of the water there are concentrations of dark ink spatters suggesting rocks and vegetation. Ink patches in the lower right corner, rocks no doubt, are connected by a bridge that could not be represented more perfunctorily. A vertical dark blob in the foreground defies any specific interpretation. In sum, there are no complete shapes of any sort. They are dissolved into shreds of visible matter. Intuited as forms that may be unintelligible in terms of natural objects, these shreds count as representations only in so far as they possess directional energies and tone values that create an atmosphere, and only in their entirety do they read as landscapes. What, then, is the quiddity of a landscape such

FIG. 114 Yü-chien, *Boats Returning from a Distant Shore*. Section of a handscroll. Nagoya, Tokugawa Art Museum.

as Yü-chien's? Abstractness, spontaneity, the technical brilliance, or the visibility of the hand? All of these qualities count. But more important is the fact that in a landscape of this kind it is impossible to isolate any part. The forms are so interlocked that none can be removed. The landscape is conceived as an indivisible whole, not as an assemblage of discrete elements.

The three sections of the *Eight Views* are not signed, but each is inscribed with a poem of twenty-eight words in the seven-word metre, followed by a seal that reads *San-chiao ti-tzu*, 'Disciple of the Three Religions' (Confucianism, Taoism, Buddhism). However, a magnificent fragment of another scroll (in the Yoshikawa Eiji collection, Tokyo), the surviving section of which depicts the *Lu-shan Waterfall*, bears not only a poetic inscription of twenty-eight characters that may well have been written by the same hand but also the signature Yü-chien (Fig. 115).[36] The style of this *Lu-shan Waterfall*, too, is comparable to that of the *Eight Views*. Unfortunately there were no fewer than four late Sung to early Yüan monk painters named Yü-chien, as noted by Suzuki Kei, who is inclined to identify the painter with Yü-chien Jo-fen, a Tendai monk from Chekiang, without however definitely excluding Ying Yü-chien, a Zen monk at Ching-tz'u-ssu on the West Lake who painted landscapes in the manner of Hui-ch'ung.[37] If the affiliation with Hui-ch'ung, an early eleventh-century monk painter from Fukien, as stated in the *T'u-hui pao-chien* (preface dated 1365) is at all credible, it would all but rule out Ying Yü-chien's authorship, however. As for Jo-fen, to whom is accorded a longer entry in the same text,[38] which stresses his preoccupation with the subject of clouded mountains, Suzuki feels constrained to make allowance for the apparent Zen style of the work of a Tendai priest.

過溪　一笑意何殊中巖
風流入畫圖四首社賢
覓無重爐奉香冷水
靈祗

玉澗

FIG. 115 Yü-chien, *The Lu-shan Waterfall*. Section of a handscroll. Tokyo, Yoshikawa Eiji collection.

Zen Painters of Southern Sung. Some interpreters of late Sung painting are inclined to see the inspiration of Zen (Chinese, Ch'an) Buddhism in the stylistic achievement of that phase. Not a few eminent painters of the time were indeed Zen monks. But there was no stylistic uniformity among them. Their works do not form a clearly distinguishable group, nor can they be separated from either academic or scholar painters' traditions. If Paul Demiéville takes Western sinologues to task for having tended to exaggerate the importance of the Zen contribution to Sung painting, therefore, he doubtless has good reasons.[39] As early as 1946, however, Bachhofer found that 'there was no such thing as a special Ch'an style'.[40] Even so, a kind of Zen school with its unmistakable iconography and a style derived from the great Sung masters had come into being at least by Yüan times, a school that was to be transferred—along with Sung philosophy, Taoism and Confucian learning, to say nothing of Buddhist metaphysics—to Japan by the Chinese Zen priests seeking refuge there. Obviously this was the result of a previously unthinkable syncretism: 'Zen Buddhists are sometimes Confucianists, sometimes Taoists, or sometimes [in Japan] even Shintoists', in Daisetz T. Suzuki's astonishing characterization.[41] Like the scholar·painter, the priest who paints is a thoroughly Chinese figure.

Rather than assuming that late Sung art came into being under the influence of Zen Buddhism, should we not, perhaps, think of Zen painting as proof of the complete acceptance of Chinese aesthetics by the last—and least Indian—of the Buddhist sects in China?

Notes

1. Moule, *Rulers of China*, p. 88.
2. Two of his seals are found on the magnificent horse painting attributed to Han Kan, eighth century, in the Metropolitan Museum. See *CP*, III, pls. 99 & 100.
3. Chu and Li, *T'ang Sung*, p. 355; *Keng-tzu hsiao-hsia-chi*, ch. 3.
4. *Three Hundred Masterpieces*, vol. 3, pl. 109.
5. *KKSHC*, vol. 19; *CP*, III, pl. 308.
6. *KKSHC*, vol. 3; *Three Hundred Masterpieces*, vol. 3, pl. 111.
7. Maeda, 'The Water Theme', p. 255, with illustrations of the complete series.
8. John Knoblock in *Ancient Chinese Painting*, exhibition Lowe Art Museum, p. 16.
9. Lee, *History of Far Eastern Art*, pp. 354 ff.
10. David, *Chinese Connoisseurship*, p. 27.
11. *Hua-k'ai-hsü*, apud *Ch'ing-ho shu-hua-fang*, ch. 10, 38b; Chu Li, *T'ang Sung*, p. 169.
12. Ch'ien Wen-shih from Ch'eng-tu, apud *Chung-kuo hua-lun lei-pien, shang*, p. 84.
13. *Shan-hu-wang*, as quoted in Chu and Li, *T'ang Sung*, p. 183; *Nan Sung Yüan hua-lu*, in *I-shu ts'ung-pien*, part I, vol. 15, p. 246.
14. *Garland*, vol. 1, pl. 31.
15. Ch. 4.
16. Cohn, *Chinese Painting*; *CP*, II; Tanaka and Shimada, *Ryōkai*.
17. Seckel, 'Shakyamunis Rückkehr'.
18. *Select Chinese Painting in the National Palace Museum*, vol. 6, p. 26.
19. *CP*, III, pls. 328–9; Tanaka and Shimada, *Ryōkai*, pls. 4–7; Fontein and Hickman, *Zen Painting*, nos. 5 & 6.
20. Fontein and Hickman, no. 6.
21. Seckel, *Einführung*, pp. 125–37.
22. Catalogue of the Tokugawa Art Museum, no. 34.
23. Sickman, ed., *Crawford Collection*, no. 38.
24. Sun Ta-kung, *CKHCJMTTT*, p. 218; Ch'en Yüan, *Shih-shih i-nien lu*, p. 271.
25. *Hsüan-ho hua-p'u*, ch. 2, s.v. Hsin Ch'eng for a 'White-Robed Kuan-yin' by this otherwise unknown T'ang painter.
26. Reproduced in colour in *Hihō*, vol. 11: *Daitokuji*, pl. 7.
27. Matsumoto, *Tonkō-ga no kenkyū*, p. 350.
28. Translated in Maeda, *Two Twelfth Century Texts*, p. 61.
29. Edition *Mei-shu ts'ung-shu*, ch. 9.4.28b.
30. With the exception of the *Dragon* and the *Persimmons*, they are illustrated in *CP*, III, pls. 335, 342, 343, 344. For the *Persimmons*, see Sickman and Soper, pl. 107B; Cohn, *Chinese Painting*, pl. 111; Lee, *History of Far Eastern Art*, fig. 468. The *Dragon* is reproduced in *Sōgen no kaiga*, pl. 72, to name one source. Excellent large plates of the Daitokuji holdings are contained in *Hihō*, vol. 11. A masterly interpretation of the *Six Persimmons* is found in Seckel, *Einführung*, pp. 345–65.
31. Shen Kua, *Meng-ch'i pi-t'an*, ch. 17—'toward 1078', according to *Sekai Bijutsu Zenshū*, vol. 14, p. 300.
32. *Hsüan-ho hua-p'u*, ch. 12.

33. *Tu Fu's Gedichte*, II, 57.
34. Cf. Cahill, *Chinese Painting*, p. 96.
35. *Sōgen no kaiga*, nos. 120–2.
36. *Sōgen no kaiga*, nos. 124–5.
37. *Sōgen no kaiga*, pp. 33 ff.
38. *T'u-hui pao-chien*, ch. 4.
39. Demiéville, 'Le Tch'an et la poésie chinoise', *Hermès*, vol. 7 (1970), pp. 123–36; reprinted in Demiéville, *Choix d'études bouddhiques*, pp. 456–69.
40. Bachhofer, *Short History*, p. 117.
41. Suzuki, *Zen and Japanese Culture*, p. 44.

Masters of the Yüan Period
(1279–1367)

Toward the middle of the thirteenth century, when the northern provinces had been lost by the Chin Tatars to the Mongols, the long, unbroken tradition of Chinese painting was entering a critical phase. Further advances were scarcely possible once a landscape had come to consist of nearly empty space, animated only by the compellingly treated atmosphere. Landscapes of this kind were the last word, the ultimate of sophistication attained in an evolution that had begun thirteen centuries earlier with the depiction of objects surrounded by neither space nor atmosphere. Within that realistic tradition now coming to its close, the things of the visual world had been given final form in masterly works of greatly varying subject-matter. Styles, in that tradition, were handed down from generation to generation as the essential tools. They could be modified but they were not questioned. Being given, the style was a secure possession, not a problem, of the artist, whose primary concern was still the intensity and convincingness of his images of reality.

What now happened in painting not only separated Yüan irreversibly from Sung and earlier art, but was also to determine much of its future course. The decisive steps in this radical departure from the Southern Sung modes were undertaken by hardly more than a handful of earnest innovators, solitary seekers rather than a group. All they had in common was what they were breaking away from: the Sung legacy of washes and tonality, suggestion, asymmetry of composition, and the harmonious blend of rationality and feeling. What their works exhibit instead are such features as archaistic designs, whole forms, linear structures, and new graphic idioms characterized by the use of a dry brush. The paintings are no longer simply records of external realities: they are images of a supra-representational order. Nature is replaced by symbolic conformations, and these, the ostensible motifs, serve as the carriers of the artist's personal and unique style. In Yüan art the style becomes the ultimate substance of the work, the painter's foremost concern. And because the function of style as such had changed that way, it would be inadequate to describe the Yüan achievement as a matter of stylistic change.

The first unmistakable signs of a conscious alienation from the late Sung manner of realism appear in the oeuvre of **Ch'ien Hsüan** (c.1234–1300) from Wu-hsing in Chekiang. Of his life we know little except that he earned a doctoral degree between 1260 and 1264 and never took office under the Mongol government. The earliest biographical source, *T'u-hui pao-chien*,[1] offers nothing much of importance in its colourless entry, whereas Hsü Ch'ien (1270–1337), a younger contemporary and renowned student of philosophy, supplies the surprising information that Ch'ien Hsüan was unable to paint unless he was drunk.[2] The statement is surprising because Ch'ien's works do not give the slightest hint of having been conceived, or finished, in a state of inebriation. They never seem to betray abandon, or release, or even just tempo. What they reveal instead is great restraint and sobriety. Be that as it may, Ch'ien's habits did not prevent him from leaving an impressively large and

stylistically consistent oeuvre—swelled, alas, by imitations that were current already in his lifetime, as he himself has testified in an inscription on his *White Lotus*. The *White Lotus* (Fig. 116), a short handscroll, was miraculously discovered as recently as 1970 during the excavation of the tomb of Chu T'an (1370–89), tenth son of the first Ming emperor, in Tsou-hsien, Shantung.[3] This rarity of a fully authenticated work cannot fail to influence the judgement of future critics when attempting to sift the extant material—a necessary if difficult task that was begun, with partly contradictory results, before the Shantung find was made known.[4]

None the worse for having lain in a princely tomb for nearly six hundred years, the *White Lotus* scroll still shows its gossamery lineament and light, flat colour washes intact. Three flowers and three leaves in varying stages of growth are drawn with extreme precision. The arrangement is compact and shuns decorative effects. The plants are so finely delineated that they seem almost dematerialized and transparent. Thus contrasting with the more familiar, sensuously appealing, coloured lotus pictures of Chinese Buddhism, such as Yü Tzu-ming's diptych at the Chionin in Kyoto,[5] Ch'ien Hsüan's lotuses exist on a plane above theirs, beyond the grosser forms of reality: no wind is blowing and no petals falling, no waterfowl sporting, and no water that smells. In his close-up presentation, concentrating on what is essential and not accidental, the painter may have evoked a feeling of sanctity that was no longer present in the usual depictions of the lotus. A colophon by Feng Tzu-chen (1257–after 1327) indeed refers to *puṇḍarīka*, the Sanskrit name of the white lotus, as in the title of the renowned *Saddharma-puṇḍarīka-sūtra*, 'Lotus Sūtra of the True Law', which makes the Buddhist connotation explicit. The Lotus scroll is a late work of Ch'ien Hsüan, as his inscription tells, but its historical significance is not *ipso facto* clear as yet. The majority of the works

FIG. 116 Ch'ien Hsüan, *The White Lotus*. Short handscroll, excavated in Tsou-hsien, Shantung, in 1970.

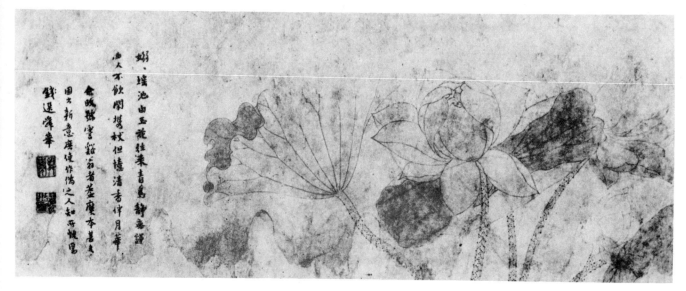

attributed to the painter are still lifes of plants and fruits and flowers whose chief characteristic seems to be that they take us into a twilight region between nature and history, or between realism and archaism.

If Yü-chien's *Lu-shan Waterfall* (Fig. 115) can be taken as a majestic *finale* of Southern Sung landscape painting, a short handscroll by Ch'ien Hsüan, named *Dwelling in the Mountains* (Figs. 117A–B), may be among the earliest and most forceful statements of a revolutionary re-orientation in Yüan art. Gone are the large and bare peaks enveloped in brewing mists, the tonality of graded washes, and the feeling of infinity. Instead there appear strangely primitive forms, almost of a child-like character: carefully and seemingly timidly drawn, simple and complete, never abbreviated or merely suggested. The trees are reduced to types, which are repeated throughout; even where they represent distant forests they remain separate, with their trunks and their every leaf depicted. Only in the dark scrub on top of the mountain at the right do the units merge into a nondescript mass of foliage—a motif doubtless taken over from the pictorial world of Fan K'uan. The two mountains, constructed of fissured slopes and rhombic rocks clearly reminiscent of T'ang or Wu-tai models, are exemplars of true archaisms. These curiously structured heaps are here quoted, as it were, not in emulation of the old technique and form but to savour the expressive potential of their hoarily antique shapes. As he explores these shapes of a preclassic age, Ch'ien Hsüan takes the liberty of exaggerating such features as to him, the post-classical artist, must have seemed peculiarly attractive on account of their naïveté, their oddity, or their forgotten charm. In other words, he romanticized the world of the primitives where he, unquestionably, discovered a well-spring of precisely such forms as he needed in his struggle for a new beginning, beyond Sung.

A *terminus ante quem* of the date of the scroll is provided by a colophon dated Yen-yu 4th year, 9th day (no month given), presumably corresponding to 22 January 1317. The scroll passed through the hands of eminent private collectors before it entered the Palace collection under Ch'ien-lung.[6]

Ch'ien Hsüan's landscape archaism formed an important element in the larger and less homogeneous oeuvre of his fellow-townsman and sometime pupil, **Chao Meng-fu** (1254–1322). An eleventh-generation descendant of the founder of the Sung Dynasty and heir to his father's title, Duke of Wei-kuo, Chao, immensely gifted, 'like an immortal among men', was a more conspicuous figure than his teacher, both as a citizen and as an artist. When offered a governmental position by Kublai Khan in 1286, he found it impossible to decline and in 1288 moved with his wife, Lady Kuan Tao-sheng, to Khanbaliq (the Cambaluc of Marco Polo), as Peking was named then. Whatever his motivations, it was a decision never quite forgiven by posterity.

Like Su Tung-p'o and Mi Fei, Chao was a celebrated calligrapher, the foremost, in fact, during the Mongol century. Yet, unlike them, he was no mere amateur as a painter. Although his social rank saved him from the 'stigma' of professionalism, his works are so diverse in style and subject-matter as to cover every conceivable genre with the exception of Southern Sung styles and the flower-and-bird theme. As a whole, Chao's oeuvre lacks unity. A degree of unity is found only in such well-

defined categories as his pictures of horses or of old trees, rocks and bamboos. It is likely that this diversity was not intentional, but sprang naturally from his versatile nature. As a consequence, Chao Meng-fu was rarely imitated by Ming and later artists, who depended on clear and unambiguous prototypes of style. Chao's guiding principle in painting, 'the spirit of antiquity' (ku i), was evidently not a factor of stylistic unification, for as a mere idea or postulate it permitted of greatly varying realizations. If none the less he was influential in the formation of a nascent Yüan art, it was not simply on account of his archaistic tendencies as such, but rather because of some very original, innovative contributions to landscape painting that pointed a way beyond archaism and into the future.

A fan-shaped album leaf named *The Joys of Fishing at a River Village*, in light ink and thin colour wash with opaque blue and green areas of mountains and rocks (Pl. VII), is one of Chao Meng-fu's archaistic works. Title and signature are written in a neat and atypical hand, suggesting an early date, say, around 1280 or so, when he was presumably still dependent on his teacher, Ch'ien Hsüan. But in the discrepancy of the almost colourless receding plain and the flat blue and green patches of the rocks and hills we may feel the presence of a more daring intellect than Ch'ien Hsüan's, as suggested also by the strange repetition of the hollow escarpments bordering the water at the left. Without that discrepancy or colouristic incoherence the blueness of the hills would not be so intense. And it is possible that this very intensity was the *raison d'être* of this picture. The landscape it shows is not seen but constructed as a setting for the blue hills, which allude to T'ang traditions, and for the pine trees, which probably refer to Li Ch'eng. The antique motifs are here combined, regardless of their historical age, for effects unknown in the past.

In January, 1296, the year after Marco Polo's return to Venice, Chao painted two mountains in western Shantung in a short handscroll known as *Autumn Colours at the Ch'iao and Hua Mountains* (Fig. 118).[7] It is now kept in the Palace Museum, Taipei. Distinguished by the motif of two stone-blue hills rising abruptly from a plain, this scroll naturally reminds us of the album leaf just described. *Autumn Colours* lacks the precise spatial definitions and the cool formalism of the album leaf to a degree that suggests two different hands. *Autumn Colours*, however, is more deeply unlike Sung than *The Joys of Fishing*. There is an oppressive stillness in it, resulting not from harmony but from monotony and lack of movement. Time has come to a standstill here as in a vacuum, and the spatial relationships are as uncertain as if the scenery was seen in a dream. In a word, the landscape seems unreal—which is a remarkable expressive achievement in view of the fact that it consists of nothing but realities, such as trees, the mountains, fishermen, and sheep.

Only six years later Chao Meng-fu added to his oeuvre a beautiful and unproblematic short handscroll, *The Water Village* in the Peking Palace Museum (Fig. 119). Though long known through literary records, this painting was first reproduced as recently as 1959; it was first discussed in Western literature by Chu-tsing Li in 1965.[8] Painted in ink without colour on paper, it carries a precious burden of documentary evidence of its authenticity and importance: a set of over fifty colophons, nearly all of them from the Yüan period, the earliest written by Chao himself one month after the completion of the painting, which is dated in accordance with 4 December 1302. Thematically the painting resembles the two earlier works,

FIG. 117A–B Ch'ien Hsüan, *Dwelling in the Mountains*. Shanghai, Shanghai Po-wu-yüan.

FIG. 118 Chao Meng-fu, *Autumn Colours at the Ch'iao and Hua Mountains*. Handscroll dated in accordance with 1296. Taipei, National Palace Museum. See also Plate VIII.

which, too, represent 'water villages' on level or marshy terrain with long mud-flats darting into the surrounding waters, with homesteads among trees, tiny boats, and distant hills. On formal grounds, however, the 1302 version surpasses the others. The composition is compelling and limpid. There is a sure sense of scale, and the accents are placed effectively. While the wavy lines indicating the ground recall the net pattern of 1296, they are free of artifice, unobtrusive, terse and graceful. Above all, the brushwork is carried out in a purely linear manner almost as if the painting had been written down, without a superfluous stroke. Thus unified and technically simplified, the painting is devoid of the heavy literalness of the *Autumn Colours*, where the characteristics of the type forms were rather laboriously stated. Here, the type forms are few, and they are assimilated. Moreover, instead of competing for the viewer's attention they are neatly subordinated to each other: the mountains dominate over the trees; the trees, over the terrain; the terrain, over grasses and reeds. The few homesteads are so sheltered by trees that they have to be discovered. The only discordant motif is the group of trees at the beginning of the scroll. Unrelated to the rest except for its role as a *repoussoir*, this group appears to be a carry-over from Ch'ien Hsüan, a convention of little more than decorative significance in the present context.

This context, the substance of *Water Village*, shows two distinct new achievements: one is the commonplace quality of the scenery (clear of romantic trees, beautiful cliffs, spectacular waterfalls); the other, the ever visible stroke of the brush (with the concomitant effects of effortlessness, spontaneity, and naturalness).

'The ever visible brush-stroke' is not merely a calligraphic, or at any rate graphic, feature contrasting with late Sung wash, but also accounts in part for the character of the scenery. For what the brush does is not to describe but to create scenery, so that it becomes part of the expression. That Chao was aware of this condition is clear from both his paintings and some of his inscriptions, where he speaks of the role of brushwork in terms of various script types as fit for drawing old trees, bamboos, and rocks, respectively, in keeping with his primary interest, the art of calligraphy.

Another short handscroll attributed to Chao, *Poetic Thoughts on the Rise of Autumn* (Fig. 121), known only through a reproduction,[9] and a brief mention by Sirén,[10] agrees well with the style of *Water Village* without quite equalling the graphic trim of the latter. Conceivably this appealing scroll with its intriguing resemblances to Wu Chen and Huang Kung-wang antedates *Water Village* by a few years. The attached colophons were written by Wei Su (1295–1372), Yang Wei-chen (1296–1370), Hu Yen (1361–1443), and Tung Ch'i-ch'ang (1555–1636); their evident importance notwithstanding, the scroll does not seem to be recorded.

A further example of Chao Meng-fu's astonishingly diversified contributions is his handscroll of *Winding River and Layered Ranges* in the Palace Museum, Taipei, an often recorded work with many colophons, dated in accordance with February 22, 1303. Done in ink on grey paper, this serene, abstract, and almost musically conceived design stands apart from all his earlier works discussed so far. Set far back into the distance beyond open waters, the 'layered ranges' consist of hills and cliffs with sparse vegetation; their shapes are not unlike Northern Sung formations, and the atmospheric effect of their *valeurs* is distinctly Southern Sung in character.

FIG. 119 Chao Meng-fu, *The Water Village*. Short handscroll with the artist's colophon of 4 December 1302. Peking, Ku Kung Po-wu-yüan.

FIG. 120 Chao Meng-fu, *The Water Village*. Detail of Fig. 119.

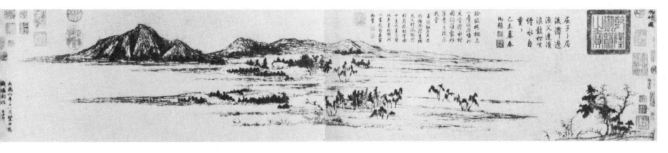

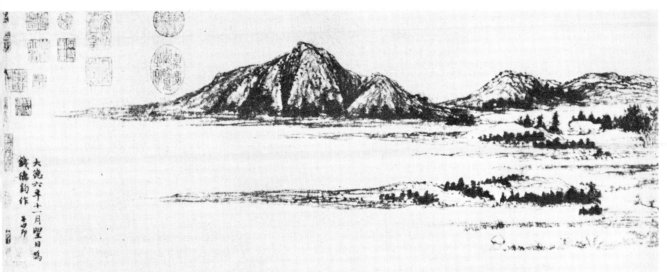

The vast, open space is unencumbered by detail. Mountains and water are not truly represented as such. What matters is more abstract, something like the grandiose pattern formed by hills and cliffs and river in a design reduced almost to outlines. A pair of pine trees at the end, drawn in the Li Ch'eng–Kuo Hsi manner, affirms a relaxed stance *vis-à-vis* Sung.

The pair of pines reappears among more freely and nervously drawn forms of near-by rocks and distant hills at the beginning of a scroll named *Twin Pines Against a Flat Vista* in the Metropolitan Museum.[11] Possibly this scroll was done soon after *Winding River and Layered Ranges* of 1303, with which it shares a few features other than the twin pines. But the indifference toward objective definitions is even more pronounced here. 'The landscape', in Sherman Lee's telling interpretation, 'is not the subject of the picture; the brush is.'[12] The display of powerful brushwork is more obvious in Chao Meng-fu's studies of old trees, bamboos and rocks, a category that we shall not touch upon here.

Neither can we do justice to his paintings of horses, so strangely distinct from his immeasurably more personal landscapes and bamboos. In their classicist perfection and smoothness they remind us of Li Lung-mien rather than the T'ang masters on whom they were allegedly modelled, even though Chao may have owned one or several original works of Han Kan.[13] Whether or not they were done for Mongol dignitaries or the Khan himself, these horse paintings were without future. They found no followers in later ages, except forgers.

FIG. 121 Chao Meng-fu, *Poetic Thoughts on the Rise of Autumn*. Short handscroll. Whereabouts unknown.

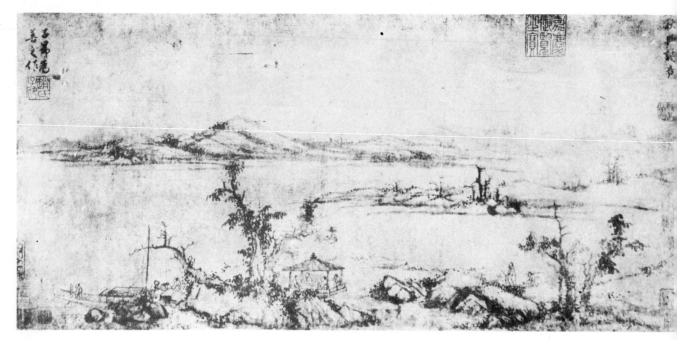

What finally should at least be mentioned is the fact that Chao tried his hand in figural compositions of secular as well as religious subjects. An early, mysterious and beautiful archaistic work in colour is the handscroll designated as *Yü-yu's Hills and Valleys*, referring to Hsieh K'un (280–322). The painter himself speaks of this work in a colophon as having been done 'when I began to work in paint . . . when the brush was still wanting in strength and the antique spirit was but clumsily realized;'[14] and his son, Chao Yung, in another colophon affirms the earliness of the scroll.

Of four dated figure paintings, a handscroll of *Episodes in the Life of T'ao Yüan-ming* of 1298[15] and a hanging-scroll, *The Sung-shui Hermitage* of 1310[16] are fine and more or less convincing works, whereas *Three Religions* of 1318[17] and *The Lan-t'ing Gathering* of 1320[18] are unacceptable. Undated works of secular topics further comprise the *Elegant Gathering in the Western Garden*,[19] *Wen-chi's Departure from the Hunnic Camp* in the Smith College Museum, Massachusetts,[20] and *Football*,[21] all of which seem to be based on older prototypes, although a similar version of *Football* is attributed to Ch'ien Hsüan, Chao's teacher. Of the Buddhist subjects, a *Śākyamuni Buddha* is possibly modelled on Ch'ien Hsüan;[22] *The Red-Robed Lo-han* is an archaistic, dry, precise and heavy work worthy of being connected with Chao Meng-fu;[23] *Dragon King Worshipping the Buddha* in the Boston Museum of Fine Arts, a hanging scroll in rich colour showing the Buddha in a deep cavern in a hilly landscape, differs so widely from the styles of all the foregoing works that it can only be taken on faith.[24]

The reader may wonder why this bare list of titles should be inserted here at all. Apologetically the writer, departing from his usual procedure of discussing only such paintings as are illustrated, feels that the list does suggest two things. One is the baffling incongruity of styles in Chao Meng-fu's works; the other, the enormity of his artistic ambition. His ambition, nowhere stated expressly, seems to have been nothing less than a restatement of any and all traditional subjects, as if to give a *summa* of earlier painting. The world may not have been waiting for quite so grand a contribution. But neither did it ignore Chao's genuine innovations in landscapes and bamboos, mindful, perhaps, of the fact that his foremost concern was not a painter's but a calligrapher's.

Huang Kung-wang (1269–1354), a native of Ch'ang-shu in Kiangsu, whose original surname was Lu, received his name and new surname when at the age of ten he was adopted by the Huang family of Yung-chia in Chekiang. His name or *ming*, Kung-wang, and his man's name or *tzu*, Tzu-chiu, allude to an early Chou episode: Wen Wang, meeting Lü Shang, 'The Angler on the Wei River', said, *Wu T'ai kung wang tzu chiu i* (My [father, the] Grand Duke, had been hoping [to meet you,] Sir, for a long time.)[25] Huang, fifteen years younger than Chao Meng-fu, did not begin to paint until he was fifty.[26] To speak of him as a pupil of Chao's may, therefore, be misleading, but we may think of him as a follower. His dry, graphic, and structurally transparent technique seems to derive straight from such models as Chao's *Water Village* and *Poetic Thoughts* (Figs. 119–21). Huang Kung-wang's late start as a painter, compensated for to some extent by the fact that he could build on such models, may well account for his single-minded concentration on landscape.

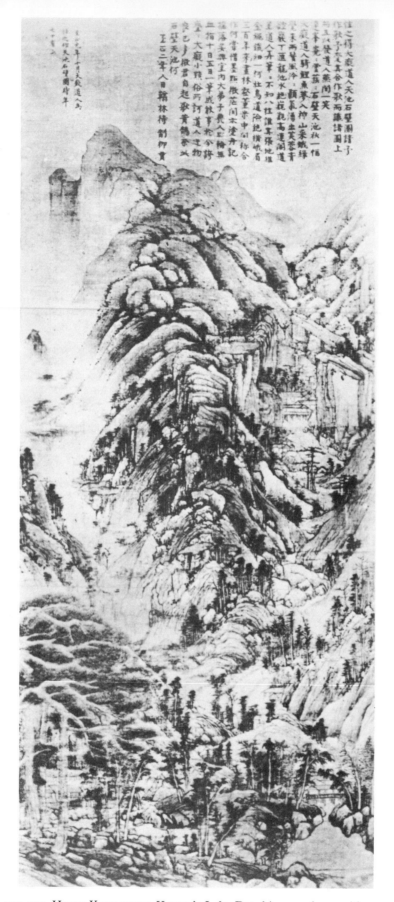

FIG. 122 Huang Kung-wang, *Heavenly Lake*. Dated in accordance with 1341.

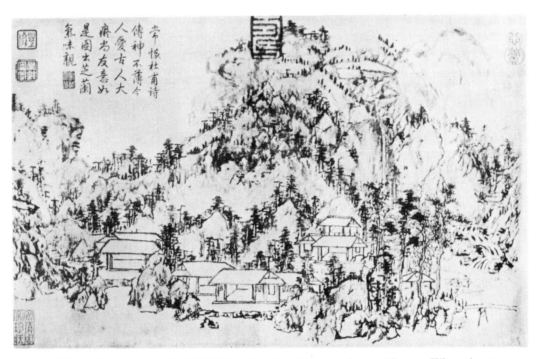

FIG. 123 Huang Kung-wang, *The Orchid Pavilion*. Dated in accordance with 1342. Whereabouts unknown.

Unlike Chao he entertained no illusions of universality, but in his chosen field was able to create an imagery that was unmistakably his own. As a consequence, after three centuries or so Huang came to represent Yüan painting, while Chao was almost forgotten.

Again in contrast to Chao Meng-fu, the number of works credibly attributed to Huang is quite small. But they are stylistically consistent; and even the less convincing pictures assigned to him do not stray far from the accepted ones.

An important example of the latter group is the *Heavenly Lake* of 1341 (Fig. 122), existing in more than one version.[27] This is our first encounter with a full-blooded Yüan landscape. The picture is crammed with small forms, which in their entirety evoke an endlessly rising formation, ever close to the surface and without either recession or space. The subject, apparently, is not a mountain, but mountainness; nothing seen, but something constructed; awesomely defined to the last detail, yet without real substance. The myriad phenomena, in Chinese parlance, are brush-created appearances.

The Orchid Pavilion of 1342 (Fig. 123), a large album leaf of unknown whereabouts, accepted as an original work of Huang's, was described with great warmth by Sirén as a picture that ranks 'among the noblest of all the Chinese ink-paintings that have been preserved'.[28] The remarkable thing about this picture is that it is completely unpicturesque. A cluster of very simply drawn houses by a rocky shore is surmounted by a sparsely forested formation of hills and cliffs. There are no memorable

shapes and no tone values to speak of, and hence no atmosphere. The trees are
constructed of vertical and horizontal strokes, lacking individuality. Yet all these
unpromising forms vibrate with life, and in their spontaneous execution possess
gracefulness. Huang's colophon, dated in accordance with 18 June 1342, tells us
that this picture was painted in praise of friendship—the theme to which the Ch'ien-
lung inscription on the painting itself refers.

The work that Huang Kung-wang himself considered his best is a long hand-
scroll named *Living in the Fu-ch'un Mountains* (detail, Fig. 124) done for the Taoist
master Wu-yung over a time span of four years (1347–50). It passed through the
collections of Shen Chou (1427–1509) and Tung Ch'i-ch'ang who shortly before
his death gave it in pawn for a thousand pieces of gold to one Wu Cheng-chih from
I-hsing. The third son and heir of the latter loved the scroll so much that on his
death-bed he ordered that it be burned, but a nephew of his was able to save it with
only the outer layers and the beginning of the painting scorched. Afterwards the
scroll was owned by Kao Shih-ch'i (1645–1703) and An Ch'i (c.1683–after 1744)
from Tientsin. In 1746 it was acquired for the Peking Palace, although another
version of the same subject and design and supposed authorship had entered the
imperial collection one year earlier. Fortunately, this second version known as 'Tzu-
ming' was then regarded as the original, and it was literally plastered with Ch'ien-

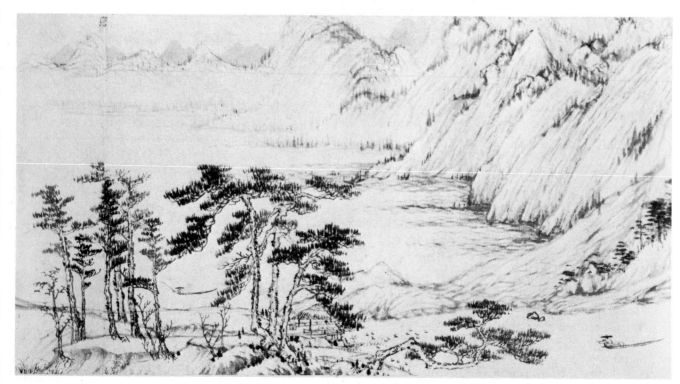

lung's encomia, while the original was spared. Both are now kept in the National Palace Museum in Taipei, whose recent publication, *The Four Great Masters of the Yüan*, makes it possible to compare the two paintings inch by inch. Their juxtaposition leaves no doubt whatsoever as to the superiority of the 'Wu-yung' scroll, whose marvellous qualities are invariably bungled in the 'Tzu-ming' copy. If the latter is a tracing, as suggested by its identical layout, its actual execution must have been done from memory—inexactly, mechanically, insensitively. Even so, the 'Tzu-ming' version, purporting to be dated 1338 in Huang's own hand, bears a short inscription written in 1466 by Liu Chüeh (1410–72) and therefore must have existed as early as the middle of the fifteenth century.

Despite its slow-paced execution, *Living in the Fu-ch'un Mountains* is of a piece, and in its sustained inspiration is a work of astonishing grace and freshness. In keeping with Yüan tendencies the landscape is not an assemblage of beautiful motifs and exciting shapes, but is constructed, rather, of commonplace forms, which are repeated throughout, as is the texture of the hills and lowlands and shoals. The artist seems to have been interested only in the pictorial structure, something at the borderline of abstraction and realism. To Huang Kung-wang, according to his brief treatise, *Hsieh shan-shui chüeh*, 'A painting is nothing but an idea . . . [and] what matters most when making a painting is the principle of rightness.'[29]

FIG. 124A–B Huang Kung-wang, *Living in the Fu-ch'un Mountains*. Detail of a handscroll dating from 1347–50. Taipei, National Palace Museum.

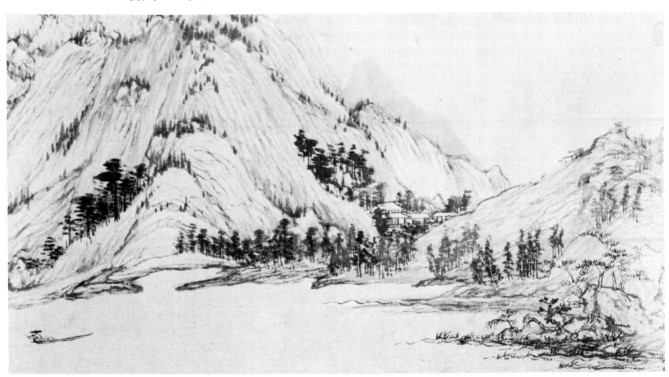

A

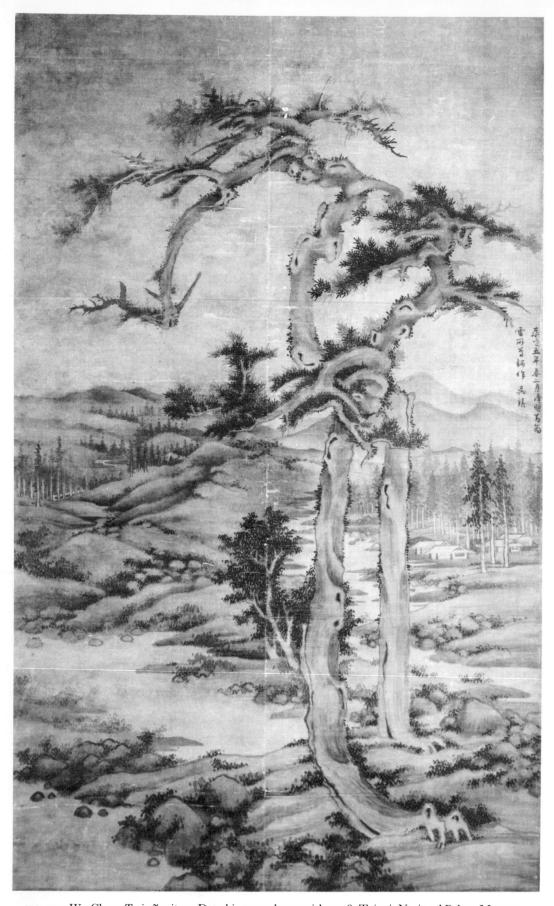

FIG. 125 Wu Chen, *Twin Junipers*. Dated in accordance with 1328. Taipei, National Palace Museum.

A landscape, in other words, is a mind-created thing and not given by nature; its success or 'naturalness' depends on the right relationships of all parts of the design, the pictorial logic, in short. Naturalness in this unnaïve and art-conscious view does not mean naturalism, but refers to the freedom and ease with which the artist expresses his individuality, that which is natural to him. No less a critic than Tung Ch'i-ch'ang felt that to convey joy in a painting is something that was first done by Huang Kung-wang.[30]

Of Huang's contemporary, **Wu Chen** (1280–1354) from Wei-t'ang in Chia-hsing, Chekiang, Tung Ch'i-ch'ang's friend, Ch'en Chi-ju (1558–1639), wrote sweetly and imaginatively, 'The master lived hidden in the country. During his life he enjoyed fishing, reciting, singing, writing, and painting. When nearing death he built his own tomb—emulating those who in antiquity "were intelligent about life and understood the decree of Heaven", like Chung-kuei himself, for he was one of them.'[31] While the lyrical finality of Ch'en's few words takes us beyond cumbrous biographic detail, we should not ignore the fact that the terms 'life' and 'decree of Heaven' are specific allusions to Wu Chen's expertise in *Hsing-ming* (temperament and fate) and *I-ching* (Book of Changes) studies, which enabled him to make a living by selling prognostications—as done earlier by Huang Kung-wang. Allegedly he did not start to paint before the age of thirty-nine, but the earliest now extant work, which clearly presupposes years of training, dates from 1328, when he was forty-eight: *Twin Junipers* in the National Palace Museum (Fig. 125). A tall scroll in ink on silk, it shows a pair of junipers or cedars reminiscent of the Li Ch'eng-Kuo Hsi tradition, placed in a terrain of the most ordinary character, slowly rising in barely coherent recession toward distant, hazy peaks. The forms of the terrain, the small boulders and moss dots (*t'ai-tien*) and distant forests are repeated time and again. While distinctly unlike Sung, the painting offers little of a personal character. A similarly timid air prevails in his landscapes of the earlier thirties, modelled on Chü-jan.

By 1336, when he painted his engaging handscroll, *The Central Mountain* (Fig. 126), Wu Chen had forged his own means of expression from the derived type forms and techniques of his earlier attempts.[32] Done in juicy ink-tones on paper, this scroll shows a range of five hills shaped as truncate cones in an almost symmetrical arrangement, with the biggest of the five placed in the middle. No cliff, no rocky overhang disturbs the harmony of the nearly uniform shapes of these hills and their verdure, a harmony that is much intensified by the effect of a soft, diffuse light like that of the setting sun in a hazy atmosphere. It is an effect produced by the broad, wet, wash-like strokes slanting to the left on the smooth slopes of these hills, and by the inky silhouettes of some of the lesser cones, which receive light no longer. The conventional *ts'un* texture strokes have disappeared. The inscription in the upper left corner, in fluid yet refractory characters, is Wu Chen's; that on the right, in a mundane and smooth style, is Emperor Ch'ien-lung's, curiously contrasting with the hand of the old painter.

But there is a late Wu Chen of around 1350, and this is the Wu Chen who really counts in any serious appraisal of the Yüan innovations in landscape painting. The works in question are album leaves that have been given little attention in Western

FIG. 126 Wu Chen, *The Central Mountain*. Dated in accordance with 1336. Taipei, National Palace Museum.

literature thus far: two in the Abe collection in the Osaka Museum, eight in the former Saitō collection, and twelve in the collection of Mr Siu So (in Peking, Hsiao Su) of Hong Kong, published as recently as 1963. Perhaps it was Sirén's unfavourable judgement of the former two items that led to such neglect.[33] The important Hong Kong set, which bears a colophon of the painter dated in accordance with March 15, 1351, and addressed to Wang Kuo-ch'i, father of Wang Meng, for whom he had painted these leaves, was in the Ch'ing Imperial collection.[34] Stylistically the three works are almost as one. The leaf from the Saitō album (Fig. 127) represents the mature Wu Chen as well as a little known facet of late Yüan painting. The subject-matter is utterly commonplace, not to say irrelevant, but the brushwork is simply exciting. A structure of slashing horizontal dabs and vertical strokes combined with light washes evokes a remote valley with a pavilion by a stream, enclosed by steep cliffs. But all that matters are those powerful brush strokes, which, depending on where they are, will be read as branches or foliage, terrain textures or, simply, darknesses. The old man heading for the pavilion in the lower left corner is reduced to a funny cipher, as is the pavilion with its irrationally conceived ridgepole. None of these few formulas count as representations; the latter, if not indeed accidental, are secondary effects of the rhythmic and spontaneous play of the brush. Seemingly sketchy, the picture is a wholly personal, graphic statement, devoid of references to raw nature, of beautiful motifs, and of archaistic reminiscences. It is a pure Wu Chen, incomparable and independent.

It was **Ni Tsan** (1301–74) who, rather than Chao Meng-fu, Huang Kung-wang and Wu Chen, came to be regarded as the foremost of the Yüan masters, although less favourable judgements are not wanting. Undeniably he was the least painterly among the masters. The adjectives most fit to describe his works are those such as frugal, remote, cool, thin, abstract and, perhaps, carefree. There was a measure of subtlety in his finest works, riverscapes all of them, that was not equalled in the paintings of his contemporaries, who probably were less concerned with subtleties than with strength and directness.

FIG. 127 Wu Chen, Album Leaf. Formerly in the Saitō collection.

Ni Tsan was born into a family of great wealth, which in the beginning of the Southern Sung had settled at Mei-li between Wu-hsi and Ch'ang-chou in Kiangsu. Educated and wealthy, surrounded by his collections of antiques and books, he led the life of a grandseigneur until, suddenly, in 1352 he decided to distribute his possessions among relatives and old acquaintances. Henceforth he and his wife lived on a boat like simple fisherfolk, cruising over the majestic expanse of Grand Lake and adjoining waters. Unlike the real fisherman, however, Ni Tsan did not deny himself the amenity of extended shore leaves to visit his friends. As recorded in his own colophons, he was the guest of Ch'en Wei-yün or Ya-i-sheng (a friend of Wang Meng's) starting from 11 December 1352, and of Lu Hsüan-su for about four months from January to April, 1353. The sacrifices of his years of peregrination presumably saved him from worse miseries during the time of unrest before the final fall of the Mongol régime. But when he returned in the end, he had no home of his own, and he died in the house of Chou Wei-kao, a son-in-law, on 14 December 1374.

Ni Tsan's landscapes are, with few exceptions, variations on a single motif: a rocky shore with a few trees and an empty pavilion in the foreground, separated by a vast expanse of water from a range of bare hills in the distance. Dated works of this kind known today cover the years from 1339 to 1372, that is thirty-four years. This haughty indifference toward subject-matter is one of the characteristic traits of Ni's oeuvre. What to him seemed to matter was his hand or his brush, which, too, offers little variety. Yet withal we never doubt the presence of an individuality in those works, however uniform in structure and unchanging in mood. Another important trait is the absence of what might be perceived as anything like a development in his paintings. Nothing looks so much like a late Ni Tsan as does an early Ni Tsan. And consequently there seems to be less derivativeness in his work than in that of his great contemporaries, even though he was no doubt indebted to Chao Meng-fu, Chao Yung, Huang Kung-wang, and possibly Wu Chen.

One of Ni Tsan's most appealing works is a short handscroll entitled *The An-ch'u Studio* (Fig. 128). It happens to be mounted on one and the same scroll with Wu Chen's *Central Mountain* (Fig. 126), immediately preceding the latter. Compared with Wu's deep, warm, glowing ink, the Ni Tsan seems almost icy. Yet in his infinitely sparing technique and minimal definitions of his frankly uninventive forms we may sense a profound tenderness, rather than mere discipline or calculated poverty. Despite the lack of tonality and atmosphere, Ni's rocks and distant hills have an effect of volume, due primarily to the orderliness of their construction. The trees, overly tall and sparsely foliated, contribute to the forlorn, melancholy mood of the scenery. In a work of this kind, the nature and purpose of painting appear to have changed further. It is like a negation of all that painting used to be. There is no realism, no feeling for the object; no technical elegance or seductiveness; and no display of temperament, let alone passion. What we find here is a rational assemblage of sheerly expressive forms, almost reduced to signs, austere and disembodied. This mode of subjective expressionism was unprecedented, and it may account for Ni Tsan's eminent position among the Yüan masters. It was the most radical departure from all traditions.

Wang Meng (*c.*1308–85), a grandson of Chao Meng-fu and Lady Kuan Tao-sheng (who died on 29 May 1319 on a boat trip to Shantung), and the son of Wang Kuo-ch'i for whom Wu Chen painted the album of landscapes in 1351, added a manner of grandeur to Yüan painting. His birthplace, Wu-hsing or Hu-chou in Chekiang on the south shore of Grand Lake, was the native town of Chao Meng-fu, Ch'ien Hsüan, Yen Wen-kuei (eleventh century) and Ts'ao Fu-hsing (third century). Although Wang Meng was only about fourteen when his grandfather died, he may well have received some lastingly important impressions of his formidable elder's genius, and he may have had some memories of Lady Kuan. He doubtless profited from encounters with his uncles, Chao Yung (born 1289 in Peking) and Chao I, noted painters both of them. His father, too, painted on occasion and was no bad calligrapher either. Still, Wang Meng was to surpass them by far. As stated by the late Ming critic Chang Ch'ou, 'In the ranking of painters, the men of Yüan stand supreme, and among them stand out Chao Meng-fu, Huang Kung-wang, and Wang Meng.'[35] It is a judgement that sounds peremptory

FIG. 128 Ni Tsan, *The An-ch'u Studio*. Short handscroll mounted in a collective scroll with the title 'Yüan Jen Chi Chin'. Taipei, National Palace Museum.

enough, yet agrees entirely with that of Wang Shih-chen (1526–90), compiler of the renowned anthology of art-historical texts known as *Wang-shih hua-yüan*, who also had spoken of Huang Kung-wang and Wang Meng as innovators, while denying such praise to Mi Fei, Mi Yu-jen, Kao K'o-kung (1248–1310?) and Ni Tsan.[36] And did not Ni Tsan himself, Wang's only competitor, even more peremptorily say of Wang Meng that 'in the last five hundred years there was no one like him', as quoted with approval by Tung Ch'i-ch'ang?[37]

Wang's contribution to Yüan painting was the image of the mountain as a colossal organism. There was nothing comparable before him. His vision was very unlike that of Ni Tsan: never sparing or detached, but exuberant, rich and passionate always. The contrast deepens further when Ni Tsan's uniform and motionless compositions are compared with Wang's multifarious and powerfully dynamic ones. Where the two ultimately do agree is in the fact that each represents himself in his landscapes.

Wang Meng's oeuvre is large and comprises some dated works, covering the years from 1343 to 1370(?). This oeuvre remains to be sifted, as preliminarily done by Sirén, who accepted no more than thirteen titles as fully convincing among the sixty-nine in his *List*.[38] Without prejudice to possibly earlier works, I am inclined to take Wang's *T'ien-hsiang Shen-ch'u*, 'Deep Place of Heavenly Fragrance', a tall scroll of 1357 (Fig. 129), as a mature and significant work even though it is rejected by Sirén. This very strange work is perhaps the most solemn of all Yüan landscapes. A homestead surrounded by trees in a deep gully is closed in by tall pines, boulders and cliffs. Behind it towers dreadfully an enormous cliff, structured like bundled pillars that scarcely deviate from straight verticality, like stalagmites on a gigantic scale. The contours of these pillars are softened by a nondescript fuzz of transverse flicks, a myriad of them, imparting an oscillating effect to the rocks.

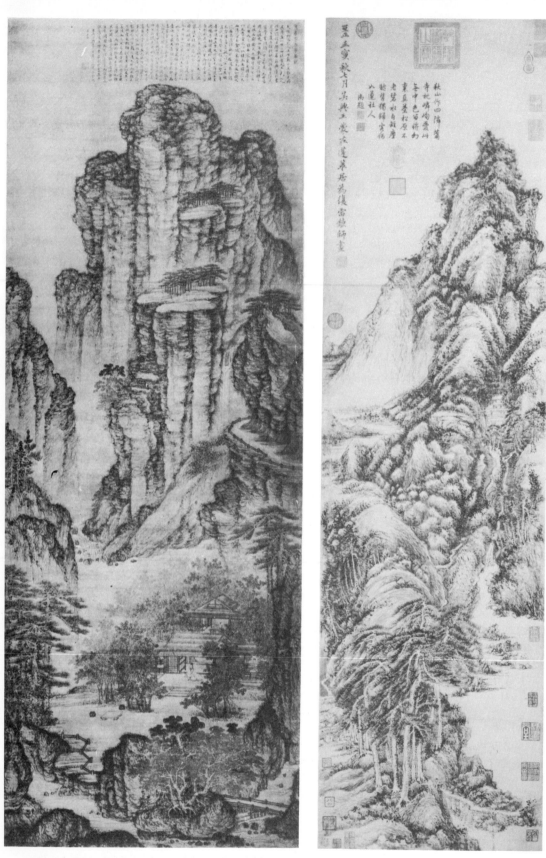

FIG. 129 Wang Meng, *T'ien-hsiang Shen-ch'u* ('Deep Place of Heavenly Fragrance'). Dated in accordance with 1357. Japan, formerly Saitō collection.

FIG. 130 Wang Meng, *Remote Monastery in Autumn Mountains*. Dated in accordance with 1362. Taipei, National Palace Museum.

There is a weird touch in this mountainscape. The immensity of the formations contrasts oddly with the minuteness of their execution. And, typical of Yüan painting, illusionistic features are suppressed. (A painting of the same title by the early Ming painter Tu Ch'iung (1396–1474) appears like a Ni-Tsanesque version of the same motif.)[39] 'Deep Place of Heavenly Fragrance' may have been the name of the hermitage of the man for whom this painting was done, Chou Min, *tzu*, Hsün-hsüeh.[40] This is suggested by the presence of a seal on a Wang Meng painting of 1350, the preserved left half of which reads 'Shen-ch'u'.[41]

In Wang's smaller scroll of 1358 depicting the *Ya-i Mountain Studio* of his friend Ch'en Ju-yen (who was executed under Hung-wu after 1380), that unnatural effect of unrest in the walls of rock is even more pronounced.[42] A superb scroll of 1361 in the Art Institute of Chicago, *Secluded Home in a Wooded Glen* (Pl. IX), compares well with the painting of 1357 as to the artificiality of its forms and the meticulousness of its execution; it retains the trait of unrest in the solid masses by the play of slanting plateaux, but in its neat separation of rock and forest and its light colour is much less oppressive. On the contrary, the painting has a touch of serenity that might have endeared it to more than one Ming master.

A series of three landscapes of the years 1362, 1366 and 1368 can give us some insight into Wang Meng's major concerns in his fifties (Figs. 130, 131, 132). What they have in common is the conception of the mountain as a complex, soaring organism, a more pliant brush-stroke, and a stress of unified movement. They do not *ipso facto* represent a clearly readable progression, however. In *Remote Monastery in Autumn Mountains* of 1362, dedicated to the Taoist master (Tsou) Fu-lei, the mountain rises and recedes along a slanting axis between open chasms (Fig. 130). In the Shanghai Museum's tremendous mountainscape of 1366, *Secluded Dwelling in the Ch'ing-pien Mountains* (Fig. 131), the mountain leaps upward convulsively, in chaotic malformations, as if not yet congealed into its final shape. That in a scenery so turbulent there are trees at all seems almost incongruous. Their presence intensifies the sense of chaos on purely formal grounds. This very strange work contrasts as strongly with the other Yüan masters as with Southern Sung. The 1368 composition, *Dwelling in the Summer Mountains* in the Peking Palace (Fig. 132), shows a mountain rising from continuously receding slopes, its towering peak twisting triumphantly in the wide, bright sky over a low horizon. Here the layered shapes of mountain and pine grove are in harmony, dynamic but stable. The date, given only in the characters of the sexagenary cycle, coincides with the first year of the Ming Dynasty.

There seem to exist no works safely datable to the years after 1370, so that the question of Wang's latest style cannot be fully answered yet. Perhaps a conception of landscape so spacious, reposeful and monumental as the Taipei Museum's *Thatched Dwelling in Autumnal Mountains* (Fig. 133) can give a hint of Wang's ultimate direction. (In the 1975 exhibition catalogue, *The Four Great Masters*,[43] the painting is tentatively placed about 1368, whereas a stylistically incompatible scroll, *Forest Mansions at Chü-ch'ü*,[44] is dated as late as about 1375. This date is based on the assumption that the recipient of the *Chü-ch'ü* picture was a Buddhist priest named Jih-chang, whom Wang Meng knew around 1375. But a far earlier work, *Ko Hung Moving his Residence*,[45] reminiscent of Chao Meng-fu rather than

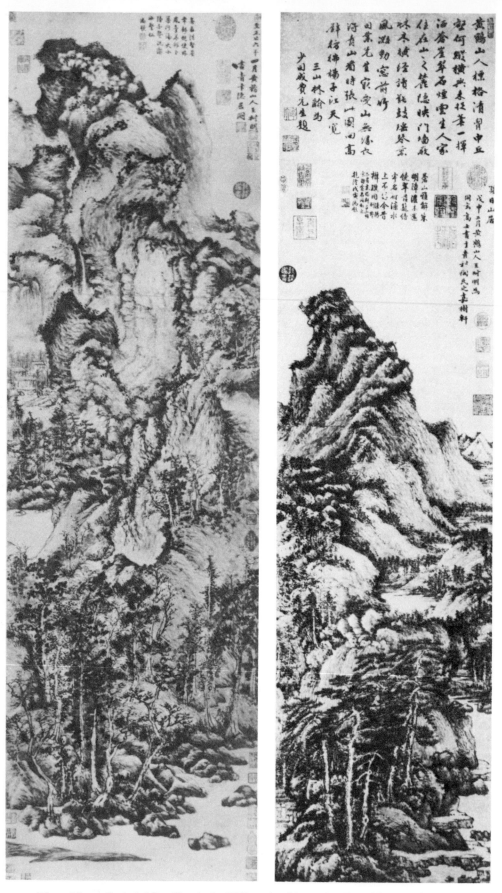

FIG. 131 Wang Meng, *Secluded Dwelling in the Ch'ing-pien Mountains*. Dated in accordance with 1366. Shanghai, Po-wu-yüan.

FIG. 132 Wang Meng, *Dwelling in the Summer Mountains*. Dated in accordance with 1368, Peking, Ku Kung Po-wu-yüan.

Wang Meng himself, was also dedicated to one Jih-chang who, more likely than not, was the same for whom Wang painted *Forest Mansions*.)

After Hu Wei-yung's fall in 1380, Wang Meng, somehow involved in the all-powerful minister's affairs, was imprisoned; he died in prison in 1385.

If our discussion of Yüan painting were to end here, the history of post-Yüan painting would still remain meaningful and intelligible. To the Ming painters, the past consisted mainly of 'Sung' and the new Yüan styles of Chao, Huang, Wu, Ni, and Wang. That these individuals could initiate five distinct traditions is an extraordinary circumstance. Yüan painting, of course, was more diversified, but as soon as an attempt is made to do justice to the lesser men, the contributions of the few great would stand out even more strongly. Yet there were exceptional cases of artists specializing in particular genres who created works of matchless perfection. Such genres were bamboo, plum blossoms, orchids, grape-vine, and the rarer examples of vegetables like cabbage or the rice-plant, to be briefly discussed in the next chapter. A curious speciality was the painting of architectural complexes in miniature as practised by Wang Chen-p'eng and Hsia Yung. In the category of flowers-and-birds, Ch'ien Hsüan remained unsurpassed, though Wang Yüan, *tzu* Jo-shui, while more conventional, should at least be remembered. As for the subject of horses, Chao Meng-fu was the acknowledged master; Jen Jen-fa (1254–1327), his contemporary, whose exact dates became known only when his tombstone was rediscovered in the township of Shanghai in 1953,[46] and Chao's son, Chao Yung (b. 1289), were his most notable successors. Some painters contributed admirable pictures of squirrels and fish, but there were no remarkable dragon specialists comparable to Ch'en Jung or Mu-ch'i of Southern Sung. Nor was there any major achievement in the category of religious painting except for Yen Hui's almost monumental Taoist and Buddhist saints. Zen pictures such as those by Yin-t'o-lo and Tsu-weng hardly count as paintings; at best they are attractive cartoons carrying a message.

It was the landscape that provided the yardstick of greatness in Yüan painting. Measured in terms of either originality or lastingness, none of the school manners of the period could compete with the styles of the great innovators. The schools in question were based on Li Ch'eng and Kuo Hsi, Ma Yüan and Hsia Kuei, and Mi Fei, thus covering nearly the whole of Sung (except for Fan K'uan). In contrast to the innovators' styles, which, though said to be derived from Tung Yüan and Chü-jan, are completely individual ones, those of the Li–Kuo, Ma–Hsia and Mi followers never transcended their prototypes. **Kao K'o-kung** (1248–1310), of Central Asian descent and a friend of Chao Meng-fu, whom he succeeded in office at the Ministry of War, plainly imitated Mi Fei.[47] The Ma–Hsia tradition, least in accord with the new tendencies of the time, was in the capable hands of **Sun Chün-tsê** (early fourteenth century?) from Hang-chou. Unaffected by the current trends of archaism and subjective expressionism, he devoted his talents to the creation of images worthy of Ma Yüan. Even though his oeuvre may be historically irrelevant, lacking as it does newness, it may well be the first of its kind in history: wholly and objectively devoted to a master of the past, whose style takes the place of nature. Sun's

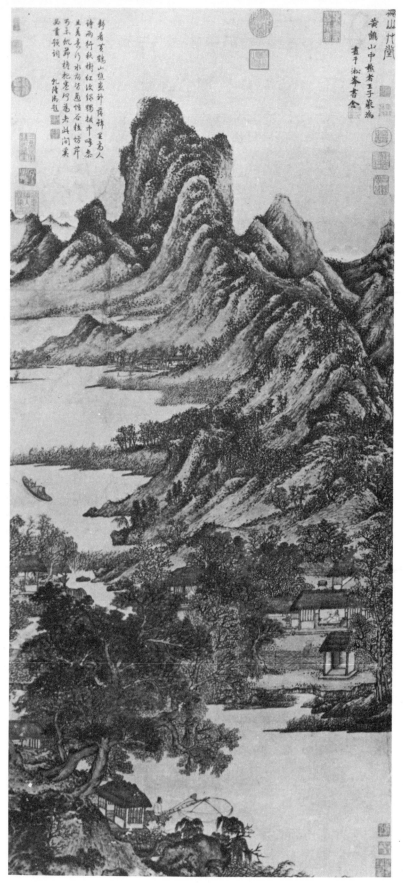

FIG. 133 Wang Meng, *Thatched Dwelling in Autumnal Mountains*. Taipei, National Palace Museum.

work was anomalous for the period because his style was Ma Yüan's with its formulas of beautiful things; in the fifteenth century it would have been less puzzling.

More in keeping with the leading painters' endeavours were the contributions of those who revived the Li–Kuo tradition. The Li–Kuo repertory of type-forms was not particularly significant for Yüan, and even though it may have languished in the works of minor painters in northern China throughout the Southern Sung period, it was a repertory of greater antiquity than Southern Sung. Chao Meng-fu had sanctioned this tradition in some of his works; for others it became the dominant source of style. Four of these, known by their extant works, ought to be mentioned here. **Ts'ao Chih-po** (1272–1355) from Hua-t'ing, Kiangsu, a friend of Huang Kung-wang and Ni Tsan, who became very wealthy as an engineer of swampland improvements, has left a few paintings of trees and of mountain scenery dating between 1329 and 1351, honest works of lyrical appeal and undisguised derivativeness.[48] **T'ang Ti** (c.1286–1354) from Wu-hsing in Chekiang, a fellow townsman of Chao Meng-fu, with whom he is said to have studied, was both an official and a painter of semi-professional standing and great ambition, whose technically immaculate and romantic landscapes are based on Kuo Hsi. Another Wu-hsing artist was **Yao Yen-ch'ing** (active second quarter of the fourteenth century), a professional painter known by a single work in the Boston Museum of Fine Arts, whose contribution is impossible to judge. The last of this group of Li–Kuo followers is **Chu Te-jun** (1294–1365) from K'un-shan, east of Su-chou, in Kiangsu, whither his ancestors had moved from Sui-yang in Honan. A Confucian scholar and Han-lin academician, whose writings include a small book, *Ancient Jades Illustrated* (1341, reprinted 1753), he seems to have painted throughout his later life—extant dated works spanning the years from 1339 to 1364—producing rather conventional landscapes in the Kuo Hsi mode, if occasionally experimenting with bizarrerie.

All of these Li–Kuo followers died before the end of the Yüan Dynasty, and none of them was remembered in the works of subsequent generations.

Equally ignored by later artists, however, were the more important men active at Su-chou in the late Yüan and early Ming years, who as scholars in administrative posts under Chang Shih-ch'eng and in the Hung-wu era were amateur painters, friends of Ni Tsan and Wang Meng, and faithful followers of their styles. Most, if not all, of these men lost their lives in prison because to the plebeian first Ming emperor they were an odious lot, chiefly on account of their education. Foremost among them were **Ma Wan** (active c.1325–65) from Nanking, whose highest office was that of prefect of Fu-chou, Kiangsi; **Ch'en Ju-yen** (active c.1340–70), a native of Su-chou, who held an administrative post in Shantung; **Chao Yüan** (active c.1370) from Shantung, a military adviser to Chang Shih-ch'eng in Su-chou; and **Hsü Pen** (1335–80) from Szechwan, who lived at Su-chou and, in discharge of his duties as a minor official, in Honan.

This group of amateurs under the spell of the leading contemporary masters might have effected the transition of scholar painting from Yüan into Ming if their

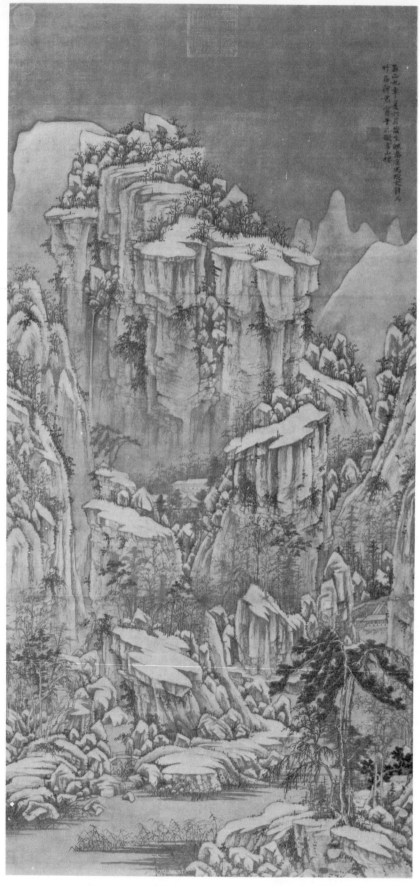

FIG. 134 Ma Wan, *Secluded Dwellings under Lofty Cliffs*. Dated in accordance with 1349. Taipei, National Palace Museum.

FIG. 135 Ma Wan, *Evening Clouds Conveying Poetic Ideas*. Dated in accordance with 1349. Shanghai Museum.

FIG. 136 Ma Wan, *Angler's Boat under Autumn Trees*. Taipei, National Palace Museum.

lives had not ended prematurely and their oeuvres been cut short. Despite their orientation toward the great models of the age and their personal contacts with Ni Tsan and Wang Meng in particular, their paintings are far less uniform than might be expected. In fact, there are instances of a puzzling diversity even within individual oeuvres. A case in point are three works of Ma Wan (Figs. 134–136). The first, *Secluded Dwellings under Lofty Cliffs*, dated 1 July 1349 (Fig. 134), in a graphic technique of sharply outlined forms and crammed with solids built up of many small, ever repeated units, is vaguely reminiscent of Huang Kung-wang, whereas the snow-covered slanting plateaus are a motif that was to recur in the Wang Meng in Chicago (Pl. IX). The second work, *Evening Clouds Conveying Poetic Ideas*, signed and dated 29 August 1349 (Fig. 135), is composed of large forms in strong tonal gradation; its style, while ultimately based on Mi Fei, seems to derive from Kao K'o-kung. The third of the Ma Wans, by contrast, appears to presuppose Ni Tsan for the scenery and Wang Meng for the technique; it is an undated work entitled *Angler's Boat under Autumn Trees* (Fig. 136), rather typical of late Yüan and therefore rather impersonal and unexciting. How can this diversity of styles be interpreted? If these works were not signed, they would probably not be attributed to the same hand. Ma Wan's authorship has not been doubted, to be sure, but where do we find the 'real' Ma Wan? Is any of these works expressive of his personality? Was he, perhaps, merely experimenting? Or was he drifting with the models that became accessible to him? We have to admit that we have no solution. The case of Ch'en Ju-yen is similar, that of Hsü Pen, comparable. Unavoidably, we may have to accept the fact that there are oeuvres without stylistic consistency, the legacy of lesser artists who were eclectics, like Chao Meng-fu, but who never quite found themselves.

Notes

1. Ch. 5.
2. *Pai-yün i-kao*, quoted in Sun Ta-kung, *CKHCJMTTT*, p. 679; Harada, *Shina gagaku sōron*, vol. 1, p. 267. The entire passage is translated in Cahill, 'Ch'ien Hsüan and His Figure Paintings', p. 13.
3. *Wen Wu* 1972/5; *Wen-hua ta-ko-ming ch'i-chien ch'u-t'u wen-wu*, pl. 135; Fontein and Wu, *Unearthing China's Past*, no. 122.
4. Edwards, 'Ch'ien Hsüan and "Early Autumn"'; Cahill, 'Ch'ien Hsüan and His Figure Paintings'; Fong, 'The Problem of Ch'ien Hsüan'; Lee and Ho, *Chinese Art Under the Mongols*, pp. 27–30.
5. E.g. *CP*, III, pls. 369–70; *Sōgen no kaiga*, no. 62.
6. It is catalogued in *Shih-ch'ü*, part 2, vol. 6, p. 3197.
7. Chu-tsing Li, *Autumn Colors*.
8. Ibid., ch. 6.
9. *Famous Chinese Paintings*, vol. 22.
10. *CP*, IV, p. 23.
11. *CP*, VI, pl. 23; Lee, *Chinese Landscape Painting*, fig. 28; Fong and Fu, *Sung and Yüan Paintings*, no. 14.
12. Lee, *Chinese Landscape Painting*, p. 40.
13. Cf. Chu-tsing Li, 'Freer Sheep and Goat', p. 300.
14. *Ch'ing-ho shu-hua-fang*, 10 (*po*), 51a.

15. *Garland*, vol. 2, pl. 11:1–6.
16. *Ta-feng-t'ang*, vol. 1, 9.
17. Ferguson, *Chinese Painting*, facing p. 140.
18. *Garland*, vol. 2, pl. 9:1–4.
19. *Ku-kung chou-k'an*, no. 288.
20. Bachhofer, *Short History*, pl. 117.
21. *Kwen Catalogue*, no. 42.
22. *Garland*, vol. 2, pl. 8.
23. *Li-tai jen-wu-hua hsüan-chi*, pl. 33.
24. Tomita and Tseng, *Portfolio (Yüan to Ch'ing)*, pl. 5.
25. *Shih-chi*, ch. 32; Giles, *B.D.*, nos. 343 and 1862.
26. Wen Chao-t'ung, *Yüan-chi ssu-ta hua-chia*, s.v. 1319.
27. *CP*, IV, p. 65, n. 2; Hsieh Chih-liu, *T'ang Wu-tai*, pl. 99.
28. *CP*, IV, pp. 66 ff.
29. *Hua-lun ts'ung-k'an, shang*, p. 57.
30. Wen Chao-t'ung, *Yüan-chi ssu-ta chia*, p. 9.
31. *Mei-hua-an chi,* apud Wen Chao-t'ung, *Yüan-chi ssu-ta-chia*, p. 3.
32. *Four Great Masters of the Yüan*, no. 204; Cahill, *Hills Beyond a River*, pl. 27.
33. *CP*, VII, p. 143, s.v. *Hakubundō Album*; *Sōraikan*, vol. 1, pl. 22.
34. *Shih-ch'ü pao-chi*, part 1, ch. 30, pp. 33 ff. The colophon is translated in *Four Great Masters of the Yüan*, p. 22, with the fortunately erroneous remark that the work is now lost.
35. *Ch'ing-ho shu-hua-fang*, ch. 11, 13b.
36. Sirén, *Chinese on the Art of Painting*, p. 126.
37. In an inscription on a Wang Meng painting mentioned in Fang Hsün's *Shan-ching-chü hua-lun, hsia*, 21a.
38. *CP*, VII, pp. 137–9.
39. Naitō, *Shina kaigashi*, fig. 89.
40. Cf. *Four Great Masters of the Yüan*, Chinese text, p. 31; English text, p. 37.
41. *KKSHL*, vol. 5, p. 191, s.v. *Yu Lin Ch'ing I*.
42. *KKSHC*, vol. 19.
43. *Four Great Masters of the Yüan*, no. 408.
44. Ibid., no. 411; reproduced in colour, Cahill, *Chinese Painting*, p. 114.
45. *Famous Chinese Paintings*, vol. 7; *Shina Nanga shūsei*, vol. 3.
46. *Wen Wu* 1959/11, pp. 25 ff.
47. A balanced evaluation of Kao's importance is given in Cahill, *Hills Beyond a River*, p. 48.
48. Cf. Chu-tsing Li, 'The Art of Ts'ao Chih-po', pp. 153–92.

Masters of the Ming Period
(1368–1644)

After nearly a century of Mongol domination, Chu Yüan-chang (1328–99) success-fully established the Chinese dynasty named Ming that was to rule the empire from 1368 to 1644. However important politically, the change of power did not, of course, affect the quite unprecedented situation in which the artists of early Ming found themselves: it was theirs to look back upon two distinct, and in principle irreconcilable, traditions, Sung and Yüan. For Sung meant the perfection of objective representation, whereas Yüan meant the unlimited freedom of subjective expression. To the Sung painter, style was a tool handed down, inherited, and almost unproblematic; to the Yüan master, style was his ultimate achievement. No new style was likely to appear that was not linked to either of the two traditions. A choice was unavoidable, and for the first time in the history of Chinese painting the factor of an inner necessity seems to be absent, while eclecticism becomes a matter of course.

The two competing traditions are embodied in the division of two schools that, respectively, represent the Sung and the Yüan traditions in early Ming: the Che School (named after Chekiang Province) and the Wu School (denoting the area of Su-chou, Kiangsu). What is interesting about the two schools is that, while coeval, they are tied to different historical levels. This circumstance results in a glaring discrepancy of intellectual content in their works. The Che and Academy painters, who ignored Yüan, exploited the technical perfection of Sung in works of decorative appeal but usually lacking spiritual depth. The Wu School, by contrast, grew out of the Yüan movement and thus was heir to a still living tradition with all its promises and unexploited potentialities. Reduced to the briefest formula, what the Ming painters did was to revive Sung and continue Yüan. Sung, particularly Southern Sung, was then conceived of as an almost unitary style, whereas Yüan, an epoch without period style, to put it bluntly, projected itself in the several traditions of the great masters' individual styles.

The separation of the Ming schools was not an absolute one. Even Shen Chou (1427–1509), considered the founder of the Wu School, painted in the manner of Tai Chin (1388–1462), the recognized founder of the Che School.[1] In time, how-ever, the Che School professionals began to fall in line with the Wu School literati, so that toward the end of Ming there were no clear boundaries left. Moreover, Che and Wu had something in common; in both schools, painting became a matter of learned discourse with the past, a strongly intellectual pursuit where individuality was expressed in a personal statement on ancient styles. To some extent the Ming painters became historians of painting, encyclopaedists, commentators—scholars, in a word, regardless of their social status.

Yet, astonishingly, despite such seemingly stifling conditions, Ming saw a sequence of creative, highly original masters whose styles are readily recognizable. The phenomenon of consciously manipulated layers of style began in Ming. So did the reactions against too much traditionalism, rationalism, and sheer depen-

dence on antique models. The studies of Tung Ch'i-ch'ang (1555–1636) after ancient masters are, all of them, pure Tung Ch'i-ch'angs. Others, perhaps of lesser stature, abandoned what hitherto was almost inviolate, 'brush work', the basic ink structure of virtually all Chinese painting (with very few exceptions among the traditional styles), and adopted a water-colour technique instead—as did the Su-chou painters, Sheng Mao-yeh (fl. c.1594–1637), Shao Mi (active c.1620–60), Chang Hung (c.1580–1660), and Pien Wen-yü (active c.1620–70); the Nanking painters, Hu Yü-k'un (active c.1610) and Fan Ch'i (1616–94); and the Hua-t'ing men, Shen Shih-ch'ung (active c.1611–40), Yeh Hsin (active c.1670), and Lu Wei (active c.1700). The Fukien master, Hua Yen (1682–1756), carried this experimentation with inkless painting deep into Ch'ing.

Some of these painters' innovations—coloured skies, reflections in the water, and a carefully observed diminishing scale of distant trees or figures—strongly suggest that they were aware of European conventions such as were first brought to the attention of the Chinese by the eminent Italian missionary, Matteo Ricci, S.J., who arrived in China in 1581.

There exist far more authentic works by identifiable Ming painters than from any earlier period. The leading artists are represented with large bodies of works, many of them dated to the year and day, enabling the student to form an idea of their individual progress and of the presence of contradictory forces in their work. At the same time the contributions of the lesser masters become sufficiently clear to justify their inclusion or exclusion in a condensed survey such as ours. On a still lower level we find a multitude of recorded names—over thirteen hundred, in fact[2]—names without faces, obscure, and without historical significance. Fortunately a hierarchy of talent has long since been established by the Chinese critics, who accorded supremacy of rank to the following tetrarchy: Shen Chou, Wen Cheng-ming, T'ang Yin, and Ch'iu Ying. All these men came from Su-chou except Ch'iu Ying from T'ai-ts'ang in the same province of Kiangsu, who, too, later chose to live in Su-chou. Yet, failing to take Tung Ch'i-ch'ang into account, this grouping cannot be accepted as satisfactory. Ch'iu Ying did not leave an indelible imprint of style as did Shen, Wen, and Tung, who moreover had a far-reaching influence as critic, theorist and calligrapher. Ch'iu Ying does not even measure up to T'ang Yin, especially as far as the ink landscapes are concerned.

Ming painting did not fare uniformly well in the judgement of later critics. In 1937 Yü Chien-hua wrote that, 'Ming painting might well be called the period when copying flourished and creativeness declined.'[3] Nineteen years later Yonezawa Yoshiho said of Ming painting in general that 'It is impossible to praise Ming painting unconditionally; one gets the feeling that Chinese art was rather stagnant during this period,' and of the Wu School masters, Shen Chou and Wen Chengming, specifically, that 'If we seek the inspired art of the genius in their work, we shall be disappointed . . . We simply have been led to expect too much of these two painters.'[4] This verdict, though severe, is not entirely contradicted by a critic far more sympathetic to the period such as Chu-tsing Li who, too, speaks of a century of decline in the literati painting of early Ming and seems to be inclined to write off altogether the Ming academicians' and professionals' attempts at reviving Sung.[5] Still, theirs are aesthetically motivated judgements as compared to the completely

unrestrained, politically inspired condemnation of all Ming and Ch'ing painting by no less a personage than K'ang Yu-wei (1858–1927), who felt that Chinese painting was suffering from 'five centuries of erroneous art criticism'.[6] What the great reformer, who disapproved of literati painting, regarded as the remedy was a fusion of Chinese and Western art, as begun by Giuseppe Castiglione in the eighteenth century during the Ch'ien-lung reign. His extravagant verdict, failing as it does to do justice to individual artists and works, remains historically irrelevant.

PAINTERS ATTACHED TO THE COURT, THE ACADEMY, AND THE CHE SCHOOL.

The Hung-wu and Chien-wen years passed uneventfully but for the first emperor's persecution of the Su-chou intelligentsia. The only painters of true stature were the still active late Yüan masters Ni Tsan and Wang Meng, the long-lived, somewhat elusive Taoist priest Fang Ts'ung-i (c.1301–93)[7] from Kiangsi, and the remarkably independent amateur, Dr Wang Li (1332–after 1383), a physician from Kiangsu whose only known works are the remaining leaves of an album of Hua-shan scenery in the Shanghai Museum.[8] None of these painters was in any way related to the Nanking court. Possibly in the later Hung-wu years (1368–98) but certainly in the Yung-lo reign (1403–24) we hear of two celebrated court painters, **Hsieh Huan** (active until c.1435) from Chekiang and **Pien Wen-chin** (active c.1403–35) from Fukien. Of Hsieh's work we know too little to judge; his meticulously finished, unsigned scroll in the Chen-chiang Museum, *Elegant Gathering in the Apricot Garden*, antedating the year 1437 and reminiscent of Liu Sung-nien,[9] is doubtless of the kind acceptable to his imperial patrons who liberally rewarded his services. It was Hsieh, by the way, whose sycophantic fuss about the impropriety of a fisherman wearing a red coat in a picture submitted by Tai Chin during the Hsüan-te reign led to the young painter's expulsion from the Academy. Pien Wen-chin, the first Fukienese in our account, but soon joined by Li Tsai and Chou Wen-ching from the same province, was appointed painter-in-attendance (*tai-chao*) at the Peking Palace under Yung-lo, who in 1421 made Peking his capital. Pien was a man of great learning, a poet, and an impressive painter. He apparently limited himself to the genre of flowers and birds, nearly equalling Sung models in design and feeling. *Birds and Flowering Trees in Spring* of the Shanghai Museum (Fig. 137) is a perfect example of his work done for the Ming court. If there is any shortcoming, it is, typical of Ming at large, that of being 'too much', as when nature is turned into an aviary, or when a setting such as a tree is presented with artful complexity. In justice to the Ming painter we have to remember, however, that many Sung pictures of like subject-matter were album leaves, whose small size made simplicity almost inevitable.

Li Tsai, who joined the Academy in the Hsüan-te reign (1426–35), was a landscapist whose oeuvre is now reduced to two major works, a *Winter Landscape* in the Ogawa collection, Kyoto, and a *Summer Landscape* from the collection of Baron Inō Dan in the Tokyo National Museum (Fig. 138). Neither is easy to place, but the *Summer Landscape*, which is signed, is related to Northern Sung, especially Kuo

FIG. 137 Pien Wen-chin, *Birds and Flowering Trees in Spring*. Shanghai Museum.

Hsi. A scenery of chaotic grandeur is pervaded by heavy mists, above which rise peaks of tremendous height. Some of the lower rocks in the foreground and middle ground are outlined with arbitrary flicks of the brush, graphic elements that in the context of strictly representational outlines and washes remain isolated and ambiguous. The composition as a whole lacks clarity and simplicity; too many heterogeneous forms are competing for attention.

FIG. 138 Li Tsai, *Summer Landscape*. Tokyo, National Museum.

Unexpectedly Li Tsai was singled out (beside a now forgotten Chang Yu-sheng) as one of the notable masters of the time by Sesshū (1420–1506) in an inscription of 1495, where he also refers to his trip to China in 1467 or 1468.[10]

Chou Wen-ching (active *c.*1430–63) was the third Fukien artist of this period. In contrast to Li Tsai his style was based on Southern Sung. Said to have studied in particular Hsia Kuei and the Yüan master Wu Chen, he apparently failed to grasp the economy and precision of Hsia, the appealing orderliness of Wu, and the deep reposefulness of either. Even in a work as late as 1463, a tall landscape scroll showing *Chou Tun-i Admiring Lotus Flowers from his Pavilion*,[11] he seems to have difficulties in organizing his spatial layout, while proving himself a master in drawing the figures of the philosopher seated in a pavilion and a boatman standing in his punt. Equally excellent are the few figures in Chou's *Visiting Tai K'uei on a Snowy Night* in the Palace Museum collection:[12] the visitor who did not visit is Wang Hui-chih (d. 388), a son of Wang Hsi-chih, occupying the small cabin of a boat manned by two boatmen, and looked after by his boy servant. The landscape, despite reminiscences of Hsia Kuei is, again, almost ruined by a muddled arrangement of the solids and the coarsely treated brushwood in the foreground.

Of the several Chekiang painters active during the period of 1426–35 we need only consider **Tai Chin** (1388–1462) from Ch'ien-t'ang, below Hang-chou. A glance at some of the numerous works that go under his name will tell that here we have to do with a superior intellect who knew no difficulty in matters of technique or design. Though modelled on Southern Sung, his landscapes, built up of large, clearly defined parts, demonstrate a distinct, dynamic style of his own. Unlike Sung the formations of distant cliffs or mountain tops are almost invariably stressed by heavy ink or dense vegetation. It is a delight to behold his sure handling of the contrasts of tone and of textures. The brushwork is lively and nervous, admirably secure in fixing the rhythms that permeate such bodies as trees and forests, bare or in foliage. His subject-matter seems to be wholly conventional and unimportant, and, to all appearances, he was not much interested in figure painting.

The narrow spread of known dated works leaves little hope of tracking Tai Chin's course as an artist. But the range between some quite academic, meticulously finished Sung-like pictures and a series of rather different pictures done with fluidity, tempo, and complete freedom does suggest a development from an early phase to a late one. The *Autumnal River Scene* (Fig. 139), datable presumably to 1444, the same year as its companion piece, *River Landscape in Winter*,[13] and painted when he was fifty-six years old, is a magnificent example of his mature period. The bold design of a slightly overhanging wall of rock cutting through the entire length of the scroll and contrasting with the delicately rendered trees is no longer like Sung in feeling or content, however much it is indebted to Sung for the motif, form, and technique. That delicacy is inspired by a love of brushwork or technique as such rather than by a feeling for the object. Yet, such was the Ming painter's condition, more or less clearly perceived by him: in evoking nature, Sung could not be surpassed; in evoking Sung, he could do as he pleased.

Regrettable though Tai Chin's early separation from the Academy may have been as far as his career was concerned, the story of Ming painting was the richer

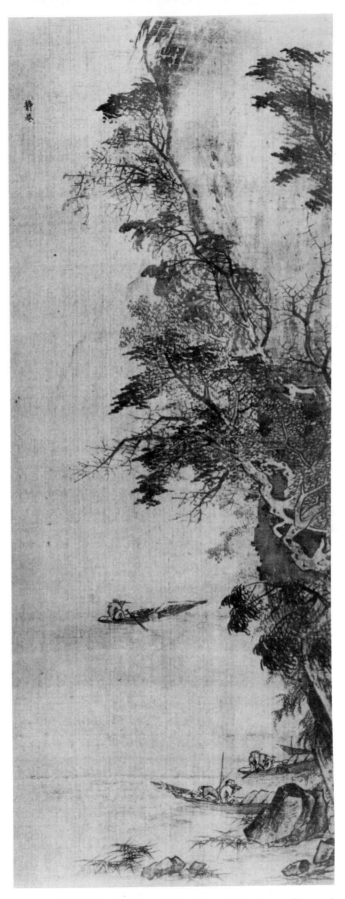

FIG. 139 Tai Chin, *Autumnal River Scene*. Dated 1444. Formerly in the collection of Ct. Tanaka Mitsuaki.

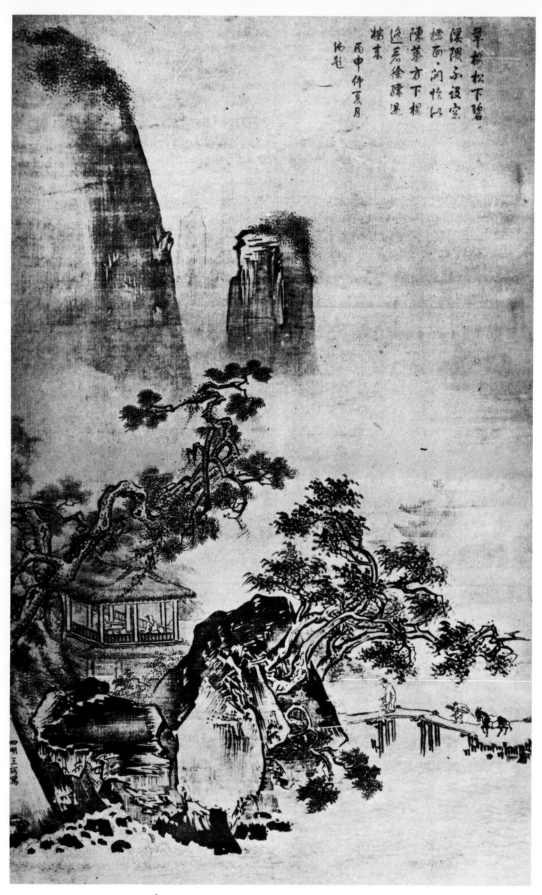

FIG. 140 Wang Ê, *Visitor Crossing a Bridge*. Taipei, National Palace Museum.

for it. Ironically his work became so influential that much of the court painters' achievements of the later fifteenth century is unthinkable without him. In any case he came to be regarded as the founder of the Chê School, whose existence can be inferred from the stylistic continuity seen in the work of his followers.

Among the masters employed at the court during the reigns of Hung-chih (1488–1505) and Cheng-te (1506–21), **Wang Ê** from Chekiang appears to have been the most notable of the Ming followers of Ma Yüan. Even where he exaggerates features of style—as in his juicy ink washes, his atmospheric blurs, and, at times, uneasy juxtapositions of contrasting types of trees—he always seems to work with conviction. He was a technician of the first order, never loath to display his sharp graphic formulations and his limpid constructions (Fig. 140). Perhaps his oeuvre can be enlarged by an unsigned vertical scroll given to Tai Chin, in the Palace Museum,[14] and a likewise unsigned vertical scroll in the Freer Gallery loosely ascribed to Chou Wen-ching.[15] It is quite fitting that the Hung-chih emperor should have spoken of him as 'the Ma Yüan of our time'.

Chu Tuan from Hai-yen, Chekiang, chiefly remembered by his monumental *Wintry Riverscape* in the Tokyo National Museum (Fig. 141), was probably a slightly younger contemporary of Wang Ê, with whom he has little in common. He, too, is said to have been a follower of Ma Yüan; but this is not at all borne out by his *Riverscape*, which rather presupposes Tai Chin. A cluster of big rocks rises and recedes along the left edge of the picture, not cutting across the horizon. A snow-covered tangle of trees about these rocks is suggested in a furioso of spontaneous brushwork—a burst of pure mental energy—and displayed against the grey and motionless expanse of the majestic river. A chain of pale, low ranges clear across the horizon draws the eye into an immense distance. This open, unobstructed horizon is a peculiarly expressive feature of the *Riverscape*, a painting which, moreover, is free of the archaistic mannerisms of the period. Chu Tuan, who began as a versatile eclectic, has here achieved a degree of independence that would be rare in any period, and wholly unpredictable from two apparently earlier works of his. They are a *River Scene* in the Stockholm National Museum datable 1501, according to Sirén, and *Searching for Plum Blossoms* in the Taipei National Palace Museum.[16] The date of the Stockholm picture, which is reminiscent of Yüan paintings in the manner of Kuo Hsi, especially those of Chu Tê-jun, is based on a seal indicating the year when Chu was summoned to the court (*hsin-yu* = 1501), which, however, provides no more than a *terminus ante quem non*.

The oeuvre of **Chang Lu** (*c*.1464–1538) from K'ai-feng, Honan, though larger than Chu Tuan's, is surprisingly uniform. His *Fisherman* (Fig. 142) at Gokokuji in Tokyo is a classic example of his typical compositional devices and of his masterly ink-wash technique as applied to the surface of the ponderous cliff or the weightlessly hovering foliage beyond it. The fisherman who is about to throw his net is caught in a characteristic, not to say timeless, pose, and his state of concentration is symbolized in the harshly calligraphic outlines of his garment. It may be noted that these outlines seem alien in the context of the setting, revealing perhaps the in-

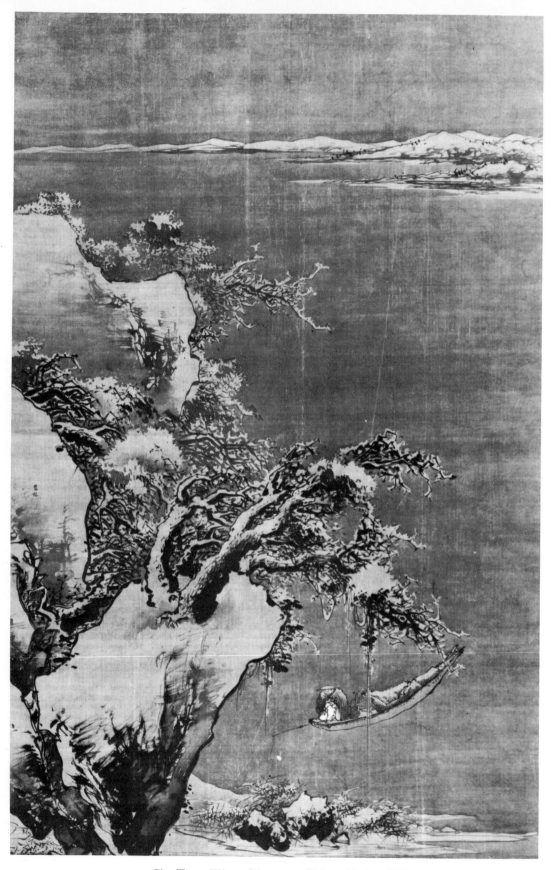

FIG. 141 Chu Tuan, *Wintry Riverscape*. Tokyo, National Museum.

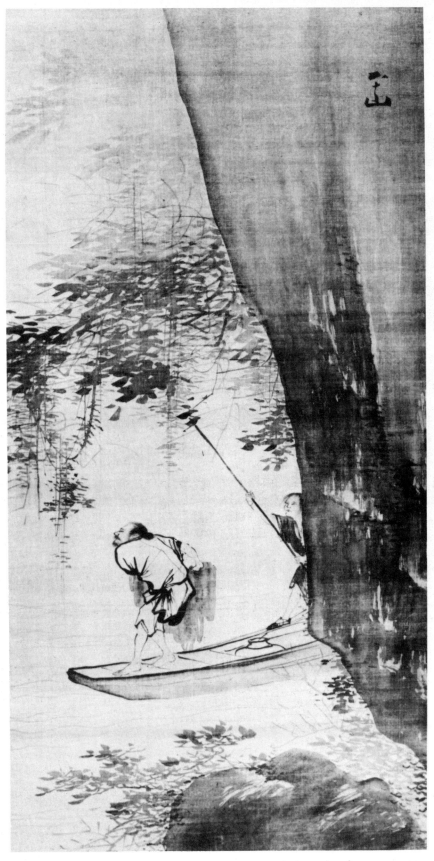

FIG. 142 Chang Lu, *The Fisherman*. Tokyo, Gokokuji. With the kind permission of the Temple and the Tokyo National Museum.

FIG. 143 Chou Ch'en, *The Northern Sea*. Kansas City, Nelson Gallery and Atkins Museum.

fluence of the figure painter Wu Wei. The signature in the upper right corner reads P'ing-shan, Chang Lu's *hao*.

Chou Ch'en (*c*.1450–1535), a native of Su-chou, was possibly the most ambitious among the Sung followers of his time. Unlike Wang Ê and Chang Lu he did not limit himself to Southern Sung but, as the records tell, studied Li Ch'eng and Kuo Hsi, besides Ma Yüan and Hsia Kuei; and some of his works reveal that he was also conversant with Fan K'uan and Li T'ang. The engaging quality of Chou Ch'en's paintings, however, is not versatility or brilliance but, rather, his warmth, substantiality, and romantic feeling. His short handscroll *The Northern Sea* (Fig. 143) in the Nelson Gallery is a model of precision and dramatic flair: the encounter of the raging sea with a rocky headland may not have been depicted with greater intensity even in Sung. Another handscroll in the same collection, entitled *The Clear Pool* (Fig. 144), is of a more timid air and probably earlier than *The Northern Sea*. It is interesting as an instance of the 'small axe-chip' rocks *à la* Li T'ang and of the foliage and tree trunks *à la* Fan K'uan.

Despite his ardent concern with the ideal world of Sung landscape Chou was not indifferent toward the achievements of his contemporaries. In a late work, dated to 1534, he paraphrases the style of Tai Chin;[17] in another in the Museum of Fine Arts, Boston, that of Wu Wei.[18] Why Chou Ch'en should at all have cared to produce such paraphrases is a difficult question to answer; in any case, they suggest that Chou knew exactly where he stood as a painter. Further, he appears to be one of the first Ming artists to have given serious attention to a new format in painting, namely, the folding fan, of which there are no less than a dozen in the collection of the National Palace Museum that bear his signature. Although the folding fan was introduced from Japan as early as 988, according to L. C. Goodrich,[19] it appears to have remained an alien article up to the fourteenth century as far as Chinese painting was concerned.

Not easily reconciled with the image of a Sung-oriented, idealistic antiquarian is Chou's album of 1516, *The Vagrants*. Its twenty-four leaves represent lowly street-

characters, seen with compassion and some amusement, and drawn with an animated brush that endows their miserable draperies almost with elegance. The series was split between the Cleveland Museum of Art and the Honolulu Academy of Arts.[20]

Two outstanding younger men at Su-chou chose Chou Ch'en as their teacher: T'ang Yin and Ch'iu Ying. Their works, which clearly betray that relationship, will be discussed later on.

Wu Wei (1459–1508) from Chiang-hsia in Hupei, much esteemed by the Ch'eng-hua (1465–87) and Hung-chih (1488–1505) emperors under whom he served, was a celebrated figure painter. His oeuvre is distorted by false attributions to an unfortunate extent, imperilling his reputation. A convincing work such as the *Li T'ieh-kuai* (Fig. 145),[21] representing the tragic figure of the Taoist immortal whose soul was reincarnated in the body of a beggar, reveals the degree of Wu Wei's sophistication. Offhand we might see a clever composition derived from Liang K'ai of Southern Sung, although the brushwork, masterly, flashy and not quite terse, clearly presupposes Ming attainments. The outlines of the jagged rock and the undulating hanging branch seem to conform to the silhouette of the figure. The face with its dilated, rolling eyes aptly symbolizes a state of terror, sensitively imagined by the painter, and probably unprecedented. His signature, Hsiao-hsien,

FIG. 144 Chou Ch'en, *The Clear Pool*. Kansas City, Nelson Gallery and Atkins Museum.

FIG. 145 Wu Wei, *Li T'ieh-kuai*.

is unobtrusively placed on the rock surface in the upper left third. Paradigms of calligraphic elegance, the two characters alone seem to vouch for the authenticity of this work.[22]

In the categories of birds and flowers, the court painters had to satisfy demanding patrons, who expected monumentality, exactitude, and decorative grandeur, with Sung reminiscences if possible. Delivering, the artists produced technically flawless works of admirable draughtsmanship that do possess grandeur. But their hardened Sung patterns have lost the intimacy and mystery of the prototypes. Unequalled in his time as a painter of birds was the southerner, **Lin Liang**, from Kwangtung (c.1416–80, according to Cahill), who submitted his work at the Palace around 1460. Compared with the earlier and more refined Pien Wen-chin, Lin's style was greatly influenced by Tai Chin, hence fairly typical and without surprises, at least in his common subjects of birds of prey and their victims.[23] With the grander theme of the *Feng Bird* (or phoenix) Lin's level rises considerably, as in the large *kakemono* of the Shōkokuji in Kyoto.[24] The engaging, anatomically preposterous mythological creature with its enormous plume is perched on a rock surrounded by bamboos and silhouetted against a large sheet of cloud that almost obscures a grove of tall bamboos. The bird faces the sun disk, which has cleared the clouds. Rock and bamboos notwithstanding, the setting seems supramundane; in fact, no ground is indicated, and the leaves of the bamboos around the rock are drawn like little birds winging past. Wu Wei, in his marvellous *Fairy and Phoenix* in the British Museum, has dispensed with a setting altogether as his bird strides proudly and obediently beside the fairy, his mistress.[25]

Lü Chi (1477–1521) from Chekiang is the last of the court painters to be mentioned here. Having studied Pien Wen-chin as well as T'ang and Sung masters, he stood on solid ground when acquainting himself with the styles of Tai Chin, Chang Lu, or Lin Liang, as no doubt he had to. His specific contribution—rather unexpected in the case of a flower-and-bird specialist—was a harsh and powerful style of enormous plastic energy, as typified by his *Winter Scenery* (Fig. 146) from a series of the four seasons in the Tokyo National Museum. The churning waters of a mountain torrent confined between the rocks of a narrow gorge dominate the design. Plunging down with tremendous force, the torrent has the compactness of a sculptured object. Its smooth curves contrast with the jagged, sharply fissured shapes of the rocks and with the tangle of gnarled roots, sections of trunks and twisted branches growing from them in artful confusion. Some fresh-fallen snow lights up and sharpens the contours of the flowering prunus trees, the white of their blossoms competing with the gorgeous red of green-leaved camellias. A brace of pheasants under the big fissured rock is readily seen, but a group of four finches near the upper right corner all but disappears in a black-and-white reproduction of a painting that relies on the ordering function of colour.[26] None of the motifs in this painting is without Sung precedents; but their arrangement in studied confusion and their three-dimensional heaviness are Lü Chi's own achievement.

Most bird-and-flower paintings attributed to Lü Chi are more conventional, however. One of them, *Ducks Swimming Under a Rock* in the Shanghai Museum,[27]

is a work of surpassing quality, signed, and convincing. Dramatically arrayed rock masses are done in a limpid technique in diluted ink, light brown and bluish grey, while *t'ai-tien*, or moss dots, are sparingly used. The unusual motif of a rose bush in the upper right half is represented in perfect gradations.

THE PAINTERS OF THE WU SCHOOL AT SU-CHOU, KIANGSU.

The stylistic contrast between the court painters and **Shen Chou** (1427–1509), founder of what came to be known as the Wu School, is comparable to that between Sung and Yüan. Shen Chou was primarily a Yüan follower who studied by copying works of Chao Meng-fu and Chao Yung, Huang Kung-wang, Wu Chen, Ni Tsan, and Wang Meng. But, his basis was even broader, as his 'repertory' comprised Sung and pre-Sung masters as well, specifically Tung Yüan, Chü-jan, Li Ch'eng, Chao Ta-nien, and a few lesser men like Hui-ch'ung, Chao Po-chü, Yang Pu-chih. Among the early Ming painters, **Wang Fu** (1362–1416) from Wu-hsi near Su-chou must have been dear to him, although he probed even into the style of Tai Chin.[28] Conspicuously absent from the list of famous names of concern to him are those of Ma Yüan and Hsia Kuei. If the selection of his models was at all planned (within the limits of available originals), it may have been done by Shen Chou's first tutors, his father Heng (1409–77) and his uncle Chen (1400–82?). 1482 is the latest ascertainable year when Chen was still alive; it is the date of a colophon he wrote on a hanging scroll by Wang Fu in the Lowe Art Museum, University of Miami, Coral Gables, Florida.[29] The likelihood of programmed studies seems almost inescapable when in his biography in the *Ming Annals* we read that his prose was modelled on the *Tso Chuan*; his poetry, on Po Chü-i (772–846), Su Tung-p'o, and Lu Yu (1125–1209); and his calligraphy, on Huang T'ing-chien (1050–1110).[30] None of these matters would be worth mentioning were it not for the fact that some critics set Shen Chou above all other Ming painters, as stated in the same source. One may feel reminded of Chao Meng-fu's encyclopaedic efforts, 180 years earlier, but in Shen's case we are confronted with a far more uniform style than Chao's. In view of his very large oeuvre this uniformity is astonishing. Moreover, his style appears to be almost fully prefigured in the works of Wang Fu, a literati painter who was exiled under Hung-wu, became a court painter under Yung-lo, and died eleven years before Shen Chou was born. Perhaps the name of Wang Fu was not glamorous enough for the critics who sang Shen Chou's praise by linking him to the grander names in painting history. Even an apparently exact statement such as that of Li Jih-hua (1565–1635), to the effect that Shen Chou in his middle years was attached to Huang Kung-wang but in his later years was entirely carried away by Wu Chen, would be difficult to verify from the works now known.

Shen's paintings seem to be always typical, nearly from the beginning. The brush stroke takes the place of washes, except in the silhouettes of distant ranges. Flat colour replaces the sophisticated gradations of a Chang Lu or Lü Chi. Of the grand rhetoric of Sung-derived motifs nothing remains. There is no pathos. The subjects are humble everyday scenes, presented objectively, neatly, dispassionately. There is an air of simplicity, almost as if his works were meant to be seen and enjoyed by

FIG. 146 Lü Chi, *Winter Scenery*. Tokyo, National Museum. ZHEJIANG

1477-1521 CHEKIANG

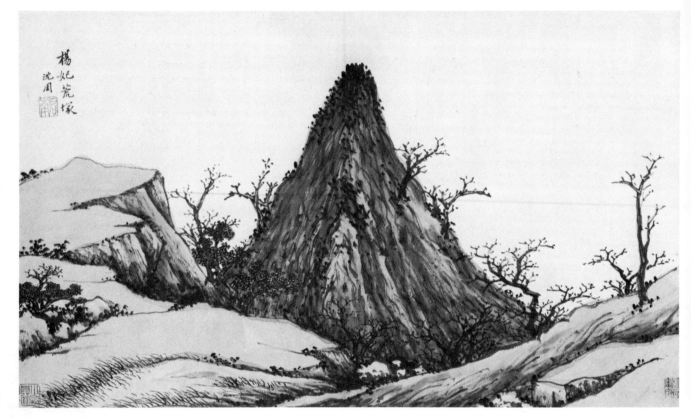

FIG. 147 Shen Chou, *The Tomb of Yang Kuei-fei*. From an album of *Eight Views of Ma-wei*, 1482 or earlier. Present whereabouts unknown. Photograph, courtesy of the Art Institute of Chicago photographic archive.

children. In accord with that simplicity, his pictures possess strength and directness, even though in their graphic manner they retain a decorative touch.

Not infrequently Shen's landscapes represent specific places. A case in point is an album of *Eight Views of Ma-wei*, one leaf of which depicts the forlorn *Tomb of Yang Kuei-fei* (Fig. 147), T'ang Emperor Ming-huang's concubine who was put to death at Ma-wei during the flight of the court to Szechwan in 756. From a dissected terrain the stark earthen cone rises into the blinding light of the white paper. A few leafless, sad-looking trees surround the cone. Shen Chou, who himself had not travelled that far, has here conjured up a powerful presence from his imagination. Yao Shou (1423–95), a contemporary painter, has added poetic inscriptions to all of the eight leaves. A colophon dated to 1482 supplies a *terminus ante*, but, curiously, does not refer to Shen Chou. The album, which bears seals of the noted twentieth-century Shanghai collector P'ang Yüan-chi, does not seem to be recorded.

Rather more characteristic is an album kept in the Nelson Gallery. Named *Ten Views of Ku Su* (Wu-hsien, or Su-chou), it was painted by Shen Chou in 1488, when he was 61. The leaf illustrated here, *Heng-t'ang* (Fig. 148), shows a village along a stream. The treatment is extremely unpainterly. The houses are one like the

other, and the willows are one like the other. The contours of a hazy range of hills in the distance follow those of the willow trees, which in turn seem to follow the banks of the stream. The impression of a deserted village is scarcely relieved by the presence of a lonely boatman and the two figures bowing to each other at the hour of parting. The forms of the objects that matter here—houses, willows, and the banks of the stream—are uningratiating, coarse, seemingly naïve, yet almost final. They are also enigmatic: while certainly free of sweetness, and in a way objective, are they in any manner expressive? A glance at comparable motifs in Chang Tse-tuan's *Ch'ing Ming Shang Ho* (Fig. 82) of the early twelfth century will tell us of an irreparable loss of meaning. Chang's was a world seen in an infinite variety of individual things—seen, not constructed or merely imagined. Shen's, by contrast, is divorced from that flavour of a here and now; a world of symbols and schemata which, because they are changeless, seem timeless or final; a world whose logic and strength are conceived in purely pictorial terms, as they were far earlier by the Yüan masters, such as Huang Kung-wang (Fig. 123).

FIG. 148 Shen Chou, *Heng-t'ang*. From an album of *Ten Views of Ku Su*. Formerly Hashimoto collection, Tokyo.

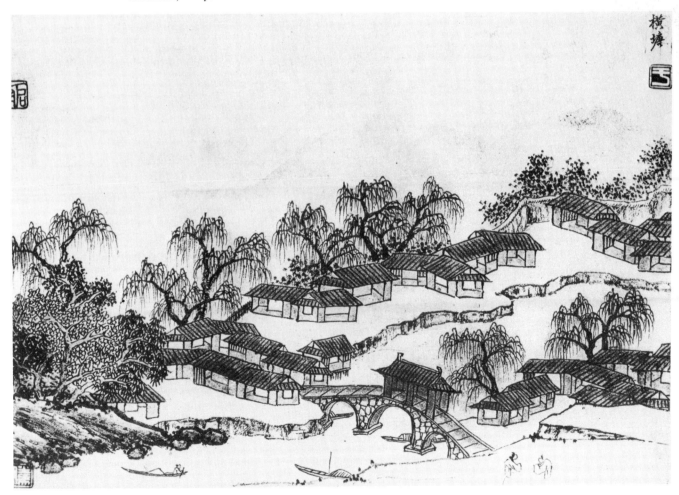

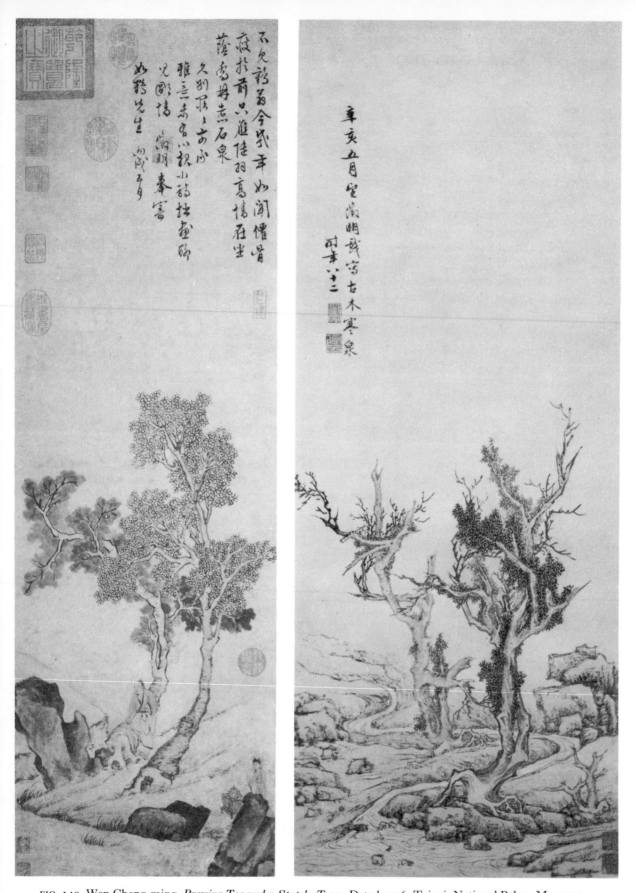

FIG. 149 Wen Cheng-ming, *Brewing Tea under Stately Trees*. Dated 1526. Taipei, National Palace Museum.

FIG. 150 Wen Cheng-ming, *Old Trees and Cold Springs*. Dated 1551. Cleveland, Ohio, Mr and Mrs A Dean Perry collection.

Foremost among the pupils of Shen Chou was **Wen Cheng-ming** (1470–1559) from Su-chou, another of the four great masters of the Ming. He did not seriously start to paint before he was almost sixty, after spending his earlier years in studying calligraphy, history and literature in hopes of passing the examinations that would open an official career to him. With incredible tenacity Wen sat for the civil service examinations over a period of 28 years but failed time after time. Finally a recommendation by the Governor of Wu led to his appointment as *tai-chao* at the Han-lin Academy in Peking in 1523, but after five years he found himself constrained to resign. Returning to Su-chou in 1527, he apparently was reconciled at last with a fate that had destined him to be remembered as a painter. Long-lived and energetic, he had 32 years left to establish his artistic reputation. It was an achievement that could to some extent be measured in terms of his independence from his teacher, Shen Chou, with whom he had begun to study as early as 1489—well after his first instructions in calligraphy by Wu K'uan (1435–1504) at the age of eight.[31]

Even a slight acquaintance with Wen's painting reveals that he was not a faithful follower of his teacher. Neither in style nor in subject-matter does his large oeuvre show much resemblance to Shen's, which was characteristically uniform from beginning to end. Wen rather admired the encyclopaedism of Chao Meng-fu. Not unlike Chao's, his artistic image became too complex and elusive for 'easy replication'.[32] And his efforts toward an ever greater intensity of vision remained unattainable to his followers. There was no clear-cut development, or style that loomed large in the consciousness of potential imitators, despite his lasting contributions to the imagery of mountains and trees.

Wen Cheng-ming's most deeply personal forms may be found in his trees, especially those which resemble the cedar and cypress, thuya or juniper. Two tree pictures, done twenty-five years apart, present a telling contrast. The earlier one, *Brewing Tea under Stately Trees*, dated 1526 (Fig. 149), relies on a transparent construction with obvious directional shifts; shaded rocks set against a toneless slope; foliage in pattern and wash on trees rising somewhat awkwardly in parallel curves. The figures of master and servant are placed, the one in front of the further tree, the other behind the nearest rock. Both are facing the viewer. There is no indication of a background. The forms are undistinguished and conventional. *Old Trees and Cold Springs* of 1551 (Fig. 150) is a far more profound work, unified, and mysteriously expressive. The trees are not treated as conventional types but as individual beings, differentiated by the degree of their decay. Their pathetic, shattered forms speak of suffering and ultimate death. Beside them the trees of the earlier work are flat, inexpressive, at best decorative. The terrain consists of subtle formations of small, angular, brittle-looking rocks, all more or less of the same basic shape, which somehow corresponds to the angularity of the trees. Washes are avoided. The foliage is realized in compact, dark areas of ink dots clinging tightly to the trunk and live limbs in a design of great complexity. No background formations interfere with that design. The trees are Wen Cheng-ming's own creation; there were none like them before, because they are symbols of his particular, deeply personal inward experiences.

The mountain images of Wen Cheng-ming lack this moving quality of pure feeling. Instead they delight us by the consummate skill of their construction, even

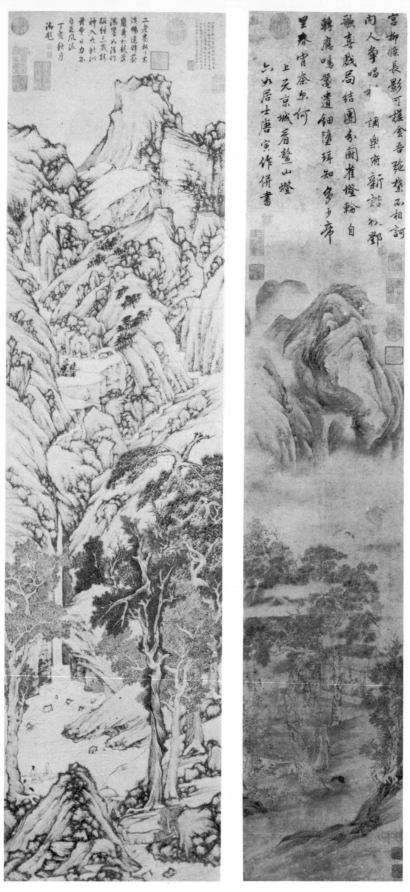

FIG. 151 Wen Cheng-ming, *A Thousand Cliffs Vying in Splendour*. Taipei, National Palace Museum.

FIG. 152 T'ang Yin, *The Lantern Festival*. Taipei, National Palace Museum.

FIG. 153 T'ang Yin, *The Lantern Festival*. Detail of Fig. 152.

by their frank artificiality. These features are unmistakably present in *A Thousand Cliffs Vying in Splendour*, painted during 1548–50 (Fig. 151). In the upper half of the narrow, tall scroll rises the inorganic world of sheer rock, presented in infinite detail and crystalline clarity, airless and changeless—like an anatomy of a mountain, rather than its appearance or its idea. At the foot of these stony formations a pool has formed, fed by a waterfall and framed by the flattish, luxuriant, meticulously executed foliage of big trees, the tops of which reach up halfway. The pool, the trees, and a cone-shaped heap that serves as a somewhat arbitrary repoussoir in the immediate foreground form the only instance of a marked recession in this picture, the rest of which reads almost like a vertical wall. That this type of mountainscape caught on among Wen's followers was due, no doubt, to the very challenge posed by its formal organization, which required thought, not feeling. For 'Wen's aesthetic interest focussed on style itself rather than subject . . .'[33]

Wen Cheng-ming's only true competitor was his contemporary, **T'ang Yin** (1470–1523 or 1524) from Su-chou, the son of a restaurateur or grocer who did his utmost to provide for his education. Yin was a brilliant student who, when only fifteen, won top honours in the prefectural examination. In 1497 he was able to

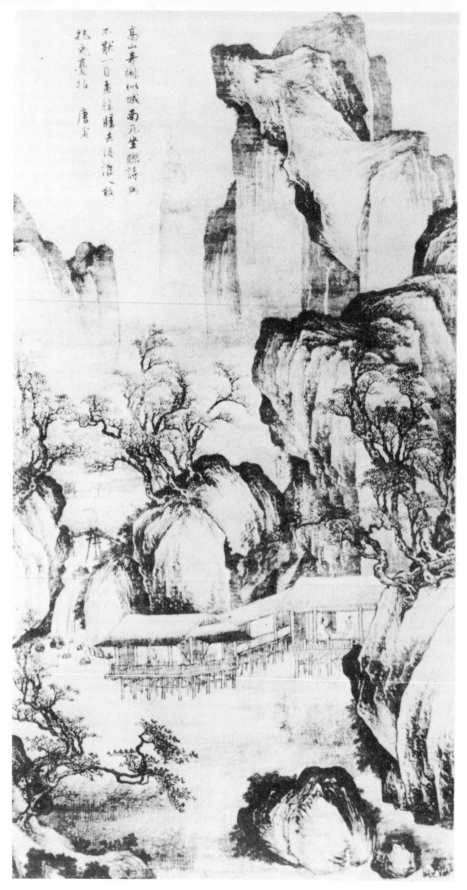

高山峰絕似城南几堂賺詩興

不默一自垂絲睇去陵谁小敲

林见友拈　唐寅

FIG. 154 T'ang Yin, *Tall Mountains and Wonderful Trees*. Whereabouts unknown.

repeat this achievement in the provincial examination.[34] He seemed certain to pass the ultimate test of the state examination in Peking with equal success. He did, but because of a bribery scandal caused by a close friend of his, a wealthy playboy from Su-chou, he was stripped of his academic honours. He returned home, almost an outcast, forced to subsist on what he could earn with his paintings. Erstwhile protégé of Wen Lin (father of Wen Cheng-ming) and Cheng-ming's friend of many years, he saw himself reduced to the status of a professional picturemaker. Yet in the end he triumphed as an artist, regardless of his social standing and despite the fact that his style was based on Chou Ch'en rather than Shen Chou.

That T'ang Yin gave up his prestigious discipleship with Shen Chou may well have been caused by his degradation in 1499. At any rate it was Chou Ch'en—and hence the style of Li T'ang of late Northern and early Southern Sung—who from now on determined T'ang Yin's direction, especially in his very consistent, dense, and radiantly sensuous mountainscapes. The detail of a scroll painted in Peking shortly before the examinations of 1499 and entitled *The Lantern Festival* (Fig. 152) precedes those mountainscapes by a short interval. It shows a mountain formation of monumental character in turbulent motion and vivid chiaroscuro. The forms and the brushwork are so free and spontaneous that it would be difficult to link them with any existing tradition.

A later and more typical work, *Tall Mountains and Wonderful Trees* (Fig. 154), combines the orderliness of Southern Sung with the crowding of Ming and the idiosyncrasy of T'ang Yin's sharp contrasts of light and dark areas in his rocks and cliffs and crags. As in Wen Cheng-ming's mountainscapes there is little recession, but the forms are large and enveloped by space and atmosphere. There is a touch of routine but no coldness. When compared with Wen Cheng-ming's mature works, the derivativeness in the T'ang Yin is obvious. But then, Wen Cheng-ming lived thirty-five years longer than T'ang Yin.

It is difficult to imagine that T'ang Yin should have acquired fame as a painter of women on the basis of such conventional and unalluring pictures as are generally attributed to him.[35] His surpassingly graceful ink drawing of *A Beauty Sleeping on a Banana Leaf* (Fig. 155) in the Metropolitan Museum goes far to settle the question, however. The frail, almost incorporeal figure, silhouetted against the dark ink of the leaf, is rendered with a calligraphic vigour that does not really represent, but effectively suggests, the drapery playing over the surface of a scarcely defined human form. We noticed something comparable in the draperies of Chou Ch'en's album, *The Vagrants*.

Ch'iu Ying, the fourth of the great Ming masters, was about 20–30 years younger than T'ang Yin. He died probably in 1552.[36] A native of T'ai-ts'ang, he moved to Su-chou and like T'ang Yin became a pupil of Chou Ch'en. Although of humble origins and by no means a literatus, he was on good terms with the local luminaries, who obviously took him seriously as a painter. Many of his pictures carry inscriptions or colophons supplied during and after his lifetime by scholars of such resounding names as Wen Cheng-ming, Wen P'eng, Wen Chia, Wang Ch'ung, Lu Shih-tao, Ch'en Tao-fu, P'eng Nien, Tung Ch'i-ch'ang and Hsiang Yüan-pien. Yet it is not easy to pin down the real Ch'iu Ying. Apparently he was equally at

home in the camps of both literati and professionals, as was T'ang Yin before him. Possibly Tung Ch'i-ch'ang's characterization, 'he was Chao Po-chü reborn', best sums up Ch'iu Ying's contribution, a combination of extreme skill and archaic subject-matter, or of technical perfection and stylistic versatility. The models acknowledged in Sirén's *List*[37] comprise Chou Fang, Li Kung-lin, Li T'ang, Chao Po-chü, Liu Sung-nien and Tai Chin, to whom we should add Chao Meng-fu, Wen Cheng-ming and, of course, Chou Ch'en. The only group left out of account is that of the four Yüan masters (Huang, Wu, Ni, Wang). Its omission goes some way to establish Ch'iu's position, that of a protagonist of encyclopaedism unconcerned with a personal style. It is a position in keeping with the aims of a professional rather than those of the scholar or amateur struggling for self-expression, for a style of his own. Ch'iu Ying's superior skill may not save his work from historical insignificance, but it should certainly guarantee the artistic value of a good number of his paintings. His landscapes, burdened with overly precise detail, lack monumentality. Better suited to his talents was the gardenscape, especially when treated with the miniaturesque refinement of which he was a master, but coarse and unconvincing when done in a neo-Academic or Che School manner. (Compare the famous *Peach and Pear Garden* of the Chion-in, Kyoto, with *Playing String Instruments in a Garden with Banana Plants* of the Palace Museum, Taipei.[38]) Ch'iu was noted as a figure painter, too, although he never reached the levels of Wu Wei's daemonic inspiration or of T'ang Yin's elegance.[39]

A flower study such as the *Orchids* from the Chiang Er-shih collection,[40] is a rare subject in Ch'iu Ying's oeuvre (Fig. 156). The flowers are nearly hidden among the expansively curving leaves which, almost unshaded, impart a quality of transparency, not to say insubstantiality, to the design. Neither in the flowers nor in the leaves is there the slightest attempt to exploit their geometric potentialities, and no effort is made to transpose the sensitively drawn forms into a calligraphic idiom.

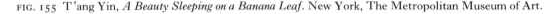

FIG. 155 T'ang Yin, *A Beauty Sleeping on a Banana Leaf.* New York, The Metropolitan Museum of Art.

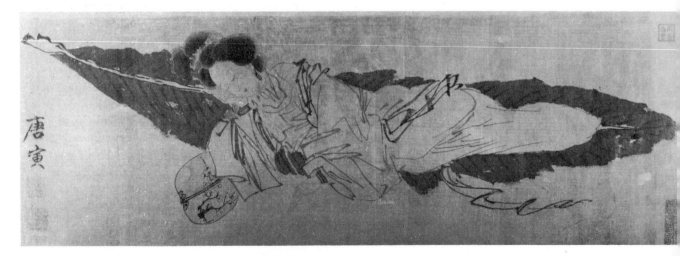

We are indeed faced with a representation of timeless perfection and without historical relevance. Wen Cheng-ming's inscription, a poem of twenty characters, appropriately speaks of orchids only, not of Ch'iu Ying's style.

Tung Ch'i-Ch'ang (1555–1636), the last of the great Ming painters according to the traditional rating, was the only true *wen-jen* or scholar-official among his peers— Shen, Wen, T'ang, Ch'iu, none of whom held an office of such importance as Tung did, and none of whom attained a comparable standing as a calligrapher. He passed his doctoral examination in 1589, and was elected a member of the Han-lin-yüan the same year. Tung was a native of the then still small town of Shanghai in Kiangsu. When as a commoner holding a piece of land he found himself threatened by the corvée statute, he escaped to Hua-t'ing (or Sung-chiang) in the same province where he first met with the learned and elegant people that were to set him on his path: Ku Cheng-i the painter, Hsiang Yüan-pien the collector and connoisseur, and Mo Shih-lung, his 'elder brother', who may have stimulated Tung's theorizing on the Northern and Southern Schools in Chinese painting. His closest friend throughout his life, however, was Ch'en Chi-ju (1558–1639), from Hua-t'ing, who after his *hsiu-ts'ai* examination renounced all ambition of further advancement in the bureaucracy but in 'retirement' lived a life of such activity that he was spoken of as 'Prime Minister in the Mountains'.[41]

Tung, climbing the ladder of officialdom and braving its dangers, became a compiler of history; Tutor of the Crown Prince, Chu Ch'ang-lo (who as Emperor Kuang Tsung reigned one month in 1620); and finally President of the Board of Ceremonies, retiring in 1634.

That Tung Ch'i-ch'ang became China's most celebrated calligrapher of late Ming may have to do with his humiliating experience early in his career of being placed second, not first, in his *hsiu-ts'ai* examination, on account of his poor hand, a shortcoming he at once set out to rectify by sheer will-power. His chief models were Mi Fei and Chao Meng-fu.

Our interest in Tung Ch'i-ch'ang depends, however, on his achievements as a painter, whose avowed models were Huang Kung-wang, Tung Yüan, to whom he used to refer as 'Tung of my family', and the more elusive Wang Wei of T'ang, of whom he probably knew little more than we do today. Whatever his acknowledged prototype, Tung always seems simply himself, just as if his protestations regarding his dependence upon this ancient master or that were not meant to be taken seriously. Theoretically they were, for Tung insisted on the painter's ability to transform (*pien*) the style of his models. Thus it is correct to say that he 'showed, even in copies, nothing but his own personality'.[42] Yet there are limits to the painter's freedom. Tung explains that in layout (*wei-chih*) and texturing (*ts'un-fa*) there are definite ancient styles that must not be mixed, just as there are trees whose archetypes created by certain ancient masters cannot be changed in a thousand ages—even though these archetypes may be used simultaneously in a modern landscape.[43] This contrast of what Tung considers the dogmatically correct treatment of the larger landscape elements and of the trees is curious and difficult to understand. A hint is given in another passage of the same text where he says: 'In painting, the foremost necessity is to work out the trees, although it is [always]

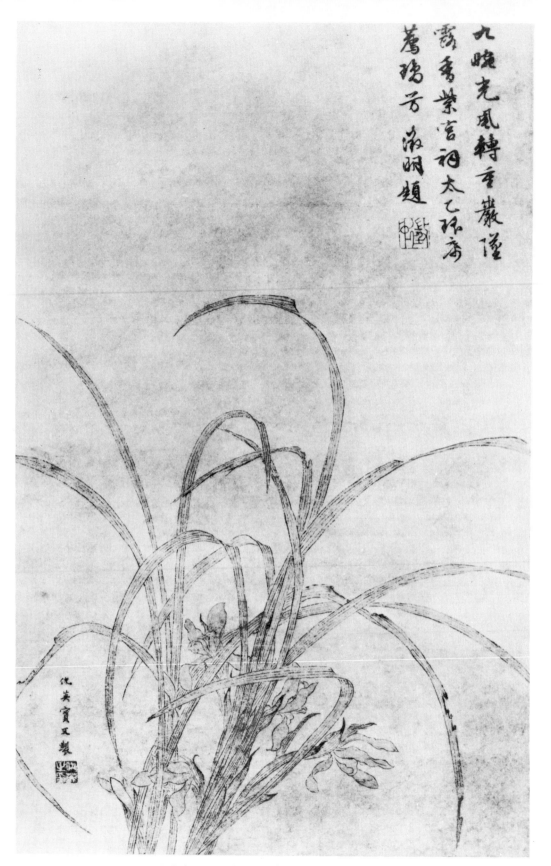

九畹光風轉玉巖隈
露香秀葉當階太乙瑤房
薦瑞芳 澈明題

仇英實父製

FIG. 156　Ch'iu Ying, *Orchids*, Chiang-Er-shih collection.

difficult to make the branches extend in all directions. The mountains need not be many: simplicity should be valued.'[44] Speaking, less abstractly, of Ni Tsan, Tung Ch'i-ch'ang offers a no less baffling statement dealing with the same matter:

> In Yün-lin's painting method, the trees, by and large, resemble Li Ch'eng's wintry forests; mountains and rocks are derived from Kuan T'ung; [while] his texture strokes resemble Tung Yüan. Yet all of them are changed. If a man studying antiquity cannot make such changes, he is like someone between fences and walls, [but] when departing far [from the prototypes] may well closely resemble them.[45]

Surely Tung Ch'i-ch'ang was convinced of his ability to make precisely the kind of stylistic transformations with which he credits Ni Tsan; and he would scarcely have expected to be criticized on this count as severely as he was by Ch'ien Tu (1763–1844) in his *Sung-hu hua-i* of 1830: 'Of those who [in contrast to Wang Meng of the Yüan period] were not good at making transformations, Hsiang-kuang [Tung Ch'i-ch'ang] was the worst.'[46] How seriously should this verdict be taken? The fact that Ch'ien as a painter is dwarfed by Tung need not entirely invalidate it. Moreover, it is concerned with theory rather than painting as such. Whether or not Tung was true to his own theories at all times, his pictures certainly attest to ample transformation of his alleged models; rather, perhaps, our outspoken critic found Tung's transformations too radical and therefore bad.

Radical he doubtless was, as we may gather from an undated landscape of unknown whereabouts (Fig. 157).[47] An exciting work, it resembles none of the Ming landscapes we have seen before. The forms, though based on conventions, seem unconventional, as does the almost disjointed composition, which entirely lacks organic feeling. What we are faced with is a kind of construction slightly chaotic in the arbitrary diversity of shapes which are flattish and without recession, yet ordered to some extent by the insistent presence of triangles. Not to be overlooked among those triangular formations is the one effected by the three darkest accents in the painting: the half-shaded hummock topmost, the row of pine trees left edge centre, and the foliage right edge centre—three heavy areas that hold the composition together. In all its simplicity the half-shaded hummock may be one of the most curious mountain shapes invented by any Ming painter. With its smoothly rounded contour and undefined surface it presents a strange contrast to the sharply textured hills and cliffs in front of it. Projected against these hills are the tops of tall trees set on arbitrarily dissected hillocks in the foreground. No atmosphere relieves the harsh and tangled encounters of those projections. The trees, a fantastic mixture of uncouth and graceful, screen out the only area apt to create spatial depth: an expanse of water that separates the foreground from the more distant formations.

Tung's inscription begins with a couplet from Wang Wei (699–759),

> The sound of springs is swallowed by steep rocks,
> The sun's splendour is calmly received by the green pines,

which is followed by the dedication to a relative.

A rare and enchanting small mountainscape in colour on silk in the Nelson Gallery bears an inscription by Tung Ch'i-ch'ang, dated in accordance with 1615

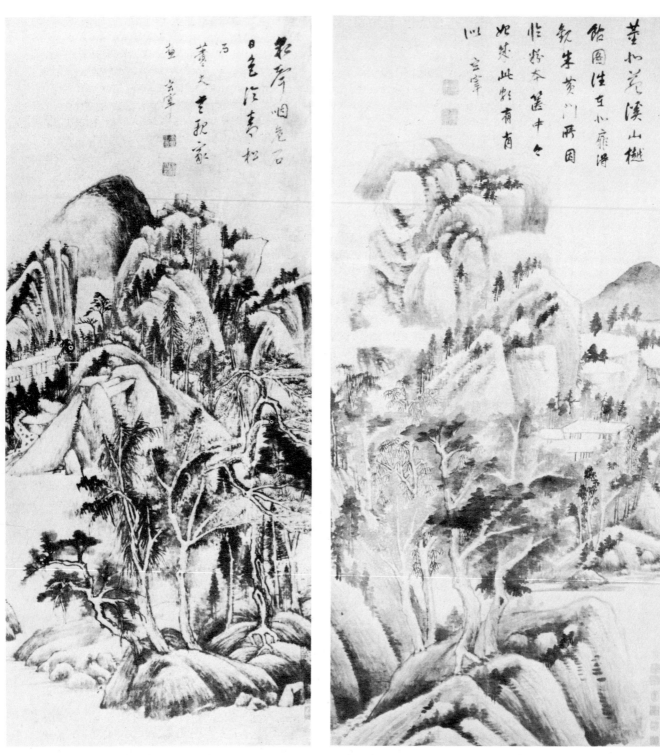

FIG. 157 Tung Ch'i-ch'ang, *Landscape*. Whereabouts unknown.

FIG. 158 Tung Ch'i-ch'ang, *Shaded Dwelling among Streams and Mountains*. New York, The Metropolitan Museum of Art. Lent by Douglas Dillon.

(Pl. x). His inscription says, 'I once saw an authentic work by Yang Sheng, Mountains in the boneless manner, showing the playful brush of an artist of antiquity . . ., something rare to behold in this world. This is a copy of it. *I-mao* (1615), Spring, Tung Hsüan-tsai recorded.' There seems to be no reason to doubt the genuineness of Tung's hand; what has to be asked, however, is whether the inscription signifies that Tung was also the painter. The inscription reads as the statement of the connoisseur Tung who can proudly claim to know the original behind this copy, but who makes no claim to have been the author of the copy himself. Nor does the style of this copy necessarily remind us of Tung Ch'i-ch'ang. Be that as it may, there exists a *Landscape* by Tung closely resembling the Kansas City painting, so that the latter cannot be dismissed out of hand.[48] Here, in contrast to the forced graphic harshness of the preceding work (Fig. 157), the forms are gentle and lucidly disposed, the recession clear, and the colouring luminous, opalescent, mysterious. But for the inscription we should be hard put to advance any guess as to a possible prototype. All we might be able to say is that the painting —in addition to its inkless technique—is of archaizing character in its stress on blue and green hues. Continually shaded and thus producing the effect of scattered light and atmosphere, these hues are, of course, a far cry from the flat blues and greens of true archaic works. We might further point out that the gracefully drawn foliage retains something of the ornamental beauty that was commonplace in the past. Technically this painting seems more accomplished than the preceding one. (It may be worth noting that Tung painted an archaistic landscape, after Chao Po-chü, in the same year, 1615.)[49]

An indubitable work of Tung Ch'i-ch'ang's is the monumental hanging scroll in the Metropolitan Museum of Art (Fig. 158). The inscription tells us that we have to do with a 'copy' after Tung Yüan's *Shaded Dwelling among Streams and Mountains*. The painting, which is not dated but likely to be later than our first Tung Ch'i-ch'ang (Fig. 157), once more explores the same subject-matter in a softer, more painterly technique. The steeper banks in the foreground relate more easily to the towering structures beyond them, hazy crags of many shapes and precariously joined. It has been said that trees and rocks are done in calligraphic brushstrokes, but this I fail to recognize. On the contrary, what little there is of linear components is never independent from a descriptive function and often is blurred or virtually obliterated by rows of transversely placed *t'ai-tien* (moss dots). A genuine calligraphic stroke possesses life and meaning in itself, whether or not it can also be read as a depiction of something. Strokes of this nature seem to be consistently absent in Tung's works.

The study of Tung Ch'i-ch'ang's oeuvre has not sufficiently advanced of late to take us beyond Sirén's frank admission of bafflement as regards the master's stylistic evolution.[50] Yet, despite open attributions and unsettled dates, we must try and understand the importance of Tung's contribution. What to me seems most noteworthy is the fact that his style amounts to a clear break with earlier Ming painting—in agreement with the accepted view that after him Chinese painting was never the same again. He avoided the decorative, the appealing, the laboured, and the bizarre. What he offers is a new imagery of landscape whose character and strength lie in its very abstractness. His constructions are fascinating intellectually,

delightful aesthetically, and almost devoid of feeling.[51] When looking back toward the earlier Ming men from the plateau of Tung's creations we may experience a sense of disappointment.[52]

The later in Ming, the more diversified and innovative were the painters. Divisions such as scholar painters and professionals gradually lost their importance. All that counted was individuality. It is difficult, therefore, to decide on the absolute importance of any painter who was not counted among the supreme few. Those whom I wish to mention in this short appendage are Hsü Wei, Sung Hsü, Wu Pin, and Ch'en Hung-shou.

Hsü Wei (1521–93) from Shan-yin, Chekiang, was a tragic, yet not altogether attractive figure. Precocious and enormously talented, he passed the examinations for the first (or *hsiu-ts'ai*) degree, but failed in seven attempts to advance further. Even so, his reputation as a man of letters was such as to earn him an appointment as secretary to the governor in 1557. Five years later the governor was imprisoned. As a close associate, Hsü Wei, fearing for his life, feigned madness. In 1565 he attempted suicide, terribly mutilating himself. In 1566 he stabbed his second (or third) wife to death. He was in prison for seven years, but finally, thanks to the intercession of a friend, was released in 1573, the first year of the Wan-li emperor. For years thereafter he lived in Peking. When his health began to fail he returned to his home town, where he died in extreme poverty, and without friends.

In a self-appraisal of his attainments, Hsü Wei rated them in this order: calligraphy, poetry, prose writing, painting. Later critics did not agree with him, but placed his painting above the rest.[53] His strength lay in pictures of plants, vegetables, and flowers, rather than in landscapes or figures. A powerful, convincing work in Stockholm, *Rock with Banana, Bamboo and Plum Blossoms* (Fig. 159), combines such contradictory qualities as abandon and discipline. The rock 'like a black fantastic shadow', is painted in grey to black wet ink in almost shapeless strokes; the tattered banana leaves with their very precise shapes are done in parched ink; the stems and leaves of the bamboo appear in pure outline drawing (*kou-lo*). The inconspicuous plum blossoms are treated in a nondescript, conventional manner.

Although Hsü Wei had no direct followers, the influence of his art 'did not fade away or cease with his death', but 'rose again to the surface . . . in the works of some of the so-called Strange Masters of Yang-chou, e.g. Huang Shen, Li Shan, Li Fang-ying . . .'[54] As regards his *Rock, Banana, Bamboo and Plum Blossoms* specifically, it seems resurrected in Pa-ta Shan-jen's glorious *Banana Tree and Bamboos* in the Peking Palace Museum.[55]

The barely known landscapist **Sung Hsü** (1525–*c.*1607), of whose early life we know nothing, was a native of Ch'ung-te near Chia-hsing in northern Chekiang, who came to Sung-chiang, Kiangsu, around 1573. He was educated well enough to become a member of a literary club at Hua-t'ing, which led to a friendship with Mo Shih-lung. Beyond that, his social life presumably was restricted: he lived like a monk at a Taoist shrine, and in Buddhist monasteries when he was travelling. His inclination toward Buddhist learning apparently was deep and serious. Little

is known about his artistic training. It is said that he studied Shen Chou and Sung masters; and Cahill notes that in 1543, at the age of eighteen, he copied a handscroll after Hsia Kuei. The degree of his independence from current fashions in painting is clear from his words of praise for Li Ch'eng, Kuan T'ung, and Fan K'uan as the supreme masters of all time.[56]

The work shown here is a hanging scroll in the Nanking Museum, *Mount Omei after a Snowfall* (Fig. 160), which he finished painting on 25 October 1605, at the age of eighty. It is a tightly organized composition. The weirdly folded terrain rises up to the top, in congealed waves, as it were, without really receding into depth, and without a clear focus. There is restlessness but no movement or flow. Save for a few trees in the foreground, the vegetation is indicated by small dots, which also give shape to the terrain forms. On closer scrutiny one discovers here and there tiny complexes of temples, shrines and gates half hidden in gullies, a stone bridge, a tall pagoda, and near the lower right corner a cavern with meditating monks: details proper to the characterization of one of the sacred mountains of Buddhism in China.

This strange, unbeautiful landscape is quite incompatible with Sung's earlier professed admiration for Li, Kuan, and Fan of Northern Sung. Indeed his style had changed much in the last decade of the sixteenth century, as dated works preceding and following it can show. Unable to go into detail here, I wish to refer the reader to published works of 1589, 1600, and 1604.[57]

Wu Pin (active *c.*1591–1626) presumably was trained as a painter in the local school of his home town, P'u-t'ien, in Fukien, where Sung traditions had somehow stayed alive. Administrative positions took the young man to Nanking, and his paintings soon attracted the attention of the Court. Appointed as a court painter, he was able to travel to distant Szechwan and to experience the famous scenery along the route.

Wu Pin's oeuvre is surprisingly diversified, comprising as it does Buddhist themes, birds and flowers, small landscapes, and monumental mountain images. An exquisite album from around 1600 in the Palace Museum, Taipei, which contains a series of twelve landscapes entitled *Record of the New Year's Holidays*, is of particular historical interest. Leaf number eight, *Enjoying the Moon*, offers one incontestable instance of European influence in a Chinese painting: the reflection in a pond of a pavilion surmounted by a small pagoda. Other Europeanizing features are noted by James Cahill in his study of Wu Pin.[58] But the prize definitely goes to the eleventh leaf, which represents in an incredibly refined technique a scene called *Admiring the [Fresh-Fallen] Snow* (Pl. XI).

The subject which seems to have fascinated Wu Pin most deeply, however, was the monumental mountain image. There are no less than nine pertinent works in existence, four of which are dated (1591, 1609, 1615, 1617). No epithet will quite suffice to describe this material entirely. While unique in its time, it is linked to the heroic type of landscape of Northern Sung, six centuries earlier. But, unlike the ancient prototypes, the seventeenth-century creations are disturbingly unnatural, fantastic, colossal, and fragile. The mountain becomes a *lusus naturae*, as in *A Thousand Peaks and Myriad Ravines* of 1617 (Fig. 161). The flickering light on the

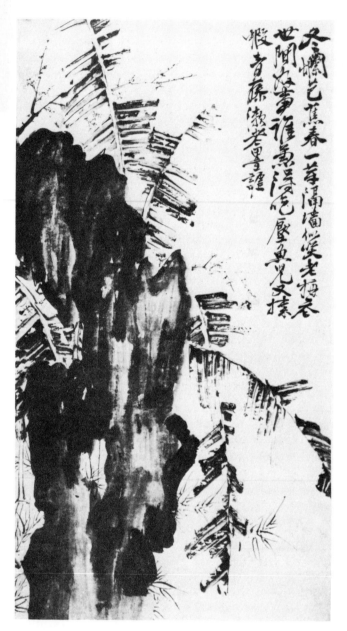

FIG. 159 Hsü Wei, *Rock with Banana, Bamboo and Plum Blossoms*. Stockholm, Museum of Far Eastern Antiquities.

evenly textured rock surfaces, and the luminous mists that serve effectively as foils for the trees in the foreground and the preposterously shaped cliff in the middle distance endow this painting with space and atmosphere to an unwonted degree. It seems almost unimaginable that the painter was a contemporary of Tung Ch'i-ch'ang.

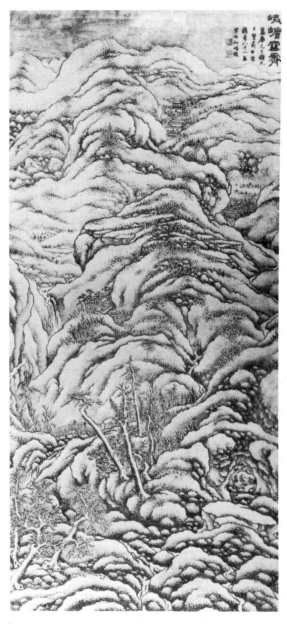

FIG. 160 Sung Hsü, *Mount Omei after a Snowfall*. 1605. Nanking Museum.

Ch'en Hung-shou (1599–1652) from Chu-chi, Chekiang, who at the age of ten received instruction in landscape painting from the last Che School master, Lan Ying (1585–c.1660), was a court painter during the last years of the Ming in Nanking. Having failed to advance academically beyond the first degree, he led a bohemian life until 1644, when he became a monk. Although he returned to a

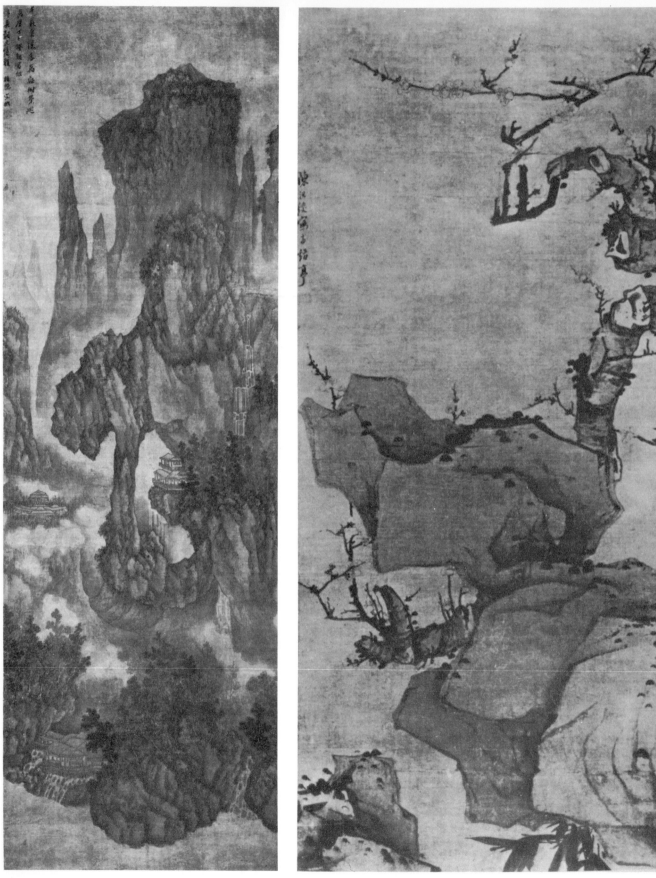

FIG. 161 Wu Pin, *A Thousand Peaks and Myriad Ravines*. 1617. Berkeley, California, Ching Yüan Chai collection.

FIG. 162 Ch'en Hung-shou, *Prunus, Bamboo and Rock*. Hong Kong, Liu Tso-ch'ou collection.

secular existence before long, his last years were filled with remorseful memories: unlike some of his peers, he had not had the courage to die for the fallen Ming. Ch'en excelled in figure painting of strangely archaistic character—combining, in Chang Keng's evaluation, the marvels of Li Kung-lin and Chao Meng-fu, and surpassing both Ch'iu Ying and T'ang Yin.[59] From the same writer we hear of Ch'en's serious self-criticism:

> He further copied the picture of a *Beauty* by Chou Fang. As he repeated this up to four times and still seemed dissatisfied, someone pointed to his copies and said, 'these already surpass the original; why do you yet seem dissatisfied?' He replied, 'this is precisely the reason I do not equal him. If my paintings are so obviously good, then my skill appears to be inadequate; Chou's work is extremely skilful yet seemingly without skill—which is difficult to achieve.'[60]

Once more, as in the case of Ch'iu Ying before, I have chosen a flower painting to represent an artist known chiefly as a figure painter: *Prunus, Bamboo and Rock* (Fig. 162) in a Hong Kong collection.[61] Painted in ink and colour on silk, this captivating work is thematically comparable to Hsü Wei's *Rock with Banana* (Fig. 159); stylistically it is very different. Here, the forms are fully defined: the tortuously grown tree with its pathetic knot-holes; the small boughs; the bulky, smooth, layered rock with its distinct overlaps and tonal gradation; and the moss-dots, sparsely applied on the tree and stones. While belonging to a definite repertory of mannerist forms, the images evoke a feeling of an austere and remote setting.

Notes

1. Edwards, *Field of Stones*, pl. 27 B; *CP*, VI, pl. 177.
2. According to Cheng Ch'ang, *Chung-kuo hua-hsüeh ch'üan-shih*, p. 395.
3. Yü Chien-hua, *Chung-kuo hui-hua-shih*, vol. 2, p. 56.
4. Yonezawa, *Painting in the Ming Dynasty*, pp. 45 and 19.
5. Chu-tsing Li, *A Thousand Peaks and Myriad Ravines*, pp. 44 ff.
6. Hsiang Ta, 'European Influences', p. 178.
7. Dates according to Chu-tsing Li in *Dictionary of Ming Biography*, pp. 435–8.
8. *Shang-hai Po-wu-kuan*, pl. 32; *CP*, VI, pl. 114 A.
9. Poorly reproduced in *Wen Wu* 1963/4.
10. Paine and Soper, pl. 77 B; Cahill's translation of the relevant passage is quoted in *CP*, IV, p. 117.
11. *CP*, VI, pl. 152.
12. *KKSHC*, vol. 43.
13. Both formerly in Count Tanaka Mitsuaki's collection; *Tōyō Bijutsu Taikan*, vol. 10.
14. 'In Search of Spring', *KKSHC*, vol. 30.
15. *CP*, VI, pl. 153; Bachhofer, *A Short History*, fig. 121.
16. Both pictures are reproduced in *CP*, VI, pls. 166–7; *Searching for Plum Blossoms* is published in *KKSHC*, vol. 19.
17. *KKSHC*, vol. 29.
18. Tomita and Tseng, *Portfolio (Yüan to Ch'ing)*, pl. 54.
19. *A Short History of the Chinese People*, rev. ed. New York, 1951, p. 150.
20. One leaf in *CP*, VI, p. 234.
21. *Ausstellung Chinesische Malerei*, Museum für Kunst und Gewerbe, Hamburg, October 1949 – January 1950, no. 6.

22. They pitilessly expose the rawness of the same characters on an album leaf in *CP* VI, pl. 155, as does the drawing of both figures and setting in the handscroll, reproduced ibid., pl. 154.

23. E.g. *CP*, VI, pl. 163.

24. *CP*, VI, pl. 162.

25. Binyon, *Painting in the Far East*, pl. 29.

26. See colour plate 16 in *Min Shin no kaiga*.

27. Yonezawa, *Paintings in Chinese Museums*, colour plate 12.

28. See *CP*, VI, pl. 177.

29. *Ancient Chinese Painting*, exhibition Lowe Art Museum, no. 27.

30. *Ming-shih*, ch. 298, *Lieh-chuan* 186; K'ai-ming ed., IX, 7826.

31. Clapp, *Wen Cheng-ming*, ch. 1.

32. Ibid., p. 90.

33. Ibid., p. 93.

34. Tseng Yu-ho, 'Notes on T'ang Yin', p. 103.

35. E.g. Sirén, *History of Later Chinese Painting*, vol. 1, pl. 96; *CP*, VI, pl. 231; *Ninety Years of Wu School Painting*, no. 072; and *T'ang Liu-ju hua-chi*, pls. 5, 6, 14, 26, 27.

36. Lawton, *Chinese Figure Painting*, p. 65.

37. *CP*, VII, pp. 174 ff.

38. *CP*, VI, pls. 244 and 242.

39. See *CP*, VI, pls. 238, 243 ff.

40. *Seize peintures de maîtres chinois*, exhibition Musée Cernuschi, Paris, no. 6.

41. Cf. Nelson Wu, 'Tung Ch'i-ch'ang', in *Confucian Personalities*, pp. 250–93.

42. Bussagli, *Chinese Painting*, p. 123.

43. Tung Ch'i-ch'ang, *Hua-chih*, in *Hua-lun ts'ung-k'an, shang*, p. 79.

44. Ibid., p. 94.

45. Ibid., p. 93.

46. *Sung-hu hua-i* in *Hua-lun ts'ung-k'an, hsia*, p. 478.

47. After *Chung-kuo ming-hua*, vol. 1; cf. *Shina Nanga Taisei*, vol. 9, pl. 185.

48. See *Chung-hua wen-wu chi-ch'eng*, first part, vol. 4, pl. 103.

49. Lawton, *Eighteenth Century Chinese Catalogue*, ms., p. 300.

50. Cf. *CP*, V, p. 6.

51. Loehr, 'Phases and Content', p. 291.

52. We have to forgo a discussion of Tung's influential theory of the Northern and Southern Schools, a non-geographic division analogous to the schism in the Ch'an (Zen) sect of the T'ang period, and with the same undertone of superiority of the 'South'. Relevant discussions will be found in the following: Wen Fong, 'Tung Ch'i-ch'ang and the Orthodox Theory'; Fu Shen, 'Authorship of the Hua-shuo'; Bush, *Chinese Literati on Painting*; and Wai-kam Ho, 'Tung Ch'i-ch'ang's New Orthodoxy'.

53. Cf. *CP*, IV, p. 228.

54. *CP*, IV, p. 232.

55. Fourcade, *Treasures of the Peking Museum*, pl. 40.

56. *Wu-sheng-shih shih*, ch. 3, in *Hua-shih ts'ung-shu*, p. 55; reminiscent of Kuo Jo-hsü's *T'u-hua chien-wen-chih*, translated in Soper, *Experiences*, p. 19.

57. See *Tō Sō*, pls. 334–7, 338; Cahill, *Restless Landscape*, no. 25; *CP*, IV, p. 172; Cahill's forthcoming book on Late Ming Painting.

58. Cahill, 'Wu Pin', pp. 637 ff.

59. *Kuo-ch'ao hua-cheng-lu*, ch. 1, in *Hua-shih ts'ung-shu*, pp. 3 ff.

60. Ibid.; cf. *CP*, V, p. 64.

61. See Chuang Shen and Watt, *Exhibition of Paintings of the Ming and Ch'ing Periods*, no. 26.

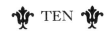

The Ch'ing or Manchu Period
(1644–1911)

In 1618 the Manchu, descendants of the Tungusic Jurchen, formed a nation, and in 1625 they set up Mukden as their capital, close to the Chinese frontier. This frontier, secured by the Chinese General Wu San-kuei, was suddenly opened in 1644, when Wu asked the Manchu for support in his struggle against the rebellious Li Tzu-ch'eng. Li's forces had entered Peking on 25 April 1644, causing the last Ming emperor to hang himself. They abandoned the city on 2 June, retreating westward, pursued by Wu's army. Four days later, the Manchu occupied Peking unopposed. Their conquest of China met with serious resistance only in the south, where the last pockets of Ming opposition persisted until the early 1680s; and the south remained disadvantaged and hostile to the end.

Unlike the Mongols of the Yüan Dynasty, the Manchu admired Chinese civilization profoundly. Never was China's prestige greater in Asia and Europe than under the emperors K'ang-hsi (1662–1722), Yung-cheng (1723–35) and Ch'ien-lung (1736–95). That period of prosperity was followed by a rapid decline in the nineteenth century, which was marked by increasingly dangerous uprisings and by foreign interventions of growing seriousness. Paradoxically the nearly successful Taiping rebellion led by the Christian and pro-Western Hung Hsiu-ch'üan (1813–64), whom the Manchu could not subdue, was crushed with help from the European powers. With their support the feeble Ch'ing government carried on for half a century. In 1912 China became a republic, which in 1949 was replaced by the People's Republic of China.

That the Manchu, only of late concerned with the business of governing a far larger and culturally superior nation, were unable to participate fully in the intellectual life of the Chinese is understandable. Even so, they made admirable efforts, and they succeeded in such fields as philology, lexicography, encyclopaedism, as well as in ceramic technology. Their proficiency in military organization enabled them to conquer Mongolia, Turkestan, Tibet, and Formosa. Once they felt secure after the decades of warfare, the Manchu rulers gave the Chinese people a century of peace.

All of their Chinese subjects did not feel quite so secure, however. Some of the Ming loyalists ended their lives when their dynasty fell, as did the scholar-painter Ni Yüan-lu (1593–1644), while others like Huang Tao-chou (1585–1646), another official and respectable painter, were executed. Among those who survived, the *Ming i-min*, descendants of the Ming imperial house, were least safe of all. Two of them, princes by descent and both of them ranking supreme among the painters of their time, found a precarious refuge in the semi-anonymity of the monastic life: Pa-ta shan-jen and Shih-t'ao.

Pa-ta Shan-jen was the last and best known of the many names used by **Chu Ta** (1626–*c.*1705/6) from Nan-ch'ang, Kiangsi. In 1644 he became a monk, adopting the name of Ch'uan-ch'i.[1] Perhaps it was to hide his identity that he signed his

works as Hsüeh-ko, 'Snowflake'; Ko-shan, 'This Mountain'; Jen-wu, 'Man's home'; Lü, 'Donkey'; Wu-lü, 'Donkey at home'; Shu-nien, 'Years of Writing' (?); Lü-han, 'Donkey Fellow'; and, finally, from about 1685, Pa-ta shan-jen, 'Hermit of the Eight Great [Awakenings of Man]', assumed to be derived from the title of a Buddhist sūtra, *Pa-ta jen-chüeh ching*. Usually, Pa-ta shan-jen was characterized as an almost demented, deaf-dumb genius, the way he is shown in picturesque Chinese anecdotes, and his works with their often baffling subjects and enigmatic inscriptions certainly encouraged such portrayals. A recent critic, however, thinks of Chu Ta as 'an ambitious and enterprising person, who could very well have pretended to be mad and dumb in order to survive the purges of the foreign Manchu conquerors'.[2]

So far there are no exhaustive investigations of Chu's oeuvre in print, and we are without much guidance in matters of authenticity and stylistic development.

One work clearly links Chu Ta to the recent past, specifically to the artistic developments at the time of his childhood: the work in question is a set of six album leaves of landscapes purporting, in jest, to be from the hand of Tung Ch'i-ch'ang in the manner of ancient masters and signed with Tung's *hao*, Hsüan-tsai.[3] The sixth leaf (Fig. 163) represents Ni Tsan, so to say, or, rather, a secondary image of Ni Tsan in Tung's idiom transposed into a tertiary image in Pa-ta shan-jen's idiom. The latter is the strongest presence among the three layers of style, while Ni's share is the weakest. Of Ni's delicate, sparing, and tidy manner, nothing is left; in its stead we find Tung's studied coarseness and Pa-ta's disdain of repre-sentational attractiveness, his pathetically reduced trees, his oppressive, top-heavy, carelessly textured cliff. The inscription states—in Tung Ch'i-ch'ang's diction but Pa-ta's own, mildly forbidding calligraphy—that

> Ni Yü's painting was ordinary and natural, free of the ubiquitous vulgarity of the professional painters. This album was done after the genuine originals in Mr Wang's collection. Hsüan Tsai.

The actual author's name is given in the form of a seal (printed upside-down) in the lower right corner; it reads either Shan-jen, 'Mountain Man', as I believe, or I-shan-jen, 'One Mountain Man';[4] Ko-shan, 'This Mountain', as deciphered by Contag and Wang, is less likely to be correct.[5]

Steep Rocks by a Quiet Bay (Fig. 165) is Sirén's fitting appellation of another landscape from the same collection.[6] It is a broad leaf mounted with four calli-graphies and three more landscapes in a handscroll. Done in ink only, *Steep Rocks* is a work of perfect spontaneity and consummate skill. Traditional types of brush strokes are dispensed with; the shapes of the objects, especially of the trees, are without prototypes; the meaning of the individual terrain forms depends largely on their relation to the total image. Even so, by the contrasts of light and dark a compelling spatial order is achieved, and the orderly encounter of many vertical forms with less weighty horizontals has the effect of stability and calm. At the same time this almost sketchy small landscape may be a kind of technical *tour de force*: it was done, as the inscription tells, with 'one brush'—a brush charged with ink only once, if I understand the phrase correctly.

Pa-ta shan-jen's technical mastery may nowhere be better exemplified than in his

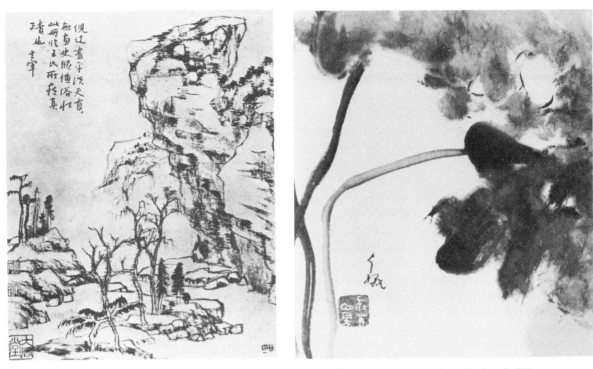

FIG. 163 Chu Ta, *Rocky Scenery*. Album leaf, ironically purporting to be from the hand of Tung Ch'i-ch'ang in the manner of Ni Tsan. Chang Ta-ch'ien collection.

FIG. 164 Chu Ta, *Lotus*. Album leaf. Sumitomo collection, Japan.

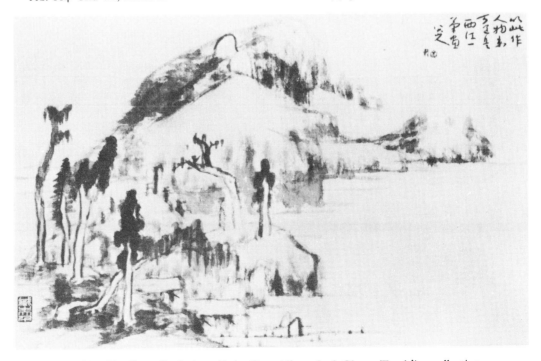

FIG. 165 Chu Ta, *Steep Rocks by a Quiet Bay*. Album leaf. Chang Ta-ch'ien collection.

flower pictures, among which those of the lotus abound. Our Figure 164 shows an exquisite album leaf from the Sumitomo collection in Japan.[7] When compared with Ch'ien Hsüan's *White Lotus* (Fig. 116), the Chu Ta is seen to forsake much of the literalness and completeness, and all of the charm and precision of the linear definitions, of the earlier work. What we are given instead is a sense of immediate involvement in a painterly, blurred, close-up of suggestions, in velvety greys and blacks, of leaves, and in small white patches, of almost hidden flowers. Everything seems out of focus, except for three powerfully drawn smooth stalks that curve upward over the large blank area in the left half of the picture.

To arrive at a proper estimate of the *Lotus*, we might do well to acquaint ourselves with an exciting earlier design from an album of eleven leaves at Princeton University, datable, according to Wen Fong, to the late 1660s.[8] The leaf shows a *Magnolia* (Fig. 166). Its most captivating quality is a combination of energy and elegance in the flowers, realized in their shapes, their spacing, and their brushwork. Contrasting with the stately forms of the flowers are the brittle flicks describing small boughs. The *Magnolia* is the work of a mature artist conscious of his powers, which he is not loath to display. But the *Lotus* seems to be a more profound work. There is not one expendable stroke in it. Substance and brushwork are identical, reality and form are one.

Tao-chi, *alias* **Shih-t'ao**, was the other Ming prince of grand stature as a painter. Fifteen years or so younger than Pa-ta shan-jen, he was born in Kwangsi, probably between 1638 and 1641; he died at Yang-chou in Kiangsu, probably before 1720.[9] Much of his life he spent travelling, and his residences were many: the Lu-shan in Kiangsi (intermittently for twenty years?), Hsüan-ch'eng in Anhui (about ten years), Nanking (about seven years), Yang-chou (about three years), Peking (close to three years), and finally Yang-chou again (about twenty-five years).[10] Of his excursions, none may have been so important as that undertaken in the company of Mei Ch'ing (1623–97) from Hsüan-ch'eng to the Huang-shan mountains in Anhui toward 1670, when he was still young, impressionable, and of mystical bent. Of his secular encounters we cannot pass over in silence two audiences he was granted by the Emperor K'ang-hsi, once in Nanking and once in Peking when, obviously, neither the Manchu sovereign nor his Chinese subject had to overcome unsurmountable political *ressentiments*.

With Tao-chi's works we enter a world of esprit, high intelligence and extraordinary inventiveness, yet never far removed from nature. His 'rediscovery' of nature was not, however, a matter of keener observation or of a new naturalism. He was searching for an imagery expressive of the awesome forces that shaped the mountains and rivers, an imagery of the *natura naturans*. In his own words, 'Heaven has such powers that it can alter the soul of a landscape. The Earth has such authority that it can keep in motion the breath and the pulse of a landscape. I myself have this "one single line" upon which I can string the forms and the spirit of a landscape.'[11]

What Tao-chi in his famous essay *Hua-yü-lu* terms *i-hua*, 'one line', 'one stroke', 'the single stroke', 'the one, first line', or 'the primordial line', is an enigmatic concept without stylistic connotation and refers to the creative process of painting.

Here our painter takes his secure place between Heaven and Earth. But he was obsessed with the question of originality, of his independence from masters and models of the past. His attitude toward them is expressed peremptorily and with seeming naïveté in his inscription on an album leaf datable to the year 1703:

> Before the ancients established their styles, we don't know what styles they followed. When the ancients had established their styles, they no longer permitted the later men to quit the ancient styles. And for hundreds and thousands of years the later men have been unable to raise their heads from the ground. Which is only fitting for those who take the ancients' footprints rather than their heart for a master. Sad indeed![12]

But Tao-chi was not the only one, nor the first, to take a stand against the Ming habit of copying the artists of antiquity. Yüan Hung-tao (d. 1614) was quite as revolutionary as Tao-chi when observing that the ancients, themselves, did not

FIG. 166 Chu Ta, *Magnolia*. First leaf in an album of eleven leaves. Princeton University, The Art Museum. Gift of Mrs George Rowley in memory of Prof. George Rowley.

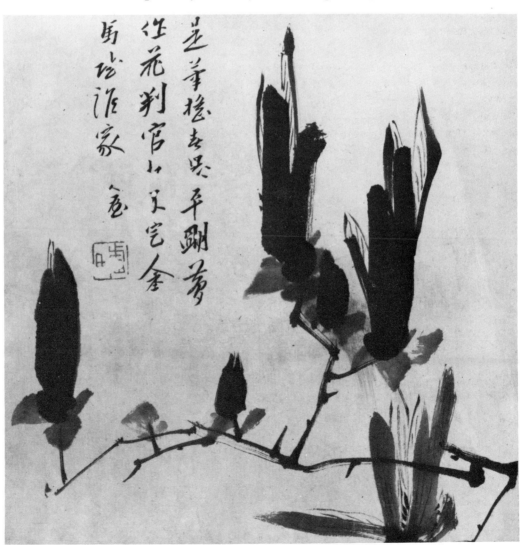

FIG. 167 Tao-chi, *Mountain Scenery*. 1679. New York, C. C. Wang collection.

FIG. 168 Tao-chi, *Ta-t'ang shan-shui*. Whereabouts unknown.

imitate;[13] similarly the eminent Kung Hsien (1617/18–1689) had stated, 'Creation knows nothing of Tung Yüan and Huang Kung-wang!'[14]

Despite Tao-chi's uncompromising subjectivism, his work was praised even by the supposedly 'orthodox' Wang Yüan-ch'i (1642–1715), his contemporary in Peking, as the finest south of the Yangtse River. And, in the perspective of the younger Yang-chou master, Cheng Hsieh, or Cheng Pan-ch'iao (1693–1765), born half a century after Tao-chi, we learn that

Shih-t'ao excelled in all genres, including *Orchids* and *Bamboos*, which to him only represented a minor subject, while I specialized in it. For fifty years I have painted nothing else. Shih-t'ao's art is universal, while mine is specialized, although specialization is not necessarily inferior to universality. His manner abounds in transformations, strange and archaizing, or fine and elegant. When compared to Pa-ta shan-jen, Shih-t'ao not only is his equal in every regard, but surpasses him in some regards . . .[15]

A relatively early work is the *Mountain Scenery* painted in 1679 and dedicated to Fei-t'ao (Ting P'eng) in 1688 (Fig. 167). Done in thin and sharp outlines with very light colours on paper, the painting, which has no washes or shading, is graphic in effect; the powerful thrusts of its crags and outcrops exhibit energy but are wanting in mass. The scattered ink dots, an important formal device, scarcely contribute anything to the modelling of the larger shapes to which they loosely cling; they form an almost independent element that lends a measure of excitement to the all-over design.

In the large hanging scroll named *Ta-t'ang shan-shui* (Fig. 168)[16] the shapes are more compact and heavy, more uniform yet less stable, and more dramatically contrasted with the steaming waterfall and haze-filled recesses. Compared to those of the 1679 picture, these rock shapes are more expressive of their being and their function: layered, slanting, overhanging and twisted, they rise upward, only to be worn down by the smooth, concentrated, plunging waters. Unquestionably the *Ta-t'ang Landscape* is a more advanced work than the 1679 landscape given to Fei-t'ao.

In the first month of summer, 1685, at Nanking, Tao-chi painted the short handscroll entitled *Ten Thousand Ugly Ink Dots* (Fig. 169), now in the Su-chou Museum. We have not thus far encountered any comparably intellectual title. In

FIG. 169 Tao-chi, *Ten Thousand Ugly Ink Dots*. Detail of a handscroll. Su-chou Museum.

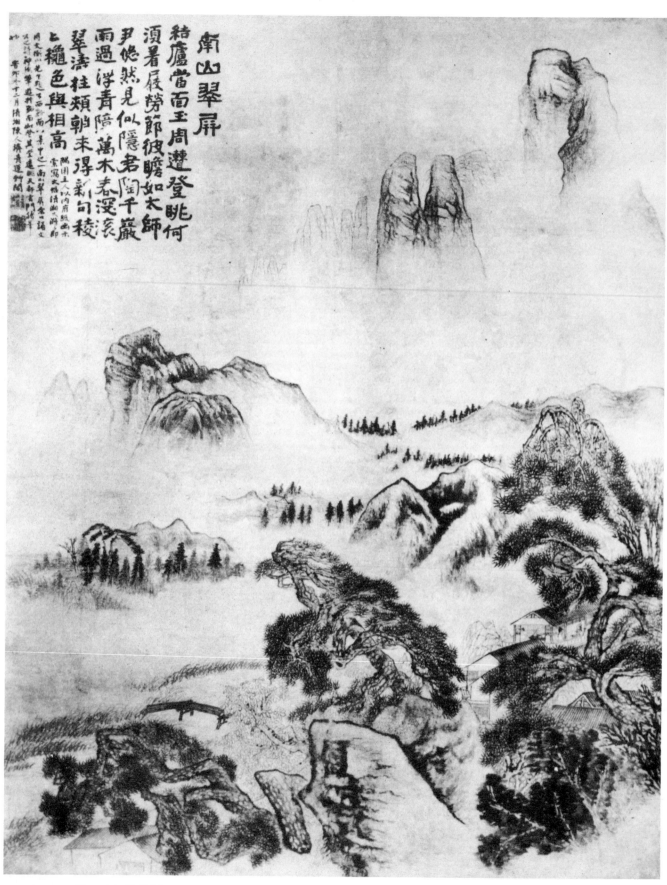

FIG. 170 Tao-chi, *Tall Mountains, Long Waters* (alternate title from the inscription: 'Emerald Screen in the Nan-Shan [Southern Mountains]'). Tokyo, National Museum.

Richard Edwards' felicitous characterization, 'Ugly Ink-dots is above all an artist's statement about art.'[17] The painting, in other words, is not a picture representing a thicket, a homestead, a cliff, and a cavern, but an assemblage of forms reminiscent of such motifs, though primarily an exposition of boisterous brushwork. The scroll exemplifies nicely how far a Chinese painter will go in abstraction: here the technique as such becomes the subject-matter.

Fourteen years later, in 1699, the unpredictable Tao-chi added a *Landscape* in ink, light blue and brown on a gold-paper folding fan to his oeuvre (Pl. XII). Now in the collection of John M. Crawford, Jr., this *Landscape*, while convincing as to the artist's hand, is quite dissimilar from the rest of his works here assembled as regards design, technique, and expression. It was done, as Tao-chi in his inscription tells, in the manner called '*i pi hua*' by the ancients. Literally, 'one-brush painting', this phrase means a painting done without retouches, or *alla prima*.

A barely known facet of Tao-chi's art is revealed in a delightful hanging scroll, *Lotus* (Pl. XIII), in the Finlayson collection at Toronto. Done in delicate colour, the close-up vision of the veined leaves in a technically varied, almost mysterious structural design seems like a poetic anatomy of the plant. A bluish wash heightens the luminosity of the open flower. In paler tones there appears at some distance the group formed of a bud and two young leaves. Doubtless Pa-ta shan-jen's *Lotus* (Fig. 164) will now, with all its ink virtuosity, seem rather familiar, as may, too, Tao-chi's own ink *furioso* of the *Ten Thousand Ugly Ink Dots*.

A landscape entitled *Tall Mountains, Long Waters* (Fig. 170) is an extraordinary, strangely solemn, even sublime work and may well set an absolute standard of landscape in the Ch'ing period.[18] Perhaps the most striking feature is the vastness of the space. The lower half is filled with a conformation of low hills and fog-covered lowland. Stretching as far as the horizon are rows of small pine trees lining saddles between the hills or growing around them. Against that terrain, frontmost, there rises from the lower left to the upper right a screen formed by three violently twisted large pines, marvellously drawn, which nowhere cut across the horizon. Partly hidden by these pines is a cluster of unobtrusively placed houses. Almost breathtaking is the upper half of the composition. High up in the sky there tower, like apparitions, above a dense haze, the pinnacles of two immense cliffs. Together with the massive bluff below, near the left edge, the two cliffs, the one with the notched peak, the other yet taller, mark a diagonal series that artfully repeats the arrangement of the large pine trees in the foreground. The design is carried out with impeccable care; there are no chance effects whatsoever. Disappointing, by contrast, is the inscription in a clumsy hand, which appears to be an effort to imitate Tao-chi's ductus. Not only is the writing unconvincing, but the date given at the end is incomplete. The title of the poem of eight lines in the seven-word metre (written in large characters), incidentally, differs from the one adopted in *Tōsō Gen Min* and quoted above; it runs, 'Emerald Screen in the Nan-shan [Southern Mountains]'. In the explanatory notes following that poem (written in small characters) Wen Cheng-ming is acknowledged as its author.

It is understandable that Tao-chi had no true successor, even though he was occasionally imitated. Protean genius that he was—scornful of styles derived from antiquity, and in whose oeuvre style was largely incidental to the image—Tao-chi

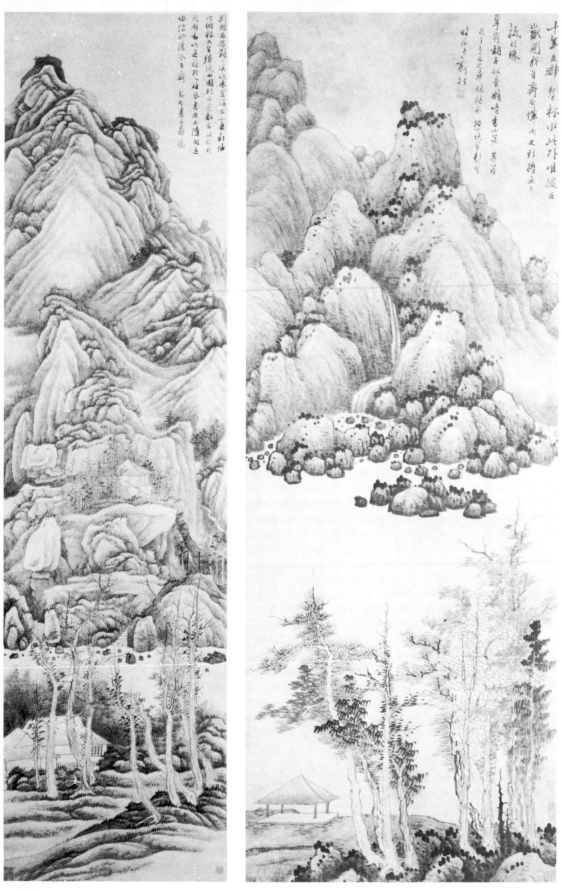

FIG. 171 Kung Hsien, *Lofty Dwelling in a Country Villa*. New York, C. C. Wang collection.

FIG. 172 Kung Hsien, *Landscape after Yün Hsiang*. 1672. New York, C. C. Wang collection.

was not the kind of artist to attract budding talents by providing them with method, style and thought, a security unknown to himself. His 'basic certainty', as R. Edwards put it, 'was faith in his own genius'.[19] Yet others among the 'individualists' of the time, less difficult to pin down as to style or manner, shared Tao-chi's fate of being without artistic offspring; they include Kung Hsien (1617/18–89), K'un-ts'an (1610/17–80/93), Fan Ch'i (1616–after 1694), Tai Pen-hsiao (1621–91?), and Mei Ch'ing (1623–97), all of whom died before 1700, and all of whom were older than Tao-chi.

Kung Hsien, from K'un-shan, Kiangsu, a commoner without degree or office, who was the most impressive painter among those early Ch'ing individualists, saw his isolation quite clearly. He said of himself, 'There has been nobody before me, and there will be nobody after me.'[20] While troubled by poverty all his life, he was recognized as the foremost of the 'Eight Masters of Nanking', the city that was his chosen residence, whose amenities and stimuli he forsook only after the fall of the Ming, between 1645 and 1655. Sixteen years later, in his *hou-pa* or postscript of 1671 to an album of landscapes in the Nelson Gallery, he declares, 'I dare not say that I have enjoyed in full measure the unalloyed happiness of [this world of] man, and yet, compared with those who move attentively in the circle of ceremony and regulations, is not what I have attained much more?'[21]

Except for his attitude toward antiquity (see page 304 above), Kung Hsien had little in common with the younger Tao-chi. His work was sober and systematic, his technique elaborate, hence unspontaneous; while aiming at, and achieving, simplicity of motifs and forms, he became intensely preoccupied with a sombre tonality. His flair for *valeurs* was matched by his gusto for monumental design. Among the ancients, he held Tung Yüan, Chü-jan, and Mi Fei in high regard; among the masters of recent times, he admired Tung Ch'i-ch'ang, Yün Hsiang (1586–1655), and possibly Yang Wen-ts'ung (1597–1645), who was the Governor of Nanking at the time of the Manchu conquest. He may also have been acquainted with engravings of European paintings such as were first made known by Matteo Ricci in Nanking.[22]

Two works of similar subject-matter and format, twelve to fifteen years apart in time, demonstrate two distinct phases in Kung Hsien's artistic career. The earlier one, *Lofty Dwelling in a Country Villa* (Fig. 171), datable toward 1660, precedes his mature phase. Its somewhat forced monumentality recalls Northern Sung modes, as do the evenly applied folds and fissures of the level terrain in the foreground and of the bigger formations higher up, shaded with soft stipples of geometric effect. There are no figures—the landscape is totally deserted. The second work, *Landscape after Yün Hsiang* (Fig. 172), is dated to 1672. Of the artificial diversity of the earlier work nothing remains. The same lush and heavy ink dots are used at the bottom and on the distant boulders and humps. Not only are the shapes of those distant formations perfectly uniform, but their relationships reveal ease and fluidity in both design and technique. The trees in the foreground are effectively silhouetted against the wide expanse of water; slight, tall, and gracefully diversified in their foliage patterns, they contrast curiously with the weighty mass of treeless heaps rising beyond the water.

We cannot do justice to Kung Hsien without mentioning his sombrely resplendent *A Thousand Peaks and Myriad Ravines* (Fig. 173) of the Drenowatz collection in Zurich.[23] A nightmare of a landscape, built of crags and gullies full of geological anomalies, eerily illuminated as if by sheet-lightning at night, with the waters glaring white and luminous mists in deep hollows, this work was judged thus by Cahill: 'Few paintings, of any time or place, set forth the interior landscape of the painter's mind with such directness and power.'[24] Its date is presumably toward 1670. Its unusual shape, like an oversized album leaf, is suggestive, according to Chu-tsing Li, of a common Western format.[25]

The degree to which Kung Hsien was aware of what he was doing as a painter becomes quite clear through a colophon of his, where he differentiates between pictures and paintings. He says:

> In antiquity there were pictures while there were no paintings. A picture represents objects, portrays persons, describes events. In a painting this is not necessarily so. With fine brushes and costly ink it presents [its subject] on old mulberry paper, these subjects being clouded mountains, mist-enveloped trees, steep rocks, cool springs, plank bridges, and rustic dwellings. There may be figures or there may be none . . .[26]

FIG. 173 Kung Hsien, *A Thousand Peaks and Myriad Ravines*. Zurich, Charles A. Drenowatz collection.

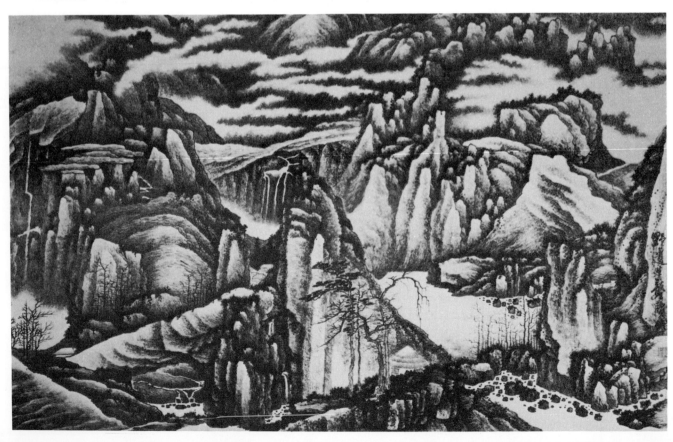

The statement is remarkable as a conception of what 'painting', as opposed to 'picture-making', means—a conception encountered in the West no earlier, I believe, than the twentieth century.[27]

Another of the Eight Masters of Nanking was **Fan Ch'i** (1616–after 1694), a contemporary of Kung Hsien though scarcely his equal. Although he outlived Kung Hsien, his oeuvre is rather small. It is also very different in character. Fan Ch'i is interesting on two accounts: his sense of colour as an expressive factor, and his extraordinary precision as a draughtsman. Good examples of his draughtsmanship are the *Yangtse River* scroll in Berlin with its low horizon and enormous depth, and the *Landscape* scroll of 1645 in the Brundage collection at San Francisco with its minutely depicted fantastic formations.

The album leaf of 1646 in the Metropolitan Museum, *A Garden Scene* (Pl. xiv), is another early work, done virtually without ink, relying on colour exclusively. The colours are few and subdued, in a minor key, of a lyrical tone. What makes the colouring expressive is the fact that it is applied integrally to all parts, especially the sky, the air, the water, and the fog that creeps along the ground. Nowhere do we find the alternative procedure of placing coloured objects on a colourless, neutral surface. Forty-six years later, in 1692, Fan Ch'i painted a handscroll, *Landscape of the Four Seasons*, which was exhibited at Hong Kong in 1970.[28] The colours are of a hard brilliance, in a major key, as it were, and the design consists of a sequence of cloud-torn hills and waters.

One of the most active 'schools' by the beginning of the Ch'ing period was the Hsin-an School of Anhui, a province that had not theretofore been heard of very much. The leading figure of that school was the monk **Hung-jen** (1610–64), whose civil name was Chiang T'ao, a Ming loyalist who took the vows after the fall of Nanking in 1645. He first received attention as one of the painters of the Huang-shan, the magnificent range in southern Anhui that to him would become 'nature'. He is commonly linked to Ni Tsan; but he was doubtless acquainted with Tung Ch'i-ch'ang (1555–1636), and he was probably indebted to Hsiao Yün-ts'ung (1596–1673), an Anhui artist fourteen years his senior. In his mature style, Hung-jen is the antipode of Kung Hsien. Hung-jen's *Landscape* (Fig. 174) may represent an extreme statement of his tendencies.[29] Instead of a mountain, we are faced with a colossal rectangular slab of ambiguous dimensions, and a group of withered trees projecting, half way up, against its undefined, empty, surface. It is a landscape without soil, atmosphere, and tonality, lucid and abstract, without a shred of Kung Hsien's warmth and density.

Tai Pen-hsiao (1621–91?) from Hsiu-ning, Anhui, remains to be discovered, to a degree at least. His early products are of a conventional sort. Later, he radically eliminates all textures, defining by contours alone the shapes of his rocks and mountains, which nonetheless appear as massive bodies, sometimes bent, sometimes twisted, or expanding toward the top. His undated *Landscape* (Fig. 175) from the C. C. Wang collection, New York, exhibits the severity of his mature period to the full; it is an image of nature that is unprecedented.

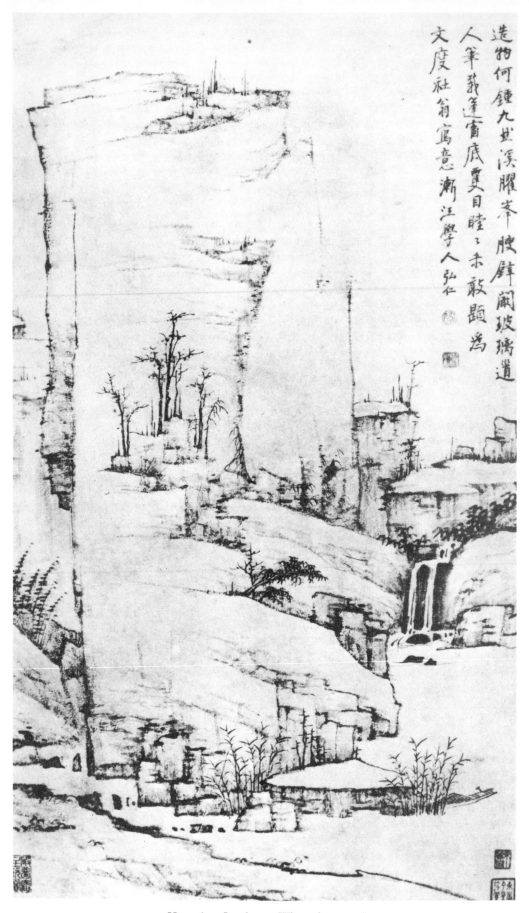

造物何鍾九嶷溪曜峯腰鏵巘玻璃道
人筆肇蓬窗底覈目睢々余敢顫為
文度社翁寫意 漸江學人弘仁

FIG. 174 Hung-jen, *Landscape*. Whereabouts unknown.

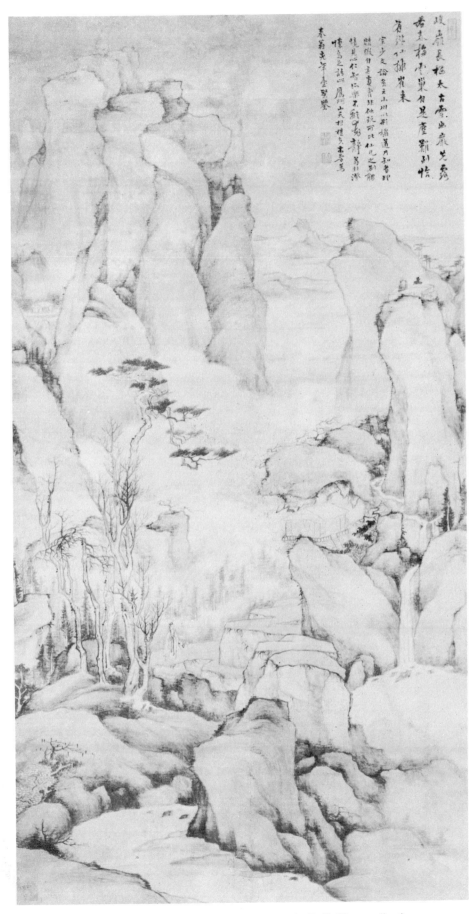

FIG. 175 Tai Pen-hsiao, *Landscape*. New York, C. C. Wang collection.

There may be no finer tribute to Tai Pen-hsiao's artistic standing than Tao-chi's painting entitled *Visiting Tai Pen-hsiao*, in the same collection (Fig. 177), a painting of great freshness, done in ink only.

Chang Feng (active *c*.1636–74), from Shang-yüan (Nanking) in Kiangsu, relinquished his privileges as a first-degree graduate after the fall of the Ming. Like many other intellectuals, this remarkably versatile scholar chose to live in poverty and freedom rather than hold an office under the Manchu. He has left a limited oeuvre of paintings in quite diversified manners, which he developed entirely from his own ideas. Yet, while being no teacher's heir, he penetrated deeply into the secrets of Yüan painting.[30] The strangely charming, short handscroll of 1648 in a Hong Kong collection, *Figure between Rocks and a Twisted Tree* (Fig. 176), is a relatively early work. It is difficult to tell whether this small composition shows a landscape, a garden, or a kind of outdoor still life. Diminishing in height from right to left, the forms consist of a rock in curvilinear outlines, a rock of rectangular shape, and a twisted tree bent low, greatly contrasting with the uprights of inorganic matter. A slight, almost ethereal human figure appears to the left of the smaller rock. What is fascinating in the design is a bold, deep-black ink blob on the first of the rocks: a mere whim, perhaps, yet apparently of its own kind, this blob seems to add a touch of mystery to the scroll, intensifying the expressiveness of its brushwork.

The last of the leading monk painters to be mentioned here is **K'un-ts'an** or **Shih-ch'i** (1612–after 1674), a native of Hunan Province, who early in his life entered a Ch'an Buddhist order and eventually became the abbot of a monastery on Niu-shou-shan (Ox-Head Mountain) near Nanking. His style is quite distinct from that of Hung-jen, his contemporary and fellow monastic from Anhui. Where the latter is cool, clear, transparent and almost incorporeal, K'un-ts'an tends toward crowding and exuberance, and even confusion; as Cahill has remarked, his paintings convey 'a slightly disorderly air of reality'.[31] In his formative years he depended on Tung Ch'i-ch'ang; later he studied Wen Cheng-ming; finally he seems to come to rely on Ch'eng Cheng-k'uei (active *c*.1645–88) from Hupei, whom he met in Nanking after 1654.[32] The Fogg Museum *Landscape* of 1659 (Fig. 178)

FIG. 176 Chang Feng, *Figure between Rocks and a Twisted Tree*. 1648. Hong Kong, Liu Tso-ch'ou collection. Courtesy of the collector and Mr J. C. Y. Watt, Chinese University of Hong Kong.

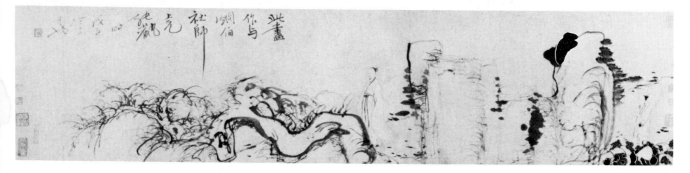

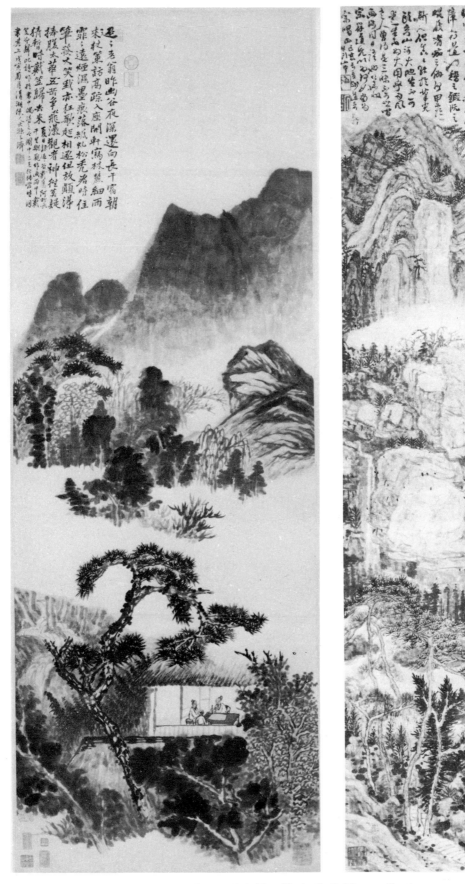

FIG. 177 Tao-chi, *Visiting Tai Pen-hsiao*. 1698. New York, C. C. Wang collection.

FIG. 178 K'un-ts'an (Shih-ch'i), *Landscape*. 1659. Fogg Art Museum, Harvard University, gift of Mr and Mrs Earl Morse.

shows K'un-ts'an in possession of his own, typical, means of expression, in which colour, notably a subdued orange in the softly modelled rocks, plays an important role. Like his painting, the long, autobiographic inscription is done in a casual, not to say careless, manner, as if he were flaunting his disdain of formal attractiveness.

In opposition to the Individualists or Eccentrics, with whom we have dealt thus far, stood the group of the **Orthodox Masters**, the faithful followers of Tung Ch'i-ch'ang and of those early artists he 'approved of': Tung Yüan and Chü-jan, and the Yüan masters, among whom Huang Kung-wang was especially favoured. The core of this 'orthodox' group was formed by the Four Wangs, Wu (Li) and Yün (Shou-p'ing)—a sextet that has long enjoyed a matchless reputation. The Four Wangs, all from Kiangsu, were Wang Shih-min (1592–1680), his friend Wang Chien (1598–1677), their pupil Wang Hui (1632–1717), and Wang Shih-min's grandson, Wang Yüan-ch'i (1642–1715). Wu Li (1632–1718), like Wang Hui from Ch'ang-shu, was a landscapist of undeniable character. At the age of fifty he became a Christian; six years later, having studied Latin and theology at Macao, he was ordained a Jesuit father under the name of Simon A Cunha.[33] Yün Shou-p'ing (1633–90) from Wu-chin, Kiangsu, achieved fame as the greatest flower-painter of his time.

 Seen from the viewpoint of the Individualists, the contributions of these traditionalists were meaningless archaeological exercises. Conversely the traditionalists saw themselves as the responsible guardians of values endangered by reckless innovators. It is a controversy that can only be resolved by taking the measure of either camp by the criterion of newness or originality, which clearly favours the individualists. Even so, there is much to admire in the work of the 'orthodox' painters too, although regrettably we have to limit our discussion to a very few examples.

Wang Chien's *Green Pines and Steep Rocks* of 1661 (Fig. 179), done at the age of 63, is a sane, almost radiant, sunlit mountain scenery with strong and harmonious tonal contrasts in a style based on Tung Ch'i-ch'ang and, probably, also on Chü-jan, at least as he was imagined in the seventeenth century. The painting is technically flawless and, in a gentle way, powerful. Yet it gives the impression of being well known from previous encounters with many similar works. This is its weakness.

Wang Hui was Wang Chien's discovery. His talents seemed unlimited. His particular forte was the ability to produce an exact copy of any work, no matter what its style. He was the perfect technician and blithely ignored Tung Ch'i-ch'ang's enjoiner that models must be transformed into one's own terms. On the contrary, Wang Hui's temerity consisted in copying faithfully and objectively. An instance of such objectivity is his copy of 1698 after Fan K'uan's *Snowy Mountains* (Fig. 180), which can be compared with the still existing original in the Taipei National Palace Museum.[34]

In 1715, at the age of 83, Wang Hui collaborated on a portrait showing the out-standing collector and connoisseur **An Ch'i** (*c.*1683–after 1744) from Tientsin

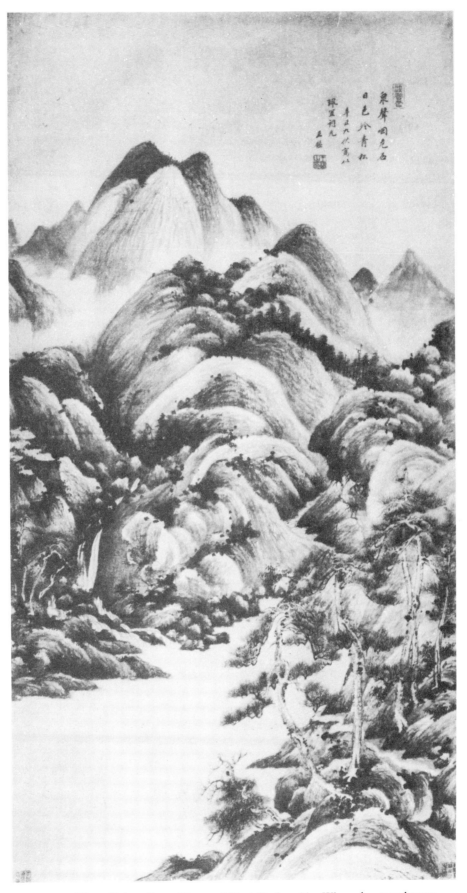

FIG. 179 Wang Chien, *Green Pines and Steep Rocks*. 1661. Whereabouts unknown.

FIG. 180 Wang Hui, *Snowy Mountains*. After Fan K'uan.

seated on a leopard skin in his garden. The inscription gives the title, *Lu-ts'un in Lofty Seclusion* (Fig. 181), and the names of the artists who took part: T'u Lo, otherwise unknown, who did the portrait; Yang Chin (1644–after 1726), an assistant of Wang Hui, who did the scenery; and Wang Hui himself, who added the bamboo and rocks. But it is primarily in homage to the great connoisseur An Ch'i, or An Lu-ts'un, a salt merchant of Korean extraction, much of whose collection was later acquired by the Emperor Ch'ien-lung (reigned 1736–95), that this rare document is mentioned here. An's lasting importance rests on his carefully redacted catalogue of the calligraphy and paintings in his possession, the *Mo-yüan hui-kuan*. The chapters dealing with paintings were translated by Thomas Lawton,[35] who also gave a description of the text in the *National Palace Museum Quarterly*.[36]

Wang Yüan-ch'i (1642–1715) died the year An Ch'i's portrait was painted. Wang Yüan-ch'i, in contrast to Wang Hui, never really copied, even though in deference to convention he acknowledged indebtedness to this or that ancient master. Instead he worked with single-minded concentration on developing a style of his own. He seems to have experimented incessantly with a limited set of motifs and spatial solutions. Accordingly his large oeuvre exhibits an astounding degree of unity. His superior standing among the Four Wangs is now widely recognized. The matter was discussed even during his lifetime:

> Wang Chien once said to Wang Shih-min, 'the two of us may have to yield the top spot [to Wang Yüan-ch'i].' Wang Shih-min replied: 'Of the four masters of the Yüan period, Tzu-chiu [Huang Kung-wang] was the foremost, but the only one to grasp his *spirit* was Tung Ch'i-ch'ang. As for a grasp of his *form*, I dare not give up yet. If you speak of grasping both form and spirit, indeed my grandson may be near it.'[37]

He was compared specifically with Wang Hui by the eighteenth-century critic and historian, Chang Keng, who in his *Hua-lun* said: 'Those who can avoid enclosing themselves in such habits (of imitation) and follow in the steps of the ancients, . . . become the models of later men. Wang Yüan-ch'i is the only one who did it to some extent. As for Wang Hui, he was certainly very talented, but he did not avoid entirely the habits of painters who are bound by a school.'[38]

Wang Yüan-ch'i himself was an outspoken critic. Notwithstanding his high praise for Tao-chi (see page 304 above) he denounced such schools as did not agree with his own objectives. He says in his *Yü-ch'uang man-pi*, 'In late Ming painting there were mannerist tendencies and evil movements, of which the Che School was the worst . . . The corrupt practices of the Yang-chou and Nanking painters today are quite as bad as were those of the Che School. Anyone who aims at a mastery of brush and ink must take pains to avoid them.'[39] Part of this may be rhetoric; still, no matter how subjective Wang Yüan-ch'i was, he at least professed to be following the Yüan masters, who in Nanking and Yang-chou were ignored. His *Autumn Mountains after Huang Kung-wang* (Pl. xv), painted when he was sixty, is a case in point. Scarcely reminiscent of Huang Kung-wang, this work will rather call to mind compositions of the tenth or eleventh century and the brush technique of Tung Ch'i-ch'ang and the two older Wangs. At the left, under an open

FIG. 181 Wang Hui, Yang Chin and T'u Lo, *Portrait of An Ch'i* ('*Lu-ts'un in lofty seclusion*'). 1715. Cleveland Museum of Art.

FIG. 182 Wang Hui, Yang Chin and T'u Lo, *Portrait of An Ch'i*. Detail of Fig. 181.

sky there rises a massive cliff, while a wide river in the right half carries the eye toward the distant horizon. In the immediate foreground, the water embraces low, rocky banks where clumps of pines and tall trees form a more complex pattern, enlivened by a bright orange foliage. Curiously it seems as though about the same areas were allotted to the three elements of sky, earth, and water. The colour, the clear atmosphere, and an engaging crispness in the design and the brushwork show Wang Yüan-ch'i's own hand. But it would require more than one example (Pl. xv) to present a meaningful sequence of his styles, more than can be given here.

Wang Yüan-ch'i, it may also be noted, is the perfect example of a scholar-painter. Apparently he did not seriously start on his painting career before he received his *chin-shih* or 'doctoral' degree in 1670, at the age of twenty-eight, whereafter he filled administrative posts till the end of his life. In addition, he served as a court painter under K'ang-hsi, and as curator of the imperial collection of calligraphy and painting. Finally, he acted, on imperial command, as chief compiler of a work on calligraphy and painting known as *P'ei-wen-chai shu-hua-p'u* in one hundred *chüan*, said to have drawn on 1,844 different sources.

FIG. 183 Chin Nung, Leaf from the Album of *Landscapes Illustrating Poems and Essays by Famous Writers.* 1736. Zurich, Charles A. Drenowatz collection.

FIG. 184 Chin Nung, *Butterfly Orchid*. Album leaf in colour on paper. Shen-yang, Liao-ning Provincial Museum.

It remains to offer one or two of the Yang-chou painters an opportunity to defend themselves against Wang Yüan-ch'i's severe attack. There is no lack of names or works to call on. It will suffice, however, to rely on the two leading masters, Chin Nung and Cheng Hsieh.

Chin Nung (1687–after 1764) doubtless ranks as one of the most innovative and charming painters of the eighteenth century. His home town was Jen-ho in the district of Hang-chou, Chekiang. After his wife's death in 1748 he moved to Yang-chou in Kiangsu, where he came to be regarded as the leading figure of the group known as **The Eight Strange Masters of Yang-chou**. That he should have begun to paint only when he had attained the age of fifty, as stated by Chang Keng, sounds unlikely.[40] Chang may have meant to say that painting became Chin's vocation at that time. There was a good reason for his decision, made, apparently, in Peking in 1736, when he failed in the examinations for an advanced degree. Moreover, an album dated 1736 in the Drenowatz collection offers proof that Chin Nung must have started to paint well before he was fifty. Containing twelve *Landscapes Illustrating Poems and Essays by Famous Writers*, the album reveals an experienced hand, especially in the skilful and striking combination of pictures and texts (Fig. 183). The texts, written out completely, fill every available empty space. The pictures, while stylistically unified, retain a delightful touch of naïveté.[41]

In 1761, a quarter-century later, when he was seventy-five *sui* [seventy-four in Western reckoning], Chin Nung painted an album of flowers now kept in the Liao-ning Provincial Museum. One of the eight leaves is Figure 184.[42] In this painting

FIG. 185 Cheng Hsieh, *Two Tufts of Epidendrum*. Ink on paper.
Boston, private collection.

everything conventional or imaginary is eliminated. The artist faces actuality with almost frightening immediacy. The flowering plant, a butterfly orchid, seems strong and somewhat clumsy, as if in obedience to a cherished ideal of awkwardness. There is not one shred of calligraphic elegance here, except in the inscription at the top, which says,

> Wild Flowers and little plants—in the garden of the Shen family there exists this view! The seventy-five year old man Chin Nung makes this record.

In its moving simplicity, this orchid picture has a character quite its own, very dissimilar from the *Orchids* of Ch'iu Ying (Fig. 156) or the *Two Tufts of Epidendrum* by Cheng Hsieh (Fig. 185), the last item in our series.

Cheng Hsieh (1693–1765), whose often used *hao* was Pan-ch'iao, was a native of Hsing-hua near Yang-chou. It so happened that he earned his doctoral or *chin-shih* degree during the examinations of 1736, the same year that brought Chin Nung's career as an official to an end. Cheng rose to the position of district magistrate of Wei-hsien in Shantung, but retired early on grounds of illness. Having returned to Yang-chou, he devoted his remaining years to painting, specializing in bamboo and epidendrum. He spoke of his speciality with unmistakable pride in his panegyric of Tao-chi, which was quoted above (see page 305). Chang Keng has words of high praise for the painter: 'an able poet and a fine calligrapher and painter, who excelled in orchids and bamboo. Particularly wonderful were his orchid leaves, done with parched brush in the *ts'ao-shu* (grass-writing) technique of the centred vertical or the long slanting stroke (*chung-chien* and *ch'ang-p'ieh*, respectively); when [the leaves were] many, there was no confusion, when few, they did not seem too sparse. He rid himself completely of the then [common] routine, and was of surpassing elegance and strength. His calligraphy, too, was unusual . . .'[43]

Two Tufts of Epidendrum (Fig. 185), done in ink on paper, appears to answer Chang Keng's characterization very well. The two plants are superposed yet closely linked by the powerful gesture of the pendant leaves of the upper plant, joined by a single leaf of the lower plant. These long strokes are of incredible perfection. Below, there is an inscription of twenty-eight characters in the seven-word metre, signed Pan-ch'iao. Its placement links it closely to the design of the plants, and the forms of the characters show correlations with the shapes of the roots and flowers. The quatrain may be translated approximately as follows:

> Who buys orchids often, wants the roots complete.
> From roots set deep in compact soil fresh roots will grow.
> There is much idle talk this year that the flowers will do well,
> And you will see, come spring, a pot full of flowers.

Notes

1. Cf. Wang Fang-yü, 'The Early Work of Chu Ta', *Proceedings*, pp. 529–61.
2. Giacalone, *Chu Ta*, p. 1.
3. The album was published in *Taifūdō meiseki*, vol. 3, pls. 14–19.
4. According to Giacalone, *Chu Ta*, nos. 1, 3, 8.
5. Contag and Wang, *Seals of Chinese Painters and Collectors*, pp. 107, 647.
6. Also see *Taifūdō meiseki*, vol. 3, pl. 20.
7. *Min Shin no kaiga*, no. 79.
8. *Proceedings*, p. 569.
9. Wen Fong, 'A Letter from Shih-t'ao', pp. 22–53; Ryckmans, 'Les "Propos sur la Peinture" de Shihtao', 183–94; Edwards and others, *The Painting of Tao-chi*.
10. Wu T'ung, 'Tao-chi, A Chronology', in Edwards and others, pp. 53–61.
11. *Hua-yü-lu*, ch. 8; cf. Contag, *Chinese Masters of the 17th Century*, p. 24 and Ryckmans, 'Les "Propos sur la Peinture"', p. 64.
12. Tomita and Tseng, *Portfolio (Yüan to Ch'ing)*, p. 137.
13. Ryckmans, 'Les "Propos sur la Peinture"', p. 223.
14. Wilson, *Kung Hsien*, p. 21.
15. The passage has been translated by Sirén, 'Shih-tao', *BMFEA*, vol. 21 (1949), p. 40 and Ryckmans, 'Les "Propos sur la Peinture"', p. 182.
16. Collection unknown; published in *Shen-chou ta-kuan hsü-pien*, vol. 5.
17. Edwards and others, *The Painting of Tao-chi*, p. 37.
18. The painting was shown in Tokyo in 1929; it is reproduced in *Tō Sō*, vol. 2, pl. 417.
19. Edwards and others, *The Painting of Tao-chi*, p. 48.
20. Chou Liang-kung, *Tu-hua-lu*, as quoted in *Kuo-ch'ao hua-shih*, ch. 3:5 and translated in *CP*, V, p. 131.
21. Wilson, *Kung Hsien*, p. 14.
22. Cf. Yonezawa in *Kokka*, 732 and 831; Cahill, 'Early Styles of Kung Hsien', pp. 51–71.
23. Chu-tsing Li, *A Thousand Peaks*, vol. 1, pp. 206 ff. and vol. 2, fig. 48; Cahill, *Fantastics and Eccentrics*, fig. 25; Cahill, 'Early Styles of Kung Hsien', fig. 26.
24. Cahill, *Fantastics and Eccentrics*, p. 73.
25. Chu-tsing Li, *A Thousand Peaks*, vol. 1, p. 208.
26. Recorded in *Shih-po-chai shu-hua-lu*, 16 a–b.
27. See Etienne Gilson, *Painting and Reality*, 1957, pp. 260 ff.
28. Chuang Shen and Watt, *Exhibition of Paintings of the Ming and Ch'ing Periods*, no. 40.
29. *Tō Sō*, vol. 2, pl. 418.
30. Ch'in Tsu-yung, *T'ung-yin lun-hua, shou-chüan*, 3a; Taipei 1967 edition, p. 15.
31. Cahill, *Chinese Painting*, p. 171.
32. Chu-tsing Li, *A Thousand Peaks*, pp. 203 ff.
33. M. Tchang and P. de Prunelé, *Le Père Simon A. Cunha, S.J.*
34. The copy in *Famous Chinese Paintings*, vol. 31, called *Mountains in Snow*; the original in *KKSHC*, vol. 10 and in *CP*, III, pl. 156 is called *Remote Monastery in Snowy Mountains*.
35. Lawton, *Eighteenth Century Chinese Catalogue*, ms.
36. *National Palace Museum Quarterly*, Special Issue, no. 1, Taipei, 1969.
37. Li T'ien-chia, *Chung-kuo hua-lun*, p. 108.
38. Sirén, *Chinese on the Art of Painting*, p. 213.
39. In *Hua-lun ts'ung-k'an, shang*, p. 206.
40. *Kuo-ch'ao hua-cheng hsü-lu* in *Hua-shih ts'ung-shu*, vol. 5, p. 111.
41. See Chu-tsing Li, *A Thousand Peaks*, vol. 2, fig. 51 A-L.
42. Reproduced in colour in *Chūgoku Bijutsu*, vol. 3, pl. 26.
43. *Kuo-ch'ao hua-cheng hsü-lu* in *Hua-shih ts'ung-shu*, vol. 5, p. 106; cf. *CP*, V, p. 246.

ACASA. See *Archives of the Chinese Art Society of America*.

ACKER, WILLIAM R. B. *Some T'ang and Pre-T'ang Texts on Chinese Painting*, Leiden 1954.

AKIYAMA TERUKAZU. *Japanese Painting*, Lausanne 1961.

—— and MATSUBARA, SABURŌ. *Arts of China*, vol. 2: *Buddhist Cave Temples*, Tokyo and Palo Alto 1969.

—— and others. *Arts of China*, vol. 1: *Neolithic Cultures to the T'ang Dynasty*, Tokyo and Palo Alto 1968.

AN CH'I. See *Mo-yüan hui-kuan*.

Ancient Chinese Painting, exhibition at the Lowe Art Museum, University of Miami, Coral Gables, December 1973–January 1974.

Archives of the Chinese Art Society of America, New York 1945.

ARNHEIM, RUDOLF. *Art and Visual Perception*, Berkeley and Los Angeles 1967.

BACHHOFER, LUDWIG. *A Short History of Chinese Art*, New York 1946.

BARNHART, RICHARD. *Marriage of the Lord of the River: A Lost Landscape by Tung Yüan*, Ascona 1970.

BINYON, LAURENCE. *Painting in the Far East*, 4th edition, London 1934.

BUSH, SUSAN. *The Chinese Literati on Painting: Su Shih (1037–1101) to Tung Ch'i-ch'ang (1555–1636)*, Harvard Yenching Studies, no. 27, Cambridge, Mass. 1971.

BUSSAGLI, MARIO. *Chinese Painting*, Middlesex 1969.

CAHILL, JAMES, 'Ch'ien Hsüan and His Figure Paintings', *Archives of the Chinese Art Society of America*, vol. 12 (1958), pp. 11–29.

——. *Chinese Painting*, Lausanne 1960.

——. tr. 'Concerning the I-p'in Style of Painting', by S. Shimada, *Oriental Art*, vol. 7, no. 2 (1961); vol. 8, no. 3 (1962); vol. 10, no. 1 (1964).

——. 'The Early Styles of Kung Hsien', *Oriental Art*, vol. 16 (1970) pp. 51–71.

——. *Fantastics and Eccentrics in Chinese Painting*, New York 1967.

——. *Hills Beyond a River: Chinese Painting of the Yüan Dynasty, 1279–1368*, New York and Tokyo 1976.

——. *Parting at the Shore: Chinese Painting of the Early and Middle Ming Dynasty, 1368–1500*, New York and Tokyo 1978.

——, editor. *The Restless Landscape: Chinese Painting of the Late Ming Period*, exhibition at the University Art Museum, Berkeley 1971.

——. 'Wu Pin and his Landscape Painting', *Proceedings*, Taipei 1970, pp. 637–88.

CHANG AN-SHIH. *Kuo Hsi*, Shanghai 1959.

CHANG CH'OU. See *Ch'ing-ho shu-hua-fang*.

CHANG KENG. See *Kuo-ch'ao hua-cheng-lu* and *T'u-hua ching-i-chih*.

CHANG KUANG-PIN. *Yüan Ssu Ta Chia (The Four Great Masters of the Yüan: Huang Kung-wang, Wu Chen, Ni Tsan, Wang Meng)*, Taipei 1975.

CHANG YEN-YÜAN. See *Li-tai ming-hua-chi*.

Ch'ang-sha Ma-wang-tui I-hao Han-mu. 2 vols., Peking 1972.

CHAO HSI-KU. See *Tung-t'ien ch'ing-lu-chi*.

CHEN, J. D. See *Ch'en Jen-t'ao*.

CHEN SHIH-HSIANG. *Biography of Ku K'ai-chih*, Institute of East Asiatic Studies, University of California, Chinese Dynastic Histories Translations, no. 2, Berkeley and Los Angeles 1953.

CH'EN CHI-JU. See *Ni-ku-lu*.

CH'EN JEN-T'AO. *Chin-kuei ts'ang-hua p'ing-shih*, Hong Kong 1956.

——. *The Three Patriarchs of the Southern School in Chinese Painting*, Hong Kong 1955.

CH'EN YÜAN. *Shih-shih i-nien-lu*, Peking 1964.

CHENG CH'ANG. *Chung-kuo hua-hsüeh ch'üan-shih*, Shanghai 1929.

CHIANG CHAO-SHEN. *Wu-p'ai hua chiu-shih nien chan (Ninety Years of Wu School Painting)*, Taipei 1975.

CHIANG SHAO-YÜ. See *Huang-ch'ao lei-yüan*.

CH'IEN WEN-SHIH. See *Tzu-yen lun-hua*.

CH'IN TSU-YUNG. See *T'ung-yin lun-hua*.

Chin-kuei ts'ang-hua-chi, 2 vols., Kyoto 1956.

Chinese Art Treasures, exhibition catalogue, Geneva 1961.

Ch'ing-ho shu-hua-fang (12 ch.) by Chang Ch'ou, preface *c.*1616, edition: *Chih-pei ts'ao-t'ang*, 1763.

CHOU MI. See *Yün-yen kuo-yen lu*.

CHOU LIANG-KUNG. See *Tu-hua-lu*.

CHU CHING-HSÜAN. See *T'ang-chao ming-hua-lu*.

CHU CHU-YÜ. *T'ang-ch'ien hua-chia jen-ming tz'u-tien*, Peking 1961.

—— and LI SHIH-SUN. *T'ang Sung hua-chia jen-ming tz'u-tien*, Shanghai 1958.

CHUANG SHEN and JAMES C. Y. WATT. *Exhibition of Paintings of the Ming and Ch'ing Periods*, City Museum and Art Gallery, Hong Kong, 12 June–12 July 1970.

Chūgoku Meiga Hōkan (The Pageant of Chinese Painting), edited by Harada Kinjirō, Tokyo 1936.

Chung-kuo Hua-chia Jen-ming Ta-tz'u-tien, compiled by Sun Ta-kung, 2nd edition, Shanghai 1940.

Chung-kuo hua-lun lei pien compiled by Yü Chien-hua, Peking 1957.

Chung-kuo Ming-hua (Famous Chinese Paintings), 40 vols., Shanghai *s.a.*

CKHCJMTTT. See *Chung-kuo hua-chia jen-ming ta-tz'u-tien*.

CLAPP, ANNE DE COURSEY. *Wen Cheng-ming: The Ming Artist and Antiquity*, Ascona 1975.

COHN, WILLIAM. *Chinese Painting*, London 1948.

CONSTEN, ELEANOR V. ERDBERG. *Das alte China*, Stuttgart 1953.

CONTAG, VICTORIA. *Chinese Masters of the 17th Century*, translated by M. Bullock, Rutland, Vermont and Tokyo 1967.

—— and WANG CHI-CH'IEN. *Seals of Chinese Painters and Collectors of the Ming and Ch'ing Periods*, revised edition, with supplement, Hong Kong 1965.

CP. See Sirén, Osvald. *Chinese Painting: Leading Masters and Principles*.

DAVID, SIR PERCIVAL. *Chinese Connoisseurship: the Ko Ku Yao Lun, The Essential Criteria of Antiquities*, London 1971.

DEMIÉVILLE, PAUL. *Choix d'études Bouddhiques*, Leiden 1973.

Dictionary of Ming Biography. See Goodrich and Fang.

ECKE, GUSTAV. *Chinese Paintings in Hawaii*, 3 vols., Honolulu 1965.

EDWARDS, RICHARD. 'Ch'ien Hsüan and "Early Autumn"', *Archives of the Chinese Art Society of America*, vol. 7 (1953) pp. 71–83.

——. *The Field of Stones: A Study of the Art of Shen Chou*, Washington, D.C. 1962.

—— and others. *The Painting of Tao-chi 1641–c.1720*, exhibition at the Museum of Art, University of Michigan, Ann Arbor, 13 August–17 September 1967.

Experiences. See Soper, *Kuo Jo-hsü's Experiences in Painting*.

Famous Chinese Paintings. See *Chung-kuo ming-hua*.

FANG HSÜN. See *Shan-ching-chü hua-lun*.

FERGUSON, JOHN C. *Chinese Painting*, Chicago 1927.

FONG, WEN. 'A Letter from Shih-t'ao to Pa-ta shan-jen and the Problem of Shih-t'ao's Chronology', *Archives of the Chinese Art Society of America*, vol. 13 (1959), pp. 22–53.

——. 'The Problem of Ch'ien Hsüan' *Art Bulletin*, vol. 42 (September, 1960), pp. 173–89.

——. 'Tung Ch'i-ch'ang and the Orthodox Theory of Painting', *National Palace Museum Quarterly*, vol. 2, no. 3 (1968), pp. 1–26.

—— and MARILYN FU. *Sung and Yüan Paintings*, New York 1973.

FONTEIN, JAN and MONEY L. HICKMAN. *Zen Painting and Calligraphy*, Boston 1970.

—— and TOM WU. *Unearthing China's Past*, Boston 1973.

The Four Great Masters of the Yüan. See Chang Kuang-pin, *Yüan Ssu Ta Chia*.

FOURCADE, F. *Art Treasures of the Peking Museum*, New York 1965.

FU SHEN. 'A Preliminary Study to the Extant Works of Chü-jan', *National Palace Museum Quarterly*, vol. 2 (1967), pp. 11–24 and 51–79.

——. 'A Study of the Authorship of the *Hua-shuo*: A Summary', *Proceedings of the International Symposium on Chinese Painting*, Taipei 1972, pp. 85–115.

——. 'Two Anonymous Sung Dynasty Paintings and the Lu Shan Landscape', *National Palace Museum Bulletin*, vol. 2, no. 6 and vol. 3, no. 1 (1968).

Garland. See *I-yüan i-chen*.

GIACALONE, VITO. *Chu Ta*, exhibition at Vassar College Art Gallery, December 1972–January 1973, and subsequently at the New York Cultural Center.

GILES, HERBERT A. *A Chinese Biographical Dictionary*, London and Shanghai 1898.

——. *An Introduction to the History of Chinese Pictorial Art*, London 1918.

GILSON, ETIENNE. *Painting and Reality*, New York 1957.

GOODRICH, L. CARRINGTON and CHAOYING FANG, editors. *Dictionary of Ming Biography 1368–1644*, 2 vols., London and New York 1976.

HACKNEY, L. W. and YAU CH'ANG-FOO. *A Study of the Chinese Paintings in the Collection of Ada Small Moore*, Oxford 1940.

HAN CHO. See *Shan-shui ch'un-ch'üan chi*.

Hihō, 12 vols., Tokyo 1967– .

HO, WAI-KAM. 'Tung Ch'i-ch'ang's New Orthodoxy and the Southern School' in *Artists and Traditions*, Princeton 1976.

HSIA WEN-YEN. See *T'u-hui pao-chien*.

HSIANG TA. 'European Influences on Chinese Art', *Renditions*, VI, pp. 152–78.

HSIEH CHIH-LIU. *T'ang Wu-tai Sung Yüan ming-chi*, Shanghai 1957.

HSIEH HO. See *Ku-hua p'in-lu*.

Hsieh shan-shui chüeh by Huang Kung-wang (1269–1354), in *Hua-lun ts'ung-k'an*, compiled by Yü An-lan. 2 vols., Peking 1962.

Hsüan-ho hua-p'u, 20 ch., preface dated 1120, edition: *Ts'ung-shu Chi-ch'eng*, vols. 1652–3, Shanghai 1935.

Hua chi, 10 ch., by Teng Ch'un, preface dated 1167, edition: *Wang-shih shu-hua-yüan*, vols. 25–6.

Hua Chien, 1 ch., by T'ang Hou, written 1329, published 1330, edition: *Mei-shu ts'ung-shu 3/2/1*.

Hua Chien by T'u Lung, c.1600, edition: *Mei-shu ts'ung-shu 1/6/2*.

Hua-lun ts'ung-k'an, compiled by Yü An-lan, 2 vols., Peking 1962.

Hua shih, 1 ch., by Mi Fei, c.1100, edition: *Ts'ung-shu chi-ch'eng*, vol. 1647.

Hua-yü-lu by Tao-chi (c.1641–1717), edition:

Mei-shu ts'ung-shu 1/4/1.

Huang-ch'ao lei-yüan, 78 ch., by Chiang Shao-yü, preface dated 1145, edition: *Sung-fen-shih ts'ung-k'an*.

HUANG HSIU-FU. See *I-chou ming-hua lu*.

HUANG KUNG-WANG. See *Hsieh shan-shui chüeh*.

HUANG T'ING-CHIEN. See *Shan-ku t'i pa*.

Hui-chu ch'ien-lu by Wang Ming-ch'ing (c.1127–1214), edition: *Ssu-k'u ch'üan-shu tsung-mu t'i-yao* 3/2921.

I-chou ming-hua lu, 3 ch., by Huang Hsiu-fu, preface dated 1006, edition: *Wang-shih shu-hua-yüan*, vol. 27.

I-shu ts'ung-pien, Shanghai, 1916.

I-yüan i-chen (A Garland of Chinese Paintings) 5 vols., edited by Wang Shih-chieh and others, Hong Kong 1967.

ISE SENICHIRŌ. *Shina sanzui-gashi, Kenkyū Hōkoku*, vol. 5, Kyoto 1934.

Keng-tzu hsiao-hsia-chi by Sun Ch'eng-tse, compiled 1659, edition: *Feng-yü-lou ts'ung-shu*.

KKSHC. See *Ku Kung shu-hua-chi*.

KKSHL. See *Ku Kung shu-hua-lu*.

KOBAYASHI TAISHIRŌ. *Zengetsu daishi no shōgai to geijutsu*, Tokyo 1947.

Kokka, Tokyo 1889–

KUEI-T'IEN-LU. See *Ou-yang Hsiu*.

Ku-hua p'in-lu by Hsieh Ho (c.500), edition: *Mei-shu ts'ung-shu* 3/6/2.

Ku Kung, vols. 1–45. Peking, 1929–36.

Ku Kung chou-k'an (National Palace Museum Weekly), Peking 1929–37.

Ku Kung ming-hua san-pai chung (Three Hundred Masterpieces of Chinese Painting in the Palace Museum) 6 vols., Taichung 1959.

Ku Kung shu-hua-chi, 45 vols., Peking 1930–6.

Ku Kung shu-hua-lu, 3 vols., Taipei 1956.

Kuang-ch'uan hua-pa by Tung Yu (late 11th–early 12th century), edition: *Wang-shih shu-hua-yüan*, vols. 64–5.

Kuo-ch'ao hua-cheng hsü-lu, by Chang Keng, preface 1739 in *Hua-shih ts'ung-shu*, Shanghai 1963.

Kuo-ch'ao Wu-chün tan-ch'ing-chih, by Wang Chih-teng, 1563, edition: *Ts'ung-shu chi-ch'eng*, no. 1655.

KUO JO-HSÜ. See *T'u-hua chien-wen-chih*.

KUO SSU. See *Lin-ch'üan kao-chih*.

Kwen Catalogue (A Descriptive Catalogue of Ancient and Genuine Paintings) by F. S. Kwen (Kuan Fu-ch'u), Shanghai 1916.

LAWTON, THOMAS. *Chinese Figure Painting*, Washington, D.C. 1973.

——. *An Eighteenth-Century Chinese Catalogue of Calligraphy and Painting*, Ph.D. dissertation, Harvard University 1970.

LEE, SHERMAN E. *Chinese Landscape Painting*, New York 1962.

——. *A History of Far Eastern Art*, New York 1964.

—— and WAI-KAM HO. *Chinese Art Under the Mongols: The Yüan Dynasty*, Cleveland 1968.

LI, CHU-TSING, *The Autumn Colors on the Ch'iao and Hua Mountains: A Landscape by Chao Meng-Fu*. Ascona 1965.

——. 'The Freer *Sheep and Goat* and Chao Meng-fu's Horse Paintings', *Artibus Asiae*, vol. 30, no. 4 (1968), pp. 278–345.

——. 'Rocks and Trees in the Art of Ts'ao Chih-po', *Artibus Asiae*, vol. 23, no. 3/4 (1960), pp. 153–208.

——. *A Thousand Peaks and Myriad Ravines: Chinese Paintings in the Charles A. Drenowatz Collection*, Ascona 1974.

LI LIN-TS'AN. 'Fan K'uan Ch'i-shan hsing-lü t'u' in Li Lin-ts'an, *Chung-kuo ming-hua yen-chiu*, vol. 1, Taipei 1973, pp. 39–49.

——. 'A Study of a Masterpiece, T'ang Ming-huang's Journey to Shu', *Ars Orientalis*, vol. 4 (1961), pp. 315–21.

Li-tai jen-wu-hua hsüan-chi (Selected Figure Paintings of Successive Dynasties), Shanghai 1959.

Li-tai ming-hua-chi, 10 ch., by Chang Yen-yüan, preface dated 847, Taipei 1971.

LI T'IEN-CHIA. *Chung-kuo hua-lun*, Taipei 1968.

Liao-ning-sheng Po-wu-kuan ts'ang-hua chi (A Collection of Paintings from the Liaoning Provincial Museum), Peking 1962.

Lin-ch'üan kao-chih by Kuo Ssu, c.1100, edition: *Mei-shu ts'ung-shu* 2/7/1.

LIU HAI-SU. *Chung-kuo hui-hua shang-ti liu-fa lun*, Shanghai 1931.

Liu-ju chü-shih hua-p'u, 3 ch., attributed to T'ang Yin (1470–1523), edition: *Mei-shu ts'ung-shu* 2/9/2.

LIU TAO-CH'UN. See *Sheng-ch'ao ming-hua p'ing*.

LOEHR, MAX. 'Apropos of Two Paintings Attributed to Mi Yu-jen', *Ars Orientalis*, vol. 3 (1959), pp. 167–73.

——. 'Art Historical Art: One Aspect of Ch'ing Painting', *Oriental Art*, vol. 16 (Spring 1970), pp. 35–7.

——. 'Chinese Landscape Painting and its Real Content', *Rice University Studies*, vol. 59, no. 4 (Autumn 1973), pp. 67–96.

——. *Chinese Landscape Woodcuts. From an Imperial Commentary to the Tenth-Century Printed Edition of the Buddhist Canon*, Cambridge, Mass. 1968.

——. *Chinese Painting After Sung*, New Haven 1967.

——. 'Chinese Paintings with Sung Dated Inscriptions', *Ars Orientalis*, vol. 4 (1961), pp. 219–84.

——. 'The Fate of Ornament in Chinese Art', *Archives of the Chinese Art Society of America*, vol. 21 (1967–8), pp. 8–19.

——. 'A Landscape Attributed to Wen Cheng-ming', *Artibus Asiae*, vol. 22 (1959), pp. 143–52.

——. 'A Landscape by Li T'ang, Dated 1124', *Burlington Magazine*, vol. 74 (1939), pp. 288–93.

——. 'Phases and Content in Chinese Painting', *Proceedings of the International Symposium on Chinese Painting*, Taipei 1972, pp. 285–97.

——. 'The Question of Individualism in Chinese Art', *Journal of the History of Ideas*, vol. 22. (1961), pp. 147–58; reprinted in *The Garland Library of the History of Art*, vol. 14, New York and London 1976, pp. 19–30.

——. 'Some Fundamental Issues in the History of Chinese Painting', *Journal of Asian Studies*, vol. 23 (1964), pp. 185–93; reprinted in *Journal of Aesthetics and Art Criticism*, vol. 24 (1965), pp. 37–43, and in *The Garland Library of the History of Art*, vol. 14, New York and London 1976, pp. 139–93.

——. 'Studie über Wang Mong (Die datierten Werke)', *Sinica*, vol. 14 (1939), pp. 273–90.

LOVELL, HIN-CHEUNG. *An Annotated Bibliography of Chinese Painting Catalogues and Related Texts*, Michigan Papers in Chinese Studies, no. 16, Ann Arbor 1973.

MAEDA, ROBERT J. 'The Chao Ta-nien Tradition', *Ars Orientalis*, vol. 8 (1970), pp. 243–53.

——. *Two Twelfth Century Texts on Chinese Painting*, Michigan Papers in Chinese Studies, no. 8, Ann Arbor 1970.

——. 'The "Water" Theme in Chinese Painting', *Artibus Asiae*, vol. 33, no. 4 (1971), pp. 247–90.

MARCH, BENJAMIN. *Some Technical Terms of Chinese Painting*, Baltimore 1935.

MATSUMOTO EIICHI. *Tonkō-ga no Kenkyū*, 2 vols. Tokyo 1937.

Meng-ch'i pi-t'an, 25 ch., *pu*, 3 ch., by Shen Kua, late 11th century, edited by Hu Tao-ching, *Meng-ch'i pi-t'an chiao-cheng*, 2 vols., Shanghai 1956.

MEYER, AGNES. *Chinese Painting as Reflected in the Thought and Art of Li Lung-mien*, New York 1923.

MI FEI. See *Hua shih* and *Pao-chang tai-fang-lu*.

MIAO YÜEH-TSAO. See *Yü-i lu*.

Min Shin no kaiga (Paintings of the Ming and Ch'ing Dynasties), Tokyo 1964.

MIZUNO SEIICHI. *Painting of the Han Dynasty*, Tokyo 1957.

Mo-yüan hui-kuan, 4 ch., by An Ch'i, 1743, edition: *Ts'ung-shu chi-ch'eng*, vols. 1577–9, Shanghai 1937.

MOULE, A. C. *The Rulers of China, 221 B.C.–A.D. 1949*, London 1958.

MUNAKATA KIYOHIKO. *Ching Hao's Pi-fa-chi: A Note on the Art of Brush*, Ascona 1974.

——. 'The Process and Meaning of the Establishment of Painting of "Trees and Rocks" in China', *Tetsugaku*, no. 53 (September 1968).

MUNSTERBERG, HUGO. *The Landscape Painting of China and Japan*, 2nd edition, Rutland, Vermont, and Tokyo 1956.

NAGAHIRO TOSHIO. 'On the Painter Wei-ch'ih I-seng', *Jimbun Kagaku kenkyūsho*, Silver Jubilee Volume.

NAITO, TORAJIRŌ. *Shina kaigashi*, Tokyo and Kyoto 1938.

Ni ku lu, 4 ch., by Ch'en Chi-ju (1558–1639), edition: *Mei-shu ts'ung-shu* 1/10/4.

Ninety Years of Wu School Painting. See Chiang Chao-shen, *Wu-p'ai hua chiu-shih nien chan*.

Ou-yang Hsiu ch'üan-chi, 2 vols., Shanghai 1936.

The Pageant of Chinese Painting. See *Chūgoku meiga hōkan*.

PAINE, ROBERT TREAT and ALEXANDER SOPER. *The Art and Architecture of Japan*, Baltimore 1955.

Pao-chang tai-fang-lu by Mi Fei, preface dated 1086, edition: *Mei-shu ts'ung-shu* 1/8/1.

PELLIOT, PAUL. 'Les Fresques de Touen-houang et les Fresques de M. Eumorfopoulos', *Revue des Arts Asiatiques*, 1928, vols. 3 and 4.

——. 'Notes sur quelques artistes des Six Dynasties et des T'ang', *T'oung Pao*, vol. 22, no. 4 (October 1923).

——, 'Les statues en "laque sèche" dans l'ancien art chinois', *Journal Asiatique*, vol. 202, no. 2 (1923), pp. 181–207.

PIEN YUNG-YÜ. See *Shih-ku-t'ang shu hua hui-k'ao*.

Proceedings of the International Symposium on Chinese Painting, Taipei 1972.

ROSTOVTZEFF, M. *Inlaid Bronzes of the Han Dynasty in the Collection of C. T. Loo*, Paris and Brussels 1927.

ROWLAND, BENJAMIN. 'The Problem of Hui-tsung', *Archives of the Chinese Art Society of America*, vol. 5 (1951).

ROWLEY, GEORGE. *Principles of Chinese Painting*, Princeton 1947; 2nd edition, 1959.

RUDOLPH, R. C. 'Newly Discovered Chinese Painted Tombs', *Archaeology*, vol. 18, no. 3 (Autumn 1965), pp. 1–8.

RYCKMANS, PIERRE. 'Les "Propos sur la Peinture" de Shitao', *Mélanges chinois et bouddhiques* vol. 15, Bruxelles 1970.

SAKANISHI SHIO. *The Spirit of the Brush*, Wisdom of the East Series, London 1948.

SECKEL, DIETRICH. *Einführung in die Kunst Ostasiens*, Munich 1960.

——. 'Shakyamunis Rückkehr aus den Bergen', *Asiatische Studien*, vols. 18–19 (1965), pp. 35–72.

Sekai Bijutsu Zenshū, Tokyo 1961.

Select Chinese Paintings in the National Palace Museum, vol. 4, Taipei.

Shan-ching-chü hua-lun by Fang Hsün (1736–99), Peking 1962.

Shan-hu-wang hua-lu by Wang Lo-yü, preface dated 1643, edition: *Mei-shu ts'ung-shu* 2/1/2.

Shan-ku t'i-pa by Huang T'ing-chien (1050–1110), in *Su Huang t'i-pa*. Ch'ao-chi shu-ch'uang, 1924.

Shan-shui ch'un-ch'üan chi by Han Cho, dated 1121, edition: *Ts'ung-shu chi-ch'eng* vol. 1641.

Shang-hai Po-wu-kuan ts'ang-hua, Shanghai 1959.

Shen-chou ta-kuan, nos. 1–16, Shanghai 1921–2; *Hsü-pien*, nos. 1–11, Shanghai 1928–31.

SHEN KUA. See *Meng-ch'i pi-t'an*.

Sheng-ch'ao ming-hua p'ing, 3 ch., by Liu Tao-ch'un, c.1048, edition: *Wang-shih shu-hua-yüan*, vol. 23.

Shi Ō Go Un, Osaka 1919.

Shih-ch'ü pao-chi, 44 ch., by Chang Chao and others, part I, 1745; part II, 1793; part III, 1817.

Shih-ku-t'ang shu-hua hui-k'ao, 60 ch. by Pien Yung-yü, preface dated 1682; Taipei 1958.

Shih-po-chai shu-hua-lu, 22 ch., compiler and date unknown, possibly c.1800.

SHIMADA SHŪJIRŌ and YONEZAWA YOSHIHO. *Painting of the Sung and Yüan Dynasties*, Tokyo 1952.

Shina Nanga Shūsei, 36 vols., compiled by Tanaka Beihō, Tokyo 1918–20.

Shina Nanga Taisei, 16 vols; zoku-hen, 6 vols, Tokyo 1935–7.

SICKMAN, LAURENCE, editor. *Chinese Calligraphy and Painting in the Collection of John M. Crawford, Jr.*, New York 1962.

—— and ALEXANDER C. SOPER. *The Art and Architecture of China*, Harmondsworth and Baltimore 1956.

SIRÉN, OSVALD. *The Chinese on the Art of Painting*, Peking 1936 (reprinted by Schocken Books, 1963).

——. *Chinese Painting: Leading Masters and Principles* (abbreviated *CP*), 7 vols., London and New York 1956–8.

——. *Early Chinese Painting from the A. W. Bahr Collection*, London 1938.

——. *A History of Later Chinese Painting*, 2 vols., London 1938.

——. 'Shih-t'ao, Painter, Poet and Theoretician', *Bulletin of the Museum of Far Eastern Antiquities*, vol. 21 (1949), pp. 31–62.

Sō Gen no kaiga, Kyoto 1962.

SOPER, ALEXANDER C. *Kuo Jo-hsü's Experiences in Painting* (*T'u-hua chien-wen-chih*), Washington 1951.

——. 'A New Chinese Tomb Discovery: The Earliest Representation of a Famous Literary

Theme', *Artibus Asiae*, vol. 24, no. 2 (1961), pp. 79–86.

——. 'A Northern Sung Descriptive Catalogue of Paintings (The *Hua P'in* of Li Ch'ih)', *Journal of the American Oriental Society*, vol. 69, no. 1 (January–March 1949), pp. 18–33.

——. 'Southern Chinese Influence on the Buddhist Art of the Six Dynasties Period', *Bulletin of the Museum of Far Eastern Antiquities*, vol. 32 (1960).

——. 'T'ang-ch'ao ming-hua-lu: Celebrated Painters of the T'ang Dynasty by Chu Ching-hsüan of T'ang', *Artibus Asiae*, vol. 21, no. 3/4 (1958) pp. 204–30.

——. *Textual Evidence for the Secular Arts of China in the Period from Liu Sung through Sui* (A.D. 420–618). *Excluding Treatises on Painting*, Ascona 1967.

Sōraikan Kinshō (Abe Fusajirō Collection, Osaka Municipal Museum), 6 vols., Osaka 1930–9.

SPEISER, WERNER. *China: Geist und Gesellschaft*, Baden-Baden 1959.

STEIN, SIR AUREL. *Serindia*, 5 vols., Oxford: Clarendon Press, 1921.

——. *The Thousand Buddhas: Ancient Buddhist Paintings from the Cave-Temples of Tun-huang on the Western Frontier of China*, 3 vols., London 1921.

SU TUNG-P'O. *Tung-p'o t'i-pa*, in *Tung-p'o ch'üan-chi*.

SULLIVAN, MICHAEL. *The Birth of Landscape Painting in China*, Berkeley and Los Angeles 1962.

——. *An Introduction to Chinese Art*, Berkeley and Los Angeles 1961.

SUN CH'ENG-TSE. See *Keng-tzu hsiao-hsia-chi*.

SUN TA-KUNG. *Chung-kuo hua-chia jen-ming ta-tz'u-tien*, 2nd edition, Shanghai 1940.

SUZUKI, D. T. *Zen and Japanese Culture*, London 1959.

TA-FENG-T'ANG. See *Taifūdō meiseki*.

Taifūdō meiseki (Collection of Chang Ta-ch'ien). 4 vols., Kyoto 1955–6.

TANAKA ICHIMATSU and SHIMADA SHŪJIRŌ. *Ryōkai* (Liang K'ai), Tokyo 1967.

T'ang-ch'ao ming-hua-lu, 1 ch., by Chu Ching-hsüan (9th century), edition: *Mei-shu ts'ung-shu* 8/2/6.

T'ANG HOU. See *Hua chien*, 1329.

T'ang Liu-ju hua-chi, Paintings by T'ang Yin, Canton 1962.

T'ang Wu-tai Sung Yüan. See Hsieh Chih-lu.

T'ANG YIN. See *Liu-ju chü-shih hua-p'u* and *T'ang Liu-ju hua-chi*.

TAO CHI. See *Hua-yü-lu*.

TCHANG, M. and P. DE PRUNELÉ, S.J., *Le Père Simon A. Cunha, S.J.*, Var. Sin. no. 37, Shanghai 1914.

TENG CH'UN. See *Hua chi.*

TENG PO. *Chao Chi*, Shanghai 1958.

Three Hundred Masterpieces. See *Ku Kung ming-hua san-pai-chung.*

Tokugawa Bijutsukan meihin zuroku, Nagoya 1969.

TOMITA KŌJIRŌ. *Portfolio of Chinese Paintings* [in the Museum of Fine Arts, Boston] (Han to Sung Periods), Cambridge, Mass. 1938.

—— and TSENG HSIEN-CHI. *Portfolio of Chinese Paintings in the Museum*, vol. II: *Yüan to Ching Periods*, Boston 1961.

Tō Sō Gen Min meiga taikan, 2 vols., Tokyo 1929.

Tōyō Bijutsu Taikan, 15 vols., Tokyo 1911–18.

TSENG YU-HO. 'Notes on T'ang Yin', *Oriental Art*, vol. 2. (Autumn 1956).

Tu Fu's Gedichte, translated by Erwin von Zach. 2 vols., Harvard Yenching Institute Studies, no. 8, Cambridge, Mass. 1952.

Tu-hua-lu by Chou Liang-kung, postface dated 1673.

T'u-hua chien-wen-chih, 6 ch., by Kuo Jo-hsü, *c*.1080; translated by Alexander C. Soper, *Experiences in Painting.* Washington, D.C., 1951.

T'u-hua ching-i-chih, 1 ch., by Chang Keng, first published in 1762, edition: *Mei-shu ts'ung-shu* 3/2/2.

T'u-hui pao-chien, 5 ch., by Hsia Wen-yen, preface dated 1365, edition: *Ts'ung-shu chi-ch'eng.* vol. 1654.

T'U LUNG. See *Hua chien, c.*1600.

TUNG CH'I-CH'ANG (1555–1636). *Hua-chih*, in *Hua-lun ts'ung-k'an*, vol. 1.

Tung-p'o t'i-pa by Su Tung-p'o (1036–1101), edition: *Ts'ung-shu chi-ch'eng*, vols. 1590–1.

Tung-t'ien ch'ing-lu-chi by Chao Hsi-ku (late 12th – early 13th century), edition: *Ts'ung-shu chi-ch'eng*, no. 1552.

TUNG YU. See *Kuang-ch'uan hua-pa.*

T'ung-yin lun-hua by Ch'in Tsu-yung, preface dated 1880, edition: Taipei 1967.

Tzu-yen lun-hua by Ch'ien Wen-shih, *c*.1180, *Chung-kuo hua-lun lei-pien* I, 84.

VANDIER-NICOLAS, NICOLE. *Le 'Houa-che' de Mi Fou (1051–1107)*, Paris 1964.

WALEY, ARTHUR. *A Catalogue of Paintings Recovered from Tun-huang by Sir Aurel Stein*, London 1931.

——. *An Introduction to the Study of Chinese Painting*, London 1923.

——. *The Life and Times of Po Chü-i*, London 1948.

WANG CHIH-TENG. See *Kuo-ch'ao Wu chün tan-ch'ing-chih* and *Wu-chün tan-ch'ing chih.*

WANG FANG-YÜ. 'An Album of Flower Studies Signed "Ch'uan-ch'i" in the National Palace Museum and the Early Work of Chu Ta', *Proceedings of the International Symposium on Chinese Painting*, Taipei 1972, pp. 529–61.

WANG LO-YÜ. See *Shan-hu-wang hua-lu.*

WANG MING-CH'ING. See *Hui-chu ch'ien-lu.*

WANG PO-MIN. *Wu Tao-tzu*, Shanghai 1957.

WANG SHIH-CHEN. See *Wang-shih hua-yüan.*

Wang-shih hua-yüan by Wang Shih-chen, preface dated 1591.

WANG SHIH-MIN. *Yen-k'o t'i-pa*, compiled and edited by Li Yü-fen, preface dated 1909.

WEN CHAO-T'UNG. *Yüan-chi ssu-ta hua-chia*, Shanghai 1945.

Wen-hua ta-ko-ming ch'i-chien ch'u-t'u wen-wu, Peking 1972.

Wen Wu, Peking 1956–66, 1972– .

Wen-wu ching-hua, Peking 1959– .

WHITFIELD, RODERICK. *Chang Tse-tuan's 'Ch'ing-ming Shang-ho T'u'*, Ph.D. dissertation, Princeton University 1965, University Microfilms, Ann Arbor, Michigan 1976.

——. *In Pursuit of Antiquity*, Princeton 1969.

WILSON, MARC. *Kung Hsien: Theorist and Technician in Painting*, exhibition at the William Rockhill Nelson Gallery of Art, Mary Atkins Museum of Fine Arts, May–July 1969, *The Nelson Gallery and Atkins Museum Bulletin*, vol. 4, no. 9.

WU CH'I-CHEN. *Shu-hua-chi*, Shanghai 1963.

Wu-chün tan-ch'ing chih, 1 ch., by Wang Chih-teng, preface dated 1563, edition: *Mei-shu ts'ung-shu* 2/2/2.

WU, NELSON I. 'Tung Ch'i-ch'ang: Apathy in Government and Fervor in Art', in *Confucian Personalities*, eds. Arthur Wright and Denis Twitchett. Stanford 1962, pp. 260–93.

Wu-sheng-shih shih, in *Hua-shih ts'ung-shu*, Shanghai 1963.

Yen-k'o T'i-pa. See Wang Shih-min.

YONEZAWA YOSHIHO. *Chūgoku kaigashi kenkyū.* Tokyo 1962.

——. *Painting in the Ming Dynasty*, Tokyo 1956.

—— and MICHAEL KAWAKITA. *Arts of China*, vol. III: *Paintings in Chinese Museums*, Tokyo 1970.

YU CHIEN-HUA. *Chung-kuo hui-hua-shih*, Shanghai 1937.

Yü-i Lu by Miao Yüeh-tsao (1682–1761), Shanghai 1840.

Yün-yen kuo-yen lu, 2 ch., by Chou Mi (1232–*c*.1308), edition: *Ts'ung-shu chi-ch'eng*, vol. 1553.